The book of
photography

JOHN HEDGECOE

The book of
photography

JOHN HEDGECOE

DK

DK

LONDON, NEW YORK, MUNICH,
MELBOURNE, DELHI

Senior Editor
Becky Alexander

Project Editor
Nicky Munro

Art Editor
Michael Duffy

Managing Editor
Adèle Hayward

Managing Art Editor
Karen Self

Production Controller
Jane Rogers

Category Publisher
Stephanie Jackson

Art Director
Peter Luff

Associate Writers
Jonathan Hilton and Chris George

This revised edition first published in Great Britain in 2005
by Dorling Kindersley Limited,
80 Strand, London WC2R 0RL

This revised edition first published in the United States in 2005
by DK Publishing, Inc.
375 Hudson Street, New York, New York, 10014

Original edition first published in Great Britain in 1994
Original edition first published in the United States in 1994

A CIP catalogue record for this book is
available from the British Library.
Cataloging-in-Publication data is
available from the Library of Congress.

UK ISBN 1 4053 0438 3
US ISBN 0 7566 0947 X

Reproduced in Singapore by Colourscan
Printed and bound in China by Toppan

see our catalogue at
www.dk.com

CONTENTS

INTRODUCTION 6

THE CAMERA 12

*The design of film and digital cameras with an
explanation of how they work. Different types of camera, lens,
and lighting equipment are also described in detail.*

HOW TO SEE
BETTER PICTURES 34

*The secret of good photography lies in the ability to "see"
good pictures, the principal elements of which – shape, tone,
pattern, and texture – are analyzed in this section.*

HOW TO TAKE
BETTER PICTURES 70

*A comprehensive and practical behind-the-camera
guide to photographing different subjects, from formal portraits
to panoramic landscapes.*

PORTRAITS 72

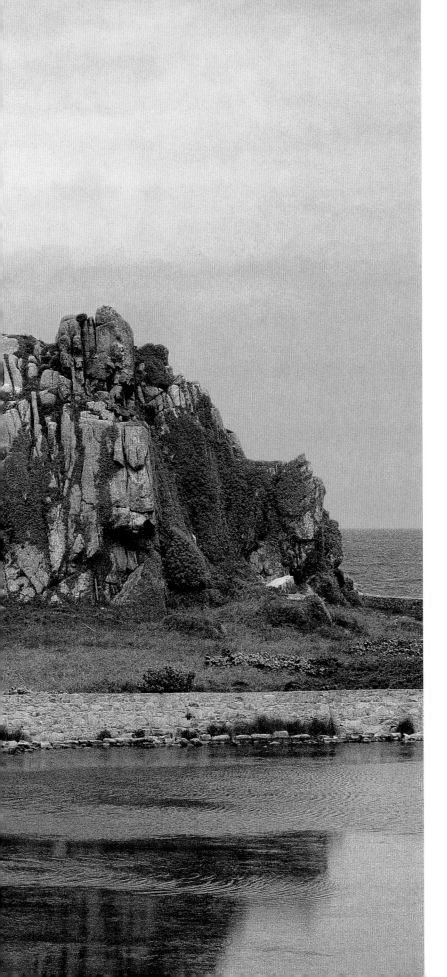

INTRODUCTION

Taking exciting photographs has very little to do with buying an expensive camera or having a massive array of photographic equipment. What is crucial is how you see a chosen subject – and then how this vision is transformed into a permanent image using photographic techniques and composition.

A PRACTICAL APPROACH

This book adopts a practical approach to help you master photography. The largest section covers a wide range of photographic genres, including portraiture, still life, landscapes, architecture, and natural history. All these are illustrated with behind-the-scenes shots of me out on location or in a studio actually taking the pictures. These photo set-ups reveal exactly how a shot was taken, the equipment that was used, the camera angle, and the wider settings from which the pictures were derived.

A technical understanding of your camera is important, as it allows you to capture the pictorial qualities of a scene in the best way possible, whether you are using film or a digital chip. These fundamental camera controls are illustrated in the first section of the book using both diagrams and photographs. The more familiar you become with the controls and lens settings on your own particular camera, the more attention you can pay to composition and timing.

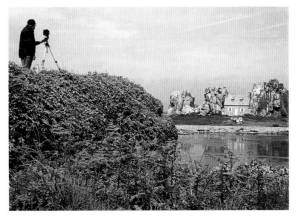

Framing the shot, *left*
The photographer's skill lies not only in knowing what to include in the photograph, but also what to leave out.

Photographer at work
The unique photo set-ups provide a practical insight into the way I work in the studio and on location.

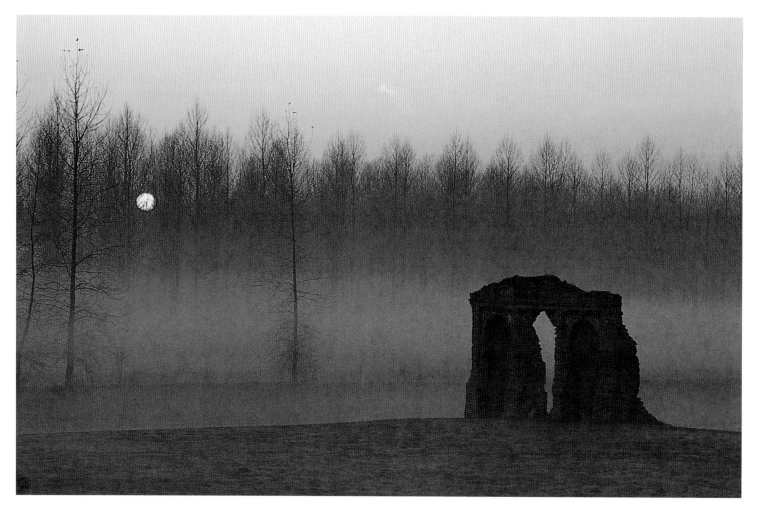

Texture and light, *above*
This image shows how light can be used to reveal contrasting textures. The composition is simple, but the effect created by the lighting is striking.

Using color, *right*
Some colors have a very powerful effect in pictures. The red of this clown's mask dominates this portrait, grabbing the viewer's attention.

Good photographs tend to capture the spirit of a subject by showing some of its features more strongly than others. To do this you need to take advantage of the fundamental elements of an image, emphasizing those that are most useful for the interpretation of the subject using composition and lighting. The most basic of these elements is the shape of a subject, for example, which is shown most graphically when the subject is silhouetted by means of backlighting and underexposure. Other key elements are form, texture, tone, and color. I explain how to use these, and other, compositional devices in the section entitled How to See Better Pictures.

THE DIGITAL REVOLUTION

In recent years, digital cameras have made a huge difference to how photographers, both amateur and professional, take pictures. In the last century it was the 35mm SLR that was the single most important invention for the serious photographer. Now, in the 21st century, many keen photographers are using digital imaging instead of film. Despite the basic difference in the way an image is recorded, many of the main camera controls are the same as they were. In fact, many digital cameras are designed to look and handle in exactly the same way as the traditional SLR. Most of the basic techniques also remain virtually unchanged. However, when there are differences in the way the different types of camera are used, these have been highlighted throughout the book, so that you can get the most out of my advice, whatever camera you use.

Where digital imaging comes into its own is in the way that it can allow you to change and improve the picture after it is taken. Whether shot digitally or on film, once on a computer the exposure and composition can be altered with an ease, precision, and subtlety that are impossible to reproduce using traditional means.

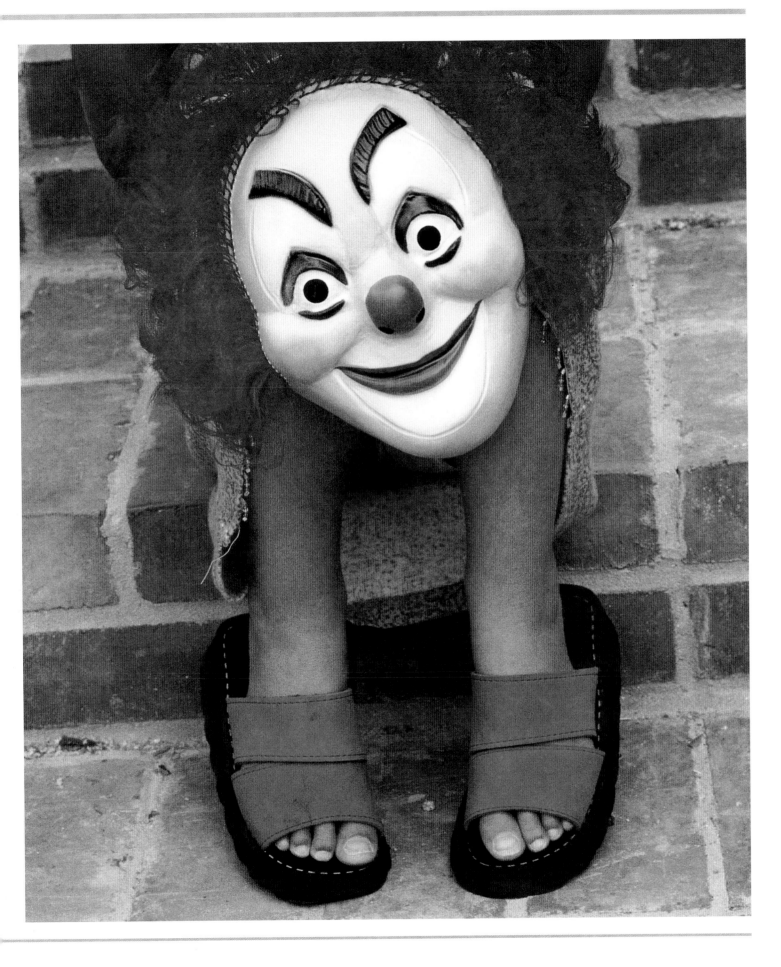

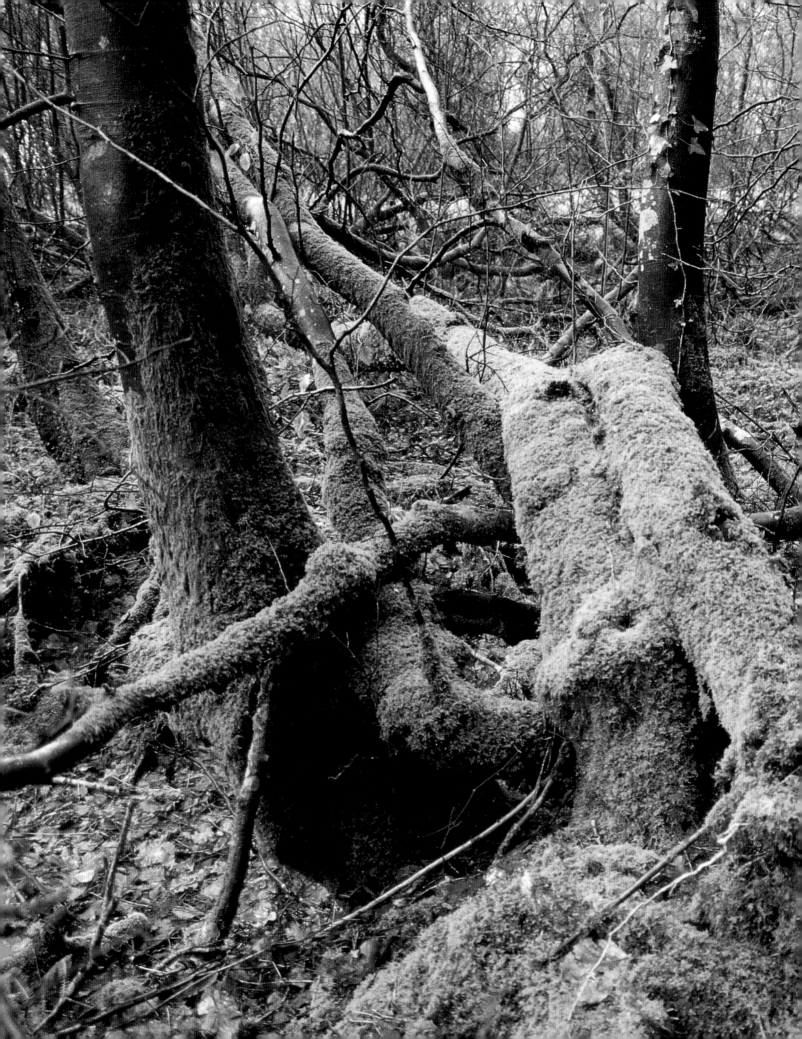

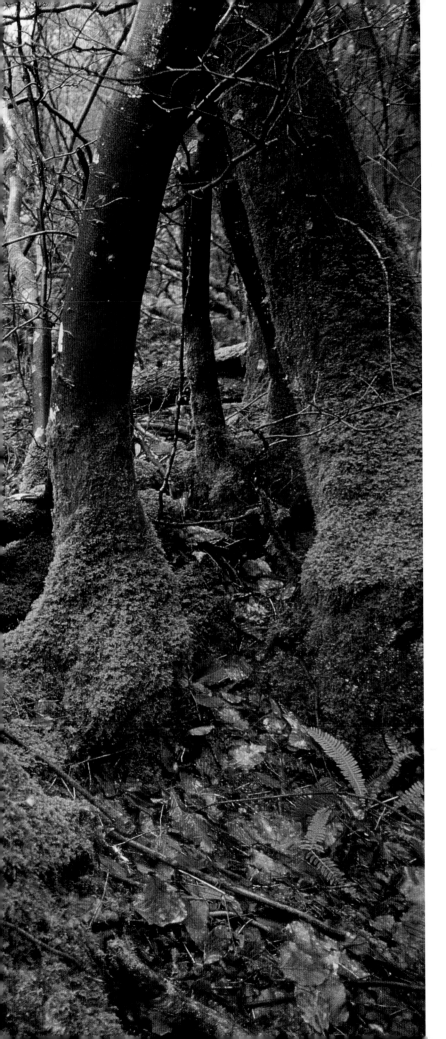

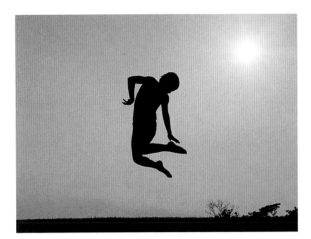

Developing an eye, *left*
Part of the skill of good
photography lies in being
able to see, and capture,
great images in the ordinary
things around you.

Unnatural view, *above*
Photography lets you see
the world in new ways. To
the eye, this athlete would
appear neither frozen nor
as a crisp, black silhouette.

Using my own examples again, I provide an
overview of how digital image manipulation
software, such as Adobe Photoshop, can not
only improve your photography, but can add
a new level of artistry to it.

THE COMPLETE PHOTOGRAPHER

The basic equipment you need to set up
a home darkroom and studio is covered
in the last section of this book. Even an
impromptu studio allows you to experiment
with lighting and control it in a way that is
impossible to achieve outdoors. Having your
own darkroom, meanwhile, allows you to
manipulate, crop, and enlarge your own
images without the need for a computer,
scanner, or desktop printer. The fault finder
section will help you see what mistakes
you might make when taking and printing
pictures, and the best way to avoid them –
as well as how to rectify the problem using
conventional or digital techniques.

 Use this book as a guide to developing
your own creativity and individual style. By
exploring the many possibilities of the
medium, you will discover limitless ways to
express your own particular vision.

John Hedgecoe

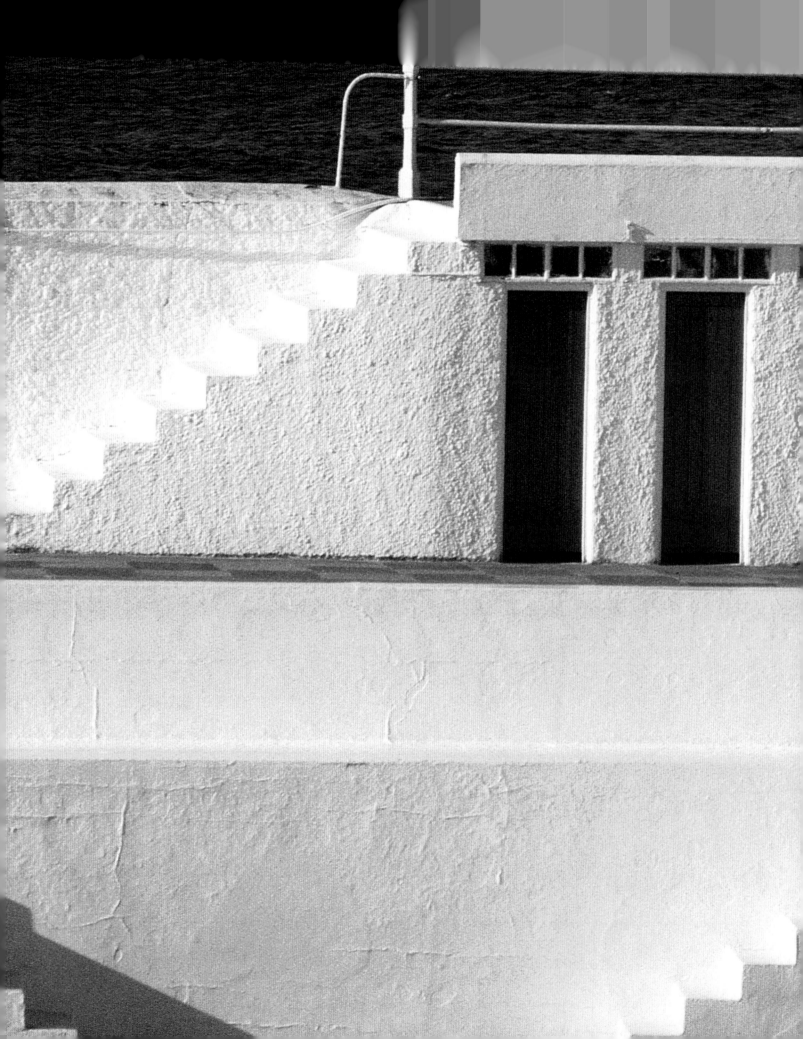

THE CAMERA

To take consistently successful photographs,
it is important to understand the basic
optical principles underlying how a camera
works; type of lens; what film speed or digital
setting to use in a particular situation; lighting
equipment; plus the advantages and
drawbacks of different camera formats.
The more familiar you are with the controls
on your camera, the more you can
concentrate on the composition and lighting
of each photograph.

THE BASIC CAMERA

If you were to strip away the electronic refinements and automatic features of any camera you would find the same basic design underneath – a lightproof container with a hole at one end over which a lens is placed and a holder opposite to accommodate either a strip of light-sensitive film, or a light-sensitive electronic chip.

To produce a correctly exposed image in a variety of light intensities, the camera lens has an iris diaphragm that can be adjusted to leave a hole of varying diameter. This is called the aperture. On a fixed-lens compact camera, the lens also contains a shutter

mechanism, known as a between-the-lens shutter, which opens to allow light to reach the film. The shutter allows you to choose the precise moment of exposure, and by selecting from a range of shutter speeds you can also control the length of exposure. The shutter mechanism on a single lens reflex (SLR) camera is located inside the body, behind the lens, just in front of the film or digital sensor, and is known as a focal-plane shutter.

Another common feature is the viewfinder. This is basically a compositional aid that allows you to aim the camera accurately and to decide what elements to focus on.

CAMERA TYPES

- SLRs are the most popular type of camera for serious photography, they are either digital or use 35mm film.
- Compact digital or film cameras are light and easy to use.
- Medium-format cameras use wide rolls of film for better image definition.

THE PATH OF LIGHT

Subject and light source
A light source to illuminate a subject is essential. Light rays reflected from the subject are transmitted through the camera to form a latent image on the film (or digital chip).

Subject and light source

Lens
A simple lens consists of a convex disk of ground and polished glass that refracts the widening light rays traveling away from every point of the subject, so that they converge to form coherent points. The point at which the lens focuses these rays – the focal plane – coincides with the position of the film when the lens is correctly focused.

Lens

Focal plane
This is where the rays of light refracted by the lens converge to form a sharp, upside-down image. Light traveling from different distances from the camera needs varying degrees of refraction to focus at the focal plane, so a focusing mechanism moves the lens toward or away from the back of the camera. The position of the film, or chip, and focal plane coincide if the lens is correctly focused.

Diaphragm

Shutter

Viewfinder

Focal plane and film

Aperture
The diameter of the lens diaphragm can be changed by turning the aperture ring. This dictates the brightness of the image reaching the film. Moving to the next f-number either halves or doubles aperture size. Aperture size also affects depth of field (*see page 17*).

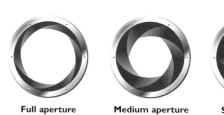

Full aperture **Medium aperture** **Stopped down**

Shutter
The shutter can be set at different speeds, which determine the length of time the film is exposed. Moving the shutter speed dial to the next stop either doubles or halves exposure time. Shutters located between the aperture and the lens or behind the aperture have overlapping blades that spring open when the release button is pressed; focal-plane shutters consist of two metal blinds that open progressively.

Blade shutter – closed **Focal-plane shutter – closed**

Blade shutter – open **Focal-plane shutter – open**

Viewfinder
Direct vision viewfinders on compact cameras do not show exactly the same image the lens sees. With an SLR, light is reflected by a mirror and pentaprism to the viewfinder. Digital cameras usually also have an LCD TV monitor to show the image being projected onto the sensor.

Direct vision **Single lens reflex**

DESIGN OF AN SLR CAMERA

The unique feature of the popular SLR (single lens reflex) camera lies in the design of its viewfinder system. Light traveling from the subject enters the lens and strikes a mirror angled at 45°. It is then reflected upward, through the focusing screen, and into the pentaprism, where it exits the camera via a rear-mounted viewfinder window. This means that no matter what focal length lens is attached to the camera, the scene the photographer sees through the viewfinder corresponds exactly to that seen by the lens.

35mm SLR cutaway
This cutaway of a typical SLR shows the link between the external controls and the internal mechanisms. Although camera models may look different, the layout of the basic features – lens, diaphragm, aperture, angled mirror, shutter, focusing screen, and pentaprism – is the same.

35mm SLR back view
This view shows a typical SLR with the hinged back removed to reveal the layout of the lightproof film chamber and position of the focal-plane shutter.

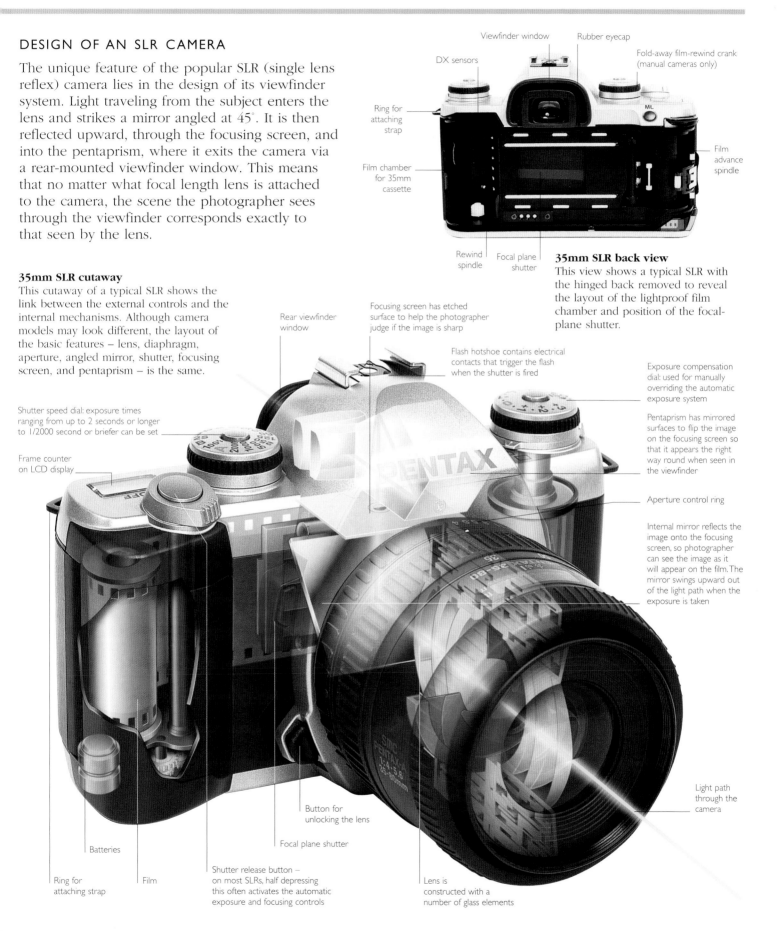

Viewfinder window

Rubber eyecap

DX sensors

Fold-away film-rewind crank (manual cameras only)

Ring for attaching strap

Film chamber for 35mm cassette

Film advance spindle

Rewind spindle

Focal plane shutter

Rear viewfinder window

Focusing screen has etched surface to help the photographer judge if the image is sharp

Flash hotshoe contains electrical contacts that trigger the flash when the shutter is fired

Exposure compensation dial: used for manually overriding the automatic exposure system

Shutter speed dial: exposure times ranging from up to 2 seconds or longer to 1/2000 second or briefer can be set

Pentaprism has mirrored surfaces to flip the image on the focusing screen so that it appears the right way round when seen in the viewfinder

Frame counter on LCD display

Aperture control ring

Internal mirror reflects the image onto the focusing screen, so photographer can see the image as it will appear on the film. The mirror swings upward out of the light path when the exposure is taken

Button for unlocking the lens

Light path through the camera

Batteries

Focal plane shutter

Ring for attaching strap

Film

Shutter release button – on most SLRs, half depressing this often activates the automatic exposure and focusing controls

Lens is constructed with a number of glass elements

OPTICAL PRINCIPLES

The main lens controls are the focus control and aperture ring. Most lenses also have a distance indicator, telling you how far away the lens is focused. Some also have a depth of field scale, indicating the extent of the zone of sharp focus. The three factors affecting depth of field are aperture, subject-to-camera distance, and the focal length of the lens. Greatest depth of field results from the smallest available aperture on the shortest lens, focused on infinity (∞). As apertures get larger, focal lengths longer, and subject distances nearer, so depth of field diminishes.

The aperture setting is a key element in exposure. However, the best setting to use depends on how much depth of field is required and also the shutter speed setting. A faster shutter speed freezes movement and keeps camera shake from affecting the image, a slower setting may produce a blurred image.

FOCUSING AND APERTURE

Depth of field

The zone of acceptably sharp focus surrounding a subject is critical to an image's appearance. To make full use of all aperture available, it may be necessary to put the camera on a tripod to prevent camera shake. The two pictures below are identical in terms of exposure – although the first was shot at 1/60 second at f2, the second one at 1 second at f16. Focusing the lens on the woman in the foreground, the man in the distance is only in focus when the smaller aperture (f16) is used.

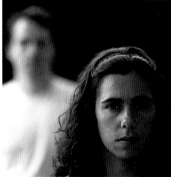

Exposure: 1/60 second at f2

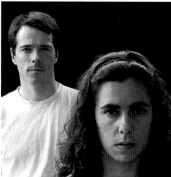

Exposure: 1 second at f16

f2 - 1/60 sec

f2.8 - 1/30 sec

f4 - 1/15 sec

f5.6 - 1/8 sec

f8 - 1/4 sec

f11 - 1/2 sec

f16 - 1 sec

The f stop and aperture size

Any type or size of lens set at a specific f stop transmits an image of near identical luminance, because the diameter of the aperture is directly related to focal length. For example, an 80mm lens used with an aperture 5mm in diameter must be set at f16. Thus, the focal length of the lens, divided by the diameter of the aperture, gives the corresponding f-stop number.

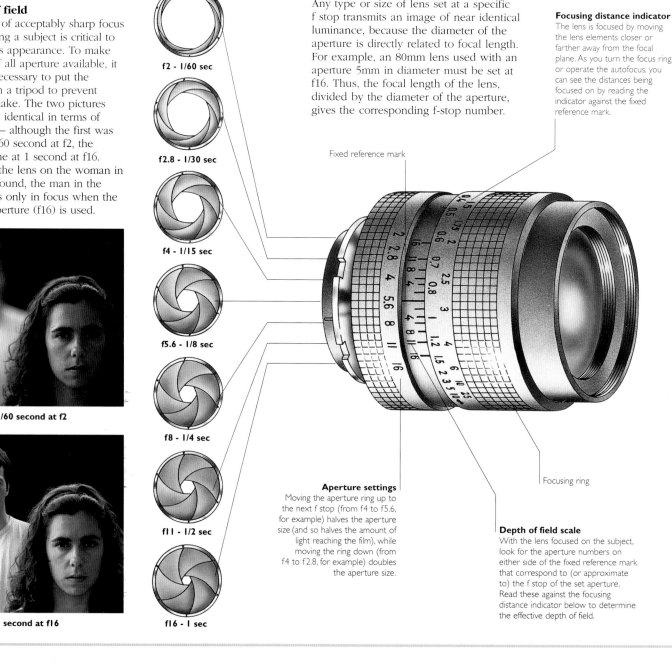

Fixed reference mark

Focusing distance indicator
The lens is focused by moving the lens elements closer or farther away from the focal plane. As you turn the focus ring, or operate the autofocus, you can see the distances being focused on by reading the indicator against the fixed reference mark.

Focusing ring

Aperture settings
Moving the aperture ring up to the next f stop (from f4 to f5.6, for example) halves the aperture size (and so halves the amount of light reaching the film), while moving the ring down (from f4 to f2.8, for example) doubles the aperture size.

Depth of field scale
With the lens focused on the subject, look for the aperture numbers on either side of the fixed reference mark that correspond to (or approximate to) the f stop of the set aperture. Read these against the focusing distance indicator below to determine the effective depth of field.

EFFECTS ON DEPTH OF FIELD

Changing aperture size
With the same focal length of lens, focused at the same distance, this diagram shows how depth of field is altered by adjusting the aperture size alone. Depth of field extends farther behind the subject than in front (except for very close focus distances). The smaller the aperture the greater the depth of field. An aperture of f2.8 gives much less depth of field than one of f22.

Changing the aperture (with 70mm lens focused at 10m)

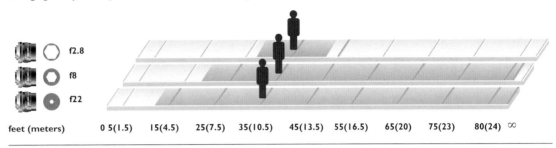

Subject-to-camera distance
This diagram shows how depth of field is also dependent on the distance of the subject from the camera, even when an identical focal length and aperture setting are used. The closer the subject is to the camera, the narrower the depth of field. Focusing the lens on 66ft (20m) yields a greater depth of field than focusing on 3ft (1m).

Changing the focused distance (with 70mm lens set at f/8)

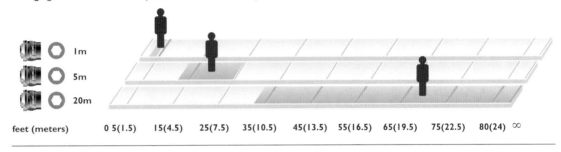

Changing lenses
With the subject at the same distance from the camera and with the same aperture size, depth of field can be altered by altering the focal length (by changing the lens or by zooming). The shorter the focal length, the greater the depth of field. Extreme (8–15mm) wide-angle lenses hardly need to be focused, as depth of field is so extensive at every aperture.

Changing the focal length (with aperture set at f/8 and focused at 10m)

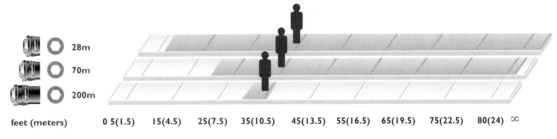

SELECTIVE FOCUSING

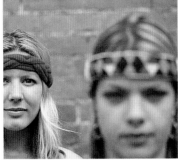

This series of photographs shows three elements positioned 3ft (1m) apart, with the closest 5ft (1.5m) from the camera. A 35mm SLR with an 80mm lens was used throughout, and an aperture of f2.8 for the first three shots. First, the lens is focused on the near figure; depth of field is shallow.

The difference here is that the camera is focused on the woman on the left. Depth of field is such that the first figure is now blurred, but because depth of field increases as the point of focus moves farther away, the rear wall is now slightly sharper, even though the other camera settings have not changed.

The lens is now focused on the far wall. Although the woman on the left is now out of focus, the woman on the right is more blurred. You can use depth of field to hide distracting elements in a picture – but being out of focus does not guarantee that they are unrecognizable.

To bring all three elements into focus, from foreground woman to background wall, the smallest available aperture size is set. For this image, again taken with the 80mm lens, the aperture is changed to f22. Focusing on the figure on the left, all elements are now within the depth of field limits.

FILM CAMERAS

The 35mm is far and away the most popular camera size. It is small, lightweight, easy to use, and generally produces good results. Its popularity has led to a steady increase in technical, optical, and design innovations, and cameras are now available with every conceivable automatic feature. For 35mm single lens reflex (SLR) users, there is the added bonus of a wide range of lenses with different focal lengths from which to choose.

AUTOMATIC FEATURES

Autofocus systems in general target anything positioned center-frame and assume it to be the subject of the photograph. Problems may arise, however, if the subject is off-center, although more elaborate systems exist that can identify the closest subject from a wide area within the frame.

Autoexposure systems vary in how they are programed to control exposure. Some cameras measure exposure in the center of the frame (assuming that this is where the subject will be). Other cameras take samples from different parts of the frame, combining these multizone or evaluative readings to callculate an intelligent reading.

Additional automatic features include film-speed recognition (DX coding), which picks up the speed of the film from a code printed on the cassette. Automated film transport not only speeds up film loading and unloading, but winds on the film by one frame each time a picture is taken. When automatic wind-on is continuous, allowing you to take up to four frames per second, this function is known as motor drive.

COMPACT CAMERAS

The other popular types of 35mm camera are compact, or point-and-shoot, models. These are less bulky than SLRs and have a fixed lens that cannot be changed. The main design problem with compact cameras is that the view seen through the viewfinder is not exactly the same as that seen through the lens. This can result in framing errors at close distances, such as chopping off the top of a subject's head. It is also not possible to see whether the image is correctly focused.

MANUAL SLR

The least expensive film SLRs tend to be those which do not have autofocus. For every shot, you turn the lens until the subject in the viewfinder appears as sharp as possible. On some models you may also need to wind the film on manually between shots and when the film is used up – but there may be a built-in motor to do this for you.

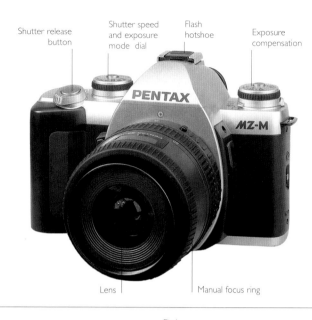

Shutter release button · Shutter speed and exposure mode dial · Flash hotshoe · Exposure compensation · Lens · Manual focus ring

AUTOFOCUS SLR

The majority of SLR cameras now have autofocus. The skill of this feature will vary greatly from model to model – with some able to track fast-moving subjects far more accurately than others. But it is still necessary for the photographer to check and control where the camera focuses – and in some situations it will be preferable to focus manually.

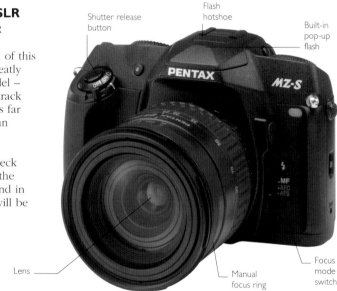

Shutter release button · Flash hotshoe · Built-in pop-up flash · Lens · Manual focus ring · Focus mode switch

APS COMPACT

An alternative to the 35mm film format is APS, or Advanced Photo System. The film area is smaller than 35mm, but this means that compact cameras can become even more compact. The cartridges just slot into the camera – you do not see or touch the film. With APS you can also change the shape of each picture between conventional, widescreen, and panoramic aspect ratios.

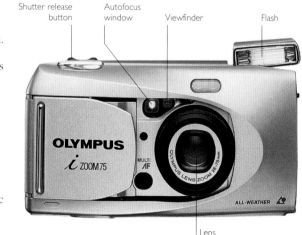

Shutter release button · Autofocus window · Viewfinder · Flash · Lens

Manual SLR can be used for close focusing

MANUAL SLR

- Ideal for technically minded photographers.

- Shutter speeds tend to be incremental and intermediate settings are not usually possible.

- Viewfinder shows the scene that will be recorded, no matter what lens is used.

- Manual focusing allows you to decide which area of the image to concentrate on.

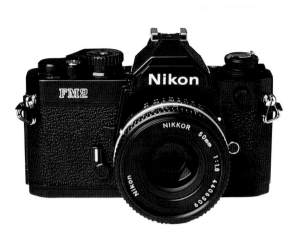

BUYING SECONDHAND

- Buying a secondhand SLR allows you to own a sophisticated camera for the fraction of the cost of a new one. It is not necessary to have the latest model in order to take great photographs.

- Secondhand film cameras and accessories have become even more affordable in recent years. This is because many serious photographers have switched to digital cameras.

- If you buy from a reputable dealer your purchase will be guaranteed against malfunction for a number of months. But you may get a better deal privately or online through an auction site.

- Secondhand price is highly dependent on the visible condition of the item. You will pay much less if you are willing to buy a scuffed item, or one that does not come in the original box.

- Lenses, and some other accessories, are also good used deals. But make doubly sure that they will work with your particular model of camera.

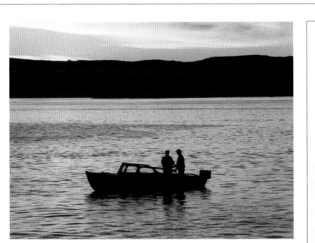
Automatic SLR can be used for low light levels

AUTOMATIC SLR

- Automatic film loading and wind-on make for quick and easy handling.

- Autoexposure is ideal for those not interested in making technical decisions about the appearance of the final image.

- Autofocus is useful for those with poor eyesight, or when the camera is being used in low-light situations.

ZOOM COMPACT

All but the most basic compacts have built-in zooms, allowing you to change the focal length to match subject size and distance. Advanced models offer a greater zoom range allowing you to get close-ups of more challenging subjects. Top models also offer more advanced metering, focusing and viewing systems. However, you still miss out on the degree of control over camera settings and focusing that is available on even a basic SLR.

Shutter release button

Autofocus window

Viewfinder

Flash and red-eye reduction lamp

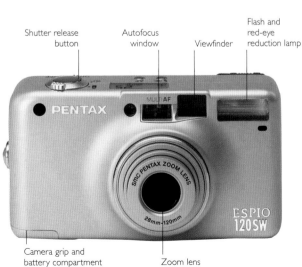

Camera grip and battery compartment

Zoom lens

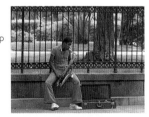
Basic compact picture

Advanced compact picture

COMPACT

- Point-and-shoot features make this camera ideal for non-technical users.

- Scene in viewfinder is not the same as that recorded on the film, so use the parallax marks to frame scene.

- Most compact cameras are lighter and less intrusive to use than SLRs.

DIGITAL CAMERAS

A principal attraction of digital cameras is the immediacy of the results. As soon as the picture is taken, you can view the shot on screen. As there is no processing stage, there is also the advantage of low running costs; even the memory can be re-used. As well as being displayed on camera, computer, or TV screen, digital pictures can also be printed at home using a standard desktop printer – or professionally using photographic paper.

HOW DO THEY WORK?

Instead of using film, digital cameras use an electronic light-sensitive CCD or CMOS chip that converts the focused image into an electrical signal. This is then converted into a digital form, using the same binary code in which all computer files are stored.

Just as with film cameras, the sophistication of digital cameras varies enormously. Some are mere point-and-shoot models, producing low-resolution on-screen snaps. At the other extreme, an ever-increasing number are capable of offering all the creative control and picture quality expected from a professional film camera.

A key consideration in choosing a digital camera is the number of pixels – the individual elements used by the imaging sensor. The more pixels, the higher the maximum resolution. This is particularly important if you want to print your images, rather than just view them on-screen. An enthusiasts' model will typically offer a resolution of 5 million pixels, and be capable of producing reasonable A3 (16x12in/40.6x30.5cm) prints.

ABOUT PIXELS

• Choose a model with two million or more pixels for good 4x6in (10x15cm)prints.

• The higher the resolution, the bigger the file size – so you get less shots on a memory card.

• You do not always have to shoot at top resolution – file size can be reduced from shot to shots. But a high resolution allows more cropping later.

DIGITAL SLR

A digital SLR is designed to offer the advantages of digital recording – but with the handling and features of a 35mm SLR. The design allows you to see the image directly through the lens using a prism and moving mirror arrangement. But there is also an additional LCD monitor, which can be used for framing shots, or reviewing pictures already taken. The lenses are interchangeable, and many digital SLRs can use lenses designed for 35mm models; but, as the imaging area is smaller than that used with 35mm, the effective focal length is increased. There is a high degree of control over exposure, focusing, color balance, and other creative functions.

DIGITAL SLR

• Reflex viewing system lets user see directly through lens. Large LCD monitor also provided.

• Interchangeable lenses. Other system accessories available to adapt camera to specific tasks.

• Wide range of creative controls and manual overrides.

• Readout of aperture and shutter speed.

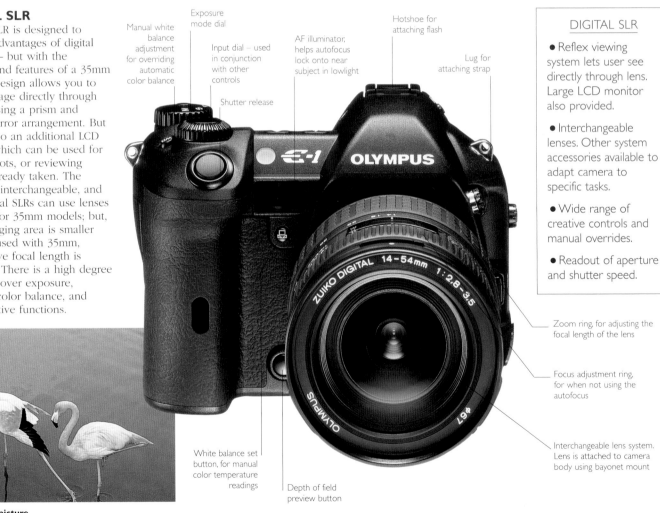

Manual white balance adjustment for overriding automatic color balance

Exposure mode dial

Input dial – used in conjunction with other controls

Shutter release

AF illuminator, helps autofocus lock onto near subject in lowlight

Hotshoe for attaching flash

Lug for attaching strap

Zoom ring, for adjusting the focal length of the lens

Focus adjustment ring, for when not using the autofocus

Interchangeable lens system. Lens is attached to camera body using bayonet mount

White balance set button, for manual color temperature readings

Depth of field preview button

Digital SLR picture

HYBRID MODEL

The hybrid is a halfway house between the SLR and the compact. It is designed to look and handle like an SLR, but as the zoom is built-in the lens can not be changed to suit different situations. The focal length range, however, is usually extensive – and there are often other system accessories such as lens converters and additional flashguns. Most significantly for the serious photographer, the user typically has complete control over aperture, shutter speed and color balance – providing a degree of creative control that is rarely found on a compact. Hybrid models are lighter, smaller, and less expensive than true SLRs.

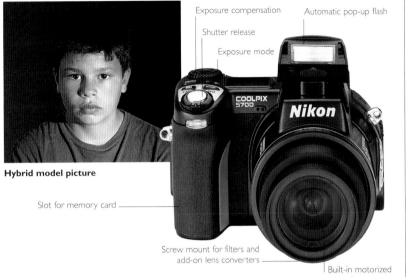

Exposure compensation

Shutter release

Exposure mode

Automatic pop-up flash

Hybrid model picture

Slot for memory card

Screw mount for filters and add-on lens converters

Built-in motorized zoom lens

HYBRID MODEL

- Designed to handle like an SLR camera – but lens is fixed.

- Lens has a wide ratio, typically with a 6x zoom ratio or greater.

- Eyelevel TV monitor shows view seen by lens. There is also a large LCD monitor.

- Wide range of creative controls and manual overrides, with readout of aperture and shutter speed.

COMPACT CAMERA

Compact digital cameras are designed for ease of use and portability, but typically provide a greater creative control than that found on a similar film camera. Most have built-in zoom lenses, but the range varies significantly from model to model. The number of pixels used (and maximum resolution) also varies greatly. There is often some control over shutter speed, aperture, color balance, and focusing – but this falls short of that provided with SLR or hybrid models. A direct eyelevel viewfinder provides a slightly different view from that seen by the lens, although a more accurate LCD monitor is also provided.

Mode dial

Shutter release

Viewfinder

Automatic flash

Compact camera picture

Built-in motorized zoom lens: retracts into body of camera when not in use

DIGITAL COMPACT

- Designed primarily for ease of use and portability.

- Maximum resolution varies significantly from model to model.

- Has a fixed lens, which usually offers short zoom range.

- Direct vision eyelevel viewfinder. But usually also has large LCD monitor.

BASIC DIGITAL CAMERA

If you do not need to print out your pictures, and are happy to view them on-screen, and without being enlarged, there is no need to invest in a model with millions of pixels. Many low-cost digital cameras are designed as "webcams" – for producing stills and movie images for internet use, where low resolution, and small file sizes, are essential. Digital cameras are also found built into other devices – such as cell phones and camcorders. Those found on phones are particularly popular, and are designed for sending thumbnail images to other phones or to email addresses. Not suprisingly, the features provided are very limited.

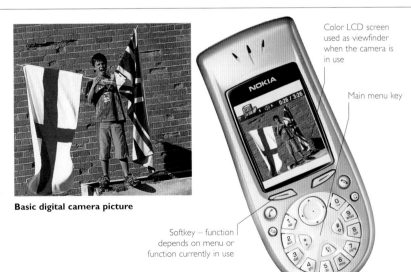

Color LCD screen used as viewfinder when the camera is in use

Main menu key

Basic digital camera picture

Softkey – function depends on menu or function currently in use

BASIC DIGITAL CAMERA

- Very small, or built into multi-function device.

- Low resolution with limited number of pixels. Designed primarily for producing on-screen snapshots.

- Usually has fixed wide-angle lens. Any zooming achieved by magnifying the image electronically.

MEDIUM-FORMAT AND SPECIAL CAMERAS

Medium-format roll-film cameras fill the gap between the lightweight 35mm compacts and SLRs and the unwieldy sheet film cameras. For many professional photographers, roll-film format cameras are ideal. Although it is not too bulky, this type of camera produces a much larger negative than a 35mm, which results in better definition and tonal qualities of prints and transparencies.

Most roll-film cameras accept interchangeable film "backs" that allow you to change from color to black and white, or from negative film to slides even halfway through a film. Many can be used with special electronic backs, which can capture the image digitally if required. Medium-format cameras are not designed for casual snapping, and in most situations must be used with a tripod.

Although a 35mm or digital SLR will produce excellent results for most purposes, there are other cameras available that have been designed for specialized applications. A waterproof camera will produce good results even in wet conditions, and an underwater camera can take excellent images. Both are widely available for the leisure photographer and can be found in digital form. The appeal of instant film cameras has diminished with the affordability of digital cameras – but the immediate prints can still be fun.

6 X 6CM CAMERA

This type of medium-format roll-film SLR is also known as a 2¼in square camera and produces an image that is roughly 6cm (2¼in) square. Some photographers are devoted to this format while others prefer the compositional possibilities of rectangular-format images. In terms of reliability and durability, the Hasselblad shown on the right is the choice of many professionals. It is supported by a comprehensive range of different lenses, film backs, and auxiliary viewfinders, including a pentaprism correction viewfinder.

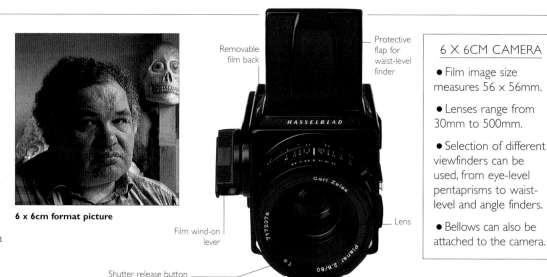

6 x 6cm format picture

Removable film back

Protective flap for waist-level finder

HASSELBLAD

Carl Zeiss

Lens

7172378

Film wind-on lever

Shutter release button

6 X 6CM CAMERA

• Film image size measures 56 x 56mm.

• Lenses range from 30mm to 500mm.

• Selection of different viewfinders can be used, from eye-level pentaprisms to waist-level and angle finders.

• Bellows can also be attached to the camera.

6 X 7CM CAMERA

The 6 x 7cm camera produces an approximately 6 x 7cm (2¼ x 2¾in) rectangular-format image, which is ideal for landscape photography. This Pentax model is similar in appearance and operation to an enlarged 35mm SLR camera. However, the range of available lenses is not as extensive as you would find with a standard 35mm SLR camera, and because of their size and bulk, the lenses are much more expensive to buy. This type of medium-format camera uses either 120 or 220 roll film (*see page 30*).

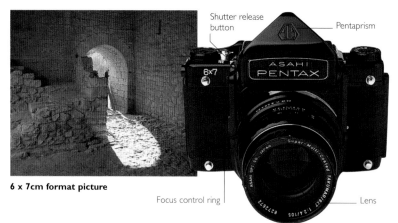

6 x 7cm format picture

Shutter release button

Pentaprism

ASAHI PENTAX

6x7

Focus control ring

Lens

6 X 7CM CAMERA

• Film image size measures 56 x 69.5mm.

• Larger overall size than a 35mm SLR, but similar handling characteristics.

• Interchangeable lenses are available, ranging from wide-angles to telephotos.

• Bellows and other close-up equipment can be attached to the camera body.

6 X 9CM CAMERA

This roll-film camera produces a rectangular image measuring roughly 6 x 9cm (2¼ x 3½in). The large negative or positive film original ensures excellent enlargements. This model has a rangefinder split-image viewing system, rather than standard through-the-lens reflex viewing, making it very lightweight. The lens, however, is not interchangeable, but different models have different focal lengths.

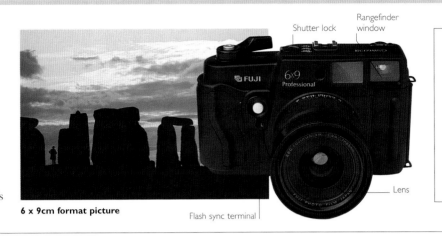

Shutter lock · Rangefinder window · Lens · Flash sync terminal

6 x 9cm format picture

INSTANT CAMERA

Instant-picture cameras produce a finished image just a few seconds after exposing the film. The model shown here uses an integral film with the final print with plastic sheet layer and mask being ejected from the camera. Some medium and large format cameras use a peel-apart version of the film. Color and black and white 35mm instant films are available for ordinary 35mm cameras, and there are also instant-picture film backs for roll-film cameras.

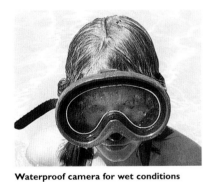

Instant camera for snapshots

Lens with automatic shutter · Photocell · Built-in electronic flash · Film exit slot

KEY FEATURES

• Focusing is fully automatic through a standard 125mm lens.

• Viewing through the lens, via a reflex mirror.

• Ten images per pack of film.

• Electronic flash.

WATERPROOF CAMERA

Specially adapted waterproof cameras have moisture-proof bodies and sealed controls for taking photographs in wet conditions. Most waterproof cameras have automatic focusing and a choice of standard and wide-angle lenses. Waterproof cameras can be submerged in water, but are not designed for deep underwater photography. Digital versions are available.

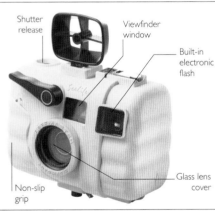

Waterproof camera for wet conditions

Shutter release · Viewfinder window · Built-in electronic flash · Glass lens cover · Non-slip grip

KEY FEATURES

• Fixed wide-angle lens.

• Fixed focus with add-on lens for close-ups down to 0.6m (2ft).

• Waterproof to a depth of 50m (164ft).

LARGE-FORMAT CAMERA

Large-format cameras have either a monorail or baseboard design. Focusing is achieved by extending the flexible bellows, holding the lens panel and lens, and moving them along the rails on the monorail or fold-down baseboard. This camera uses individual sheets of 4 x 5in (10.2 x 12.7cm) film for each image. Since the negative is so big, it requires little enlargement to produce prints of superb quality and definition.

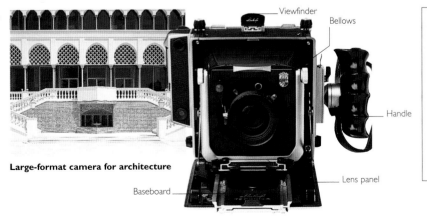

Large-format camera for architecture

Viewfinder · Bellows · Handle · Lens panel · Baseboard

KEY FEATURES

• Direct vision coupled viewfinder.

• Front lens panel can be removed and swapped for one of a different focal length.

• Uses 5 x 4in (10.2 x 12.7cm) sheet film.

STANDARD CAMERA LENSES

Camera lenses can be broken down into three broad groups: wide-angle, standard (normal), and long-focus (telephoto). It is not easy to assign focal lengths to each lens group, however, because these are dictated by the camera format. The focal length of a standard lens is approximately equal to the length of the diagonal of that format's image size. For a 35mm camera, the diagonal of the negative size measures around 50mm, so a lens with a focal length of 50–55mm is considered standard, and a lens of 80mm is a moderate long-focus lens. The diagonal of a 6 x 6cm negative measures approximately 80mm, so an 80mm lens is standard for a medium-format camera.

As the dimensions of the sensors used by digital cameras varies so much from model to model, the focal length is usually quoted as if for the 35mm film format.

FOCAL LENGTH AND ANGLE OF VIEW

The illustration and sequence of photographs below, which are all taken from the same viewpoint, show that as camera lens focal length increases so the angle of view decreases.

Fisheye lens
Extreme wide-angle lenses of 6–8mm are known as fisheyes. They record a circular image of at least 180°, with some lenses even looking behind the camera with a 220° angle of view. The resulting image is very distorted, with vertical and horizontal lines bowed.

Wide-angle lens
Wide-angle lenses of 18–35mm have more general applications than fisheye lenses. Angles of view are generous and depth of field at all apertures is extensive. Poor-quality wide-angle lenses may sometimes show some distortion toward the edges of the image.

Standard lens
A standard 50mm lens is fitted on most 35mm SLRs. Useful for most types of subject, it often has a wide maximum aperture, making it good in low light. It does not show the same distortion as a wide or long lens, and its angle of view is similar to that of the human eye.

Long-focus lens
Angles of view of long-focus lenses of 80–400mm start to diminish rapidly. With so little of the scene filling the frame, the subject is shown very large, making a long lens ideal for distant subjects or detailed close-ups. Depth of field decreases as the lens gets longer.

Extreme long-focus lens
Focal lengths above 400mm are specialized and are not usually found on standard zooms. The use of a tripod to support the lens is essential because of its relatively heavy weight. A long lens has a shallow depth of field and a small maximum aperture.

STANDARD LENS

A standard lens produces an image that is roughly equivalent to the way a scene appears when viewed with the naked eye. Most 35mm SLRs used to come with 50mm lenses, so they can be inexpensive to buy secondhand. Standard lenses usually have wide maximum apertures, making them useful in low-light situations.

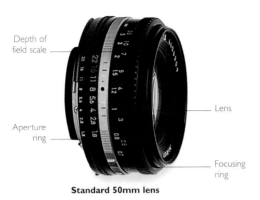

Depth of field scale

Aperture ring

Lens

Focusing ring

Standard 50mm lens

Standard lenses are useful for most outdoor subjects

WIDE-ANGLE LENS

A wide-angle lens takes in a larger angle of view than a standard lens, and is ideal for photographing a group of people or when you are working in confined space. If used too close to a subject, however, distortion may be a problem. Depth of field at each aperture setting is generous, which is useful when all parts of a subject must be sharply rendered.

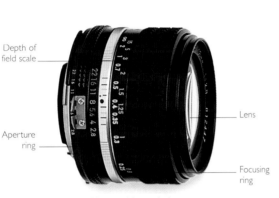

Depth of field scale

Aperture ring

Lens

Focusing ring

28mm wide-angle lens

Wide-angle lenses are useful for interiors

ZOOM LENS

A zoom lens allows you to fine-tune subject framing by adjusting the focal length of the lens. Each zoom lens covers a range of three or four fixed focal length lenses, giving you great flexibility at a reasonable cost. Since you do not have to think about changing lenses, there is less chance you will miss an important shot.

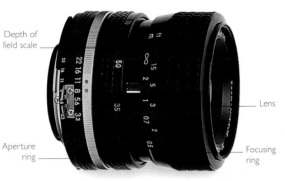

Depth of field scale

Aperture ring

Lens

Focusing ring

28–85mm zoom lens

Zooms are useful for action shots

LONG-FOCUS LENS

Longer focal lengths are useful for taking large images of distant subjects or when you cannot move close enough to the subject to use a shorter lens. Long-focus lenses can be fairly heavy, and the restricted angle of view makes the use of fast shutter speeds to avoid camera shake more important than with lighter, shorter lenses.

Depth of field scale

Focusing ring

Lens

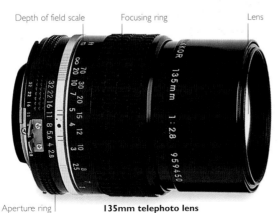

Aperture ring

135mm telephoto lens

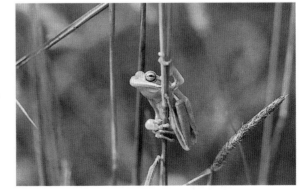

Long-focus lenses are useful for natural history subjects

SPECIAL CAMERA LENSES

A digital SLR, 35mm SLR, or medium-format camera body can be thought of simply as the film holder and control center for a vast array of different add-on attachments, including lenses, each with its own use. The lenses shown on these pages, designed for the 35mm format, are just a selection of the many focal lengths and designs available.

ZOOMS AND SPECIALIZED LENSES

A zoom allows you to vary subject magnification without moving your camera position, which makes it the popular choice with SLR users. Zoom lenses are also fitted as a standard feature on most compact cameras.

Specialized lenses, such as extreme long-focus lenses and ultra wide-angle fisheye lenses, have more limited applications. These lenses are expensive to buy, but they can also be rented for short periods. Macro lenses are designed for taking close-ups of small subjects or isolating details of larger subjects. These lenses allow the camera to focus extremely close to a subject to record a detailed image. Used for photographing buildings, shift lenses correct perspective to overcome the problem of converging vertical lines.

MIRROR LENS

Instead of using groups of glass elements to bend light rays entering the lens and traveling down the barrel, a mirror lens uses a combination of glass elements and mirrors. These mirrors bounce the light up and down the lens barrel, manipulating the light rays to allow a long focal length to be contained within a physically short space.

Mirror lens image

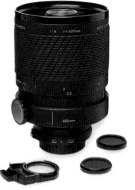

600mm mirror lens with colored filters

Advantages of a mirror lens

The compact design of a mirror lens reduces the bulk and weight associated with extreme long-focus lenses. Whereas the traditional 500mm long-focus lens (below right) is 9.25in (235mm) long and weighs 35oz (1,000g), the mirror lens (right) of equivalent focal length weighs only 17oz (485g) and is 3.4in (87mm) long.

Distance scale — Frontal mirror — Focusing ring

Mirror lens

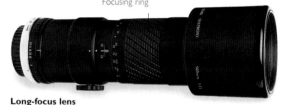

Focusing ring

Long-focus lens

WIDE-ANGLE ZOOM

A wide-angle zoom ranging from 21–35mm is effectively three lenses – 21mm, 28mm, and 35mm – with the added advantage of being able to select any intermediate focal length setting. However, a wide-angle zoom is likely to be slower and heavier and to show more image distortion than a wide-angle fixed focal length lens.

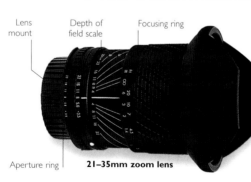

Lens mount — Depth of field scale — Focusing ring

Aperture ring — **21–35mm zoom lens**

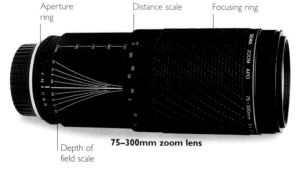

21mm setting **35mm setting**

TELEPHOTO ZOOM

A telephoto zoom ranging from 75–300mm encompasses about six fixed focal length lenses. This type of zoom is popular with sports and wildlife photographers. It is also useful for portraits and can be used to photograph architectural and landscape details.

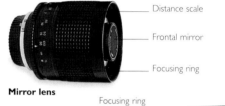

Aperture ring — Distance scale — Focusing ring

Depth of field scale — **75–300mm zoom lens**

75mm setting **300mm setting**

ULTRA WIDE-ANGLE LENS

Ultra-wides used to be expensive, but now ultra wide-angle zooms have made focal lengths under 20mm much more affordable. Linearly corrected ultra wide-angle lenses have a focal length ranging from around 21mm down to around 15mm. Some ultra wide-angles are designed to create a distorted view of the world – these are known as fisheyes.

Lens mount
Focusing ring
Aperture ring
Distance scale

15mm fisheye lens

Standard lens image

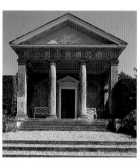

Ultra wide-angle lens image

SHIFT LENS

A shift lens (also known as a perspective control lens) gets its name because it can be shifted off-center in relation to the film frame. Instead of tilting the camera back to include the top of a tall structure and so distorting the perspective, with a shift lens you can keep the camera parallel and shift the lens upward to record an undistorted image.

Aperture ring
Shift control
Lens mount
Focusing ring

28mm shift lens

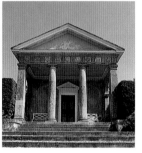

Standard lens image

Shift lens image

MACRO LENS

This type of specialized lens is designed primarily to be used at very close focusing distances (see pages 210–211). Macro lenses are available in focal lengths ranging from 50mm to 200mm. When taking close-ups outdoors, longer macro lenses produce a large image from farther back. Moving in close with a shorter macro lens may block out the light.

Aperture ring
Distance scale
Focusing ring
Lens mount

50mm macro lens

Standard lens image

Macro lens image

TELEPHOTO LENS

An ultra telephoto lens has specially designed optics that allow it to have a long focal length in a relatively short barrel. Most have a fixed focal length. Telephotos of 400mm, even lightweight ones, require some sort of camera support but to ensure some maneuverability, a sports photographer will frequently use a monopod.

Camera body
Focusing ring

1000mm telephoto lens

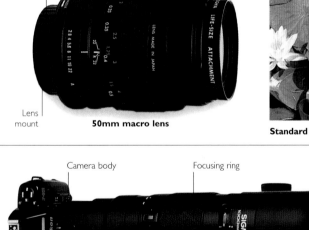

Focusing ring

Tripod mount

400mm telephoto lens

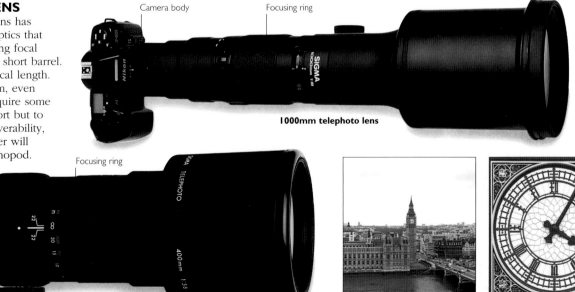

Standard lens image

1000mm lens image

FLASH LIGHTING EQUIPMENT

Flash lighting units can be divided into several groups: studio equipment, built-in flash, and portable add-on or hand-held units. Although built-in flash is a convenient source of lighting, which can also be used to supplement daylight, it does have disadvantages. First, light output is limited in strength and, if it is the sole illumination, has to be used relatively close to your subject. Second, the flash is always front facing and tends to produce a harsh, unattractive light. Third, the flash and lens are very close together and this causes red eye, in which the pupils of the subject's eyes appear red. Add-on and hand-held flash units are far more versatile. In general, they have a more powerful output, the flash head can be angled to bounce light off a wall or ceiling for a softer and more natural look, and the flash head is far enough away from the lens to avoid the problem of red eye.

Direct light from built-in flash

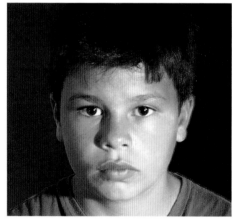

Bounced light from add-on flash

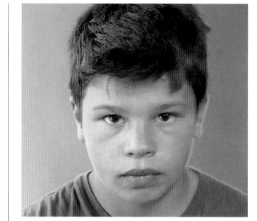

Bounced light from hand-held flash

Built-in flash

This type of built-in flash is more useful as a supplementary or fill-in light source than as the main illumination for a picture. Its low-output beam and front-facing position make its application rather limited for any creative flash effects. One useful feature of the camera shown below is an infra-red light transmitter, which bounces a beam of invisible light off the subject and helps the autofocus detector locate the subject when it is too dark to see.

Add-on flash

This flash fits into the hot shoe on top of the pentaprism. Electrical contacts connect with the camera shutter, automatically triggering the flash. This type of flashgun can be very sophisticated for its size, and a fully integrated unit (dedicated flash) allows great versatility.

Hand-held flash

This type of unit has a long handle for hand holding, but it can also be attached to the side of the camera. It may have a separate battery pack, allowing faster recharging and more flashes per charge. A synchronization cable coordinates the flash firing with the shutter.

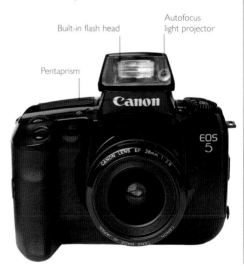

Built-in flash head

Autofocus light projector

Pentaprism

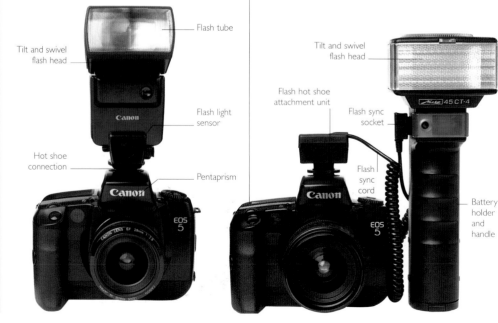

Tilt and swivel flash head

Flash tube

Flash light sensor

Hot shoe connection

Pentaprism

Tilt and swivel flash head

Flash hot shoe attachment unit

Flash sync socket

Flash sync cord

Battery holder and handle

STUDIO LIGHTING EQUIPMENT

Tungsten or flash lighting can be used for indoor photography. Tungsten lights plug into standard outlets, are adjustable, and are easy to use, particularly with digital cameras. Flash lighting stays cool during use and is a popular choice with film users. You must use the correct type of film (or white balance) with artificial lights because the color temperature of tungsten is different from that of daylight. Do not mix daylight and tungsten. Flash lighting is used with normal film and, since it has the same color temperature as natural light, can be used to supplement daylight. Flash units cannot be battery-powered due to the intensity of their light output.

FLASH METER

Because of the immediacy of flash, a light meter is required for accurate exposure measurement. Some meters are designed for use with flash and ambient light. Hold the meter where you want to take your reading and fire the flash manually.

Power pack is connected to mains supply; larger packs can be used for a higher output

Basic flash unit
An adjustable lighting stand is required for each flash unit, and accessories can be used to modify light quality. A control switch allows you to alter the strength of the light. Larger units require a power pack, linked to the flash head and shutter by a synchronization cable.

Size and shape of the reflector surrounding the flash head determine the spread of light

Central column of lighting stand is telescoped up or down to alter the height of the head

Cable connects the flash head to the power pack

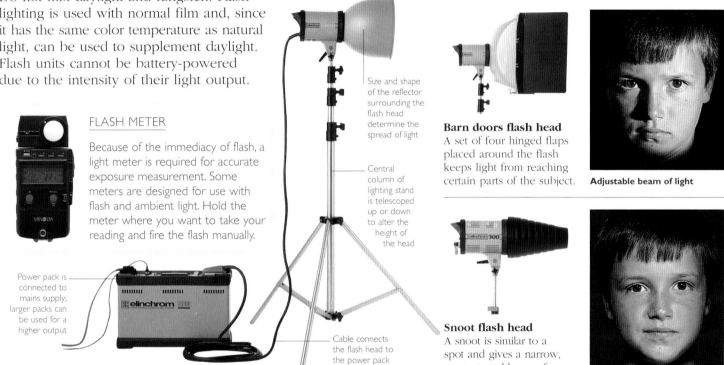

Flood flash head
A flood produces an even spread of illumination over the whole subject.

Wide beam of light

Barn doors flash head
A set of four hinged flaps placed around the flash keeps light from reaching certain parts of the subject.

Adjustable beam of light

Snoot flash head
A snoot is similar to a spot and gives a narrow, concentrated beam of light with dark shadows.

Narrow beam of light

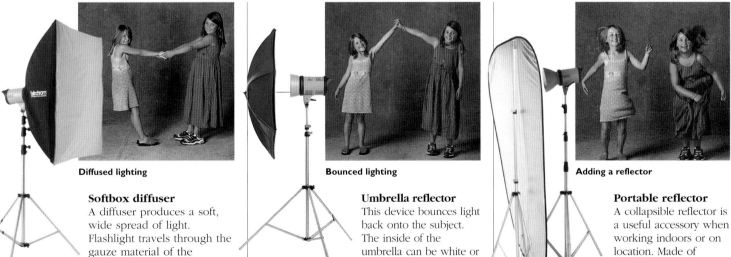

Diffused lighting

Softbox diffuser
A diffuser produces a soft, wide spread of light. Flashlight travels through the gauze material of the softbox, making the front panel the light source.

Bounced lighting

Umbrella reflector
This device bounces light back onto the subject. The inside of the umbrella can be white or silver, according to the light quality desired.

Adding a reflector

Portable reflector
A collapsible reflector is a useful accessory when working indoors or on location. Made of reflective material, it is used to soften shadows.

CHOOSING FILM TYPES

Of all the film sold worldwide, the vast majority is color negative, intended for producing color prints. The other main types of film – color positive 'slide' film and black and white film – may be less popular, but are widely used by serious photographers.

NEGATIVE OR POSITIVE FILM

Color negatives show subjects in their complementary colors, and there is an overall orange color-cast. Colors are reversed when printed to show the scene correctly rendered. Black and white negatives have reversed tones – what was a dark tone appears light, and vice versa. When a black and white negative is printed the tones are reversed to show the correct distribution of light and dark. Positive film images are known as slides or transparencies, and are intended to be projected and not printed. Therefore, the colors or tones on the film correspond to those of the original scene.

PRINTS OR SLIDES

The advantage of using color negative film is that color prints are easy and convenient to view. They can be stored in the envelopes supplied by the processors or mounted in albums. In addition, extra copies can be printed at little cost and enlargements made. In contrast, color slides must be mounted and loaded into a projector before they are viewed in a darkened room. A projected slide, however, is far more impressive than a print, since the image quality is superior, and the colors tend to be richer and truer to life.

Black and white negative *(above)*
Black and white print *(right)*

Color negative *(above)*
Color print *(right)*

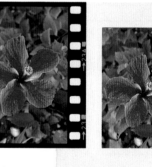

Slide *(above)*
Mounted slide *(right)*

BLACK AND WHITE

The image tones on a black and white negative appear reversed – but then appear normal when printed. Black and white prints can be made from a color original, but a black and white negative will usually give the best-quality results. In comparison to color film, black and white film is relatively easy to develop and print yourself.

COLOR PRINT

The colors on a color negative appear as the complementary colors of the subject, which makes judging image quality from the film difficult. After printing, colors should appear normal. If necessary, color can be corrected with filters during printing. You should ask for replacement prints if colors are inaccurate or there are color differences within a set.

COLOR SLIDE

Since there is no intervening printing stage with slides, the colors should be extremely accurate. Before it is ready for projection, each image has to be cut from the film strip and mounted. This is done for you automatically with process-paid slide film. Color and black and white prints can also be made from these transparencies.

FILM FORMATS

Each format of camera must be used with its corresponding film format. Film for 35mm cameras comes in metal or plastic cassettes, while roll film used in medium-format cameras has a paper backing for protection. Large-format film comes as individual sheets.

APS film

Film format used widely for compact cameras that is easier to load, and smaller, than 35mm. Lets user to choose between three different frame shapes for each shot.

35mm film

This is the most popular film format, with a large range of brands. It is available for prints or slides, and in varying lengths and film speeds.

Roll film

Also called 120 or 220mm film, roll film is used in all medium-format cameras, which all have a 2¼in (6cm) image dimension.

Sheet film

Sheet film comes in individual sheets that are loaded into holders.

DAYLIGHT AND TUNGSTEN FILM

Film is manufactured to produce best results, in terms of color, when used under specific types of lighting. Most film is balanced for use in bright daylight or for use indoors with electronic flash, both of which have the same color temperature. If daylight-balanced film is exposed using domestic lighting, or when using tungsten studio lights, then it will show a pronounced orange color-cast.

With color prints, this cast can largely be corrected during the printing stage. Color slide film, however, does not go through a printing stage, so it is vital to make sure that you buy the correct type of film for the light source under which it will be used (or filters can be used). Black and white film can be used under any type of lighting without risk of distorting its tonal response.

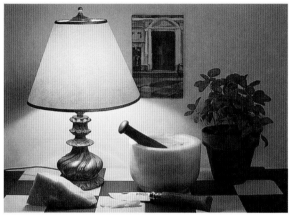

Incorrect use of daylight-balanced film

Correct use of daylight-balanced film

DAYLIGHT FILM
Color film designed for use in daylight or flash will show a distinct orange cast if used under tungsten lights. These two pictures were shot on daylight-balanced film. In the first shot (*far left*), the tungsten of the domestic bulb lighting gives the room a distinct orange cast. In the second picture (*left*), the scene is lit by natural daylight alone and is correct in color.

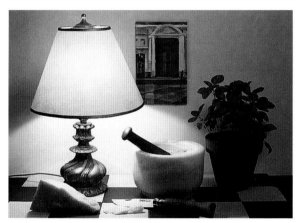

Correct use of tungsten-balanced film

Incorrect use of tungsten-balanced film

TUNGSTEN FILM
Color film intended for use in tungsten light will show a strong blue cast if used in daylight (or with electronic flash). These two pictures were both taken on tungsten-balanced film. In the first picture (*far left*), the scene is lit by domestic tungsten bulb lighting and has correct color rendition. In the second picture (*left*), daylight gives the scene a distinct blue cast.

BRAND COLOR BIAS

Different brands of color film use different dyes, which result in subtle color variations. Color may also vary between different speeds of film from the same manufacturer. These differences are most obvious when using color slide film, since there is no intermediary printing stage.

Film with blue bias

Film with yellow bias

Film with red bias

FILM SPEED AND CAMERA EQUIPMENT

Films are referred to as being fast, medium, or slow – a reference to their sensitivity to light. Fast films have high ISO (International Standards Organization) numbers and slow films have low ISO numbers. Fast films are useful in low-light situations, since they increase the chances of achieving a correctly exposed image when a less-sensitive, slower film may result in underexposure. The result of this increase in speed, however, is some reduction in image sharpness and an increase in contrast. Slow films are ideal when light levels are good and you need the highest-quality prints with fine detail.

DIGITAL CAMERAS

The sensitivity of digital sensors can often be changed electronically for each shot to give a range of "film speeds."

SLOW FILM

This marble bust was shot using a very slow-speed film (ISO 32). Note the delicate, almost creamy texture of the statue's surface and the soft gradation of tones between the lit right-hand side and the shadowy left-hand side. Even in the enlargement (*see inset*), the appearance of any grain is negligible.

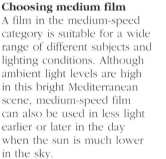

Choosing slow film
A slow film is ideal for brightly lit subjects, or where a degree of subject movement or blur is required. It is often used for still life subjects that need to be enlarged while still retaining a lot of detail and a fine-grained image. Even if light is poor, the camera can be set up on a tripod and a long exposure given.

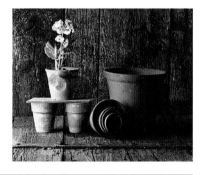

MEDIUM FILM

Using the same lighting as above, the bust was shot using a medium-speed film (ISO 200). Note that grain becomes coarser the faster the film. Here the film is much faster than the ISO 32 film (each doubling of the ISO number is a doubling of the sensitivity), but the quality is still good, and the grain can only just be detected.

Choosing medium film
A film in the medium-speed category is suitable for a wide range of different subjects and lighting conditions. Although ambient light levels are high in this bright Mediterranean scene, medium-speed film can also be used in less light earlier or later in the day when the sun is much lower in the sky.

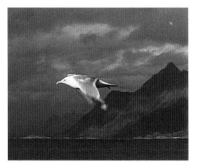

MODERATE-FAST FILM

With the film speed doubled to ISO 400, the appearance of the bust on the full-frame image is slightly different. The surface of the bust looks less fine and the contrast between light and shade is beginning to increase slightly. As you would expect with a faster film, the grain is now fairly noticeable in the enlargement.

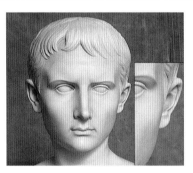

Choosing moderate-fast film
This shot of a seagull in flight requires a fast shutter speed to capture the movement of the subject and avoid camera shake, as well as a small aperture to cover any slight error in focus. The speed of a moderate-fast film enables you to photograph subjects in dim lighting conditions.

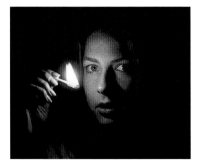

ULTRA-FAST SPEED FILM

The ISO 1000 film used for this photograph of the bust is 1.5 times more sensitive than the ISO 400 film, and now the grainy nature of the film emulsion is apparent. Note, too, that the soft gradation of tone apparent in the version using the slow film is now more abrupt and that there is a slight color shift.

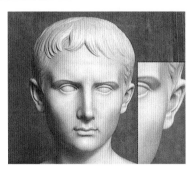

Choosing ultra-fast film
Choose an ultra-fast film when light levels are really low, for example, in a dimly lit interior or outdoors at dusk. This type of film is so sensitive that it will give you acceptable results even by the light of a match. The graininess of the resulting image can add to the dramatic impact of the shot.

BASIC CAMERA EQUIPMENT

For the 35mm SLR user there is a wide range of equipment and accessories available to cover every area of photographic interest. In terms of lenses, your camera may come with a standard 50mm lens already fitted. Additionally, you should consider choosing a wide-angle lens between 28 and 35mm for shooting a broad panorama or when working in a confined area. A long-focus lens between 90 and 135mm is useful for portraits as well as more distant subjects. However, a zoom lens gives you flexibility without changing lens. A tripod guarantees sharp images of stationary subjects and may be essential to avoid camera shake during a long exposure.

If there is room in your camera bag, then you should also include a few filters, a basic lens- and camera-cleaning kit, a notepad and pen, a portable flashgun, and some spare film of different speed ratings.

FRONT AND REAR LENS CAPS
When a lens is not in use, always keep the front lens cap on. The rear lens cap should be fitted when the lens is removed from the camera.

CAMERA STRAP
Use a camera strap and keep it around your neck in case you let the camera slip. Wider straps spread the weight of the camera and lens.

ELECTRONIC FLASHGUN
An electronic flashgun is useful when light levels are low, when working indoors, or when you want to lessen contrast by adding some light to areas of shadow.

35MM CAMERA
The body of the camera forms the heart of a system for which there are numerous accessories and lenses. Use a cap to protect the interior of the camera when a lens is not attached.

CABLE RELEASE
Releases the shutter on a tripod-mounted camera and avoids the risk of camera movement.

FILTERS
A clear ultra-violet filter can be left on the lens as protection. Strongly colored filters are used with black and white film or for special effects with color film.

LENSES
Choose lenses according to the type of shots you want to take. Wide and long lenses increase flexibility. Extension rings allow you to get in closer to a subject.

FILM
Always carry several rolls of spare film. If you have fast film you will be able to take photographs in dimly lit places.

CAMERA CARE KIT
All you need for cleaning your camera and lenses are (from left to right) a soft lint-free cloth, special dust-free tissues, lens-cleaning fluid, and a blower brush. Use the cleaning fluid very sparingly. If a hair or piece of film debris gets lodged in an awkward area, then a pair of tweezers might be needed. A small screwdriver is also useful.

NOTEPAD AND PEN
These are invaluable for noting the location of a particular shot or for details of a particular subject.

CAMERA BAG
A camera bag should be well padded inside and have adjustable compartments for holding equipment.

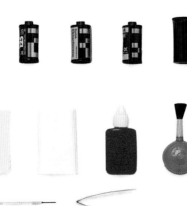

TRIPOD
A lightweight tripod is essential when you need steady images.

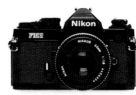

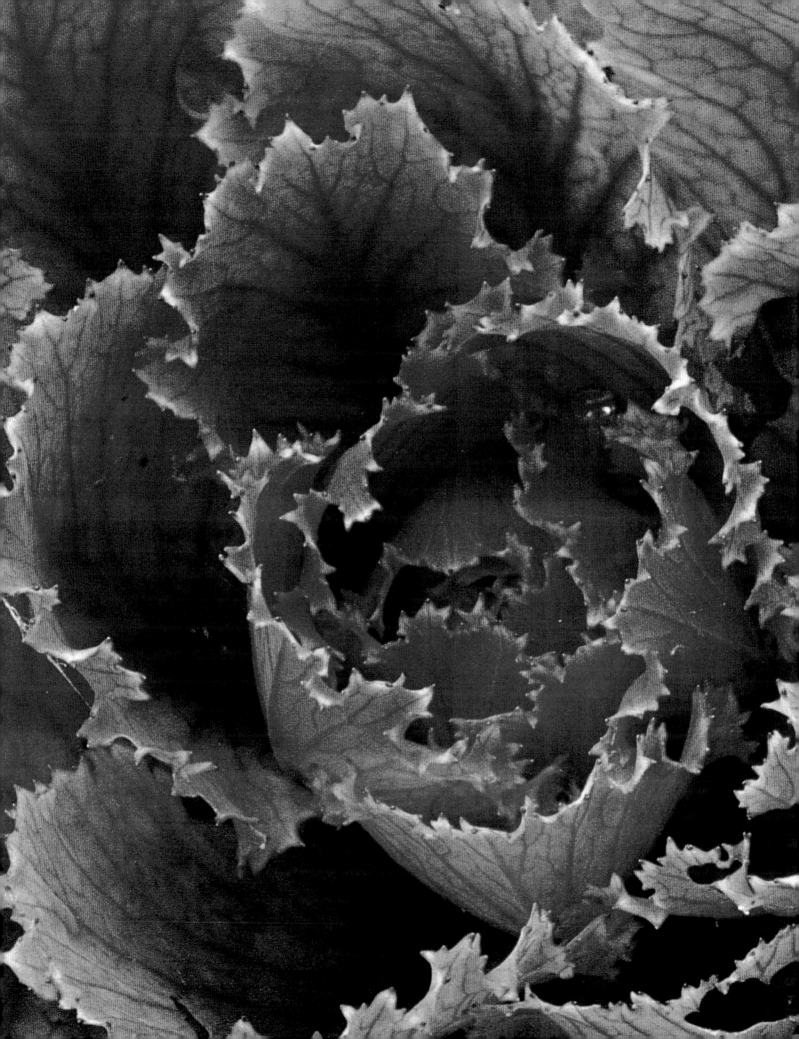

HOW TO
SEE BETTER
PICTURES

Taking photographs that have appeal and impact depends in part on your ability to see the potential in a subject and then interpret it in your own way. This section reveals how light affects form, color, texture, shape, and pattern, and shows how to compose excellent photographs by considering the different qualities of light. It also illustrates the importance of selecting the viewpoint that will show your subject in the most effective and telling fashion.

THE ESSENTIAL PICTURE ELEMENTS

It is difficult to define precisely what it is that makes a "good" photograph. With pictures taken on vacation or of members of your family, what constitutes a good photograph may be a personal judgment. However, some photographs do communicate to a broader audience because of the revealing way the subject has been treated or the way in which the elements are composed to convey mood.

The photographs on these pages are all different in terms of subject matter, but each has a quality that invites closer inspection. Some images work because the photograph has captured the subject's intriguing shape or some aspect of its form that makes it appear three-dimensional. In other photographs, the main element may be color – subtle and moody or vibrant and contrasting – or a humorous juxtaposition of subject elements.

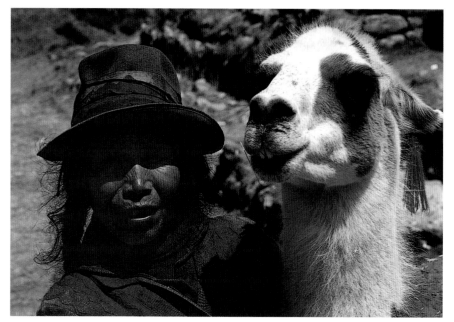

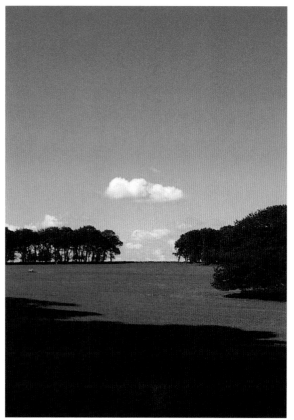

Adding humor, *above*
Looking like companionable old friends, and showing almost the same amount of teeth, this Peruvian woman and her llama makes for a very humorous picture.

Color harmony, *left*
Natural brown and green hues come together in this photograph of a decorative piece of fungus to create an image that has strong shape and color harmony.

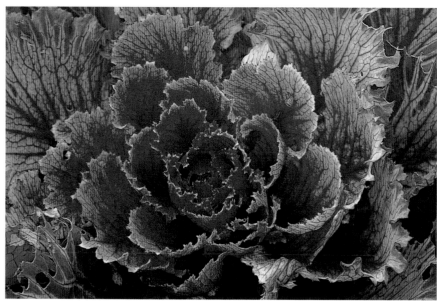

Main subject
A well-composed picture needs to have a main focal point. In this image, a central cloud directs the gaze to the distance and gives a feeling of depth.

Vibrant color
The color of this cabbage has been intensified by moving in close to exclude extraneous details and fill the whole frame with a deep, vibrant pink.

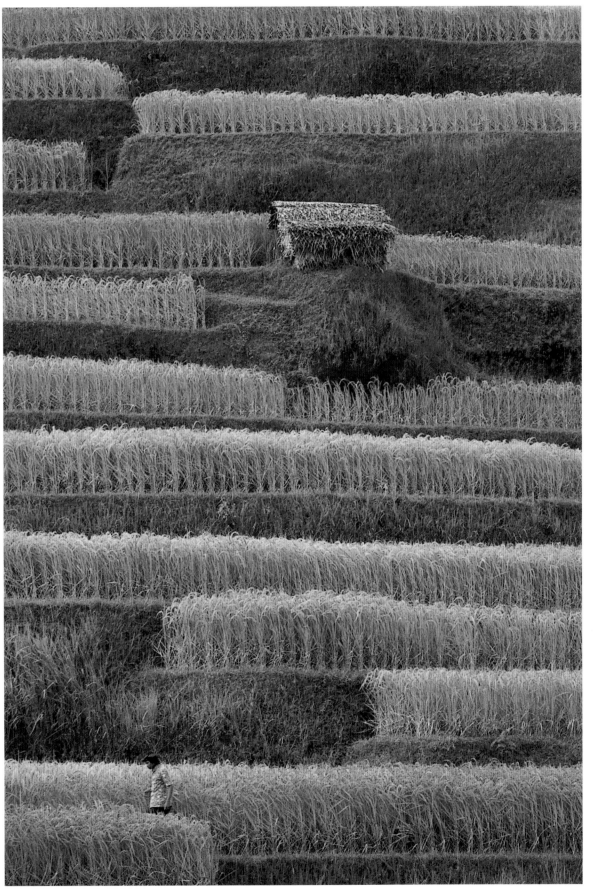

Lens effect
Extra punch is given to this photograph of Indonesian paddy fields by shooting the scene using a long lens. This has the effect of squashing the different subject planes, so that the background is enlarged relative to the foreground. A clue to the scale of the landscape is provided by the figure, whose shirt provides a splash of contrasting color.

Simple detail
Even a simple still life photograph of seemingly mundane objects such as these thermometers can be an image of considerable dramatic impact.

UNDERSTANDING COLOR HARMONY

Ideally, a photograph should have one main subject and one main color – with any other colors being supplementary to give added emphasis to the most important element. In terms of mood, a composition made up of harmonious colors of similar tones tends to be restful and calm, unlike the discordant feeling of compositions based on contrasting colors.

Even contrasting colors can be blended and subdued to create a harmonious picture if photographed in the appropriate type of lighting. The choice of lighting can affect color, but you can also affect color through exposure: slightly underexposing to give a low-key result, and slightly overexposing or using colored filters to lessen color contrast.

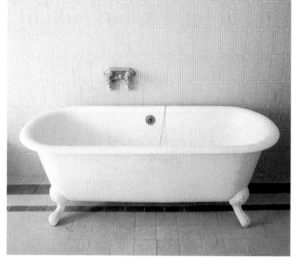

Restricted palette
The stark simplicity of this bathroom is reinforced by restricting the color palette to cream and beige, with a panel of delicate, gray-blue tiles used to link the flat bands of color.

Strong hues
Although blue and green are harmonious colors, the strength of the hues in this landscape would appear strongly contrasting if it were not for the intervening band of light gold acting as a buffer between the two.

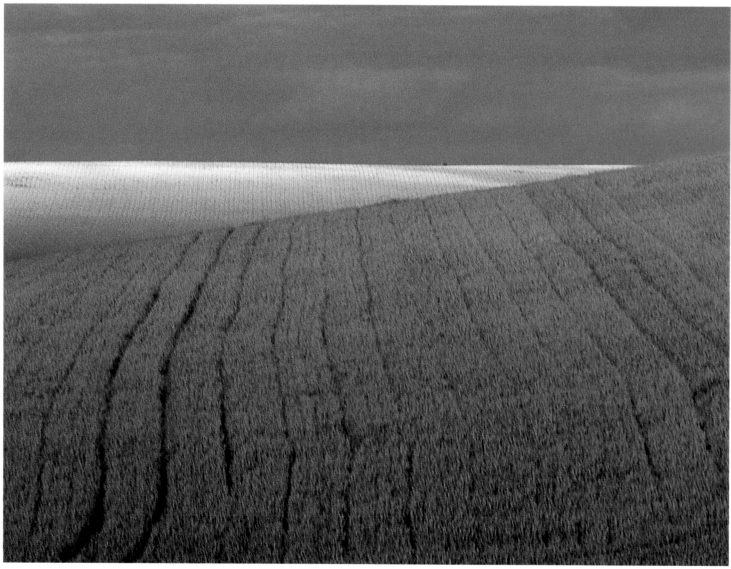

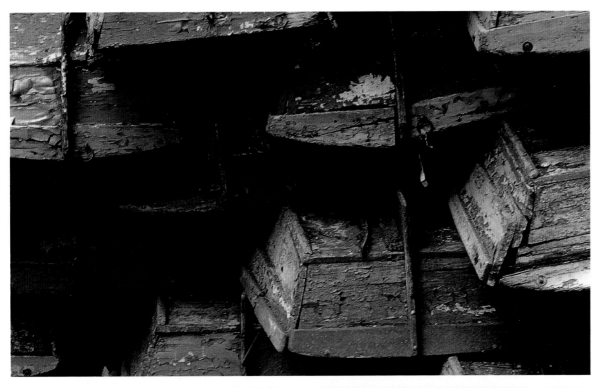

Sunset colors, *above*
As the sun dips below the horizon, red wavelengths of light dominate, turning all colors in the scene into harmonious shades of the same single hue.

Low-key image, *left*
The green, blue, and red colors of these wooden boats are blended into a harmonious scheme by underexposing the image to give a low-key result.

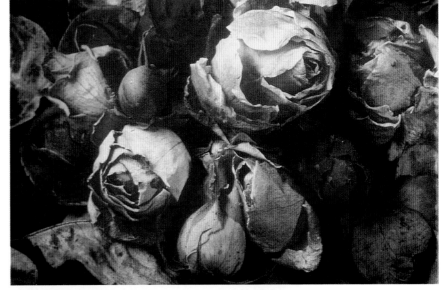

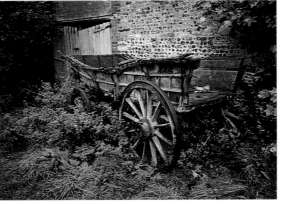

Morning light
Red and blue – opposites in the color spectrum – feature in this portrait, but in the morning light the colors complement each other rather than compete.

Faded hues
A gentle, autumnal blend of color characterizes this photograph of dried rose blooms and hips.

Natural colors
An abandoned wagon, slowly being absorbed back into the natural world is the focal point of this rural image composed of subtle, harmonious shades of green and brown.

USING COLOR CONTRAST

Color has an emotional content, conveying atmosphere and affecting how we interpret an image. Strong, bold colors can create a feeling of vitality and, if used with restraint, small areas of color contrast can draw attention to a section of an image without overwhelming it as a whole.

Color contrast is caused by the juxtaposition of primary colors – red, blue, and yellow – or results from placing a primary color next to its complementary color (green, orange, and purple, respectively). Large areas of contrasting color can have a detrimental effect on subject form, destroying depth and masking detail. Although the use of color is dependent on personal preference, as a general rule bold colors should usually be balanced with weaker ones.

Unusual view, *above*
An abstract composition consisting of strong color contrast is created here by showing part of the boat's red keel and its reflection in the inky blue water.

Spatial abstraction, *above*
Two large blocks of strong, contrasting color destroy the sense of depth in this picture. Although the yellow field is more distant, it is the green grass closer to the viewer that appears to recede.

Light and color, *left*
The light by which an object is viewed has an effect on its coloration. Here, strong, directional evening light produces intense hues of red.

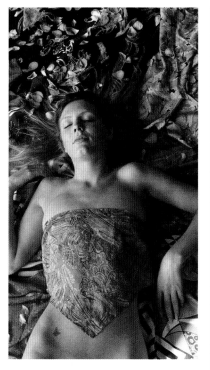

Color control, *above*
Semi-diffused light from a window on the left helps to control the riot of color provided by the scarves and petals in the background of this photograph. In more direct light, the variety of color would have detracted from the subject.

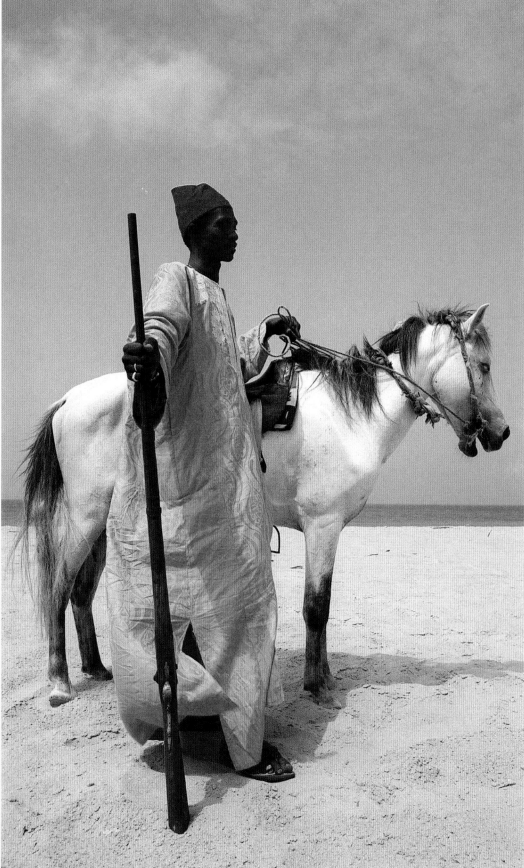

Touch of color, *right*
Although only very small in the frame, the red of the Senegalese tribesman's headdress contrasts with the blue both of his gown and of the sky, drawing immediate attention to a particular area of the image.

WORKING WITH SHAPE

One of the most powerful ways to emphasize shape in a photograph is to ensure that, at least in outline, it contrasts strongly with its surroundings in either tone or color. The shape of a subject with a lot of pattern or detail can be emphasized by photographing it against a plain, neutral background that will not compete for attention. Another technique is to use an extreme form of lighting contrast, as you would for a silhouette, to suppress all details and allow the subject to become a strong graphic outline of equal-density tone.

The shape of an object is not fixed and you can alter its appearance by changing your camera position. Shooting down on a subject can reduce its bulk overall, as well as the apparent size of its different parts, making some seem larger in relation to others. You can also manipulate shape by shooting from below the subject, or by using different lenses, from very wide-angle to long-focus.

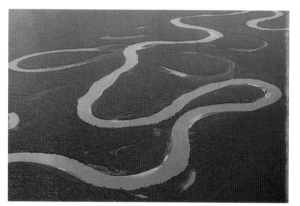

Viewpoint and shape
It is necessary to look for an unusual viewpoint to convey something of the Amazon River's huge size. This aerial shot reinforces the twisting nature of the river, making shape of paramount importance.

Competing shapes
The presence of two powerful shapes such as the Great Pyramid and the Sphinx in the same image needs careful handling to ensure a well-balanced, harmonious composition.

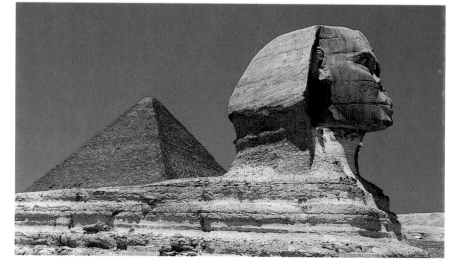

Using shadows, *above*
Two ways of emphasizing shape in a photograph can be seen in this image. First, the dark outline of the man contrasts with the pastel color of the wall behind. Second, a low afternoon sun has cast a well-defined shadow onto the wall, strengthening the element of shape in the composition as a whole.

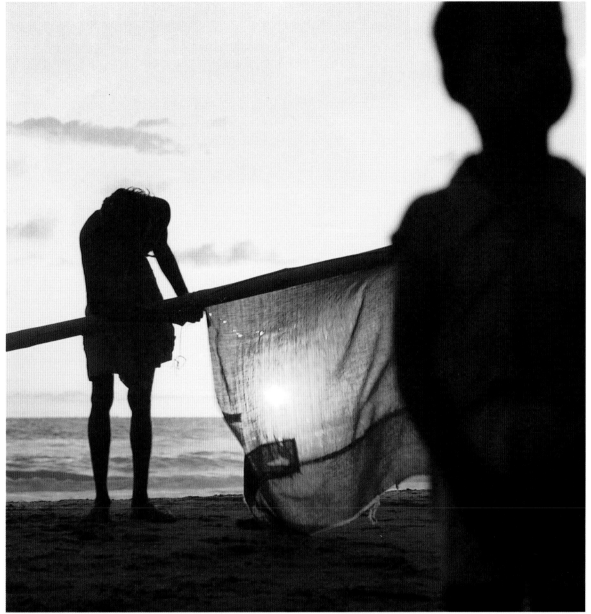

Concentrating attention
The close-up figure on the right of this photograph acts as an effective frame and counterbalance to the more distant one, helping to direct and then hold attention within the picture boundaries. Both figures are reduced to silhouettes by the strong backlighting, and the diagonally held pole helps unify the composition by bridging the gap between them.

Silhouette, *below left*
A low camera angle is used here to show off the striking Gothic silhouette of a ruined abbey against a neutral backdrop of sky. A high camera position would have shown more of the dark hills behind the building and lessened the impact of its shape.

Rim lighting, *below*
A dramatic silhouette is achieved by positioning the model directly between the sun and the camera. The sunlight is so intense that a halo of rim lighting has spilled past the subject, perfectly outlining her profile, neck, and upper body.

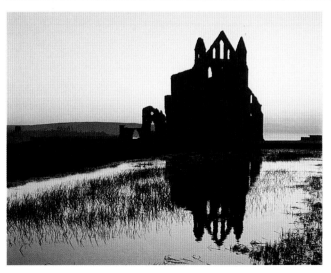

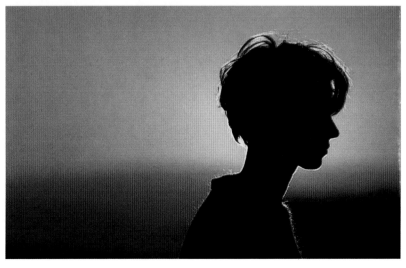

USING LIGHT AND DARK TONES

The term tone refers to any area of uniform density on a print, negative, or transparency that can be distinguished from lighter or darker parts. In its most extreme form, a photograph may consist of just two tones – black and white – with no shades of gray in between. More often, however, images are composed of a wide range of intermediary tones between these two extremes.

Tone is also used to refer to the visual weight – the perceived darkness or lightness – of an image. A photograph consisting of predominantly heavy dark tones and black is known as a "low-key" image; while one that is made up mostly of light bright tones and white is referred to as "high-key."

These terms are not restricted just to black and white photography. A color photograph can also be described as high- or low-key. We talk about shades and tints of a color to describe its intensity, and the grays making up a tonal range also form part of our color perception. The latter is mainly governed by the intensity and angle of light striking an object and you can manipulate this for effect.

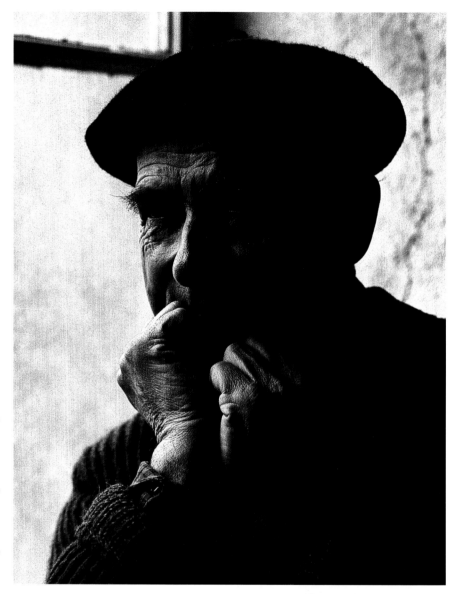

High-key color, *below*
Directional window light bathes one side of this pitcher and bowl in bright illumination that dispels any hint of deep shadow. This high-key result is helped by the white wall behind, which acts as a reflector, increasing light levels and lightening dark shadows.

Low-key results
Low-key pictures do not have to exclude all bright tones. In the portrait (*right*), daylight illuminates one side of the man's face, but most of the image is in shadow. In the still life (*below right*), the pots show a whole range of tones in what is a low-key picture.

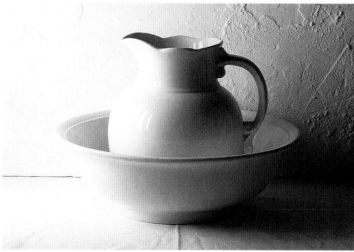

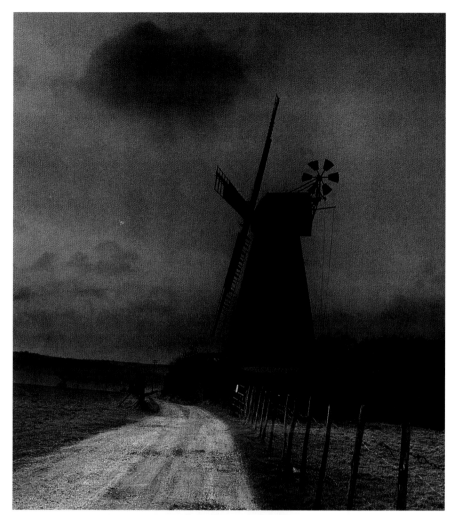

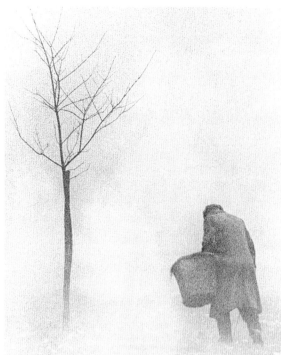

Dark imagery, *left*
This low-key image of a windmill has a brooding atmosphere. The sky seems full of foreboding and the dark landscape has a hint of menace. A red filter is used to darken the sky and other light tones, except for the path in the foreground.

Bright imagery, *above*
A combination of smoke and mist has given a light-toned, high-key result. Although practically no detail has survived, the imagery has an old-world tranquillity and there is an overwhelming feeling of space and emptiness.

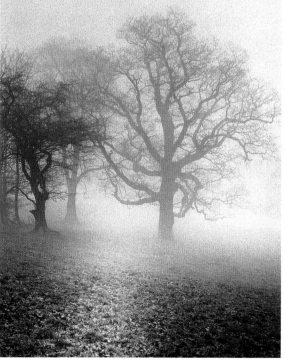

High contrast, *far left*
Contrast in a photograph refers to the difference in tone between the brightest highlight and deepest shadow. This image is high contrast because of the presence of both bright white and deep black tones.

Low contrast, *left*
The tones in this misty woodland scene all come from the middle of the tonal range. There are no strong black or stark white tones, and so this image is a low-contrast picture.

EMPHASIZING FORM

Whereas shape describes the two-dimensional outline of a subject and is recognizable even if an object is backlit with no surface details showing, form or modeling describes not only the surface characteristics of an object but also its three-dimensional qualities, such as its roundness and substance. In a photograph, form is shown by the gradation of light and shade, and the color strength, which is also related to the amount of light reflected or absorbed by the subject's surface.

Lighting that produces a flat color or tone, with little or no variation across the surface of the subject, tends to suppress the appearance of form. To accentuate form, it is therefore best to avoid harsh, frontal lighting and to use angled lighting or sidelighting, which tends to produce a gradation in color or tone. This in turn emphasizes the surface texture and tactile nature of the subject. The still life on these pages was shot in daylight and also with flash to show how the angle of light striking an object affects the sense of form.

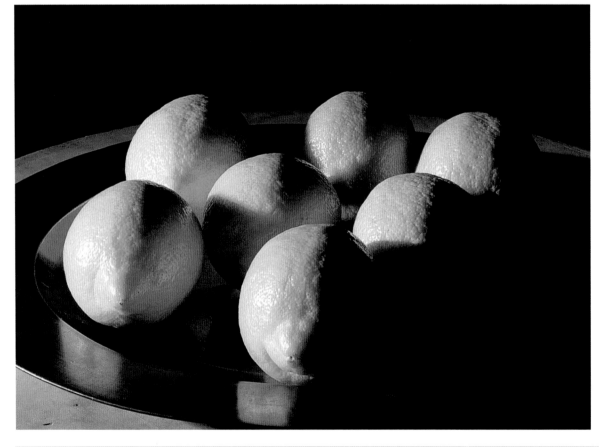

Natural daylight
Positioned by a window, these lemons are directly lit by natural daylight as well as by reflected light from the white window ledge. Note that adjacent to the window, where the lemons are most strongly lit, form is least obvious.

Low sidelighting

Light source at 90°

This still life is part of a sequence showing different lighting effects. Here a light is positioned low down at about the same height as the lemons, so that only one side is lit. Contrast between the lit and unlit sides is very strong.

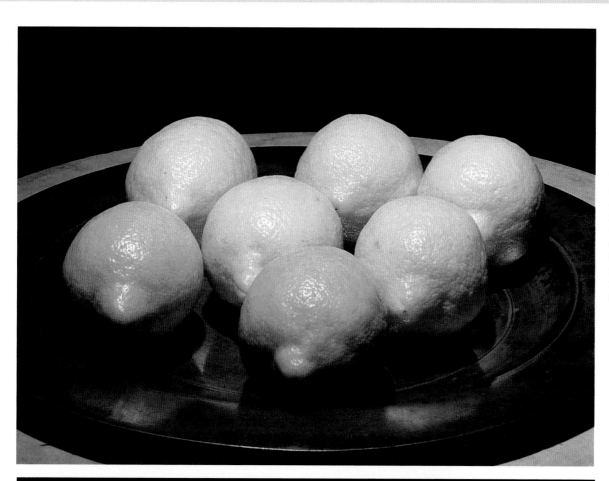

Overhead lighting

Light source above

The light is shining down from directly above the still life group, and, apart from the area near the dividing line between light and shade on each lemon, there is little sense of roundness. As a general rule, overhead lighting destroys form.

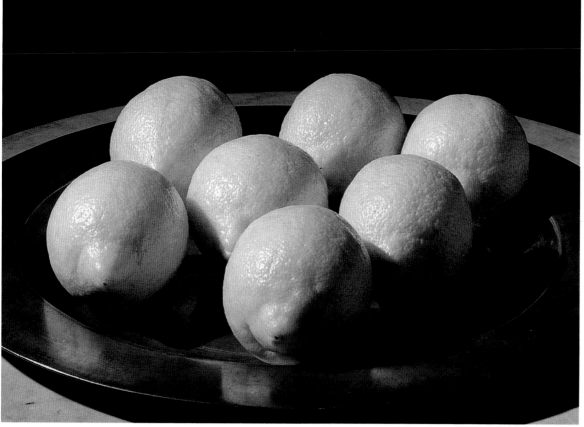

Angled lighting

Light source at 45°

An angle of about 45° is ideal to give an impression of the form of the lemons. There is a now a gradual transition between light and shade, noticeable on the right of the group, which was in very dark shade before.

REVEALING TEXTURE

The appearance of texture in a photograph gives the viewer additional information about the tactile qualities of an object. It is only by seeing the pitted quality of the skin of an orange, the coarseness of a length of woven cloth, or the smooth perfection of a piece of fine porcelain that we can imagine what it would be like to touch the object.

The most revealing type of illumination for texture comes from directional lighting, since it is the contrast between the lit, raised surface areas and the shadows in the hollows that creates a three-dimensional illusion (*see page 46*). This is the reason why the soft, directional light of early morning or evening sunshine has been the basis for so many successful landscape photographs.

Diffused light, *below*
Working in diffused light ensures that the shadows do not hide too much of the surface of this giant tree trunk. Note that the top ridges have all caught the sunlight, while the hollows are filled with deep shadows.

Depth and texture, *right*
Shot from overhead with weak sunlight striking the front of the cauliflower, it is easy to imagine the feel of the vegetable's surface. Tonal contrasts define the tactile qualities of the object and also give the picture an impression of depth.

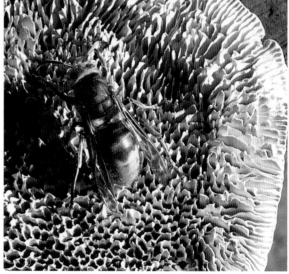

Magnified texture, *above*
By photographically enlarging a small object you can record its texture. The individual hairs on the body of this hornet and the hollows of the fungus are emphasized by the use of strong, directional lighting.

Wood surface, *above left*
Soft, oblique light reveals the texture of otherwise uninteresting pieces of old and weathered wood. Remember that individual surfaces absorb and reflect different quantities of light and must be lit accordingly.

Light and shade, *above*
The rusted and peeling surface of this sheet of metal is partly in sunshine and partly in shade. The directional lighting reveals the texture and adds to the overall composition.

Surface sheen, *left*
An old tarpaulin exposed to the weathering effects of the elements has taken on a character of its own. The lighting is subdued, since the sheen would be lost and the appearance of texture and form would be diminished if harshly lit.

DISCOVERING PATTERN

Representing order and harmony, pattern is something pleasing to the eye. To record the patterns abounding all around us, you need to choose the right viewpoint. By carefully selecting your camera position, you can record patterns even when looking at a seemingly random array of subject elements.

PATTERNS IN NATURE

As a photographer, you can draw attention to abstract patterns and repeating forms in the natural world, such as fallen autumn leaves or the frost-covered branches of a tree. Sometimes pattern is only transitory and is gone in an instant. A flock of birds, for example, can be seen as a collection of repeating colors and shapes, or sunlight on a row of houses may create a pattern of dark triangles in an otherwise bright scene.

Importance of viewpoint
To concentrate attention on the repeating shapes, colors, and forms of this flock of geese, a high camera viewpoint is vital. A lower camera angle would show more of the background and so dilute the pattern's impact.

Seeing pattern
A vortex of repeating shapes seems to draw the eye upward, following the relentless spiral of this staircase toward a distant highlight. Without the curiosity to explore different camera angles, unusual shots are easily missed.

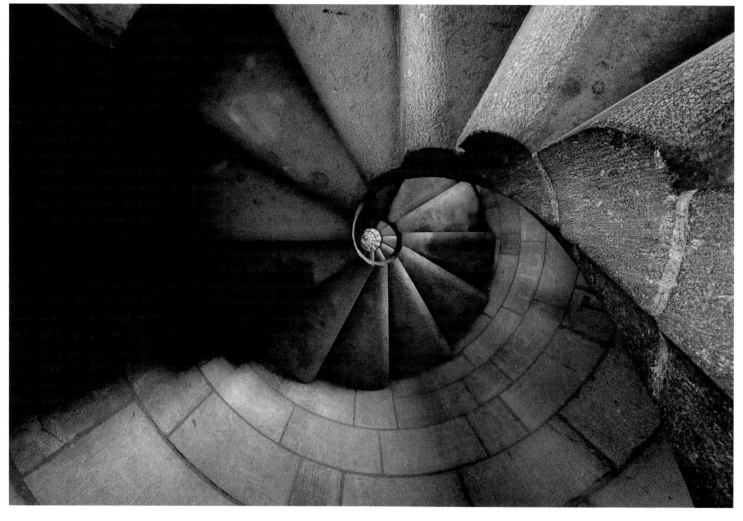

Layers of pattern, *above*
In this close-up of an aloe, many different layers of pattern can be seen in the overlapping fronds.

Isolating design, *below*
A jumble of rope can be framed in the viewfinder to create an interesting design. The twisted strands making up the rope itself represent a pattern within a pattern.

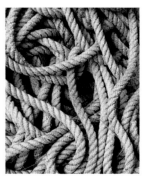

Random pattern, *left*
Although the pots are not arranged, their repeated curved shapes and the dark circles of their shadowy openings create a sense of pattern. The uniform color of the composition is another vital element.

Effective detail, *above*
The pleasing effect pattern has on the eye is illustrated in this detail of two cogs. Not only do the teeth of the cogs themselves form an obvious motif, but the interplay of light and shade also reinforces the effect.

THE BENEFITS OF BLACK AND WHITE

Black and white photography, although now a minority interest, continues to have a band of dedicated adherents. The enduring appeal of working in this medium stems from its powerful graphic potential and its ability to evoke mood and atmosphere.

Black and white film allows you a lot of flexibility in how the image will look when printed. You can use a wide range of colored lens filters to change the relative strength of tones within an image. It is also far easier than with color to manipulate the image in the darkroom, by giving a weak part of the negative extra exposure through the enlarger to increase local density, or by printing on a type of paper that gives an overall cold-blue image or a warm-brown one. Inevitably, once color is extracted from some scenes they lose much of their impact, and thus subjects such as gardens or natural history, in general, may not be ideal for black and white treatment.

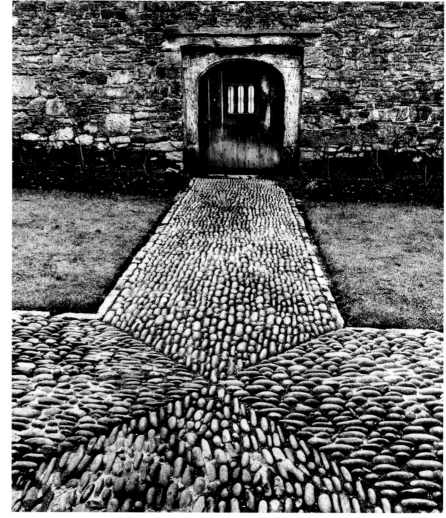

Dominant color
A wide range of tones is the main feature of the black and white picture (*right*). Although linear perspective draws attention to the door itself, the patchwork effect of the tones leads the eye in different directions around the photograph. By contrast, the colors of the door (*below*), serve to emphasize the textures.

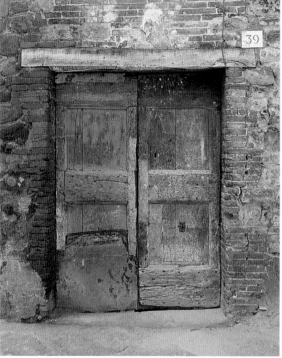

Distracting color
The color content is so overwhelming in the detail of a wall (*above*) that it does not allow the image to be seen as anything other than a color composition. Seen in black and white, a similar detail of a brick wall (*left*) has visual attributes such as texture, pattern, form, and shape.

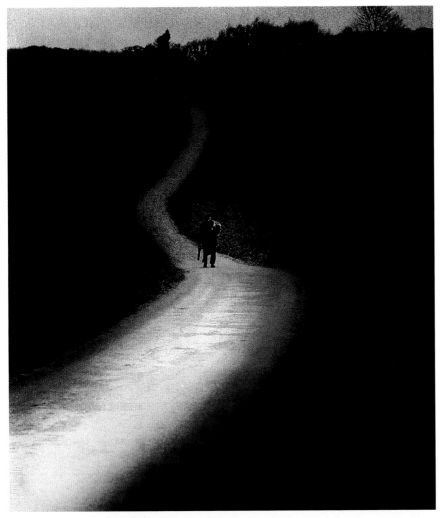

Darkroom manipulation
An atmosphere of isolation pervades this image of a solitary figure walking along a winding road. To heighten this effect, the countryside surrounding the road was given extra exposure during printing.

The human form
Black and white is ideal for showing the form and modeling of the human body by bringing out subtle gradations of tone. Sidelighting accentuates the skin texture so that every line is palpable.

Infra-red film
Infra-red film is sensitive to wavelengths in ordinary light that are invisible to the naked eye, and gives some subjects an unusual appearance. The sky in this image is unnaturally dark while the roadside foliage is unnaturally light. An infra-red or a deep red filter over the lens will exaggerate the tonal shifts when using infra-red film.

FRAMING THE IMAGE

To create a unified effect you need to decide how best to arrange the elements making up the image – what to include or omit, the angle at which to shoot, and how to show one subject element in relation to others. Just as a painter must work within the dimensions of his canvas, a photographer uses the camera viewfinder as the creative space within which to build a pleasing composition. One way of composing a picture is to use a frame within a frame. In order to emphasize the main subject of a picture you can show it surrounded and balanced by another element.

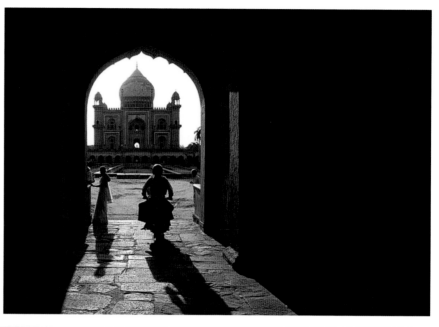

Stonework surround
The foreground stonework through which the distant landscape is viewed gives the scene an added feeling of space and distance.

Framing a building
By using an arch as a framing device, the image is simplified. Unwanted details are cut out to focus attention on the building.

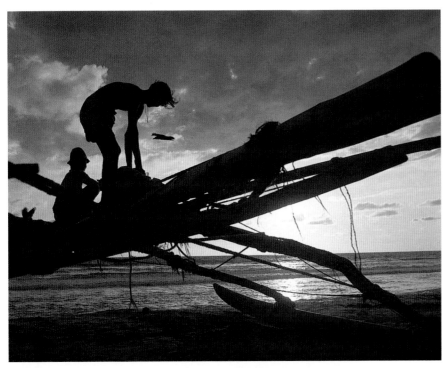

Balancing shapes, *left*
Careful composition within the viewfinder creates an evocative composition, with well-positioned silhouetted figures and the diagonal shape of the platform.

Frame effect, *above*
The viewer's gaze is drawn to the group of figures at the window by showing them within a natural frame created by a gap in the wall covered with ivy.

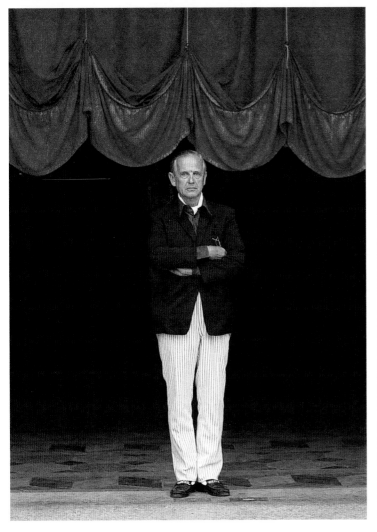

Framing choices
If using a 35mm camera, you can frame a picture vertically or horizontally. In the horizontally framed shot (*above*), there is a feeling of being enclosed by the hills rising on either side. By turning the camera around for a vertical shot (*left*), the inclusion of a greater amount of sky helps to dispel the sense of confined space.

Color contrast, *far left*
The figure is effectively framed by the red curtain as well as by the dark background against which he is highlighted.

SELECTING THE VIEWPOINT

The viewpoint from which you photograph a subject determines the apparent relationship between all the objects included in the frame and of those objects to their surroundings.

The only accurate way to determine the effectiveness of a particular viewpoint is by checking its appearance through the viewfinder. Looking at a scene with the naked eye, you are aware of a mass of peripheral information surrounding the area of interest. The viewfinder, however, shows the scene with clear-cut edges as it will appear in the finished photograph.

Look for ways to simplify the picture by positioning yourself to exclude extraneous detail, or for unusual ways to present the subject. While looking through the camera, try crouching down so that you are lower than the subject; or try standing on a small stepladder so that you can look down on it. Even by simply moving to one side you can show subject elements in a different way.

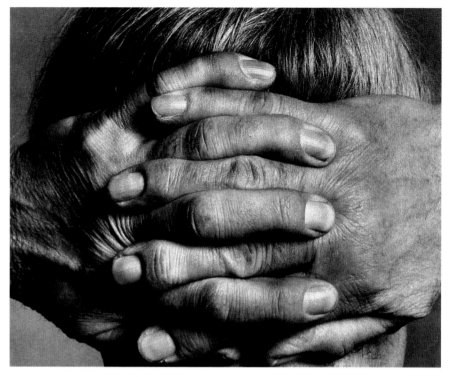

Selective viewpoint
In this unusual portrait of the sculptor Henry Moore, it is the artist's hands that are the focal point. The viewpoint forces our attention on to the strong fingers that are reminiscent of the sculptural shapes they once produced.

High viewpoint
In an overhead view, taken from standing height, these colorful toadstools growing on the forest floor seem to glow with an autumnal warmth. If taken from a lower camera viewpoint, their impact would be lessened by the inclusion of less of the background.

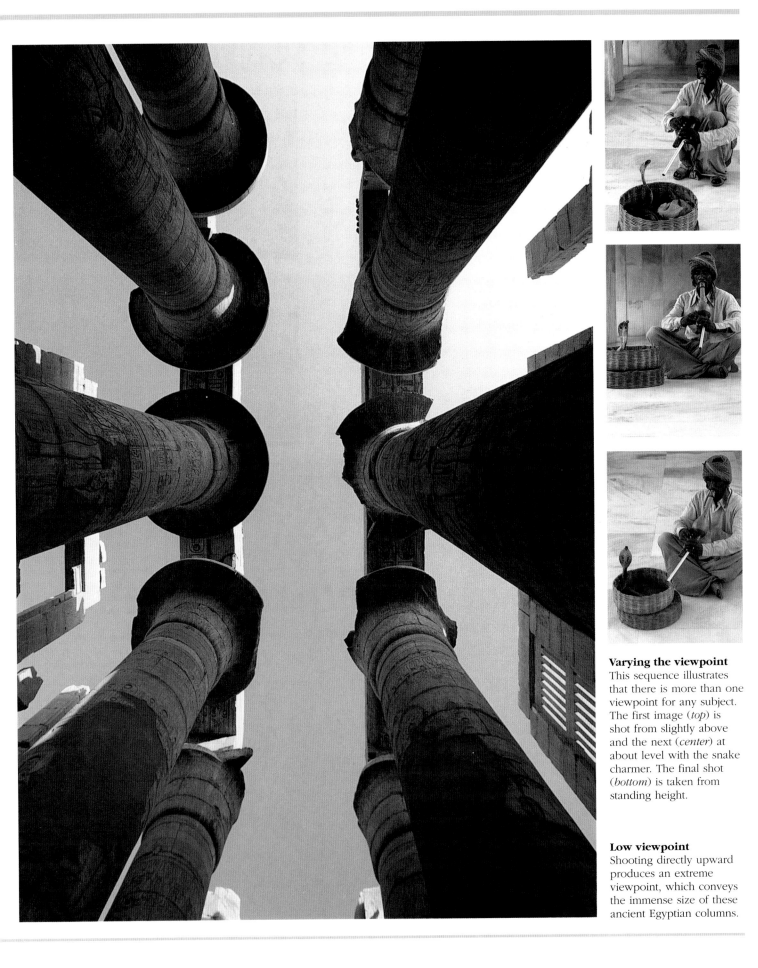

Varying the viewpoint
This sequence illustrates
that there is more than one
viewpoint for any subject.
The first image (*top*) is
shot from slightly above
and the next (*center*) at
about level with the snake
charmer. The final shot
(*bottom*) is taken from
standing height.

Low viewpoint
Shooting directly upward
produces an extreme
viewpoint, which conveys
the immense size of these
ancient Egyptian columns.

SHOOTING AROUND THE SUBJECT

While some subjects may only merit a single shot, others deserve more attention – particularly if you have traveled far to a location, or have had to wait for the right conditions. One of the simplest ways to create a different composition from the same subject is to walk around it. Not only will the lighting on the subject change, creating a different balance between highlights and shadows, there will also be a major impact on the composition. Even if the subject remains relatively unaltered as you move around it, the foreground and background may change radically. A distracting background behind a person can be made to disappear, simply by moving a few steps to one side.

With a wide-angle lens, it is the foreground that offers the greatest scope for visual variety. All manner of things, such as people, flowers, rocks, and gateways can be used to fill the lower part of the frame, providing counterpoint or balance to the main subject.

Variation of tone, *right*
The camera angle is particularly important in architecture, as straight-on shots can make the building appear very two-dimensional. A slightly angled approach means that one of the two visible sides is better lit than the other. This creates a better impression of three-dimensional form.

Half frame, *right*
By altering your viewpoint you can alter the position of foreground subjects so that they surround the main subject; here the foliage creates a natural frame around the chapel.

Using color, *left*
Because of their bright hues, flowers are good allies for the landscape photographer. If you adopt a low camera viewpoint, flowers can be made to take a leading part in the composition. Here the white blooms form a visual pathway that leads the eye to the chapel.

Leading the way, *far left*
Look out for shapes and lines that can be used in the foreground to direct the eye toward the subject. In this shot, the meandering path leads the viewer's eye to the rockery garden and the building.

Central framing, *left*
Here, although the house is centered top to bottom, it is slightly offset left to right in order to include the sea, which provides both a sense of place and a feel of harmony and tranquility.

Small focal point, *below*
The building may be the focal point in this picture, but it does not need to be large in the frame. This bold approach means that the sky and land dominate the composition.

Strong shapes, *bottom*
When using a wide-angle lens with distant subjects, use interesting foreground elements to fill the empty space that is created by the wide angle. Here, the spiky leaves contrast with the rocks and the smooth lines of the building.

DEPTH AND PERSPECTIVE

Perspective is a way of using spatial elements to indicate depth and distance in a photograph, giving the impression that you are looking at a three-dimensional scene. There are several different methods of using perspective to create this illusion of depth.

By placing one object behind another, known as overlapping forms, you can indicate that it is farther away from the camera. Diminishing scale, meanwhile, stems from our knowledge that objects of the same size appear to look smaller the more distant they are from the camera. Linear perspective describes the apparent convergence of parallel lines as they recede from the camera, and aerial perspective is the tendency of colors to become lighter in tone in distant shots. Finally, by using depth of field, you can make the background appear out of focus.

Using the horizon, *below*
The setting sun and the gradation of tones where the sea and sky meet creates an illusion of depth and distance in this scene.

Wide-angle perspective
A wide-angle lens produces an exaggerated perspective effect. The man's feet near the camera seem large in proportion to his head.

Linear perspective, *above*
The camera angle chosen for this view of a mosque in India shows strong linear perspective in the apparently converging sides of the lake.

Vanishing point, *above*
The tapering sides of these classical columns are an example of linear perspective. By picturing the pillars extending further into the sky, you can imagine them meeting at a distance – the vanishing point.

Aerial perspective, *far left*
A mountain lake makes an evocative foreground for the overlapping forms of a range of mountains in the Swiss Alps. Note how the peaks become lighter and bluer in tone as they fade away into the distance.

Diminishing scale, *left*
An avenue of trees leads the eye to a fountain, an effect reinforced by linear perspective. Another clue to perspective is present in the diminishing scale and apparent size of the trees.

USING THE VANISHING POINT

Artists perfect their drawing skills so that perspective looks natural in their work. They learn that lines need to be drawn so that they converge at an appropriate vanishing point. The photographer has no such problems, as the lens handles linear perspective automatically and with unfailing accuracy. However, by altering viewpoint and focal length, the photographer can make the effect of the vanishing point appear more dramatic within a picture.

By tilting the camera and by using a wide-angle lens, it is possible to make parallel lines seem to converge more steeply than usual. The effect is most frequently seen when shooting skyscrapers from street level, but it is more dramatic with lines that lead toward the horizon. Roads, pathways, and railtracks can all be used to create powerful angled lines with visible vanishing points if you crouch down and also angle the wide lens down slightly.

Coming to a point, *above*
The effects of linear perspective appear most marked when you can photograph the vanishing point within the frame. The lines along the edge of the subway walls and the markings on the platform all converge at the distant tunnel entrance. This provides a feeling of depth in the photograph.

High viewpoint, *left*
The effect of perspective creates strong diagonal lines, which can be used to emphasize dramatic compositions. In this shot, the lines along the glass roof converge in the distance, as the skyscraper beyond tapers into the sky. The result is a strong criss-cross pattern. The lighter tones of the more distant parts of the buildings contributes to the three-dimensional effect.

Up to the sky
Converging verticals are
caused by tilting the lens
(*above*); the top of the
building is more distant
than the base, so appears
narrower. A similar effect
is achieved with parallel
lines in the horizontal
plane (*top*) using a wide-
angle lens.

Light attracts, *left*
The focal point of this
monotonal shot is the roof,
as the light tone attracts
the eye. The lines of the
escalators also draw the
eye to this area.

DIGITAL SOLUTIONS

Digital software can be
used by photographers
to correct converging
verticals in architecture,
but the same stretching
and squeezing process
can also be used with
other pictures to
exaggerate the effects
of linear perspective.

DEFINING IMAGE PLANES

Unless you fill the camera frame with a flat, two-dimensional object, or just one face or side of a three-dimensional object, then every photograph should contain a foreground, middleground, and background, which are known as the image planes.

By ensuring that important subject elements are visible in all three image planes, you can manipulate the viewer's interpretation of the composition by leading the eye to explore the picture. However, you should try to choose a viewpoint that clearly defines one of the image planes as having a dominant compositional role, so that the idea you want to convey is not confused or lost.

Tonal separation
In this view of ornate steps leading to a church in Portugal, it is the subtle difference in tone that helps separate the fore-, middle-, and background.

Well-defined planes
Mooring poles define the foreground, the gondola the middleground, and the church the background. Each element adds to the view of Venice as a whole.

Merging planes
A long lens is used for this shot of the temple at Luxor in Egypt. By compressing the perspective, it merges the distinction between the image planes, and makes the judgment of depth and distance more difficult.

Foreground detail
Although a full and detailed picture, with well-defined image planes, the camera viewpoint emphasizes the foreground statue by showing it against a plain green middleground with the background building reduced in scale.

Middleground, *far left*
The castle in the middle distance dominates this landscape. Although the fore- and background are important, they are only assigned supporting roles.

Focusing distance, *left*
By using a wide aperture to render the background out of focus, attention is fixed on the railings at the front of the frame.

BALANCE AND PROPORTION

Practically every photograph, whether it is a visually rich interior or an abstract composition of shapes and colors, consists of a number of different subject elements. The photographer must aim to compose the shot so that there is a balance between all of them.

The concept of balance and proportion does not mean that a good photograph must be perfectly symmetrical or that the main focal point must be positioned in the center of the frame, since this leads to static, formal images. A much-used pictorial device is to divide the photograph into thirds, both horizontally and vertically, and to place the subject one-third across and one-third up or down the picture. Balance also applies to color and shape. Two strong colors or dominant shapes will compete for the viewer's attention, but if they are positioned in a sympathetic way they can provide an effective pictorial balance.

Balanced shapes
In this photograph of artist Graham Sutherland, the camera angle is chosen to balance the shapes of the seated figure and the semi-silhouetted tree stump.

Partial view
By avoiding the temptation to position the windmills in a symmetrical way, the partial view of the nearest building is balanced by the more distant structure.

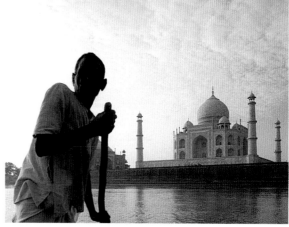

Foreground interest, *above*
The Taj Mahal is one of the most photographed sites in the world. In this picture, however, a duality of focal points makes for a more unusual representation. The boatman moving past balances the temple in the background, and also adds interest to the foreground.

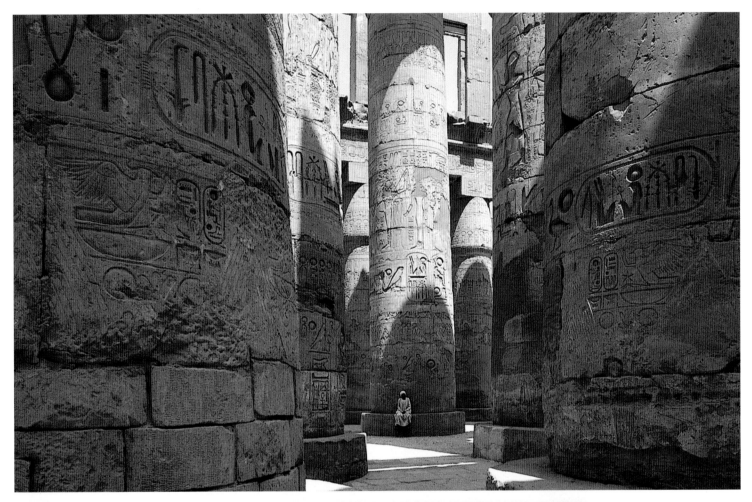

Human scale
The imposing columns of the Egyptian temple of Karnak at Luxor rivet the attention of the viewer, but without the presence of the diminutive, white-clad figure, the enormous size of the building could not be appreciated.

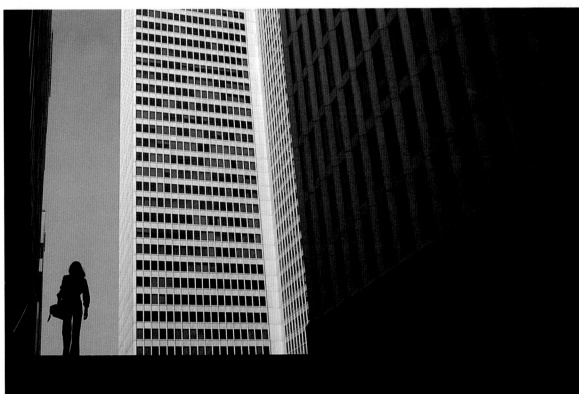

Dynamic imbalance
Although this picture is not at all symmetrical, the silhouetted figure seems to balance the bulk of the surrounding buildings. In its simplicity, starkness of tone, and geometric forms, the composition verges on the abstract.

SELECTION FOR EFFECT

Before taking a photograph of any subject you should spend some time studying and composing the image in the viewfinder. This involves arranging the subject elements to achieve the desired effect. Sometimes you may want to emphasize balance, harmony, and symmetry, while at other times you may prefer to highlight contrast by juxtaposing different elements or colors.

First decide which are the most important elements and then choose the viewpoint, focal length of lens, and film accordingly. Scenes with landscapes or buildings have many viewpoints; the interpretation of the image depends on the photographer's skill in framing the subject to exclude details that detract from the main area of interest.

 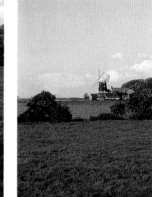 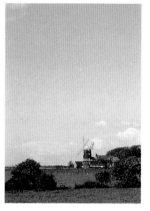

Positioning the horizon, *above*
Where you position the horizon can have a marked effect on the image. Whereas a high horizon accentuates the foreground, a low horizon emphasizes the sky.

Vertical abstraction, *below*
By framing a vertical subject such as these trees horizontally, a tension is established in the photograph. Vertical framing would weaken the overall effect.

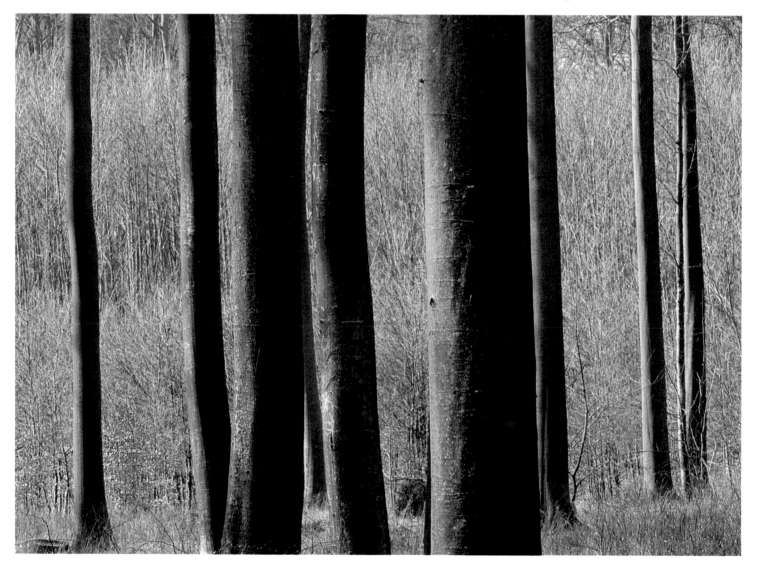

CROPPING AN IMAGE

Although it is always preferable to make major compositional decisions through the camera's viewfinder before taking a picture, you are not restricted to using the full-frame image once the film is processed. Sometimes it may be impossible to obtain the camera position you ideally want, so cropping out the foreground or background of the final image may be necessary. Alternatively, you may want to change the composition from horizontal to vertical framing by having only part of the original image enlarged. You could crop off one side of the picture to move a subject into an off-center position in the frame. Cropping can be used to concentrate attention on particular areas of interest in the picture to create balance and harmony. All the pictures on this page show how cropping can alter the appearance of an image to convey several different messages.

Horizontal cropping shows the subject and surroundings

Vertical cropping is used to isolate a detail of the image

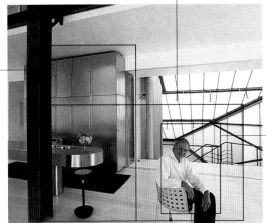

Close cropping isolates the figure in the photograph

Alternative ways of cropping
The full-frame image shows architect Richard Rogers in his home. The outlined areas illustrate different ways the image can be cropped.

Vertical image, *above*
Strong vertical cropping of the picture is used to isolate the subject and to eliminate all background detail. However, this portrait lacks some of the atmosphere of the scene shown in the uncropped shot.

Horizontal image, *above*
Cropping in on both sides of the figure and down from the top of the full frame has simplified the visual content of the image and produced a distinctly enclosed feeling.

Isolating details, *left*
A side detail of the original image has been enlarged to become the subject of this version. Enlarging should only be attempted when the image is sharp overall and there is sufficient visual content.

DIGITAL SOLUTIONS

Digital images are easier to crop precisely than those shot on film. Use the highest resolution available when shooting to allow for cropping, and edit a copy of the file rather than the original.

HOW TO
TAKE BETTER
PICTURES

The difference between an outstanding photograph and an ordinary one can often be the result of a minor adjustment in the angle of a light or a slight shift in viewpoint that totally changes the emphasis of a composition. This section reveals exactly how an experienced photographer undertakes a range of real-life photographic sessions and provides an invaluable insight into how to take successful photographs in a variety of situations, both in the studio and on location.

PORTRAITS

Photographs of people often elicit a greater response from the viewer than any other kind of subject. A good portrait photograph does not just show you the appearance of the subject. It should also be a visual biography, capturing a sitter's character and revealing their unique personality.

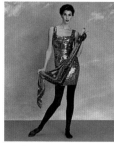

Fashion portraits
See pages 76–85

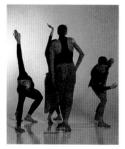

Character portraits
See pages 90–91

Dramatic portraits
See pages 96–99

Children's portraits
See pages 120–127

Photographing people

A portrait can be a photograph taken without the subject's knowledge, or it may be a more formal affair where the photographer has been commissioned to follow a specific assignment. As with all areas of photography, there are technical decisions to be made. Different types of camera and lens are needed for different conditions; lights must be arranged to achieve specific effects; and the camera viewpoint has to be positioned to suit the subject's face, or to enhance some aspect of the setting.

What makes a good portrait?

Portraits are not limited to posed shots of immobile subjects. Capturing moving subjects on film with flash can make lively, expressive portraits, and giving subjects an activity can have unexpected results. The latter approach works well with children, who become bored quickly. Do not underestimate the importance of background and setting in your portraits. Photographing people outdoors or in their own environment can add a dimension otherwise missing from a portrait in a studio setting.

Drawing out a subject

Another important aspect of portrait work is overcoming a subject's natural apprehension of the camera and lights. Try to put your model at ease by having all the camera equipment and lights set up well in advance of the photo session. This will leave you free to get to know and reassure the model before you start to take any photographs. Talking may help the sitter relax and allow you to achieve the desired result – a revealing, natural-looking portrait. The best photographs move beyond this to capture expressions that give an insight into a person's character and mood, resulting in wonderful and exciting portraits.

PORTRAIT SET-UP

The equipment illustrated here comprises a flexible set-up for a formal portrait photograph. It allows you complete control of the lighting and is highly adaptable. For full-length portraits you will need a room about 20ft (6m) long, although it is possible to shoot half-length portraits in a shorter space. Start by positioning the lights as shown below, and then adjust them to achieve different effects.

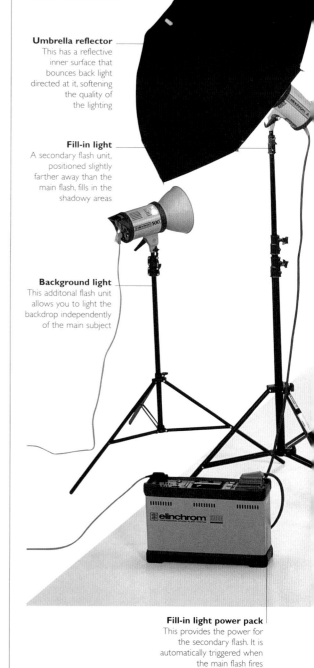

Umbrella reflector
This has a reflective inner surface that bounces back light directed at it, softening the quality of the lighting

Fill-in light
A secondary flash unit, positioned slightly farther away than the main flash, fills in the shadowy areas

Background light
This additonal flash unit allows you to light the backdrop independently of the main subject

Fill-in light power pack
This provides the power for the secondary flash. It is automatically triggered when the main flash fires

Formal portrait
This portrait is the result of the set-up below. The lighting is soft and gives good tonal separation between the model and background, with no harsh shadows across her face.

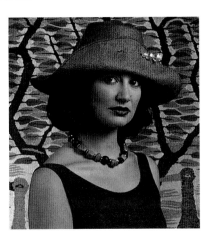

OVERHEAD PLAN

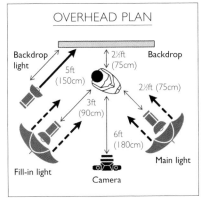

Backdrop light

Backdrop

2½ft (75cm)

5ft (150cm)

2½ft (75cm)

3ft (90cm)

6ft (180cm)

Fill-in light

Camera

Main light

Main light
Build up your lighting scheme one light at a time, starting with a main light. This flash unit is positioned so that light shines at about 45° to the model's face

Light stand
Adjustable light stand makes positioning the flash units extremely quick and easy

Cable release
This frees you from behind the camera, which allows you to interact with the subject

EQUIPMENT

- 35mm SLR camera and spare film
- Range of lenses
- Adjustable tripod
- Cable release
- Flash lighting units
- Umbrella reflectors
- Power packs
- Synchronization lead
- Diffuser panels

Camera and film
A 35mm SLR camera with a 100mm long-focus lens, loaded with ISO 100 film. The lens is set level with the model's face

Tripod
Using a tripod leaves you free to adjust lights and check the results in the viewfinder

Main light power pack
A 3,000-joule power pack provides the power source for the main flash unit. Output can be varied in one-stop increments

Synchronization lead
The cable runs from the camera to the main power pack, enabling the flash units to fire in sync with the shutter release

CREATING FORMAL PORTRAITS

A studio can be a challenging place to work. It is up to you to transform a stark space into an environment where your subject can be drawn out. However, if you have access to a studio, you have greater control and the opportunity to experiment with lighting quality and intensity, as well as with various shooting angles, and you will learn how to manipulate these variables for specific results.

LIGHTING EMPHASIS

There is no single "correct" lighting set-up for all portraits. The three-point arrangement *(see pages 72–73)* is a good starting point. However, placing diffuser panels directly in front of the flash heads and umbrella reflectors *(below)*, allows lighting to be manipulated to produce subtle variations. More obvious changes occur when whole lighting units are removed.

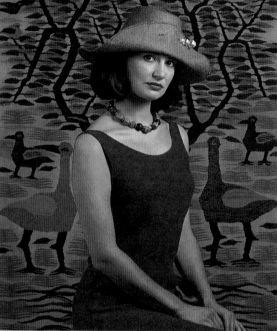

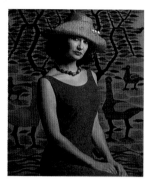

Lighting variations
If directional light is used with very little fill-in light, shadows increase (*left*). No fill-in light at all results in heavy contrast (*above*).

Soft lighting, *below*
This softly lit portrait is the result of the photo set-up using the diffuser panels.

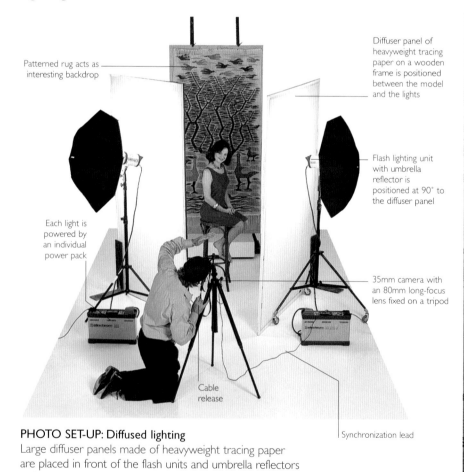

Patterned rug acts as interesting backdrop

Each light is powered by an individual power pack

Cable release

Diffuser panel of heavyweight tracing paper on a wooden frame is positioned between the model and the lights

Flash lighting unit with umbrella reflector is positioned at 90° to the diffuser panel

35mm camera with an 80mm long-focus lens fixed on a tripod

Synchronization lead

PHOTO SET-UP: Diffused lighting
Large diffuser panels made of heavyweight tracing paper are placed in front of the flash units and umbrella reflectors to increase the area of light falling on the model. This gives a low-contrast result if both lighting heads are used.

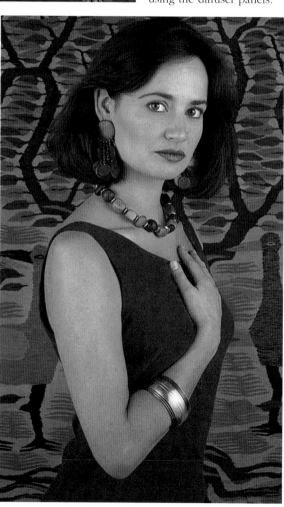

VARYING CAMERA ANGLES

A studio is the ideal type of location in which to experiment with different camera angles. By altering the viewpoint of the camera, you can bring about a variety of interesting and subtle effects. A high camera position, for example, shooting down on the model's face, tends to emphasize the forehead and the tops of the cheek bones. Moving to the opposite extreme, and taking the shot from below up toward the face, draws attention to the chin and lower jawline. This approach often results in the face taking on a slightly square appearance. The camera angle may also imply something about personality: shooting from above suggests vulnerability; while a model shot from below may appear aloof.

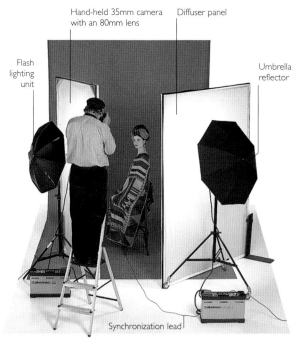

PHOTO SET-UP: High viewpoint
A little extra height considerably steepens the camera angle. Lighting is unchanged from the set-up shown on the opposite page. A long synchronization lead connecting the camera to the flash units allows freedom of movement.

PROFESSIONAL TIPS

● A three-quarter view of the face often makes it appear finer and less full than a frontal angle.

● For a 35mm SLR use an 80–90mm long-focus lens.

● Distortions occur when using a short lens close up.

● Using an extreme shooting angle may produce unwanted results, such as tapering features.

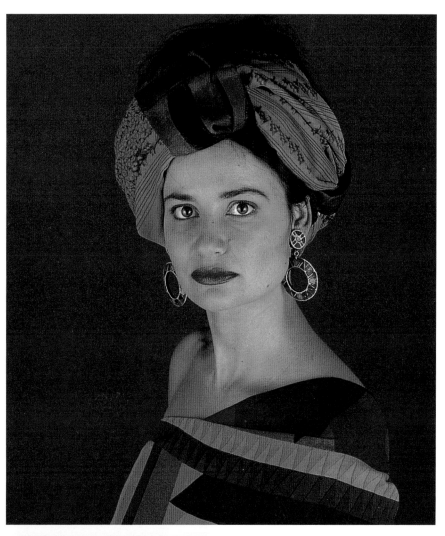

High camera angle
Shooting from a small stepladder gives strong emphasis to the model's forehead, eyes, and cheek bones, while the line of her jaw and chin is understated.

Low camera angle
Kneeling down and shooting up at the model from a low viewpoint changes the portrait's emphasis. Different facial features now catch the viewer's eye, with the chin and jaw looking stronger and squarer.

Subject in profile
A close-up profile is one of the most critical in portrait photography. Before starting to take pictures, study all aspects of your model's face and decide which angles to shoot from for the best effect.

TAKING FASHION PORTRAITS

Obtaining the services of a professional model for a day's session is not difficult, but it can be expensive. Model agencies usually charge for their models by the hour, so make sure you have a clear idea of the type of pictures you want before the shoot starts.

USING A PROFESSIONAL MODEL

Modeling is a form of acting that requires experience as well as an attractive face. A professional model will know how to react to the camera and how to change her pose to give the clothes an added elegance. She will be able to vary her facial expression and will be confident in the way she holds herself. In comparison, most amateur models will lack confidence and may appear wooden. Finally, if you do not want to use a make-up artist, a professional model will know how to apply make-up to suit the clothes she is wearing.

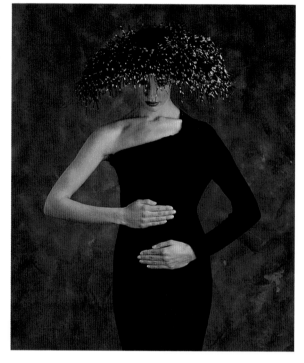

Symmetrical shape
The model's almost symmetrical pose highlights the simplicity of her dress.

PHOTO SET-UP: Fashion portrait

Two lights pick the dark-clothed model out from the mottled gray background. The flash unit to the model's right is angled at the ceiling so that its light reflects back down to give a broad spread of illumination. The flash unit to her left gives three-quarter illumination and is fitted with a softbox diffuser. A 6 × 6cm camera ensures the quality results demanded by magazines.

Wide-angle flash lighting head is angled upward at the ceiling

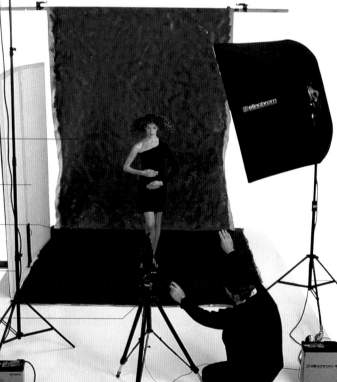

Canvas backdrop painted to give a neutral, mottled-gray effect

Reflector board ensures lighting is even

6 × 6cm camera on a tripod with a 120mm long-lens focus

Telescopic lighting stand, fitted with castors to make positioning easier

Cable release

Power pack

Posed portraits
Aim to direct the model into poses that emphasize the shape of her body and the clothes she is wearing. Note the way in which the model constantly changes her pose in this sequence of pictures.

Wide-angle flash lighting head enclosed within a softbox diffuser

Each light is powered by an individual power pack

USING ACCESSORIES

Attention to detail can transform an otherwise ordinary photograph. For a fashion portrait, any accessories or props you use should be appropriate to the type of image you want to create and should complement the model's clothes. Careful selection of accessories is vital: neutral tones can be set off by simple props, and bright, saturated colors can be complemented by unusual and exciting accessories. A portrait should communicate a message to the viewer, and each and every detail should facilitate that communication.

Framing a model
The story a photograph tells is partly dictated by how the model is framed. With a nearly full-length shot, the emphasis is on the model's general appearance. The viewer can appreciate the clothes, their monochromatic coloring, and how they work together.

Close-up eyes
Viewed in close-up, the emphasis of the image is fixed on the model's face. The pearl-studded sunglasses perched on her nose demand the viewer's special attention.

Splash of color
The use of props, such as this green hat, can complement a model's clothes and provide a bright finishing touch.

Change of mood
Confidence and poise are the hallmarks of a good model, quickly changing from one pose to the next.

PROFESSIONAL TIPS

- Keep a variety of interesting accessories on hand so that you can experiment with different props.

- Talk to your model, directing her every movement.

- Ask someone to assist with hair and make-up.

STYLING PORTRAITS

Brief models beforehand on the look and style you want to create at the photo session. If you can afford the expense, a costume supplier will be able to provide you with everything from period costumes to evening wear, and a stylist can help furnish the set. When taking fashion portraits, be sure that the models look perfect, since the final images should appear glossier and more attractive than real life. If you are working with two models featured in the same shots, coordinating the appearance of both of them is also essential.

PLANNING THE SHOOT

Once you have identified the style of the model's clothing, you can turn your attention to choosing a suitable setting. If you do not have access to a photographic studio or suitable space indoors, you could use an outdoor environment such as a deserted beach. Whatever setting you choose, be prepared to shoot a lot of film to get the most out of the session.

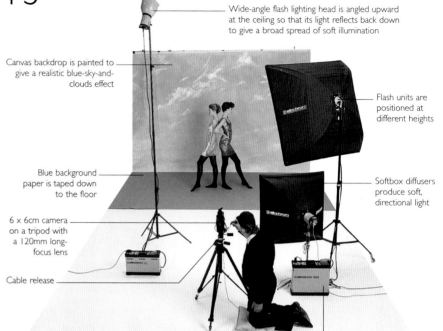

Wide-angle flash lighting head is angled upward at the ceiling so that its light reflects back down to give a broad spread of soft illumination

Canvas backdrop is painted to give a realistic blue-sky-and-clouds effect

Flash units are positioned at different heights

Blue background paper is taped down to the floor

Softbox diffusers produce soft, directional light

6 x 6cm camera on a tripod with a 120mm long-focus lens

Cable release

Single power pack runs both diffused flash units

PHOTO SET-UP: Lighting for a styled portrait
The set is lit by reflected light from a wide-angled flash directed at the ceiling on the photographer's left. The models' faces are illuminated by the two softbox diffusers.

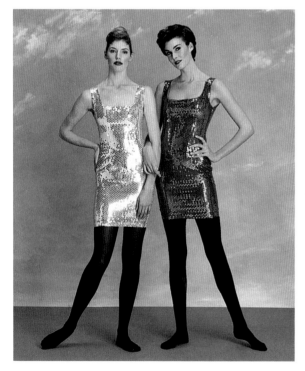

Coordinated image
The two models have a coordinated look with their matching sequined dresses. This image is emphasized by their linked-arm pose.

Making use of a prop
A silk scarf adds color as well as compositional balance. Expect to shoot a lot of film to achieve a natural-looking picture.

FILLING THE FRAME

You can achieve a close-up simply by moving the camera position closer to your subject to concentrate attention on facial features and expression. By excluding other details from the picture, the impact of the image can be dramatic if the model is well chosen. With a normal lens you may have to move very close to your subject to fill the frame with the model's head and shoulders. Alternatively, you can use a longer lens or have the central portion of the picture enlarged during printing.

The correct lighting is essential for close-up portraits. Gentle, soft lighting, such as from a window or a diffused flash, is more flattering than harsh, directional light, which tends to emphasize every fine line or misplaced hair.

Double profile, *above*
If using two models, position them so that each one is seen with her best profile toward the camera.

Critical close-up
Always check the models' appearance by looking through the viewfinder before pressing the shutter.

Unusual headwear
Hats can cause lighting problems by casting shadows over the models' faces or obscuring their eyes. To counter this, make sure the faces are lit independently, as shown in the set-up on the right.

PHOTO SET-UP: Lighting for a close-up
A wide-angle flash head reflects light bounced off the ceiling, as on the opposite page. The flash units with softbox diffusers to the photographer's right are positioned low and angled slightly upward, to throw extra light onto the models' faces.

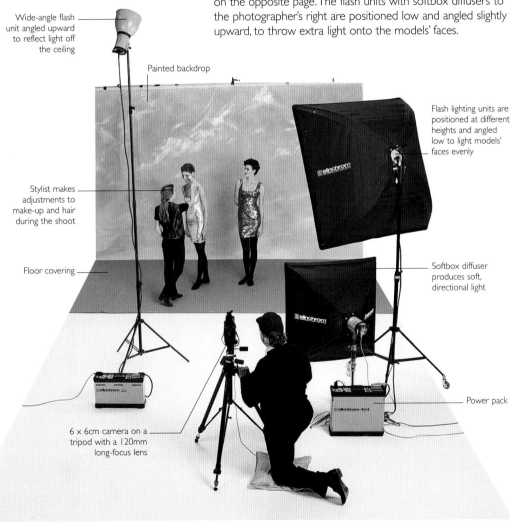

Wide-angle flash unit angled upward to reflect light off the ceiling

Painted backdrop

Stylist makes adjustments to make-up and hair during the shoot

Floor covering

6 x 6cm camera on a tripod with a 120mm long-focus lens

Flash lighting units are positioned at different heights and angled low to light models' faces evenly

Softbox diffuser produces soft, directional light

Power pack

HOW TO RELAX THE MODEL

Whether using professional models or friends, taking head-and-shoulder portraits or full-figure nudes, your photographic session will be more successful if your model is at ease. If a sitter is not relaxed, this will usually show in the pictures.

Create the right ambience from the start by ensuring the studio is not too warm or cold, and by playing suitable background music. Make sure that camera gear, lighting, and backdrops are as ready as possible before the model comes on set, and that the model has somewhere private to change costumes, adjust make-up, and sit between shots. It is the photographer that is the key, though. If you keep talking to the model, praising him or her, and suggesting poses and actions, you will obtain more successful shots than if you hide quietly behind the camera.

PHOTO SET-UP: Communicating with the model
The studio set-up can help the model to feel comfortable. By using a tripod, it is possible to maintain eye contact with the model while giving instructions, and using a standard lens allows close proximity so there is no need to shout.

Using props, *left*
The purpose of the rope in this set-up is not just to provide visual interest and a strong diagonal line. It also provides something for the model to hold on to, helping to avoid awkward-looking poses.

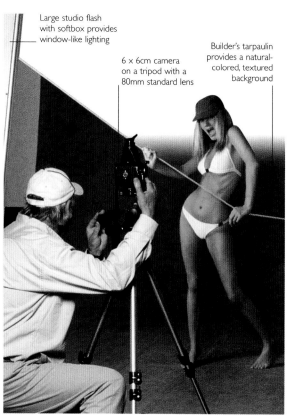

Large studio flash with softbox provides window-like lighting

6 x 6cm camera on a tripod with a 80mm standard lens

Builder's tarpaulin provides a natural-colored, textured background

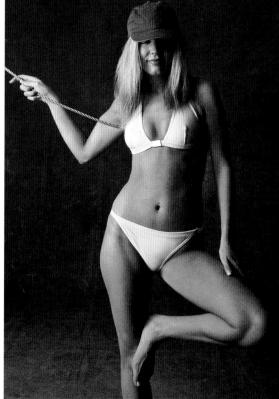

Changing the poses, *left*
When photographing people, even small changes in posture, or the way they turn their head or body, will have a major impact on the composition.

Getting a reaction, *opposite*
Often the poses that work best are exaggerated ones. To get an exaggerated pose while keeping the effect natural, ask the model to laugh or shout as you take the shot. Use lots of film to ensure you get the pose you want; this is not so necessary with digital cameras as you can review the actual facial expressions shot after each sequence.

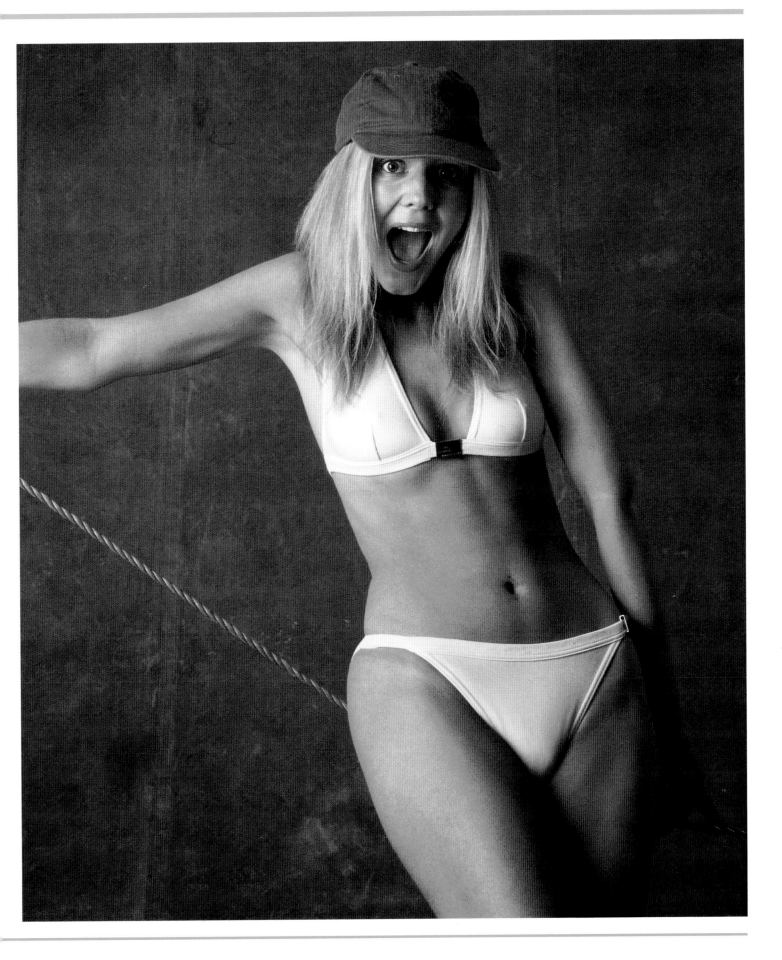

CREATING A STYLE

There are almost as many styles of fashion photography as there are styles of clothing. Glossy magazines are always trying to find "new" ways to show a new collection. Rather than just using those methods traditionally used for portraits, techniques are borrowed from other genres in the quest for an original look. For instance, models may be shot reportage-style with ambient light and grainy film, or special effects used, such as processing print film in chemicals meant for slides to give unusual color balance.

An approach that is particularly timeless, is the abstract style. The idea is to show the clothing almost in isolation; it is worn by the model, but by using close-ups her identity is hidden – putting the whole focus of attention on the clothes. The secret is then to use the thousands of poses that the human body is capable of to frame interesting shapes.

PHOTO SET-UP: Using digital backs

An advantage of a medium-format system camera is that it allows the professional photographer to switch from film to digital, between shots if necessary, or to suit the client's requirements.

Footstools are not only for model's comfort, they ensure her leg stays as still as possible during the shot

Plastic material with mirrored surface is used as a silver reflector to soften the shadows

6 x 6cm camera on a tripod with 120mm telephoto lens. A digital or film back can be used

Soft, even lighting is provided by bouncing studio flash unit into a white umbrella

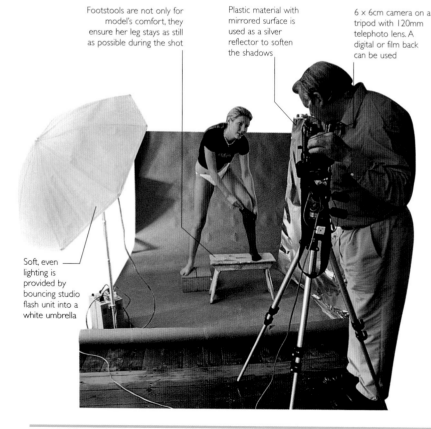

Color match, *top*
So as not to distract from the color of the stockings, it was important that the skirt and shoes were also red. The black and silver stool is neutral, as is the gray background.

Color contrast, *above & right*
A green backdrop was chosen because green is the complementary color to red. This ensured that the stockings stand out in the compositions.

Change of background,
above & left
Small changes to a set-up can create an entirely different look. Changing from a pale green tarpaulin backdrop (*above*), to a black backdrop (*left*) has created a more stylized low-key effect.
6 x 6cm camera, 120mm lens, digital back, ISO 100, f11, 1/60 sec.

Conveying purpose,
below & right
Clothes are designed for different purposes, and fashion shots must convey this. Alternative approaches communicate comfort and glamor. These two shots show ways of depicting different levels of sensuality.
6 x 6cm camera, 120mm lens, digital back, ISO 100, f11, 1/60 sec.

Defining the style, *right*
Props and background are essential for defining the style of the photograph. The wooden floor and leather chair help to give the impression that this is a candid photograph taken at a cocktail party in a grand country house.
6 x 6cm camera, 120mm lens, digital back, ISO 100, f11, 1/60 sec.

TAKING PORTRAITS ON LOCATION

You may have to overcome certain difficulties when you want to take a portrait of a subject in his home or workplace. You will have less control over lighting intensity and direction, and space may be cramped with furniture inconveniently arranged. However, a subject will be more relaxed in his own environment, and you gain the chance to record aspects of his life that could not be witnessed elsewhere.

LIGHTING POTENTIAL

In terms of lighting, you should be prepared for almost any situation – from direct sunlight streaming through a large window, to levels so dim that even fast film will require a wide aperture and still result in a very slow shutter speed. It is advisable to visit the location beforehand to see if you will need flash or additional equipment. You can then decide what type of camera to use and at what time of day the light will be most suitable.

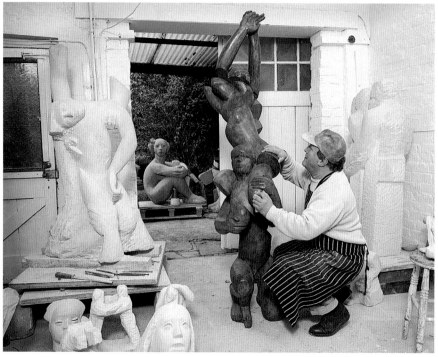

Diffusing umbrella made of sheer material creates soft directional lighting effect

6 x 6cm camera on a tripod with an 80mm lens

Light-colored walls and ceiling are ideal for bouncing flash

Flash head positioned high to reflect light from ceiling and walls

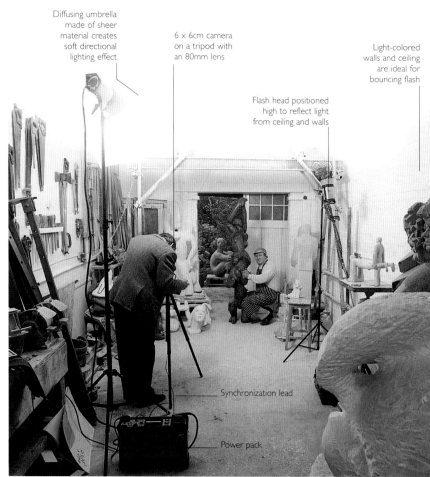

Synchronization lead

Power pack

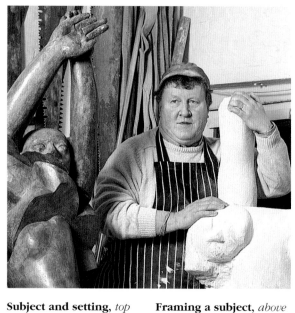

Subject and setting, *top*
The setting is as much the subject of the picture as the sculptor. Carefully placed statues mark the fore-, middle-, and background.

Framing a subject, *above*
Look for the best way to frame your subject in the available space. In this shot, the sculptures make strong shapes flanking their creator.

PHOTO SET-UP: Supplementary flash

To photograph sculptor Glyn Williams in his studio calls for soft, directional lighting to capture the subtle texture of the sculpted figures. The low level of natural daylight requires the use of flash lighting. The light-colored ceilings and walls make ideal surfaces from which to bounce light.

Walls are too far away from the light source to affect the overall exposure

Subject is leaning on sculpture to reinforce link with work

6 × 6cm camera on a tripod with a 150mm long-focus lens

Single flash head with a diffusing umbrella is angled to spotlight the subject's face

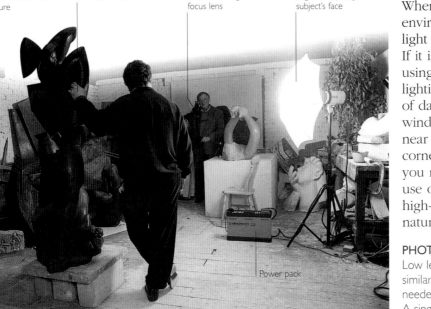

Power pack

SIMULATING DAYLIGHT

When taking a portrait in a working environment, it is preferable to use natural light to convey the atmosphere of the setting. If it is not possible to illuminate an interior using natural light, you can arrange the flash lighting to simulate some of the characteristics of daylight. Light entering a room through a window produces a directional effect, lighting near parts of the subject and casting distant corners into shadow. When taking a portrait, you may need to reduce this contrast by the use of fill-in lights and reflectors. However, high-contrast lighting does give a scene a naturalness that implies a lack of interference.

PHOTO SET-UP: Poor natural light

Low levels of natural light present lighting problems similar to those on the opposite page. Diffused flash is needed to light the sculptor evenly in the dark interior. A single flash unit with reflector is positioned to light the subject's face, but the background walls remain in shadow.

Natural daylight, *above*
Positioning the sculpture directly below a skylight produces this high-contrast lighting effect.

Simulated daylight, *left*
Diffused flash is used to supplement the weak light from an overhead skylight. The lighting direction and quality resemble natural light but ensure that the shadow areas are not too dark on the subject's face.

PROFESSIONAL TIPS

- Visit the location before the shoot.

- Exclude unwanted clutter from the shot.

- Take additional lights if daylight is very poor.

- Make sure there are sufficient power points to run your equipment.

Indirect daylight, *top*
For this portrait of artist Ivan Hitchens, indirect light bouncing off a wall produces a soft effect.
6 x 6cm camera, 150mm lens, Ektachrome 200, f11, 1/125 sec.

Flash and daylight, *above*
Flash supplements the poor light in a gallery interior for this portrait of sculptress Barbara Hepworth.
6 x 6cm camera, 80mm lens, Ektachrome 100, f11, 1/125 sec.

Filling the frame, *above*
With a strong personality such as artist David Hockney, stay alert and react to any chance expression.
6 x 6cm camera, 120mm lens (plus extension tube), Ektachrome 100, f16, 1/60 sec.

Location lighting, *right*
Bounced flash was used for this location portrait of Agatha Christie.
6 x 6cm camera, 150mm lens, Ektachrome 64, f11, 1/125 sec.

Appropriate lighting, *far right*
Artist Richard Hamilton's expressive face benefits from the punchy quality of strong natural daylight.
6 x 6cm camera, 80mm lens, Ektachrome 100, f11, 1/30 sec.

Color statement
The color and abstract flowing shapes of his paintings make an ideal background for this portrait of Terry Frost. The colors of the canvas are emphasized by the artist's beret and the contrasting vertical stripes of his waistcoat.
6 x 7cm camera, 80mm lens,
Fujichrome 100, f8, 1/250 sec.

Integrating the background
Good photographs work at all levels, from the foreground right through to the background. And in this portrait of John Bellamy, the background of one of his canvases is as much the subject of the photograph as the artist himself. Lighting is provided by a mixture of bounced flash and daylight.
6 x 6cm camera, 50mm lens,
Ektachrome 200, f5.6, 1/15 sec.

CAPTURING CHARACTER

Perhaps the most challenging aspect of taking a portrait photograph is to try to capture something more than just a likeness of the subject. In fashion portraiture (*see page 72*), for example, the models are not just vehicles for the clothes they wear; they also need to project a certain image. Similarly, an informal portrait of a person should tell the viewer something about the sitter's character.

LIGHTING FOR AN OLDER SUBJECT

Choosing appropriate lighting is critical when photographing an elderly subject. A face lined with age speaks volumes about the sitter's personal history. If you want to emphasize the wrinkles and lines that reveal character, use strong directional lighting to highlight the surface texture. However, if you want to disguise the signs of aging, you can use a soft-focus filter to blur skin texture. Diffused or reflected light as used in the images on these pages gives a flattering, subtle effect.

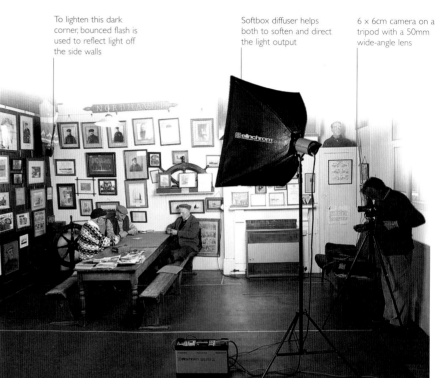

To lighten this dark corner, bounced flash is used to reflect light off the side walls

Softbox diffuser helps both to soften and direct the light output

6 x 6cm camera on a tripod with a 50mm wide-angle lens

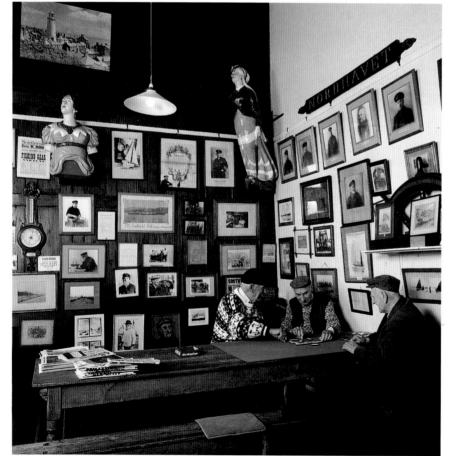

PHOTO SET-UP: Diffused flash lighting

The location is a long-established reading room for retired sailors and fishermen. The walls are covered with glass-covered photographs recording long careers spent at sea. If not treated with care, the flash could cause each picture to reflect light in the form of intense highlights known as hot spots. To prevent these reflections, check the image in the viewfinder, and adjust the picture frames accordingly.

PROFESSIONAL TIPS

- A wide-angle lens allows you to include more of the setting in the frame for added atmosphere.

- A 35mm SLR is less noticeable than a medium-format camera and may seem less intimidating.

- Remove unwanted furniture from the picture area.

- Use a dulling spray to prevent reflections.

- If you are working with a flash unit, make sure the synchronization lead allows you free movement.

Creating atmosphere
Lit mainly by reflected light bounced off the side wall, the intimate atmosphere of the setting is preserved. Lighting must be adjusted constantly and the image checked in the viewfinder.

Candid moment, *above*
Capturing an unguarded
moment is possible here
since the subject is totally
engrossed in the game and
not self-conscious.

Using the setting, *left*
Setting the subject off-
center establishes a tension
in the composition, and
the pictures visible behind
him suggest something
about his history.

PHOTO SET-UP: Character in close-up

By moving in closer with a hand-held 35mm camera and an 80mm
long-focus lens, you can isolate one person in the group. Try to
frame the image to exclude unwanted detail so that everything in
the final shot provides valuable clues to the sitter's character.
Concentrate on the feature that you most want to emphasize and
then wait for the right moment to release the shutter.

Compactness of a
35mm SLR camera
makes it ideal for
hand-holding

80mm long-focus lens is used to
isolate a single subject

Subject quickly forgets
about the photographer
and continues playing the
game of cards

Character and mood
Try to be unobtrusive and
avoid drawing attention to
the camera. Do not let your
subject pose for too long
(*top*), but follow the mood
and atmosphere of the
occasion (*above*).

TAKING PORTRAITS OUTDOORS

The advantage of shooting outdoors is that it is much easier to get natural-looking results in daylight than it is in the studio, although in the studio you have greater control over the lighting. Outdoors, the intensity and quality of light varies enormously from day to day, and often from one minute to the next, so it is important to choose the conditions with care. Harsh direct sunlight produces strong shadows that can obscure facial details, as well as making people screw up their eyes in an unphotogenic fashion, while heavily overcast conditions can lead to dull, flat portraits with weak colors. An ideal compromise is to shoot on a bright day when there is some cloud cover. Setting up the shot so that the light is at 45 degrees to the subject's face provides just the right amount of shadow. If necessary, the lighting can be balanced by using white reflectors.

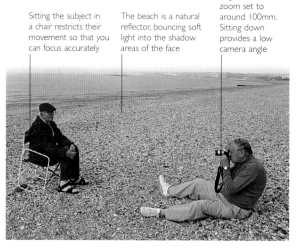

Sitting the subject in a chair restricts their movement so that you can focus accurately

The beach is a natural reflector, bouncing soft light into the shadow areas of the face

Digital SLR with zoom set to around 100mm. Sitting down provides a low camera angle

PHOTO SET-UP: Sir Terry Frost
This portrait of abstract artist Terry Frost, taken shortly before his death at age 87, was taken at a beach near his home that had been an inspiration for his paintings. The open space provided a vast backdrop to shoot against.

Selective focusing, *above & right*
By combining a telephoto lens with a small aperture, the horizon is softened, so as not to distract from the main subject.

Personal details, *left*
Include objects in the shot that tell you more about the subject. This chair has been painted by the artist in the colorful stripes that characterize his work.

PROFESSIONAL TIPS

● Red-colored clothes or accessories provide immediate impact in portraits.

● Hats are useful props to have to hand for portraits, helping to isolate the head from the background as well as adding visual interest.

TAKING BLACK AND WHITE PORTRAITS

Black and white film is a medium that attracts those photographers who want an added dimension in the process of image selection and interpretation. Color, even when used in a very abstract way, leaves little room for the viewer's imagination. Color also has certain associations with mood, some of which are cultural and some personal – fiery red, sunny pastel shades, cold blue tones, and so on. Because we react so strongly to the color content of a photograph, it can sometimes distract us from looking at other important aspects of the image.

TONAL VALUES

In black and white pictures, images become much simpler in content. The clutter of color falls away and is replaced by a range of tones – shades of black, ranging from gray to white (*see page 44*). If you think of a photograph as already being an abstraction of the real scene it records, then a black and white picture is another step away from that reality.

White reflector is set at about 45° to the subject

Single flash lighting unit is pointing directly at a large circular reflector

6 x 6cm camera on a tripod with a 50mm wide-angle lens

Walls and ceiling help reflect the light

Black and white or color
Positioning the subject so that he appears to be part of the collection of sculpted heads works better in black and white than color.

Subject is positioned against a background of sculpted heads

PHOTO SET-UP: Confined spaces
In the narrow upstairs hallway of sculptor Glyn Williams' home, there is little space for the flash lighting unit used to supplement the daylight coming through the window. In order to maneuver himself into the correct position in relation to the background of sculpted heads, Glyn improvised by standing on a plank bridging the stairwell.

Highlighting elements

The way we interpret a picture varies according to whether the image is in color or black and white. In this comical pose the viewer's eye is drawn to the sculpted hands in the immediate foreground, the sizes of which have been exaggerated by using a wide-angle lens. Although the subject's pose in the color portrait is identical to the black and white version, it is the colored checks of the subject's shirt that initially attract the viewer's eye. With the middleground demanding attention in this way, the overall image lacks the impact of the black and white portrait.

PHOTO SET-UP: Subject and background

Two aspects of Glyn Williams' work, drawing and sculpting, provide ideal background and foreground elements for this portrait, and a strange perspective is achieved by utilizing the distorting effect a wide-angle lens exerts on the apparent sizes of foreground and background objects. As with the set-up shown on the opposite page, the lighting is kept simple with a single flash lighting unit and reflector supplementing the poor natural daylight.

Single flash lighting unit with an umbrella reflector is positioned opposite the subject

6 x 6cm camera on a tripod with a 50mm wide-angle lens

Winter daylight from window supplements flash lighting

Sketches taped to the wall behind are lit by a mixture of flash and daylight

DIGITAL SOLUTIONS

- If using a digital camera it is often best to take the shot in color rather than in a black and white shooting mode. If you convert the image to black and white later you will be able to exercise better tonal control, and also retain the option of using the shot in color.

- A black and white shooting mode can also be used as it will be extremely useful for visualizing the shot without color before the final version is actually recorded.

CREATING DRAMATIC PORTRAITS

Injecting drama into a photograph often means using lighting creatively to produce a powerful or unusual interpretation of your subject. You can use strong, directional light to create a high-contrast portrait with bright highlights and dark shadows that accentuate a subject's bone structure and facial features.

LIGHTING COLOR AND EFFECT

You can also alter the color of the lighting for dramatic effect. It is best to make a radical change to the normal color since a minor deviation may look accidental. In the images on these pages, the flash heads are filtered in different colors and the lights lowered to cast long shadows. In additon, smoke is released during the shoot for added theatrical impact.

COLORED GELS

Colored light filters are usually made of gelatin or plastic, and come in a variety of sizes. If filters are too large, trim them to a manageable size and clip or tape them over the lighting heads or the inside surface of a diffuser.

Colored filter effects
The dancers and the lights illuminating the set are well defined before the addition of the smoke.

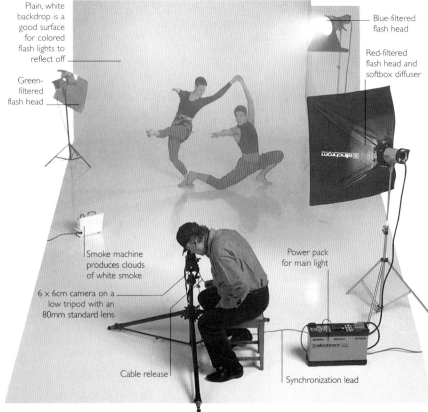

Plain, white backdrop is a good surface for colored flash lights to reflect off

Green-filtered flash head

Blue-filtered flash head

Red-filtered flash head and softbox diffuser

Smoke machine produces clouds of white smoke

Power pack for main light

6 x 6cm camera on a low tripod with an 80mm standard lens

Cable release

Synchronization lead

PHOTO SET-UP: Lighting with colored filters
Two flash units covered with blue and green gelatin filters respectively are positioned at the back of the set behind the dancers. A red-filtered flash unit with a large softbox diffuser to the right of the photographer provides general, warm illumination all over the set.

Smoke effects on lighting
When the smoke is added, the light becomes more scattered and diffused, the figures less distinct, and areas of color start to merge.

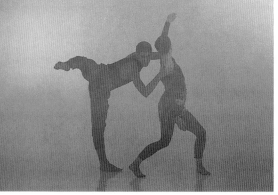

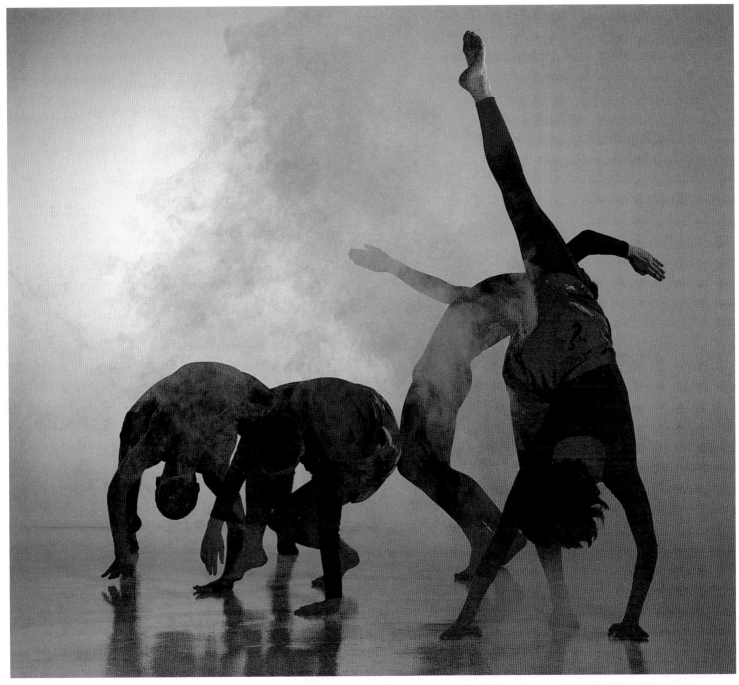

Enhancing effects
The exaggerated poses of the modern dancers are given greater dramatic impact by the addition of special-effects smoke.

Exposure compensation
Scattered light, as shown in this sequence, can cause the meter to register more light than is present. Open the aperture an extra half to one f-stop to compensate.

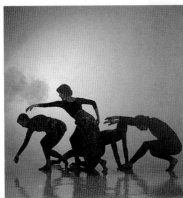

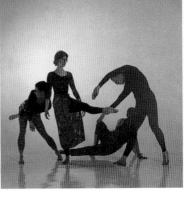

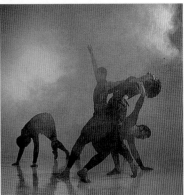

DRAMATIC PORTRAITS OUTDOORS

Rain, wind, and fog can sometimes be used to help add ambience to an outdoor portrait. Whilst these atmospheric effects can be added by waiting for the right conditions, it is more practical to create them artificially. This has the advantage that the effect can be added with minimal discomfort, and with maximum control over intensity. Real rain, for example, will cause problems with lighting intensity, and may damage camera equipment. A strategically-placed sprinkler allows you to keep equipment dry and to use brighter lighting conditions.

A favorite effect, both outside and in the studio, is smoke. This can be used to suggest clouds, fog, or mist. The smoke, however, cannot be controlled precisely, so getting the exact effect you want is hit and miss. Usually, it is best to wait for the smoke to build up, or disperse, to the right density, then quickly take as many shots as possible.

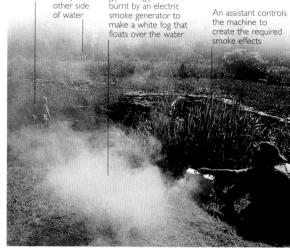

Model in lake — 35mm SLR set up on other side of water — A special solution of glycol or glycerol is burnt by an electric smoke generator to make a white fog that floats over the water — An assistant controls the machine to create the required smoke effects

PHOTO SET-UP: Morning mist on a lake
I wanted to take pictures of the model in a lake against a backdrop of atmospheric mist. By using a smoke generator I was able to do the shot on a warm, bright summer's day, rather than on a cold, gray winter's morning.

Keeping your distance, *left*
For this shot, only mist in the background was required, so that the model was not obscured from view. The smoke machine was set up on the opposite side of the water from the camera. The density of fog in shot could then be controlled by the model moving to different parts of the lake.

Ripples, *right*
In order to get a feeling of movement in the water, I asked the model to move forward as I shot the picture. This created an attractive pattern of ripples.

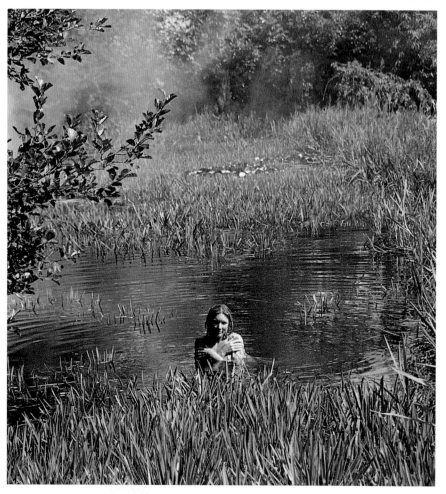

PROFESSIONAL TIPS

Smoke can be provided artificially by using cigarettes, bonfires, or dry ice. For better control, a mains-powered smoke generator can be hired from specialist theatrical suppliers.

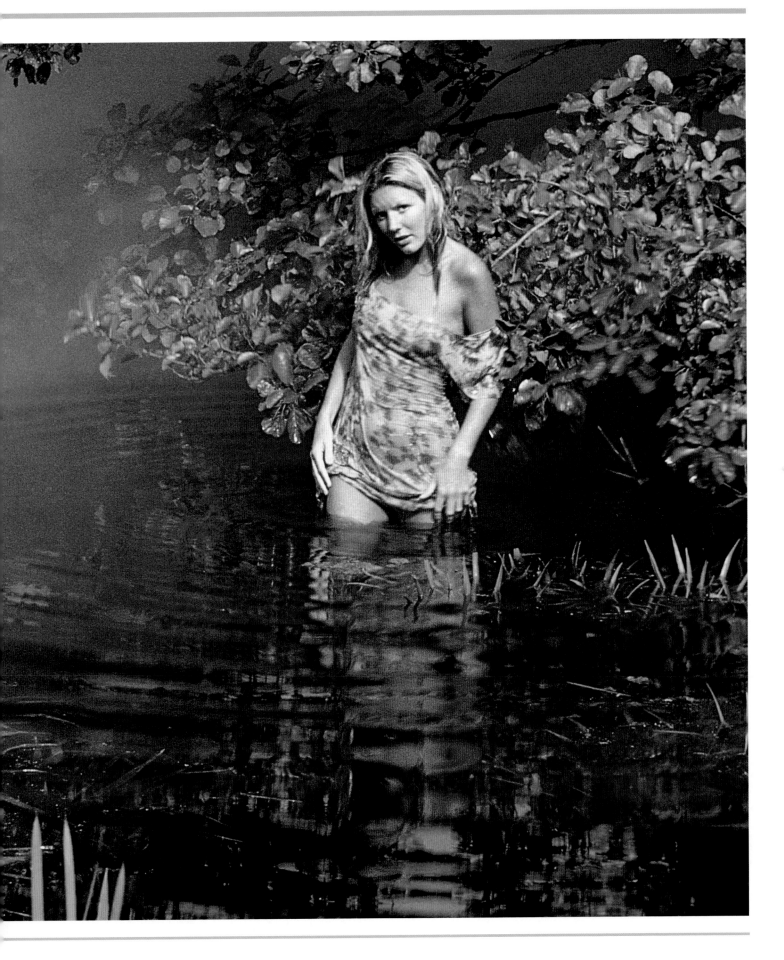

Tonal contrast, *above*
The carefully positioned sculpted heads make an ideal frame within which to place their creator, the sculptress Elisabeth Frink.
35mm camera, 80mm lens, HP5, f16, 1/30 sec.

Rural record, *below*
A single picture can tell a life story. The simple setting, the clothes on the line, and the farmer's expression tell of a way of life now extinct.
6 x 7cm camera, 80mm lens, Tri-X Pan, f11, 1/60 sec.

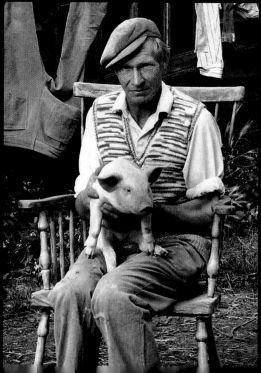

Making a connection
An old woman holding her prized pet pigeon makes for a revealing character portrait. Diffused flash is used to supplement the weak sunlight and highlight the fine lines on the subject's face.
35mm camera, 105mm lens, HP5, f16, 1/250 sec.

Window light
Weak sunlight from a window on the subject's right provides the only illumination for this picture of a Salvation Army stalwart. This type of gentle and sympathetic lighting masks some signs of aging and is in keeping with the subject.
35mm camera, 80mm lens, Tri-X Pan, f5.6, 1/60 sec.

Framing an idea

In any photograph of an artist you might expect the tools of the trade to feature prominently. In this portrait of sculptor Henry Moore, it is his hands that are held up to the camera, positioned as if sizing a block of stone, yet acting as a frame for his face.

6 x 6cm camera, 50mm lens, Tri-X Pan, f11, 1/250 sec.

Focusing attention

Although a face as powerful as this would command attention no matter how it was photographed, a wide lens aperture keeps the depth of field sufficiently narrow to keep details in the background from competing.

35mm camera, 135mm lens, HP5, f4, 1/30 sec.

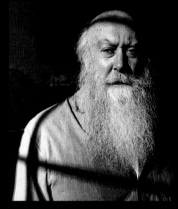

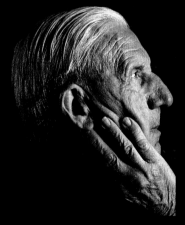

Natural spotlight, *top*

With sidelight revealing fine details, typographer David Kindersley is thrust forward in the frame.

35mm camera, 135mm lens, HP5, f16, 1/250 sec.

Directional flash, *above*

A flash is directed at the subject to throw a band of light over the face.

6 x 4.5cm camera, 120mm lens, Tri-X Pan, f22, 1/60 sec.

TAKING A SELF PORTRAIT

Self portraiture is a photographic exercise that may require the use of one or two technical aids and a great deal of patience, but it can also be a lot of fun. The simplest way to take your own portrait is to pose in front of a mirror and to photograph your reflection by holding the camera at waist level. Alternatively, you can use a long cable release or self-timer and pose in front of the lens.

DELAYED-ACTION TIMER

Practically all cameras have a delayed-action timer designed for self portraiture. Activating this before pressing the shutter release gives you between 10 and 20 seconds (depending on the camera) to get to your predetermined position. Alternatively, if you pose close to the camera, you can trigger the shutter at the precise moment you want by using a long cable release. An adjustable tripod is essential for positioning the camera at the right height.

PHOTO SET-UP: Indoor self portrait

For this self portrait, the camera's integral delayed-action timer is used. The camera is prefocused on the exact spot the subject will occupy, and a chalk mark on the canvas sheet acts as a position guide.

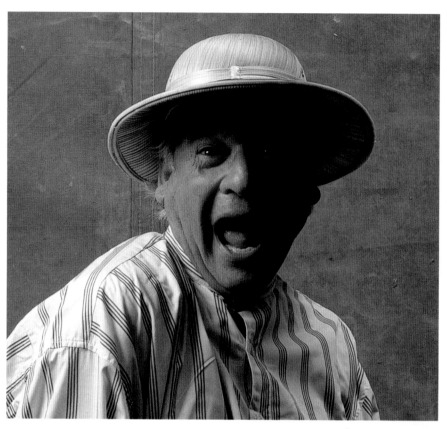

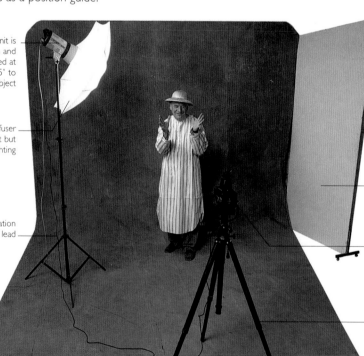

Single flash unit is set high and positioned at about 45° to the subject

Umbrella diffuser gives direct but softened lighting

Synchronization lead

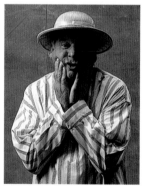

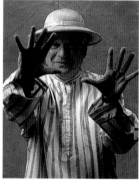

Hardboard reflector is positioned on the subject's shadow side to return some of the light and reduce contrast

6 x 6cm camera with a 120mm long-focus lens and with shutter set on a delayed timer

Adjustable tripod is positioned so that the camera frames the subject's head and shoulders

Self-timer sequence
Experiment with different poses to record a comic, dramatic, or serious self portrait. The exposure for these self portraits (*above*) was calculated using a flash meter, and the settings then transferred to the camera. Remember to wind the film on between shots and to reset the timer.

Photo set-up: Outdoor self portrait

The camera is focused and set manually for the distance of the subject from the camera, and an extra-long cable release allows the shutter to be released at precisely the right moment.

35mm camera on a tripod with an 85mm long-focus lens

Long cable release is held by the subject, low down and out of shot, allowing the shutter to be triggered at will

Silver reflector is used to lighten the subject's shadow side and even out the lighting contrast across the face

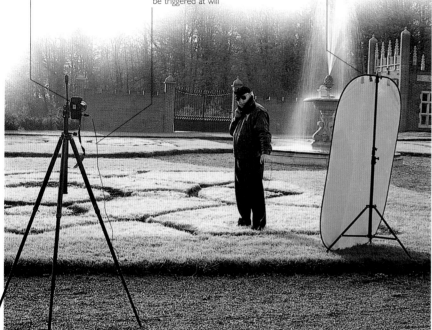

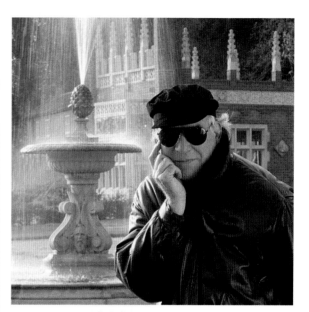

Exposure reading
To determine the exposure for these self portraits, the subject took a reading from the back of his hand while standing where the pictures were to be taken.

Self portrait setting, *below*
Using a timer allows you to position yourself some distance from the camera.

PHOTO SET-UP: Delayed-action timer

A test run timed with a stop watch determines that there is enough time for the subject to take up his position before the delayed-action timer triggers the shutter.

Colors in the scene are warmed up using a color-compensating filter

Viewfinder may have to be covered to keep stray light from affecting exposure

35mm camera with an 85mm lens is set on a delayed-action timer to release the shutter after 20 seconds

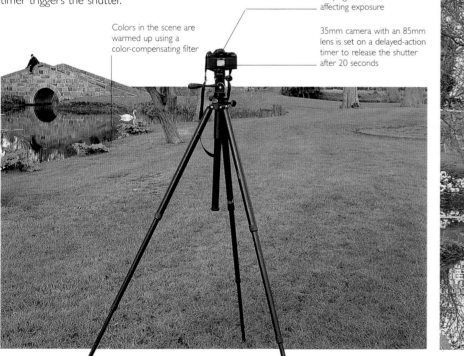

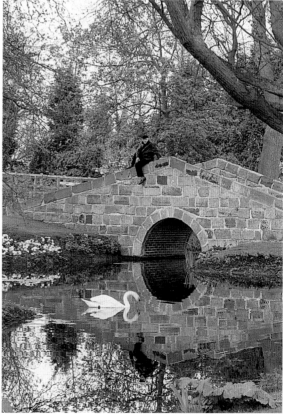

COMPOSING GROUP PORTRAITS

No matter what type of group portrait you are photographing, you need to show that all those involved are somehow associated with each other. This can be done by arranging the figures so that they all obviously relate.

ARRANGING A GROUP

When arranging a dynamic subject such as this modern-dance ensemble, aim to convey the sense of group movement. It is possible to use a slow shutter speed to record subject blur (*see pages 130–131*), but this technique can be problematic in group portraits. The solution here is to place the dancers in active poses, carefully choreographed and integrated to create a very definite compositional shape. In all group portraiture, take plenty of shots of each variation of the pose so that there is at least one frame in which every individual is seen to best advantage.

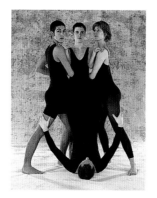

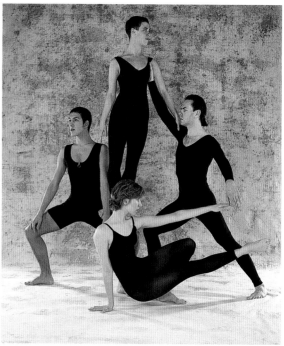

Dynamic arrangements
Try experimenting with several group arrangements. Two different compositions work in different ways. The pyramid (*above*) has greater group cohesion, but the other arrangement (*right*) emphasizes movement.

PHOTO SET-UP: Lighting a group

The lighting for group portraits needs to be generalized to create a broad spread of light over a fairly large area. Here a matched pair of diffused flash units, one either side of the camera, ensures even lighting. Two undiffused flash units at the rear of the set help increase exposure on the dancers and so pull them out of the mottled green background.

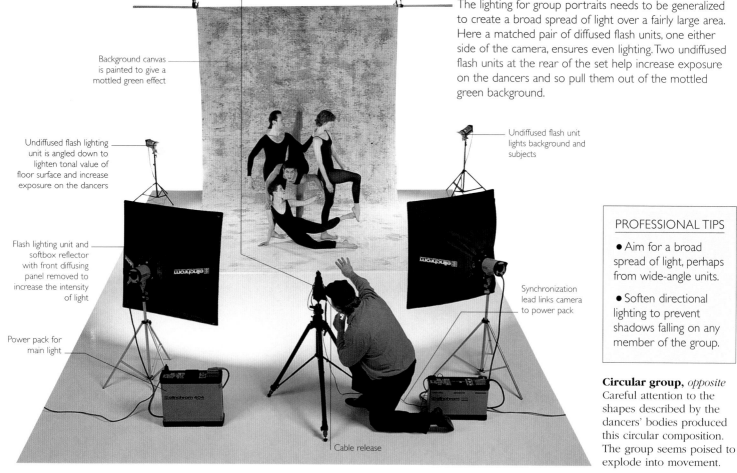

6 x 6cm camera on a tripod with an 80mm standard lens

Background canvas is painted to give a mottled green effect

Undiffused flash lighting unit is angled down to lighten tonal value of floor surface and increase exposure on the dancers

Undiffused flash unit lights background and subjects

Flash lighting unit and softbox reflector with front diffusing panel removed to increase the intensity of light

Power pack for main light

Synchronization lead links camera to power pack

Cable release

PROFESSIONAL TIPS

● Aim for a broad spread of light, perhaps from wide-angle units.

● Soften directional lighting to prevent shadows falling on any member of the group.

Circular group, *opposite*
Careful attention to the shapes described by the dancers' bodies produced this circular composition. The group seems poised to explode into movement.

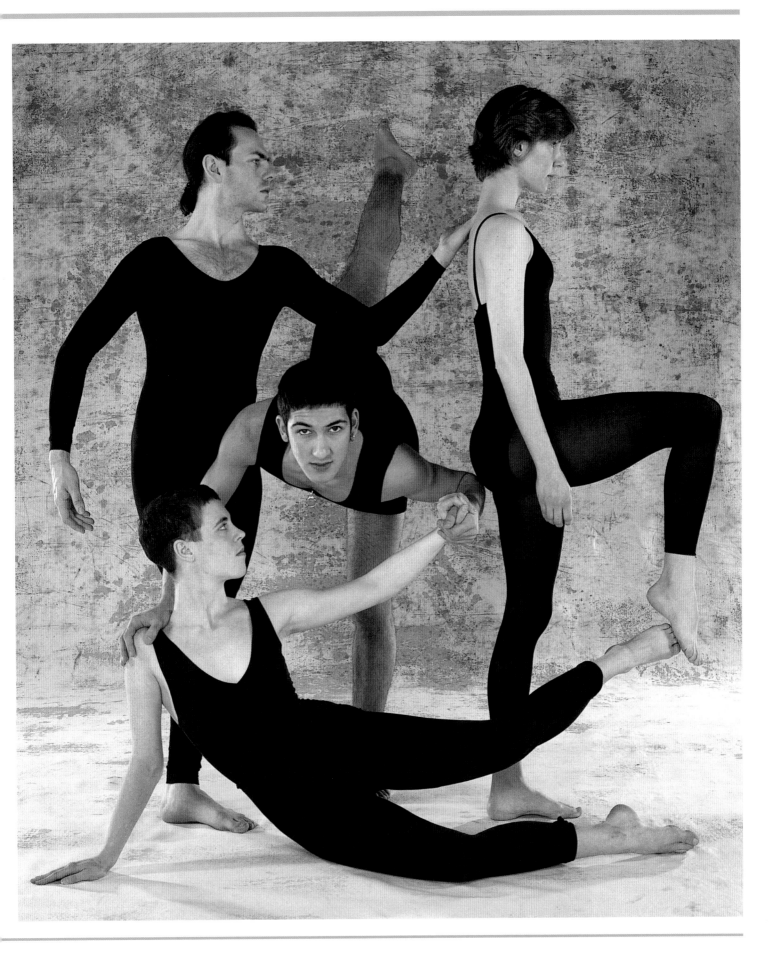

CREATING INFORMAL PORTRAITS

A good informal portrait relies on the photographer working unobtrusively. The presence of a camera may make some people self-conscious, and some subjects may not want their photograph taken. Ideally, the photographer and his camera should go unnoticed. Modern compact and SLR cameras are lightweight, discreet, and quick and easy to operate, and often ideal for this type of candid photography. However, it is always best to ask permission if you think that the person you want to photograph may object.

KEEPING YOUR DISTANCE

Successful photographs depend on awareness as well as being in the right place at the right time with your camera loaded and preset to the correct exposure. A compact camera or SLR fitted with a zoom lens allows you to distance yourself from your subject.

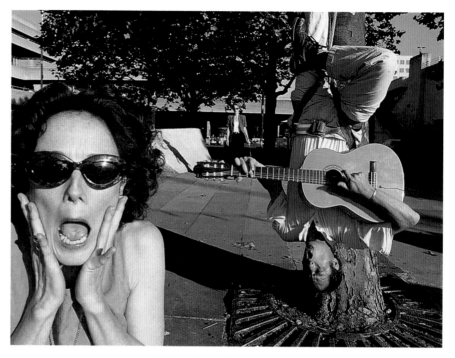

Natural reaction
At first glance, the model appears to be a casual passer-by. In fact, as the set-up picture shows, she is deliberately positioned level with the musician and is reacting for the camera.

PHOTO SET-UP: Dramatic expression

A bustling riverside setting is an ideal location to wait for the reactions of passers-by to this street entertainer's bizarre guitar-playing technique. This set-up picture shows how you can stage an expressive and amusing portrait with the cooperation of your subjects. The model is carefully positioned in the foreground to give the picture added humor and exaggerated theatricality.

Riverside location is worth staking out because there is a lot of activity

Model is kneeling in front of the camera so that her head is level with the musician

Small, fully automatic 35mm SLR with manual focus and fitted with a 28–70mm zoom lens

PROFESSIONAL TIPS

● Candid portraits are easiest to take in public places where lots of people carry cameras.

● Zoom lenses allow fine-tune cropping and subject enlargement from one position.

● Pretend to take a shot of an accomplice in the foreground, but use a zoom to focus on your real subject in the background.

Advance planning
This picture is the result of careful advance planning. If you visit the location beforehand and choose your subject carefully you will be able to envisage precisely the type of image you want to recreate.

Storyboard sequence
Each image should work on its own, but when they are viewed together, all the pictures in a sequence tell a complete story and have greater impact.

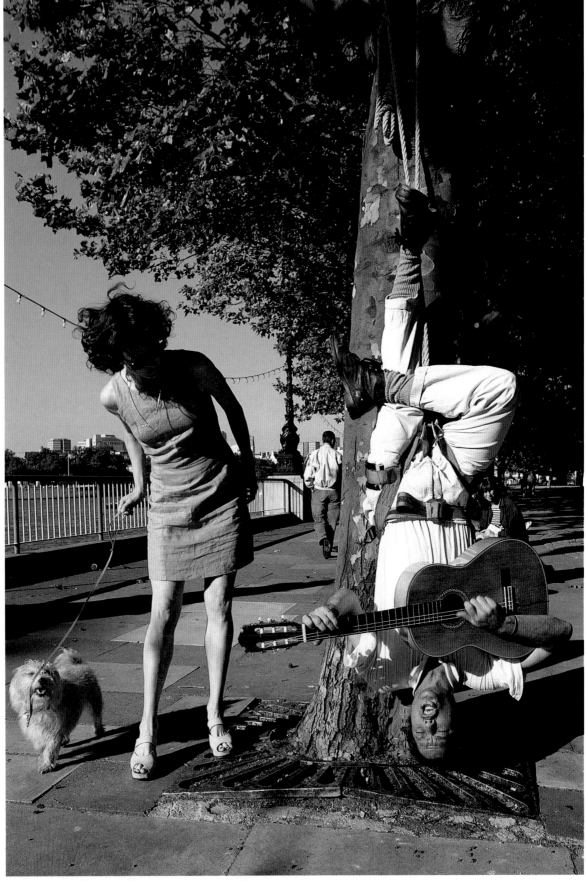

Monochromatic light, *top*
With the air heavy with wood smoke and the threat of rain, the moody light gives atmosphere to this scene of an elderly Romanian couple holding their grandchild. The light is so diffused that the landscape appears monochromatic.
35mm camera, 28mm lens, Fujichrome 400, f8, 1/60 sec.

Street life, *above*
The markets of Cairo are full of photo opportunities. This portrait of a shopkeeper with his hookah was taken using a long lens. Always ask permission before taking your picture if you think that a person may object.
35mm camera, 90mm lens, Kodachrome 100, f16, 1/250 sec.

Unposed perfection, *above*
Although completely unposed, this portrait of a Romanian boy seems to be in an environment almost too painterly to be true. Strong geometric squares and rectangles, and clearly defined blocks of color comprise most of the image. Snaking through the center is the single, sinewy shape of an ancient vine.
35mm camera, 28mm lens, Ektachrome 200 , f11, 1/250 sec.

Ultra-violet light, *right*
The hazy effect of ultra-violet light can be clearly seen in this picture of young Indian tea pickers.
35mm camera, 80mm lens, Ektachrome 200, f11, 1/125 sec.

Tropical brightness, *far right*
Intense light and heat create specific photographic problems. Depth of field has been strictly limited here.
35mm camera, 135mm lens, Ektachrome 100, f5.6, 1/1000 sec.

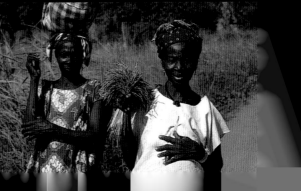

PHOTOGRAPHING THE NUDE

In the same way as the study of the human figure in fine art is an exercise in drawing and painting technique, so the nude can be used to show the photographer's skill. Lighting the figure offers numerous ways to emphasize skin texture, form, and tone. Daylight from a window, or diffused sidelighting from a flash enhances form, whereas backlighting highlights shape rather than form to create a silhouette.

WORKING WITH A LIFE MODEL

Successful nude photographs depend upon there being a good relationship between the life model and photographer. The more you involve the model in the picture-taking process, the better the results are likely to be. Working indoors assures your subject of privacy and allows you to set up equipment in advance. Remember to keep the room warm and make sure the model feels relaxed.

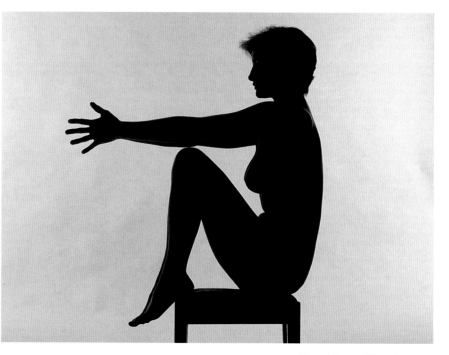

Graphic profile, *above*
The heavily diffused light reflected from the gray backdrop gives it a mottled appearance. The figure is in total shadow and stands out as a bold, stark shape.

PHOTO SET-UP: Silhouette lighting

For a silhouette effect, the background must be much lighter than the subject. A large exposure difference between the two will produce a high-contrast result. With the exposure taken for the light background, the subject appears as an underexposed shape.

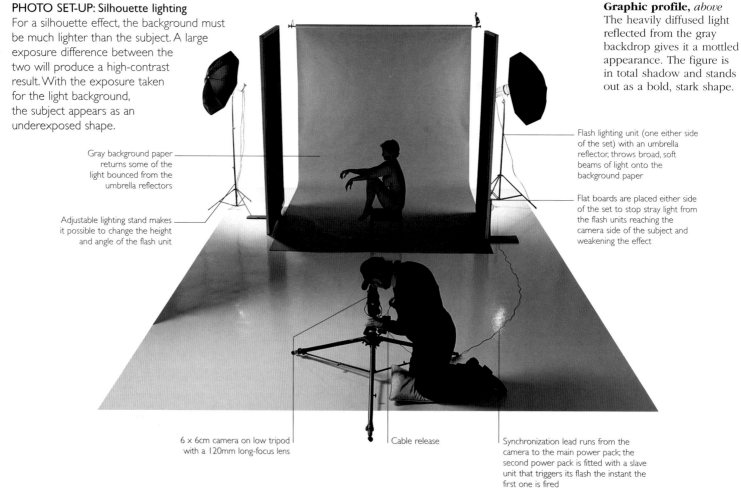

Gray background paper returns some of the light bounced from the umbrella reflectors

Adjustable lighting stand makes it possible to change the height and angle of the flash unit

Flash lighting unit (one either side of the set) with an umbrella reflector, throws broad, soft beams of light onto the background paper

Flat boards are placed either side of the set to stop stray light from the flash units reaching the camera side of the subject and weakening the effect

6 x 6cm camera on low tripod with a 120mm long-focus lens

Cable release

Synchronization lead runs from the camera to the main power pack; the second power pack is fitted with a slave unit that triggers its flash the instant the first one is fired

LIGHTING THE HUMAN FIGURE

Lighting for the human form usually needs to be not only diffused and softened, but also directional. If lighting is used in this way, some planes of the body are lit while others grade off into progressively deeper shadow. This suggests the contours and shapes of the whole, but leaves the form only partly revealed and thus abstracted. This type of lighting effect can be achieved relatively easily using natural daylight from a window covered with a large sheet of tracing paper. Harsh frontal lighting is usually inappropriate for the human figure. It often reveals too much detail, resulting in a clinical or an overly suggestive quality.

PHOTO SET-UP: Directional sidelighting

The background lights used for the silhouette on the opposite page remain the same, but a third flash is added. This flash unit has a snoot attachment and is pointed at a white reflector board to bounce a narrow beam of light onto the figure. The reflector softens the lighting effect.

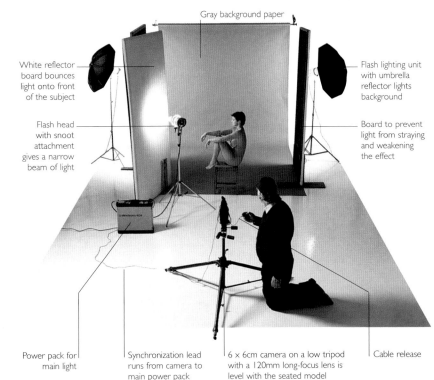

Gray background paper

White reflector board bounces light onto front of the subject

Flash head with snoot attachment gives a narrow beam of light

Flash lighting unit with umbrella reflector lights background

Board to prevent light from straying and weakening the effect

Power pack for main light

Synchronization lead runs from camera to main power pack

6 x 6cm camera on a low tripod with a 120mm long-focus lens is level with the seated model

Cable release

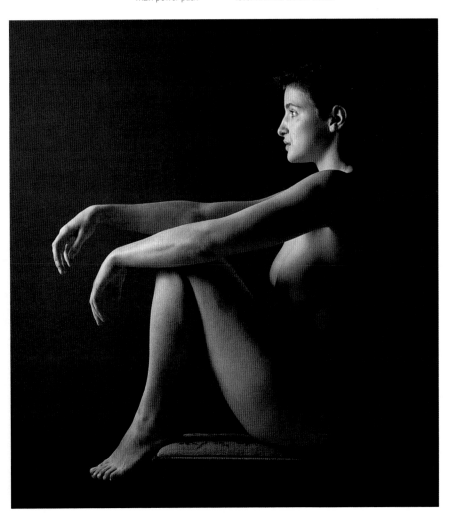

PROFESSIONAL TIPS

• For a silhouette, take your light reading from brightest part of frame.

• Brief the life model beforehand not to wear tight clothing that may leave marks on the skin.

Using a sidelight, *above*
The silhouette takes on a fuller, rounded form, as the play of light and shade helps flesh out the figure.

Enigmatic image, *right*
Using just the sidelight, the background drops away. The resulting increase in contrast produces an enigmatic, intimate image.

NATURAL LIGHTING FOR THE NUDE

The essential requirement for a photographic session with a life model is guaranteed privacy. This may be difficult if you wish to use an outdoor setting, but a secluded garden or quiet beach may make suitable locations if there are not too many curious onlookers.

Photographing a life model in an indoor setting does not mean that you have to use flash (*see page 110*). If you have access to a bright, sunny room with a large window or skylight, a wide range of subtle effects is possible using only natural daylight. Artists' studios are traditionally positioned so that they receive light from a bright, open sky rather than from direct sunlight, and this type of reflected light is the most sympathetic when photographing the human figure.

PHOTO SET-UP: Natural light source
This bright room benefits from a large window. Normally, the bigger the light source, the less contrasty the lighting effect. But by positioning the model in front of the glass, the exposure difference between the lit and unlit areas makes for dramatic pictures that emphasize form.

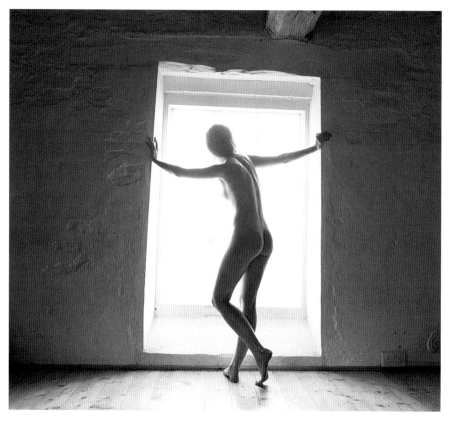

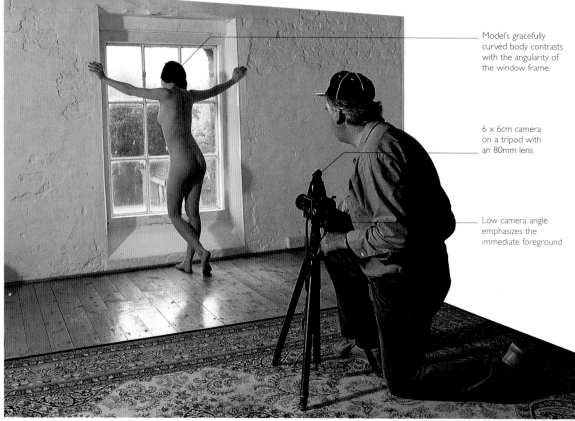

Model's gracefully curved body contrasts with the angularity of the window frame

6 x 6cm camera on a tripod with an 80mm lens

Low camera angle emphasizes the immediate foreground

Shadow reading, *above*
A wall of light floods past the model, softening her outline; exposure is judged from a dark area on her leg, and the highlights are allowed to burn out.

Bright reading, *opposite*
As well as lighting, the aperture and shutter speed can also be important. Exposure for this darker image is taken from the view outside. The model is now silhouetted.

DIGITAL SOLUTIONS

It is often worth trying to make the skintone color slightly warmer than in reality. This can be achieved by setting the manual white balance to a cloudy rather than a daylight setting, to tweak the electronic filtration.

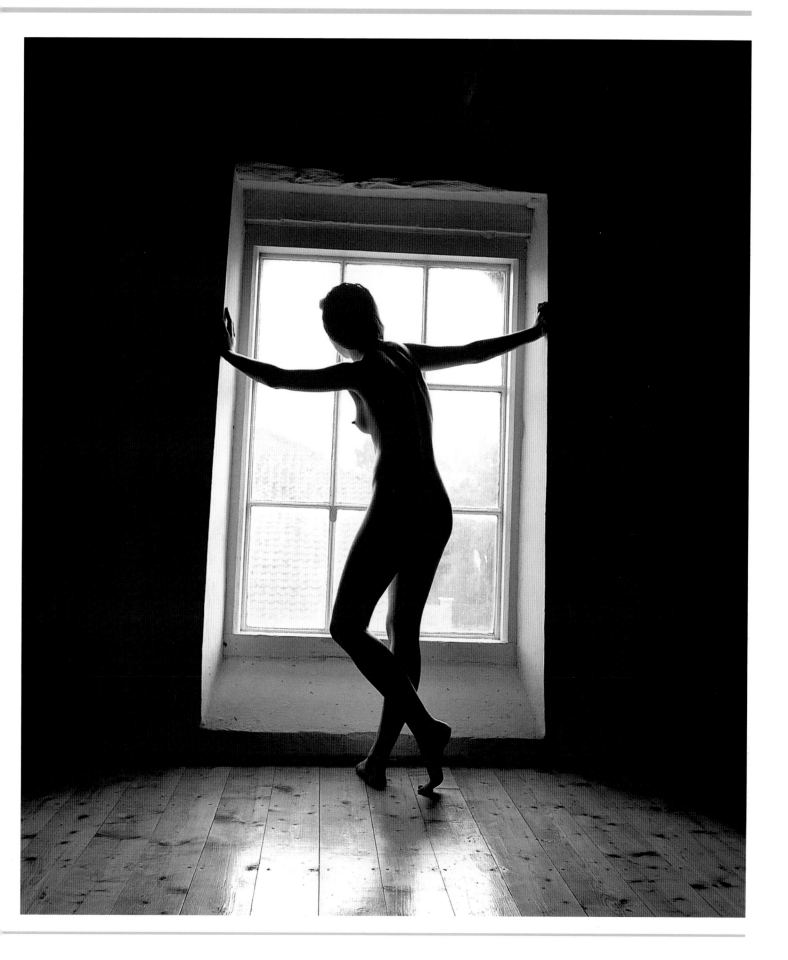

CREATING ABSTRACT NUDE IMAGES

When viewed through a camera, the human figure can be seen as a series of interacting abstract shapes. Variations in muscular tension in a model's body may seem minor when looking at the whole figure, but when filling the frame with a single area such as a torso or upper arm, every little detail is important.

LONG-FOCUS OR WIDE-ANGLE LENS

Choice of camera position and focal length are vital considerations. Long-focus lenses have a restricted angle of view and facilitate cropping. Extreme long-focus lenses flatten the subject, robbing it of clearly differentiated planes, while a wide-angle lens can cause curious distortions, exaggerating depth and distance.

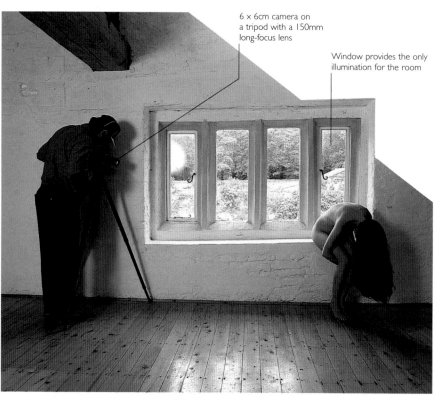

6 x 6cm camera on a tripod with a 150mm long-focus lens

Window provides the only illumination for the room

PHOTO SET-UP: Lighting for form
By positioning the model on the windowsill, the curve of her back and buttocks receives direct illumination. In contrast, her front and her lower body below the windowsill are all in heavy shadow and would require a longer exposure time to bring out additional detail.

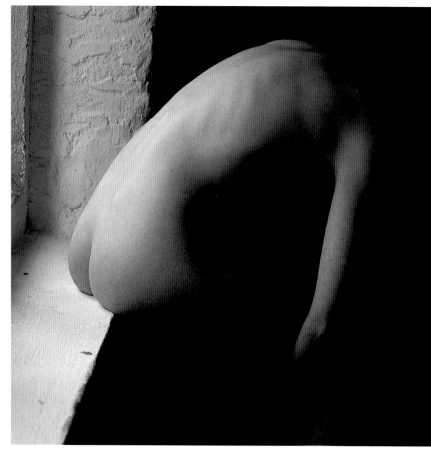

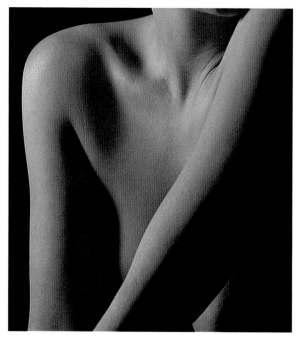

Lighting contrast, *left*
This image uses lighting contrast, rather than lens focal length, to highlight parts of the model's body. Her hair is also hanging forward, casting her face into dark shadow.

Angular form, *above*
Asking the model to bring her arm across her body creates a sense of diagonal movement. Excluding the model's head focuses attention on the abstract angularity of the form.

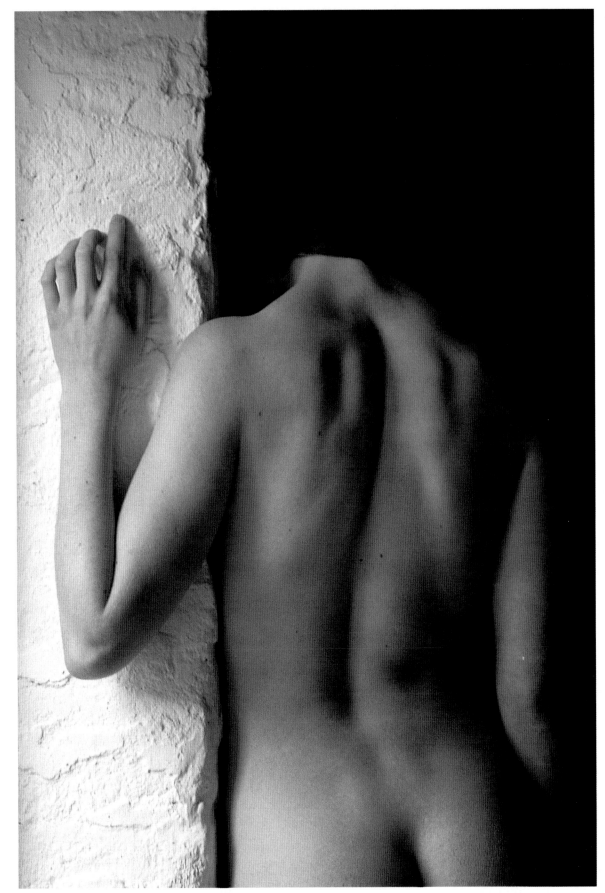

Abstract form
As the life model leans against the wall, the contours of her arms, shoulders, and back create an effect that emphasizes abstract form and textural contrasts more than her nudity.

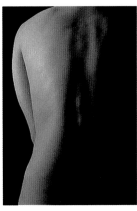

Lenses to isolate
Longer focal-length lenses are useful when you want to fill the frame with just a small aspect of the figure. In this picture a long-focus lens is used to isolate the model's back.

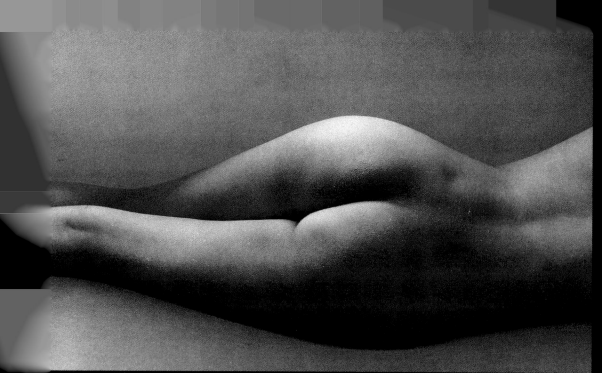

Diffused natural light, *left*
Daylight is diffused through a
blind to reveal both the texture
and form of this reclining nude.
*6 x 6cm camera, 80mm lens,
Tri-X Pan, f16, 1/8 sec.*

Tonal definition, *below left*
Superb tonal range and definition
result from an overhead skylight.
*6 x 7cm camera, 80mm lens,
Tri-X Pan, f22, 1/60 sec.*

Selective light, *below*
A tungsten spotlight illuminates
the model's arm and side.
*6 x 6cm camera, 120mm lens,
Plus-X, f32, 1/500 sec.*

Candid nude, *opposite*
Lost in her own thoughts, the
model seems unaware of the
camera. Natural light gives a
moody, low-key result.
*6 x 7cm camera, 80mm lens,
HP5 Plus, f11, 1/125 sec.*

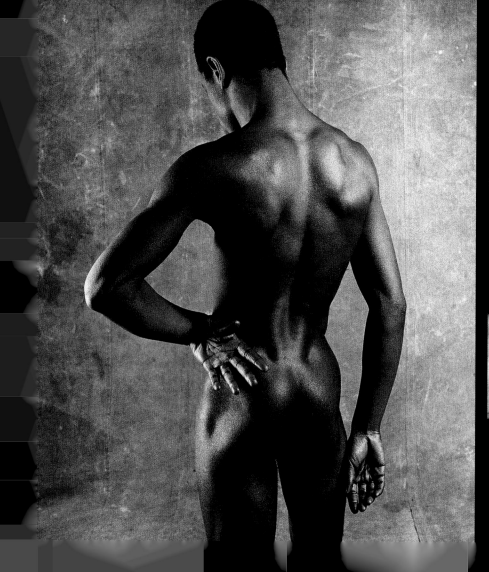

Floodlit form, *above*
The lighting for this detail comes
from a 500-watt floodlight. Tungsten
lights allow you to see the highlights
and shadows before shooting.
*6 x 6cm camera, 150mm lens,
Tri-X Pan, f16, 1/60 sec.*

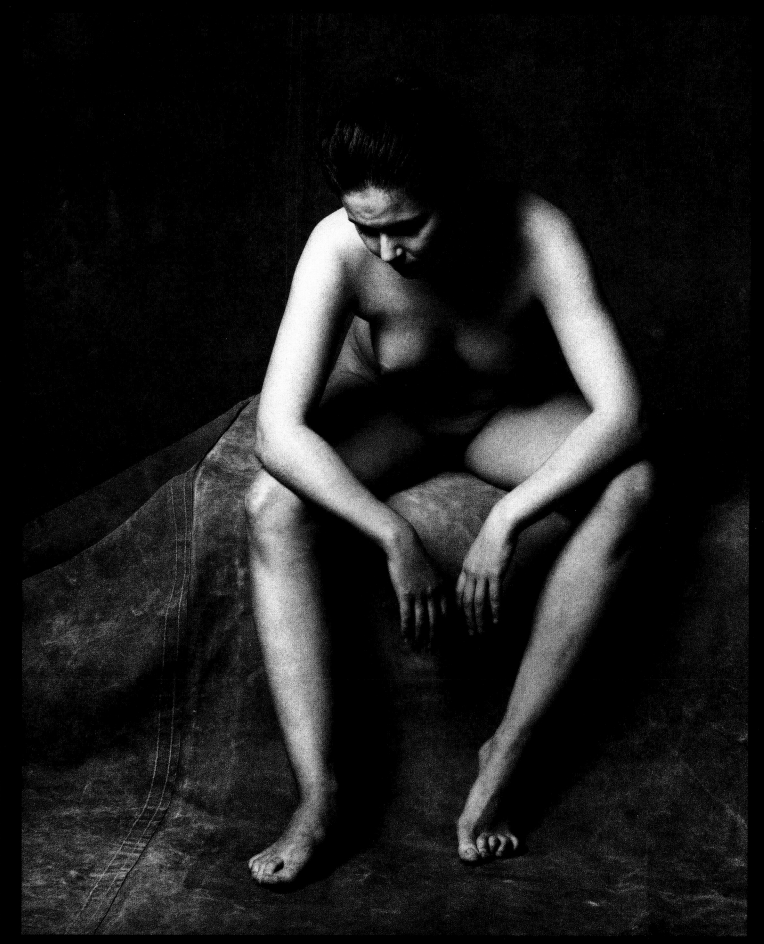

PORTRAYING A MOTHER AND CHILD

The bond that exists between a mother and her newborn child is an enduring theme for photographers. Capturing those feelings of trust and intimacy is easiest when you are photographing members of your own family. With patience you should be able to record natural, spontaneous images, especially if you stay alert to the baby's shifts in mood.

UNPOSED BABY PORTRAITS

Babies and young children cannot be directed or persuaded to stay still while you compose the shot in the viewfinder. Always enlist the help of the mother to keep the baby relaxed and happy and to divert its attention away from the camera. With portraits it is usual to take more pictures than you think you will need, but when working with babies you should show greater restraint. Constantly flashing lights, even when heavily diffused, are likely to upset a young baby.

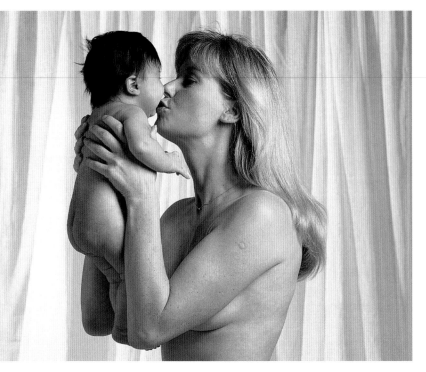

Private moment, *above*
The reflector is used to brighten the shadows and create a gentle gradation of tones without losing detail.

Open affection, *below*
A happy and relaxed pose shows the mother's natural pride and is complemented by slightly subdued lighting.

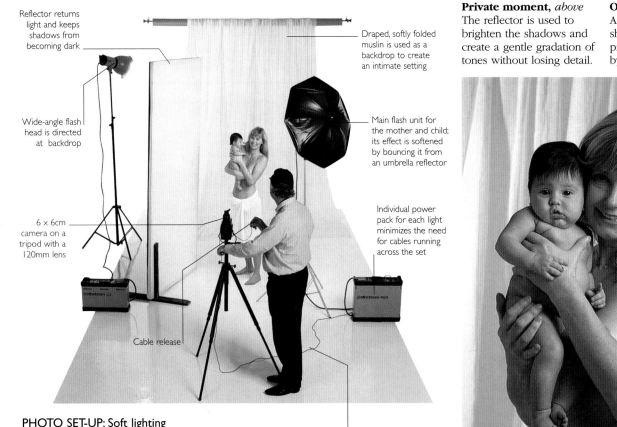

Reflector returns light and keeps shadows from becoming dark

Wide-angle flash head is directed at backdrop

6 x 6cm camera on a tripod with a 120mm lens

Cable release

Draped, softly folded muslin is used as a backdrop to create an intimate setting

Main flash unit for the mother and child; its effect is softened by bouncing it from an umbrella reflector

Individual power pack for each light minimizes the need for cables running across the set

Synchronization lead links the power pack to the camera

PHOTO SET-UP: Soft lighting
Bounced light from an umbrella reflector produces diffused light to emphasize the softness of the baby's skin. The simple background does not compete for the viewer's attention.

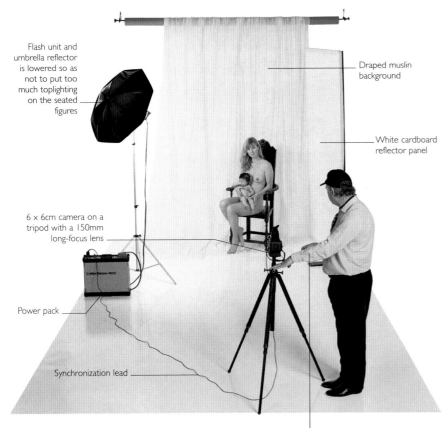

Flash unit and umbrella reflector is lowered so as not to put too much toplighting on the seated figures

Draped muslin background

White cardboard reflector panel

6 x 6cm camera on a tripod with a 150mm long-focus lens

Power pack

Synchronization lead

Cable release

PHOTO SET-UP: Baby portraits

Using a long lens allows you to take close-up portraits without altering the camera position. The flash lights and reflectors are positioned to concentrate on the baby.

USING A LONG LENS

Although long lenses result in large images of small or distant subjects, they do not necessarily give you the feeling of standing up close to the person being photographed. The longer the lens, the more obvious this effect becomes. For an intimate picture, it is often best to move in closer, if the subject is easily accessible, and to use a standard lens (*see pages 16 – 17*). With a young baby, however, moving in too close with a camera could seem threatening. You may, therefore, need to strike a balance between the ideal focal length and what a young subject seems most comfortable with.

LIGHTING AND FRAMING FLEXIBILITY

A bonus of working with a long lens is that since you are farther back from your subject, you have more flexibility in where you can place lights and reflectors. You can position lights close to the subject without danger of casting a shadow by partially blocking them. If you have a zoom lens, you will be able to adjust framing, without changing position, to ensure that unwanted parts of the set are excluded from the shot.

PROFESSIONAL TIPS

- A zoom lens gives you flexibility in framing shots.

- Keep sessions short to minimize possible distress, and allow time for breaks to rest the child.

- A slightly longer lens allows you to take detailed close-ups without intruding too close.

- Include the mother's hands in shots to highlight the difference in scale and skin texture between subjects.

- Soft, diffused lighting is best to capture the skin tones of both mother and child.

Close-ups of baby, *above*
These close-ups are linked by the repetition of gently rounded forms, the soft, directional lighting, and the contrast in scale provided by the mother's hands.

Intimate detail, *right*
For this scene, a long-focus lens produces a detailed close-up. The tight framing excludes unwanted details, and lighting is easier to control over a small area.

TAKING CHILDREN'S PORTRAITS

Photographing children requires patience and a sense of humor. In a studio, the space and equipment will all be new and fascinating, and children may well want to touch and ask questions about everything. For good results, try to make the photo session fun – let them look through the camera viewfinder, for example, and answer their questions about what you are doing and why as fully as possible, even while you are shooting.

CAMERA AND LIGHTING EQUIPMENT

Children rarely sit still, so do not try to restrict their movements too much or they may become bored and uncooperative. Flash lighting units should be set to give a broad area of even light, perhaps positioned either side of the set. You will have to be as mobile as your subjects, and a hand-held camera fitted with a telephoto zoom lens will allow you most freedom of movement.

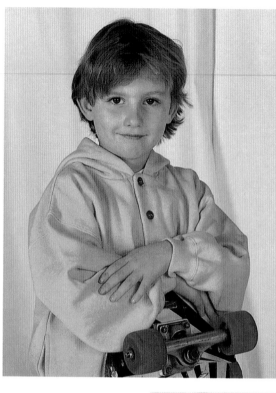

Framing the shot
A long lens allows you to photograph your subject without moving in too close. A zoom lens offers greater flexibility – you can fill the frame with a child's smiling expression (*above*) or achieve a more formal result as in the half-length portrait (*left*).

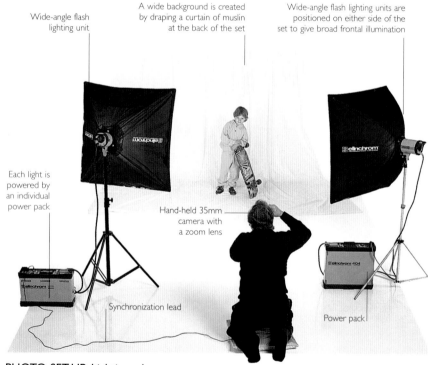

Wide-angle flash lighting unit

A wide background is created by draping a curtain of muslin at the back of the set

Wide-angle flash lighting units are positioned on either side of the set to give broad frontal illumination

Each light is powered by an individual power pack

Hand-held 35mm camera with a zoom lens

Synchronization lead

Power pack

PHOTO SET-UP: Lighting a large set
Wide-angle flash lighting units fitted with softbox diffusers give almost shadowless light over the whole set. The lights are positioned low down to suit the height of the subject and the camera viewpoint is set at the child's eye level.

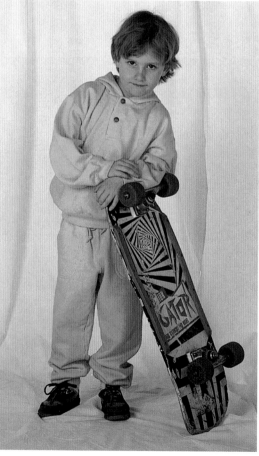

Full-length portrait
A battered skateboard gives the boy something to lean on and adds informality to this full-length portrait.

WORKING WITH CHILDREN

A 35mm camera is ideal for photographing children since it is lightweight and easy to operate. With a young subject you have to work quickly, and there is little time to focus or to adjust the exposure for each frame. Count on using more film than normal to cover inevitable framing and focusing errors. Many children enjoy having their picture taken, however, the presence of a parent or other adult family member will give a child extra confidence. A parent can also encourage or entertain a child from behind the camera to provoke laughter and smiles.

PROVIDING TOYS AND GAMES

A young child gets bored very easily and has a short attention span. You will need a supply of toys or other props, such as books and games, on hand to provide entertainment. With an interesting toy or a colorful picture book, children will soon become absorbed in what they are doing and forget about the presence of the camera.

PROFESSIONAL TIPS

- Talk to the child constantly, taking an interest in what he or she is saying to put the child at ease.

- Make sure cables, switches, and expensive camera equipment are safely kept out of harm's way.

- Kneel so that the camera is at the child's eye level.

- Lights need to be positioned lower than normal.

Candid approach, *below*
You must work quickly since a child will not stay still for long. Dancing to music, this three-year-old girl soon forgot about the lights and camera.

Center of attention, *right*
This child's debut in front of the camera is facilitated by her glove puppet. With her prop, she spent an enjoyable 15 minutes as the center of attention.

Focusing on the eyes,
above
When shooting with natural light indoors, you are usually forced to use the widest apertures that the camera has available. This means there is little depth of field. In order to ensure that the portrait looks sharp, focus on the subject's eyes rather than any other part of the face or body.
Digital SLR, 28-80mm zoom lens, ISO 200, f5.6, 1/60 sec.

Shooting at eye level,
right & far right
For natural shots of children, take the camera down to their eye level, rather than tilting the lens. Kneel if necessary.
Digital SLR, 28-80mm zoom lens, ISO 200, f5.6, 1/60 sec.

Helpful distractions,
top & above
A grudging, unhappy child
will make an unphotogenic
portrait. Having a parent
just out of shot, reassuring
and entertaining the child,
can be helpful for achieving
a relaxed, natural pose.
Digital SLR, 28-80mm
zoom lens, ISO 200, f5.6,
1/60 sec.

Relaxing the subject,
right
This little boy was
uncooperative at the
beginning of the shoot.
Adding his sister to the
composition helped to
relax him, and kept him in
one place long enough to
take his picture.
Digital SLR, 28-80mm
zoom lens, ISO 200, f2.8,
1/125 sec.

PHOTOGRAPHING CHILDREN AT PLAY

Leave nearly any group of children to their own devices and within a few minutes they will have invented some sort of game to play. Young children make ideal subjects for informal, candid photographs, and older children can also make cooperative models if you want a more formal portrait (*see page 120*). The attraction of working with children is their boundless energy, enthusiasm, and constantly changing expressions and moods.

RECORDING CANDID IMAGES

Once the photo session starts, it is often best to keep well on the periphery of the children's activity. Children tend to behave more naturally if you are out of immediate sight. To avoid distant shots with the children very small in the frame, use a long-focus or zoom lens with a range that allows you to fill the frame with the entire group or an individual. Use a fast shutter speed and fast film if you take shots of children on the move.

Sand castles, *above*
A high camera viewpoint keeps the children and the circle of sand castles from becoming confused with the breakwater visible in the set-up picture. The bright colors of the pails and spade give a color lift that helps to compensate for the flat lighting.

PHOTO SET-UP: Candid action

A quiet beach makes an ideal location for photographing children. By squatting down you can position the camera at the children's eye level (*below*), whereas by taking the shot from a standing position (*above*), you can show the children against a plain background.

Hand-held 35mm camera with an 85mm long-focus lens allows freedom of movement

Subjects are absorbed in play and pay no attention to the camera

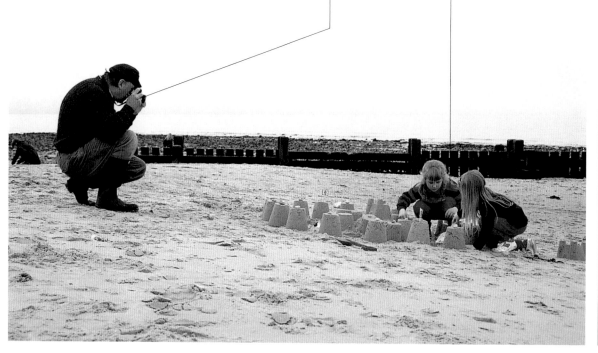

DIGITAL SOLUTIONS

• Take lots of shots to ensure you capture a wide variety of expressions and poses. Weaker shots can be deleted later.

• If taking pictures for a family web page, shoot at high resolution, then resize for the Internet later. Successful shots can then also be printed, as well as being used for on-screen images.

Sports sequence, *above*
These four pictures taken
in rapid succession show a
complete action sequence.
The boy prepares to hit
the ball, makes contact,
swings the bat, and starts
to run. Fast film was used
because of the poor
natural light.

Captured action, *right*
This shot captures the
peak of action as the boy
runs to first base. An
aperture of f16 ensures
sufficient depth of field,
and a fast shutter speed
of 1/500 is used to freeze
most movement and
overcome camera shake.

PHOTO SET-UP: Baseball game

The priority in photographing this baseball game is to
find the best camera position to photograph the boy
with the bat. It is important to keep far enough back so
as not to interfere with the game. This means using a
long-focus lens and selecting a fast shutter speed to
freeze the action.

Hand-held 35mm camera
with a 70–210mm zoom lens
is not too bulky to carry and
is also powerful enough to
bring one figure up large in
the frame

Boy with the bat is
the main subject

Facial expression, *above*
Changing to a lower
camera angle and close
focusing with a zoom lens
shows the children's
excitement on finding a
crab. The tight framing
emphasizes the boys'
friendly relationship.

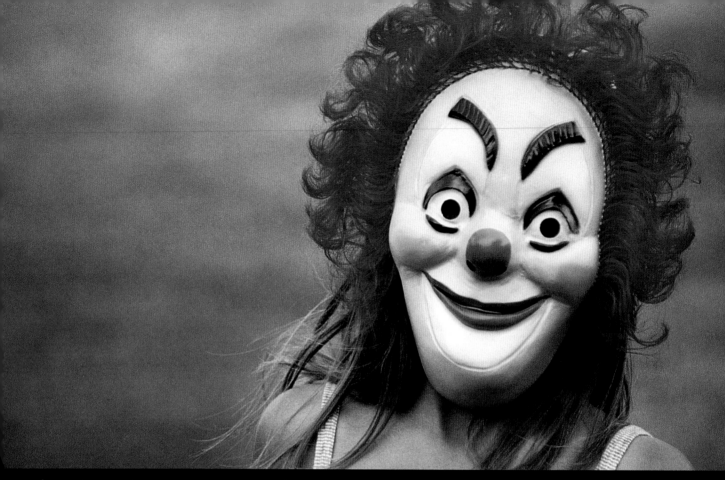

Fancy dress, *above & below*
Children love to dress up, and having a collection of masks to hand can help you get a selection of unusual portraits at a family gathering or party. *Digital SLR, 14–54mm zoom lens, ISO 200, f4, 1/125 sec.*

Change of character, *right*
Masks not only add color and shape to a shot, they often have an effect on the wearer's personality, helping you to capture unusual expressions. *Digital SLR, 14–54mm zoom lens, ISO 200, f4, 1/60 sec.*

Masks of menace, *right*
Masks strip away the visual
identity of the people
wearing them. The effect
of the transformation can
often be quite dramatic.
*Digital SLR, 14-54mm
zoom lens, ISO 200, f4,
1/60 sec.*

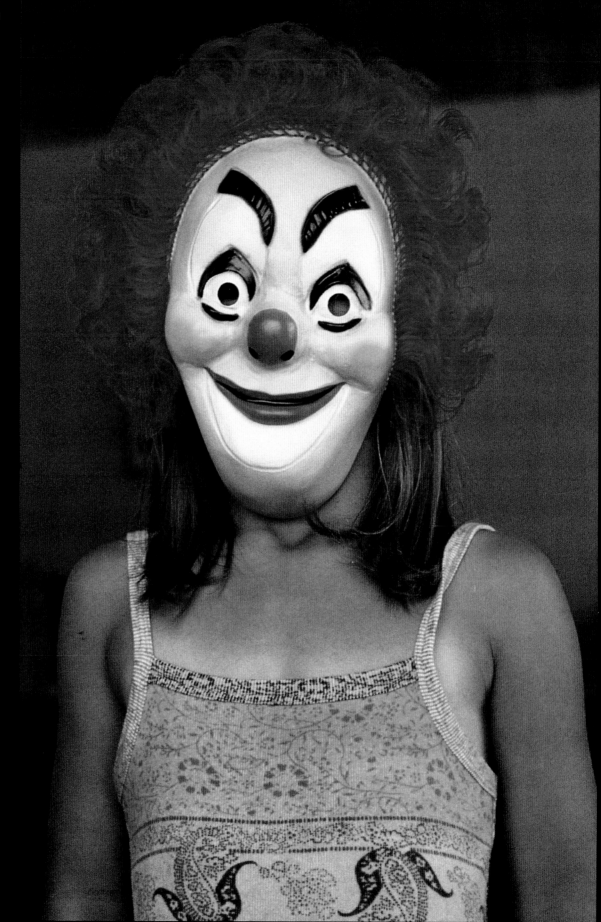

FREEZING A MOVING FIGURE

When using flash lighting as your sole or principal source of illumination, you can take advantage of its movement-stopping characteristics to create unusual action portraits that are full of "frozen" energy.

ARRESTING MOVEMENT

If, for example, you were to use a flash-synchronization speed of 1/125 second at f8, your subject would be recorded by light from the flash alone (without flash, a shutter speed of 1/30 or 1/15 second would be necessary for correct exposure). The "freezing" power of this technique stems from the fact that flash units – studio units, add-on flashguns, or built-in types found on some SLRs and compact cameras – deliver a burst of light of short duration. The longest flash duration from a small unit might be only 1/1000 second, while larger units might deliver light in 1/10,000 second bursts – brief enough to stop any normal subject in its tracks.

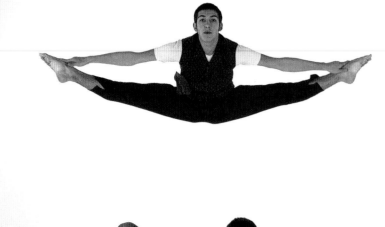

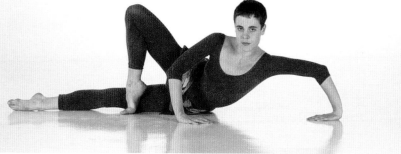

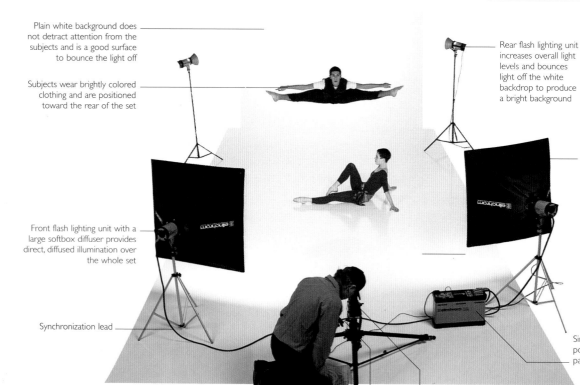

Plain white background does not detract attention from the subjects and is a good surface to bounce the light off

Subjects wear brightly colored clothing and are positioned toward the rear of the set

Front flash lighting unit with a large softbox diffuser provides direct, diffused illumination over the whole set

Synchronization lead

Rear flash lighting unit increases overall light levels and bounces light off the white backdrop to produce a bright background

Second flash unit with large softbox diffuser provides additional soft light

Single power pack

Cable release

6 x 6cm camera with an 80mm standard lens set on a low tripod

Anticipating the action
To capture the dancer in mid-leap with his legs perfectly horizontal requires anticipation so you can release the shutter at exactly the right moment.

PHOTO SET-UP: Capturing the moment
Four flash units are needed to light this large set, but it is possible to create similar effects using a single flash unit in a smaller room with neutral-colored walls and ceiling.

DIGITAL SOLUTIONS

• The delay between pressing the shutter and the shot being taken can be much longer on some digital cameras than others. This can make taking action shots difficult. Focusing manually can help shorten the delay.

• Digital cameras take time to write the data after a shot is taken, so continuous shooting is not always possible.

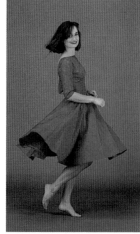
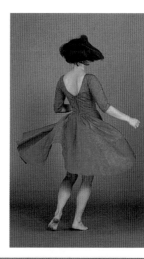
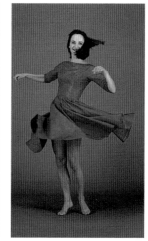
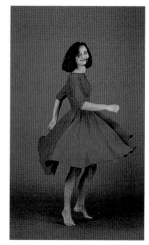

Dynamic portrait, *left*
The brief burst of flash lighting from the two units on either side of the set has perfectly captured the model – her hair is framing her face, her expression is good, and her skirt and posture convey interrupted, frozen movement.

Shooting rate, *above*
You need to shoot a lot of film since there is no way of predicting the results at the instant when the flash fires. A motor drive allows you to take a continuous sequence of exposures with a firing rate of several frames per second.

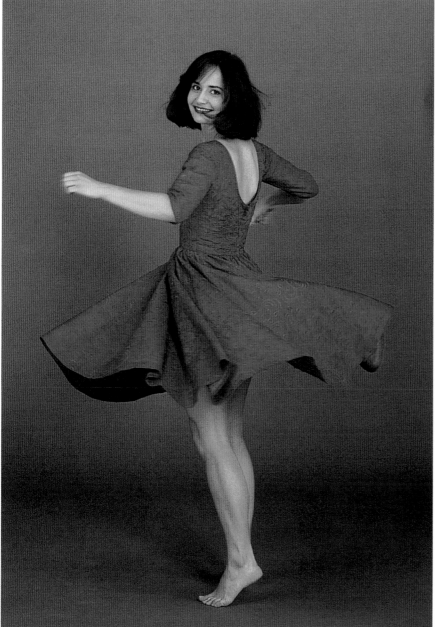

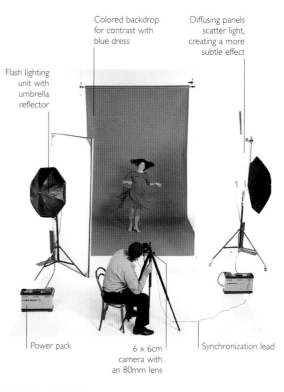

Flash lighting unit with umbrella reflector

Colored backdrop for contrast with blue dress

Diffusing panels scatter light, creating a more subtle effect

Power pack

6 x 6cm camera with an 80mm lens

Synchronization lead

PHOTO SET-UP: Freezing action

To create an even spread of light, the flash units on either side of the model are fitted with umbrella reflectors and placed in front of diffusing panels made of heavyweight tracing paper. The set above is smaller than the one on the opposite page, so fewer flash units are required.

EMPHASIZING MOVEMENT

Movement can be recorded in two ways. You can freeze a moving subject by using a fast shutter speed (*see page 128*), or you can record a more indistinct, blurred image to give a different impression of the action.

CREATING A GHOST IMAGE

To record blurred and frozen detail on the same frame, select an aperture and shutter speed combination (the recommended flash-synchronization speed or one slower) which would result in detail being recorded even if flash were not used. If, for example, you set an aperture of f11 and a shutter speed of 1/15 second, the flash would fire a burst of light lasting, say, 1/1000 second when you pressed the shutter release, but the subject would continue to move and be recorded on film for all of the 1/15 second exposure.

PHOTO SET-UP: Blurred image
If ambient lighting is sufficiently high at the slow shutter speeds used, a secondary image records after the flashes have fired. The slower the shutter speed, the more obvious the secondary ghost image becomes.

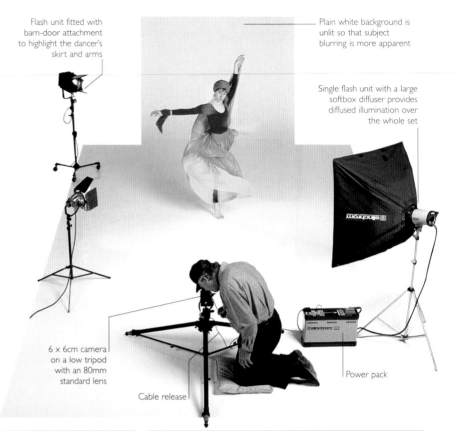

Flash unit fitted with barn-door attachment to highlight the dancer's skirt and arms

Plain white background is unlit so that subject blurring is more apparent

Single flash unit with a large softbox diffuser provides diffused illumination over the whole set

6 x 6cm camera on a low tripod with an 80mm standard lens

Cable release

Power pack

PROFESSIONAL TIPS
• Lights should be set to isolate the subject from the background.
• Ambient light levels must be kept high.
• Subtle blurring of an image may be lost if background is well lit.
• Try experimenting with different shutter speeds and exposures.

Evocative imagery
The first image of the dancer (*right*) was shot at f11 and 1/15 second, while the second (*far right*) was shot at f11 and 1/8 second.

Ghostly dancer, *opposite*
The ghostly image on the opposite page was shot at f16 and 1/4 second – the slowest shutter speed in the entire sequence.

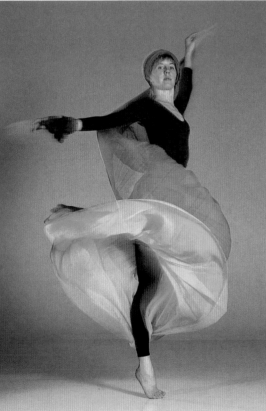

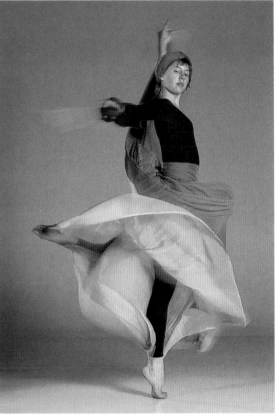

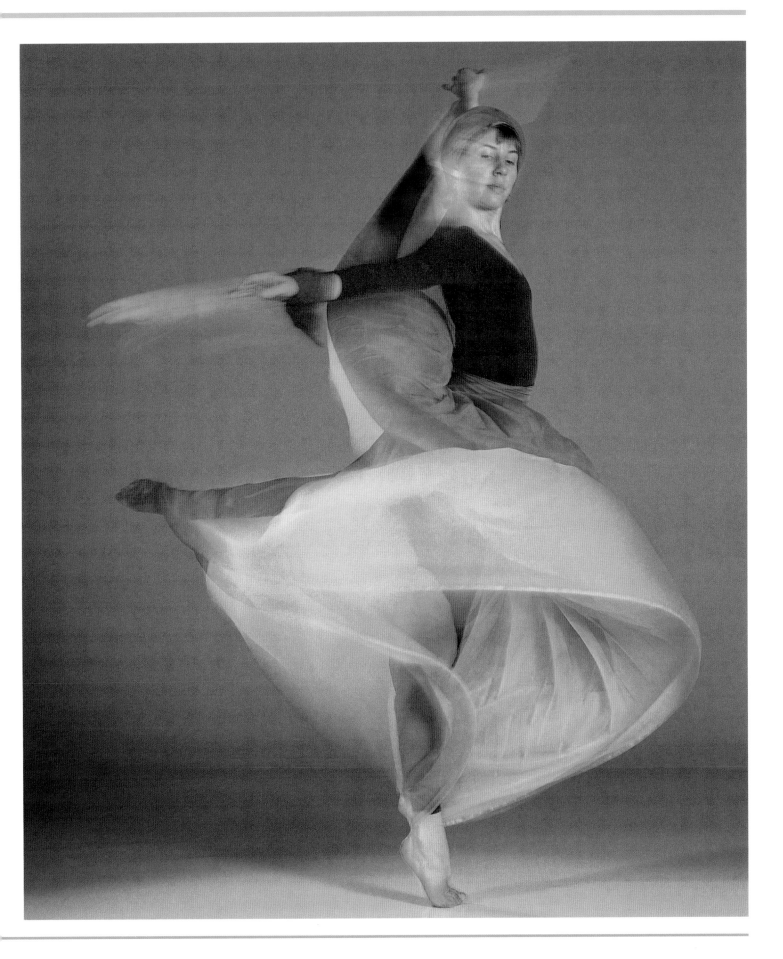

PHOTOGRAPHING SPORTS ACTION

The key to taking successful sports action photographs is anticipation. Find the most suitable camera position before the event starts and then try to interpret how the action will develop so that you can be ready with the camera. Good results are also more likely if you are familiar with the rules of play.

USING A LONG-FOCUS LENS

The most effective action shots are those in which the subject appears large in the frame; the impact will be lost if you can barely see the action. For most field events, a lens with a focal length of 200mm or longer is ideal, but for close-ups of players in mid-field, a 500mm lens may be necessary.

PHOTO SET-UP: American football
The photographer kneels at the sidelines, near the action. A motor drive attachment on the camera automatically advances the film at a rate of three to four frames per second, allowing shots to be taken in quick succession.

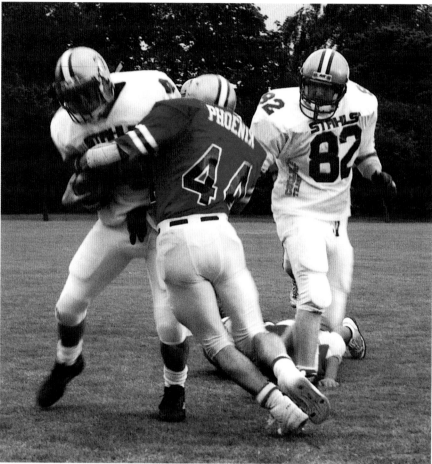

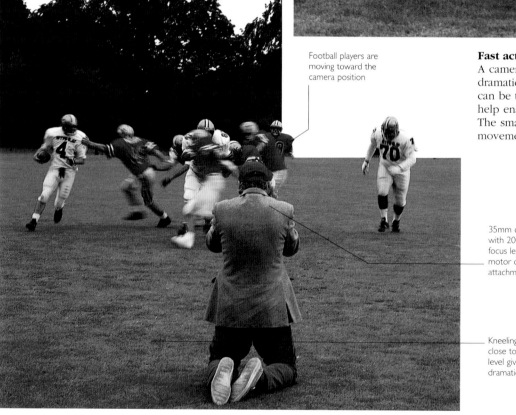

Football players are moving toward the camera position

35mm camera with 200mm long-focus lens and motor drive attachment

Kneeling position close to ground level gives a dramatic viewpoint

Fast action sequence, *above*
A camera with a motor drive allows you to take dramatic shots, such as this. A sequence of shots can be taken of a particular move, which can help ensure you capture the decisive moment. The small amount of blur due to subject movement imparts a sense of action.

DIGITAL SOLUTIONS

A digital camera has no film to wind on. Whether a rapid sequence can be taken depends on the size of the buffer memory, which temporarily stores data before it is saved permanently. A "burst" rate will only be available for a limited number of shots, and at certain resolution settings.

MOTOR DRIVE

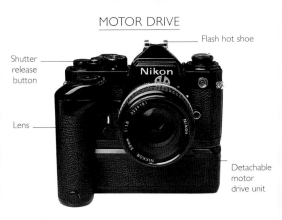

Flash hot shoe

Shutter release button

Nikon

Lens

Detachable motor drive unit

Many modern 35mm SLRs have autowinders or motor drives built in to the basic camera. Professional cameras, however, have separate units that are attached to the base of the camera. These sturdy units can be set simply to advance the film after each exposure or to take up to four frames a second, depending on the selected shutter speed. Some models can also be programed to take shots at preset intervals. Remember that at four frames per second a 36-exposure film will last only nine seconds. Use continuous exposure settings in short bursts when shooting dramatic action sequences.

Panned action, *above*
You can increase the sense of excitement in an action photograph by panning the camera to produce streaks and blurs that exaggerate the impression of movement. This photograph conveys the urgency of the football player's situation as another player sprints to tackle him.

Frozen action, *below*
Although this frozen-action photograph presents the subject in a very unnatural way, it depicts the power and athleticism of the player who is frozen in mid-air. The plain background serves to emphasize the figures of the players and the two levels of action – in the air and on the ground.

PHOTOGRAPHING ACTION SEQUENCES

A long telephoto lens is essential for many sports, but is not always easy to use with action subjects. Long lenses provide limited depth of field, which means that accurate focusing is crucial. However, as the distance of the moving subject is continually changing, keeping the image sharp is difficult.

One solution is to pre-focus on a point you know the subject will pass through, and then shoot when the subject reaches this point. However, many 35mm and digital SLRs now feature autofocus modes that help focus on a moving subject. A predictive AF system not only continually refocuses on the subject until the trigger is fired, it adjusts the lens up to the moment the shutter actually opens, by measuring the subject's speed and direction.

PHOTO SET-UP: Polo at St. Moritz, Switzerland
The large playing area, and the fast-moving action, make polo a difficult sport to photograph, but the digital camera used had a predictive autofocus system that could lock onto the moving subject.

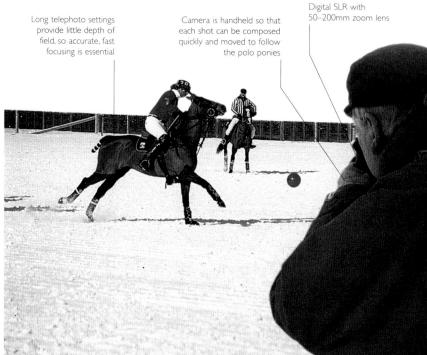

Long telephoto settings provide little depth of field, so accurate, fast focusing is essential

Camera is handheld so that each shot can be composed quickly and moved to follow the polo ponies

Digital SLR with 50–200mm zoom lens

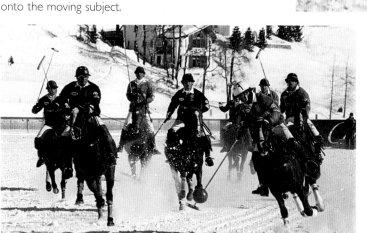

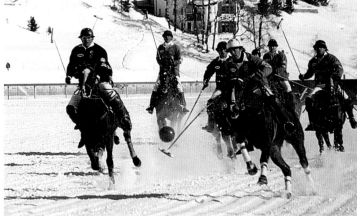

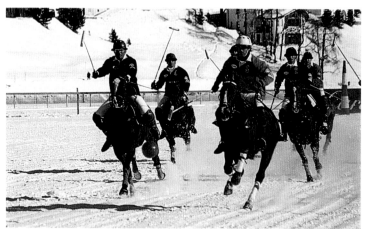

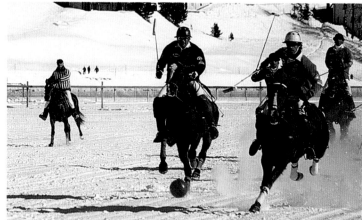

DIGITAL SOLUTIONS
Some digital cameras are slower to react than film cameras — with a delay as the on-board camera prepares itself for taking the picture, and taking time to write the image to file. Setting a lower resolution will improve the camera's reactions.

Wide approach, *right*
Although the range of shots that can be taken are limited, it is possible to take pictures of sport with a wide-angle lens. The appeal of this picture is that it not only shows a close-up of the action, but also the large frozen lake on which this polo tournament is played and the alpine scenery that surrounds it.

Multiple shots, *left*
One of the difficulties of photographing field sports is that however carefully you choose your viewpoint, the player with the ball is frequently obscured by other players on the pitch. When a clear view becomes available, it is wise to take as many shots as possible. The sequence should be sharply recorded with a predictive autofocus system.

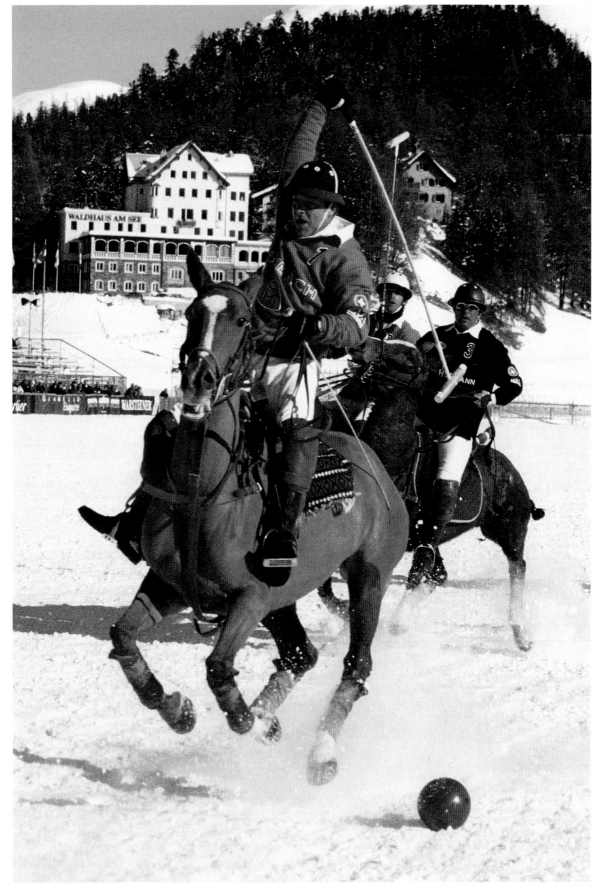

Timing
A poolside camera position and careful timing of the shot captures the swimmer's facial expression. *35mm camera, 135mm lens, Ektachrome 200, f8, 1/250 sec.*

Peak of action
This boy is photographed at the top of his jump, before gravity takes over and he falls back to earth. *35mm camera, 70mm lens, Kodachrome 100, f22, 1/125 sec.*

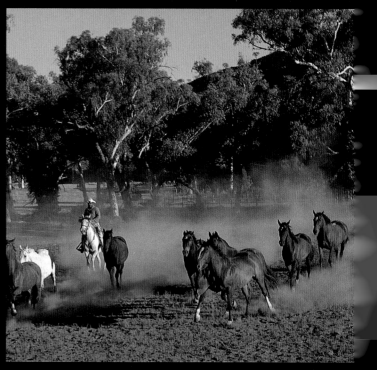

Viewpoint, *left*
The right viewpoint is often the vital ingredient of a good action photograph. If taken from the riverside, this canoeist would be obscured by spray. An overhead viewpoint shows his descent downstream in a dramatic fashion. *35mm camera, 135mm lens, Ektachrome 100, f8, 1/500 sec.*

Roundup, *above*
When you are on vacation look fo exciting action images that capture the spirit of the country you are visiting. This shot of a roundup of wild horses in the Australian outback is given atmosphere by the swirling dust. *6 x 6cm camera, 80mm lens, Ektachrome 200, f16, 1/250 sec.*

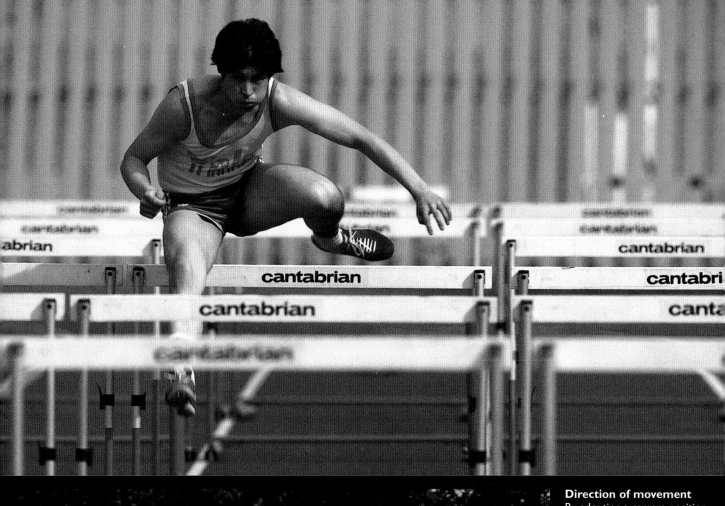

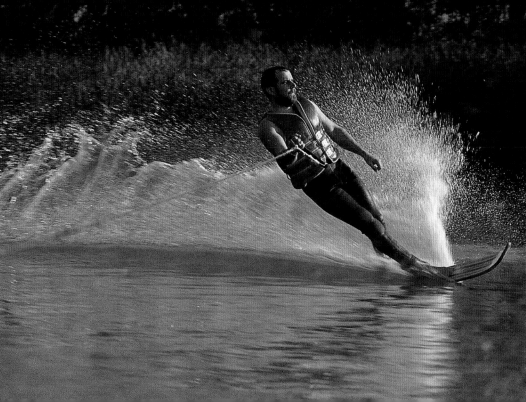

Direction of movement
By adopting a camera position head-on to the action, a relatively slow shutter speed is used to freeze movement. If the hurdler had been photographed from the side, a faster shutter speed of at least 1/250 second would be needed to get a sharp image. *35mm camera, 250mm lens, Kodachrome 200, f22, 1/125 sec.*

Panning
A plume of water, kicked up as the water skier changes direction, adds drama and excitement to this shot. To keep the rapidly moving subject in focus, it is necessary to pan the camera, resulting in the slight blurring of the background scenery despite the very brief shutter speed used. *35mm camera, 500mm lens, Ektachrome 100, f8, 1/500 sec.*

STILL LIFE

Photographing a still life can serve as an exercise in skill and creativity, honing your understanding of composition and the effects of lighting on objects. Like a painter, the photographer can use a still life picture to communicate ideas of color, form, tone, texture, and composition.

Arranging a still life

A still life is an object or group of objects, which is usually arranged as the subject for a picture. Because the subject is inanimate, you can concentrate more than is usually possible on the lighting and composition. Setting up your own still life can be rewarding, since you have total control over the selection and arrangement of the objects. It is advisable to begin with one object and gradually build up a composition in which the various parts relate to each other. The items used should not be selected arbitrarily, but should fit into a theme – for example, objects from a certain place or a particular period. The essential point is to collect as many props as possible. Gather everything you may want to incorporate and keep it on a table beside you while you work. This allows you to develop your composition carefully, one piece at a time.

Found still life

These are compositions that occur naturally around you, and "found" still life photographs will demonstrate your ability to see good pictures in day-to-day life. A collection of objects in a shop window, for example, may strike you because of their overall arrangement, or the unusual nature of the items. And the natural world abounds with found still life possibilities, from driftwood on a beach, to a pile of fallen apples.

Photographing food

Simple ingredients such as fresh vegetables and exotic fruits offer a sensuousness and a variety of color and texture not found in other inanimate objects. Food photography is a thriving area of commercial photography and professionals use special techniques for enhancing the appearance of food.

STILL LIFE SET-UP

The equipment shown here comprises an ideal set-up for photographing a still life subject. A single diffused light is sufficient to provide overall illumination, as all the shadows should fall in the same direction. Ideally, this single flash unit should be fitted with a softbox diffuser to soften the effect. Use a flash unit with a built-in modeling light, if possible, so you can see how the shadows fall. You will also need a reflector to bounce light into the shadows for overall illumination.

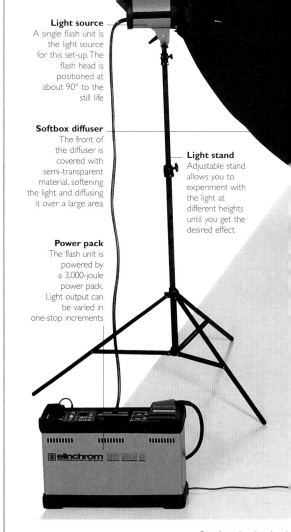

Light source
A single flash unit is the light source for this set-up. The flash head is positioned at about 90° to the still life

Softbox diffuser
The front of the diffuser is covered with semi-transparent material, softening the light and diffusing it over a large area

Power pack
The flash unit is powered by a 3,000-joule power pack. Light output can be varied in one-stop increments

Light stand
Adjustable stand allows you to experiment with the light at different heights until you get the desired effect

Synchronization lead
This links the camera and the flash unit's power pack, triggering the flash to fire in time with the shutter release

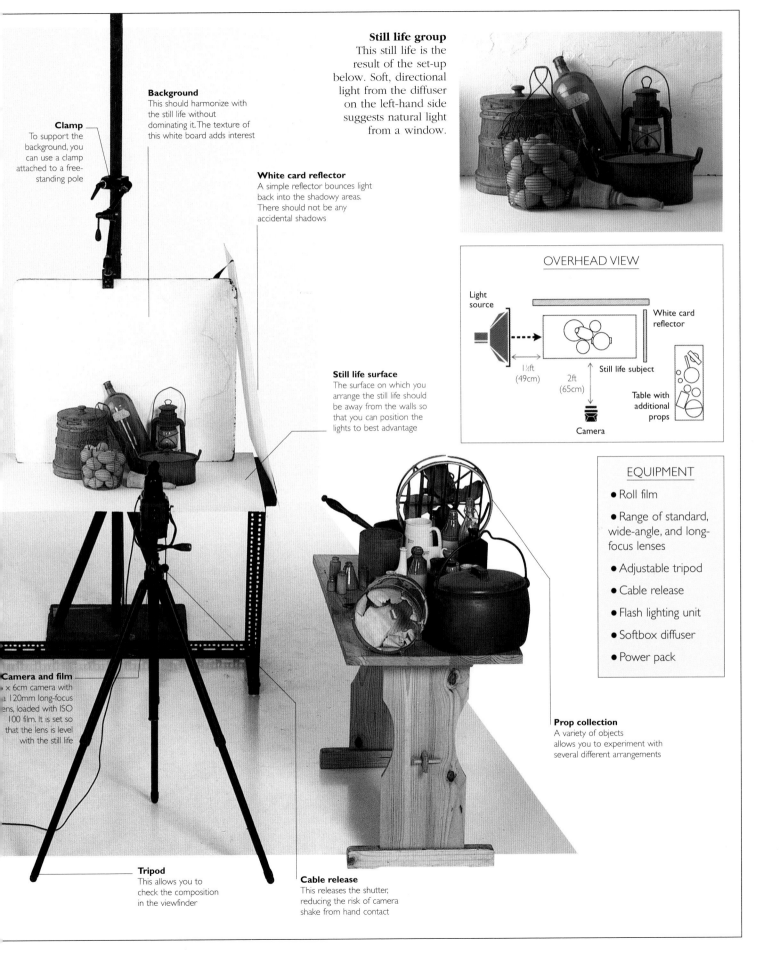

Clamp
To support the background, you can use a clamp attached to a free-standing pole

Background
This should harmonize with the still life without dominating it. The texture of this white board adds interest

Still life group
This still life is the result of the set-up below. Soft, directional light from the diffuser on the left-hand side suggests natural light from a window.

White card reflector
A simple reflector bounces light back into the shadowy areas. There should not be any accidental shadows

Still life surface
The surface on which you arrange the still life should be away from the walls so that you can position the lights to best advantage

OVERHEAD VIEW

Light source

White card reflector

1½ft (49cm) 2ft (65cm) Still life subject

Table with additional props

Camera

EQUIPMENT

- Roll film
- Range of standard, wide-angle, and long-focus lenses
- Adjustable tripod
- Cable release
- Flash lighting unit
- Softbox diffuser
- Power pack

Camera and film
× 6cm camera with a 120mm long-focus ens, loaded with ISO 100 film. It is set so that the lens is level with the still life

Prop collection
A variety of objects allows you to experiment with several different arrangements

Tripod
This allows you to check the composition in the viewfinder

Cable release
This releases the shutter, reducing the risk of camera shake from hand contact

COMPOSING A STILL LIFE

For a successful still life you have to establish some sort of link between the objects used in the composition. This link could be a theme – the objects on this page are all typical of a pastoral lifestyle and could have been found on a farmhouse pantry shelf.

BUILDING UP A COMPOSITION

Most still life pictures are built up element by element. Begin with the most important object, viewing it through the camera and adjusting its position until you are satisfied. Then add the second component, and again check the image through the viewfinder. In this way you can build up your arrangement piece by piece, making minor adjustments until you are satisfied with the result.

A wooden storage container is the starting point.

A blue bottle is positioned to provide balance.

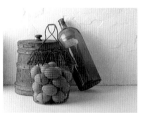

A wire basket filled with eggs confers warmth.

A weathered lamp gives character to the composition.

Adding an old copper pot anchors the still life.

Finished still life, *below*
The final addition is a small wooden pestle. Its position keeps the gaze from being drawn to the gap at the bottom. It also reintroduces the warmth and texture of the wood of the storage container, which had become slightly obscured.

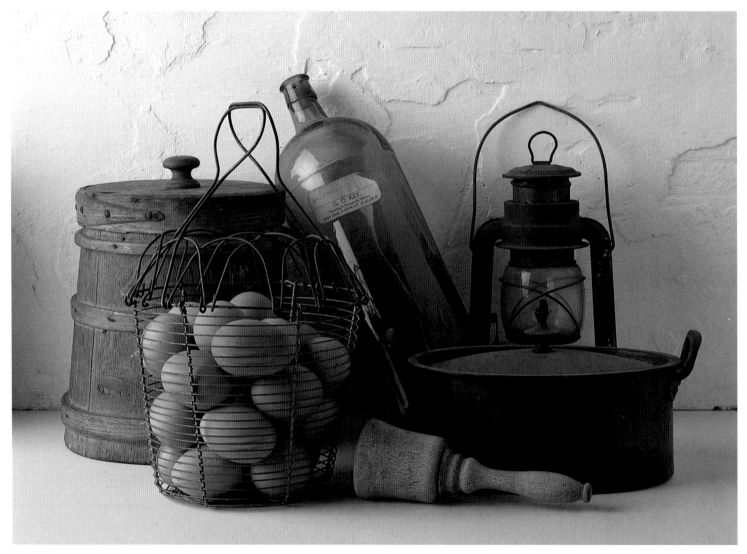

ANALYZING A STILL LIFE

A collection of still life objects arranged for the camera should have shared attributes such as shape, color, form, and texture. When you start to take note of these qualities as well as the more obvious thematic connections, your creative scope is widened immeasurably.

BALANCE AND HARMONY

The most difficult part of creating a still life arrangement is knowing when it is complete. A finished composition should have balance and harmony. The objects should be organized so that they emphasize, rather than detract from, the main focal point. Creating a balanced still life composition is instinctive, but you will recognize it when your eye is drawn from one object to the next, with the characteristics of each adding to your pleasure in the next.

Shape and pattern, *above*
The repeated shapes of fork and spade handles leaning against a fence create a strong pattern in this still life picture.

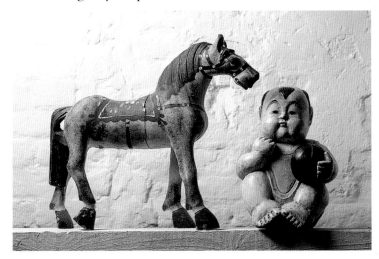

Simple grouping, *above*
The appeal of this simple still life is the wealth of detail visible on the two wooden objects as well as their strong shapes.

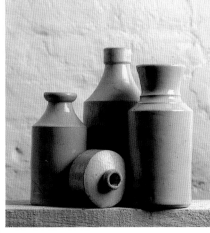

Triangular group, *left*
A group of bottles defines the apex of a triangle, a classic compositional shape. The bottle at the rear acts as a visual anchor, and the similar shapes and textures of all the bottles give the image unity.

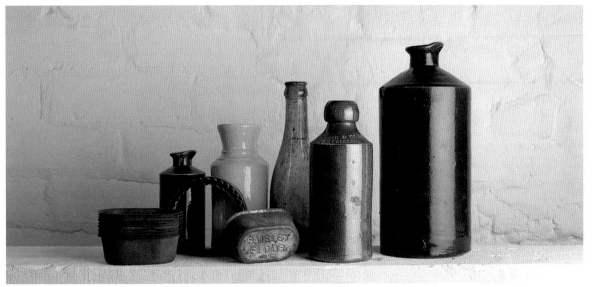

Placement and balance
Although these bottles appear to be arranged in a haphazard fashion on the shelf, they have been deliberately placed so that the densest mass sits in the central portion of the picture frame.

LIGHTING A STILL LIFE

How you undertake the lighting for a still life depends largely on the elements making up the composition and the degree of translucency, solidity, or color saturation you want them to take on in the final photograph. Generally soft lighting coming directly from in front of the camera will have a form-flattening effect, and results may appear two-dimensional. In contrast, sidelighting tends to enhance the surface characteristics of objects, but shadows may be cast that obscure surface detail.

OVER- AND UNDERLIGHTING

Overlighting by directing a lot of harsh light at the subject lightens the "visual weight" of the subject elements, but it may also cause colors to appear less saturated and weak. Conversely, underlighting by restricting the amount of light reaching the subject may make objects appear heavier and more solid, and colors, too, may appear darker and stronger. By introducing secondary lights, reflectors, or diffusers, myriad subtle or dramatic lighting effects can be achieved.

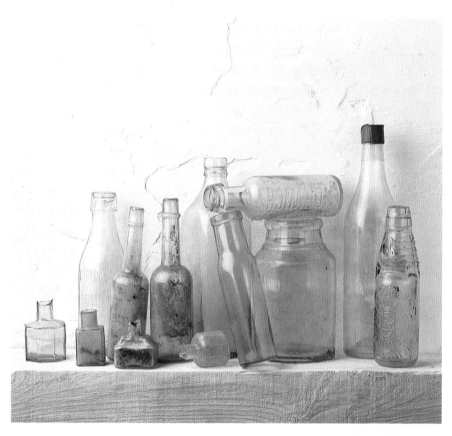

PHOTO SET-UP: Directional light

A white-painted textured board directly behind the bottles makes a visually interesting backdrop. Lighting is provided by a single flash unit fitted with a softbox diffuser and positioned to one side of the glass bottles, pointing slightly downward. On the far side of the group a reflector throws back some of the light and so lessens the exposure difference between one side of the group and the other.

Textured white board makes an interesting yet simple background

Form and modeling
Diffused sidelighting and a reflector, combined with a textured backdrop that also reflects some of the light, highlight the form and modeling to produce a subtle gradation of tone.

Reflector positioned on the shadow side of the composition makes the exposure more even across the whole arrangement

Lighting head fitted with a diffuser ensures that reflections on the glass bottles are not intense enough to pick up reflections from the flash and other nearby objects

6 x 6cm camera on a tripod with a long-focus 120mm lens, which makes it possible to shoot from farther back, lessening the chance of the image appearing as a reflection in the surfaces of the bottles

Table with selection of props to be added to the arrangement if required

Power pack is used to power the single flash unit

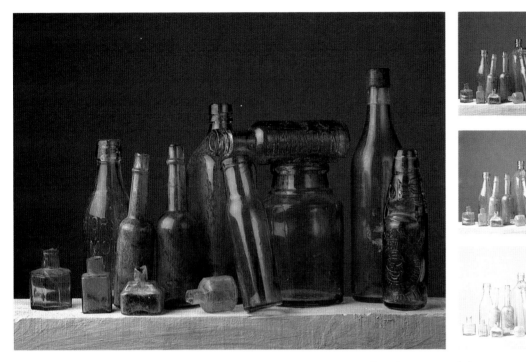

Varying light, *left*
The textured board directly behind the glass bottles is removed for this sequence of three photographs. This leaves the white-painted walls at the back of the set as the effective background. Then, for each shot, the light output from the flash is gradually increased to produce progressively lighter images.

Color saturation, *far left*
In the darkest image in the sequence, you can see immediately that the glass bottles appear more solid and heavier than in lighter versions. Note, too, that as the image darkens the red stopper on the bottle on the right seems darker and the color more saturated.

PHOTO SET-UP: Transmitted light
Flash lighting is directed at the white background behind the glass bottles so that they are defined solely by the light transmitted through them (*left and bottom left*). The shape of the bottles becomes the principal element.

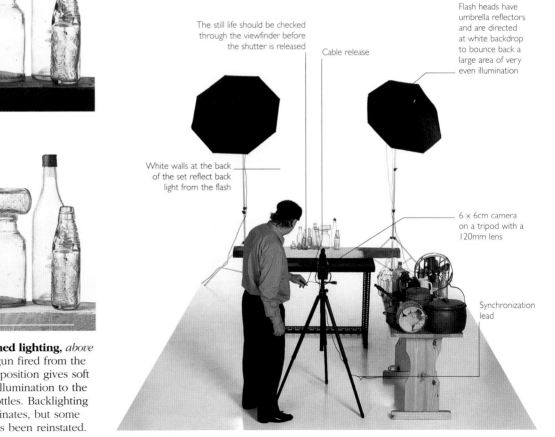

The still life should be checked through the viewfinder before the shutter is released

Cable release

Flash heads have umbrella reflectors and are directed at white backdrop to bounce back a large area of very even illumination

White walls at the back of the set reflect back light from the flash

6 x 6cm camera on a tripod with a 120mm lens

Synchronization lead

Backlighting, *top*
Lit from behind, the surface characteristics of the glass disappear. The silhouette of each bottle is defined by a dark line. The red stopper now appears nearly black.

Combined lighting, *above*
A flashgun fired from the camera position gives soft frontal illumination to the glass bottles. Backlighting predominates, but some form has been reinstated.

SELECTING STILL LIFE THEMES

Working with inanimate objects allows you time to select suitable subjects, to find the most appropriate background, to position the lights if using flash, and to make any subtle corrections to the composition. All of this can be carried out at your own pace, without having to worry about the comfort of a model.

CHOOSING ELEMENTS

Look for some aspect that unifies the items in a composition. This could be texture, function, color, shape, or age. A suitable background and sympathetic lighting are also important. In the pictures on these pages the high-key (light-toned) composition is lit by bright, reflected light, and the low-key (dark-toned) one is illuminated by daylight and fill-in flash.

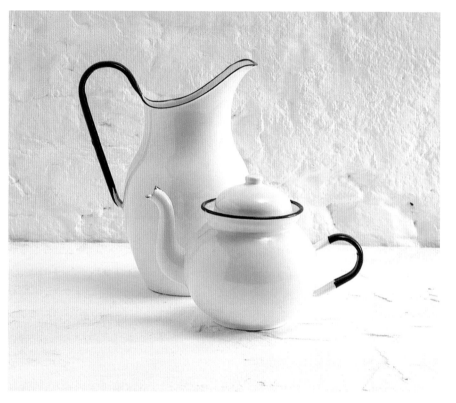

Light composition
Although composed almost entirely of white, there is sufficient tonal variation to separate the enameled pots from their surroundings, while the black rims give balance and contrast.

PHOTO SET-UP: High-key still life
For this simple still life study, the color and reflective nature of the objects dictate the lighting used. To achieve the desired high-key effect, a broad spread of reflected, indirect light from a wide-angle flash head is angled toward the ceiling and another light is reflected by a white-painted board positioned to the left of the objects.

Wide-angled flash head points at the junction of the ceiling and back wall to give a variety of toplight angles

White, plastered wall does not compete for attention, but provides a contrast in texture with the smooth surface of the objects

Objects are linked by their white coloring, rounded shapes, and enameled texture

Single power pack is the power source for both lighting units

6 x 6cm camera with a 120mm long-focus lens

Secondary flash head is directed mainly at a reflector but its light also spills over and reflects onto the subject from the rear wall

Adjustable tripod can be positioned at appropriate height for still life

PROFESSIONAL TIPS

• Nearly all still life photography requires the use of a tripod.

• For a high-key still life, provide sufficient illumination so that there is only about a one-stop difference between the main highlights and the deepest shadows.

• When shooting with a digital camera, use the LCD screen to check the lighting, composition, and exposure of your selected image in a similar way to how a professional would use a Polaroid back. Unlike film cameras, however, if the digital image is a success there is no need to shoot a final version.

PHOTO SET-UP: Low-key still life

This antique kettle and range require additional illumination since there is not much natural daylight in the kitchen. This lighting is provided by a silver reflector on the object's shadow side (to reflect the available window light) and a boost of indirect light from a flashgun.

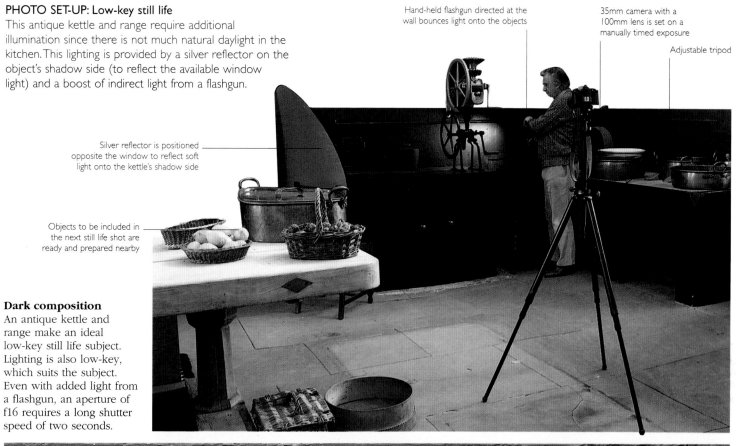

Hand-held flashgun directed at the wall bounces light onto the objects

35mm camera with a 100mm lens is set on a manually timed exposure

Adjustable tripod

Silver reflector is positioned opposite the window to reflect soft light onto the kettle's shadow side

Objects to be included in the next still life shot are ready and prepared nearby

Dark composition

An antique kettle and range make an ideal low-key still life subject. Lighting is also low-key, which suits the subject. Even with added light from a flashgun, an aperture of f16 requires a long shutter speed of two seconds.

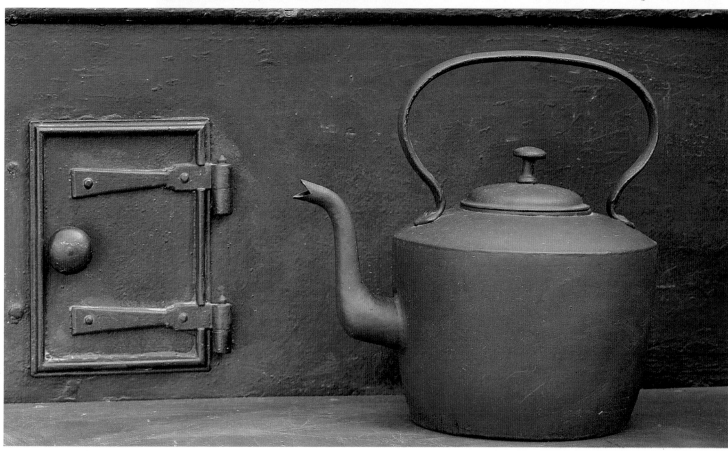

TAKING OUTSIDE STILL LIFE

The main advantage of working outdoors lies in the range of backgrounds and settings you have at your disposal. Indoor settings tend to be cluttered and the decor may compete with the subject. Photographing a subject outside allows you more space to find a setting that makes a positive contribution to the shot.

WORKING IN NATURAL LIGHT

The disadvantage of photographing a still life outdoors lies in the diminished control you have over lighting. Working inside, you can position lights and reflectors at will, and bounce light off the walls and ceiling. Outside, however, you are reliant on natural light – either direct sunlight or, preferably, an overcast sky. You can influence the lighting quality by using reflectors to redirect light into the subject's shadows and so lessen contrast, or you can use a flashgun to add highlights or raise the level of exposure.

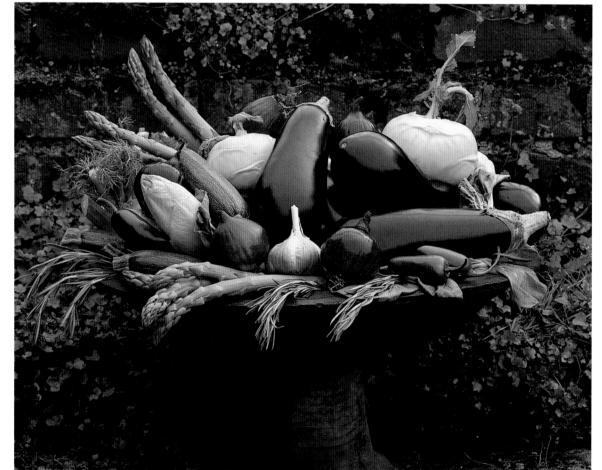

6 x 7cm camera with a 120mm long-focus lens

Tripod supports the weight of the camera and lens, and gives the camera a fixed reference point for checking the composition

PHOTO SET-UP: Still life with vegetables
The vegetables are arranged in a wooden dish in front of a red brick wall. It is lit by diffused light from a hazy sky, with no direct sunlight. The light reflected from the surrounding hard surfaces helps lift light levels by about one f-stop and ensures that the exposure is even.

Background wall adds interest, yet does not compete for attention

Hard surface of the paving stones reflects available daylight

Fruit arrangement
You can create a still life by confining yourself to one type of food, like this composition, which is made up of colorful fruits arranged in a glass vase.

Vegetable still life
In this well-balanced composition, the shapes, forms, textures, and colors of the vegetables were all carefully considered. Diffused rather than direct light is used because of the reflective surface of the eggplants and red onions.

Food still life
Daylight helps bring out the color and texture of the red and green pasta, the pink crayfish, and the slab of stone. The color contrast and shadows give an impression of depth.

Mirroring art
The inspiration for this rustic tableau is a 19th-century watercolor painting. Although the scene looks almost natural, the quail eggs were bought and placed in an artificial nest.

PHOTO SET-UP: Spring still life
Sunlight filtering through the tree canopy is the light source for this still life of an artificially re-created bird's nest and eggs. The use of a long-focus lens means that an aperture of f22 is required to ensure sufficient depth of field, and this necessitates a shutter speed of 1/4 second. A windbreak prevents unwanted subject movement.

Board is propped against the tree to act as a windbreak to prevent subject movement

Appearance of the subject is carefully checked in the camera viewfinder after every minor adjustment

6 x 7cm camera with a 165mm long-focus lens

Tripod and cable release are essential to prevent any slight movement of the camera during the exposure

PROFESSIONAL TIPS

- For professional food photography, ingredients must have no marks or bruising.

- Care and attention to detail is critical.

- Objects with shiny, reflective surfaces can be polished to remove finger marks.

- Start by positioning the largest object in the composition and then build up the other elements around it.

- Background color can affect the mood of a still life composition.

CHOOSING BACKGROUNDS FOR STILL LIFE

Backgrounds are particularly important in still life, since they are such a highly visible part of the composition. As many subjects that are photographed are relatively small, the background becomes not only what is behind the arrangement, but what is placed underneath it as well. This means that it is frequently in sharp focus in the frame.

When photographing natural objects outdoors, such as fruit and vegetables, it will complement the composition if they are placed against a natural-looking background, such as a piece of stone, a plank of weathered wood, or an expanse of grass.

Pick the color of the background so that it blends harmoniously with that of the main subject. Check also that there is enough difference in tone so that the subject stands out – for instance, with a lighter subject, use a darker background.

PHOTO SET-UP: Natural contrast

The aim of this shot was to juxtapose the smooth broad beans in their pods with the rough hands of the gardener. The man wanted to wash his hands beforehand, but the soil in the creases and under his nails provided a better colored, more dramatic backdrop for the composition.

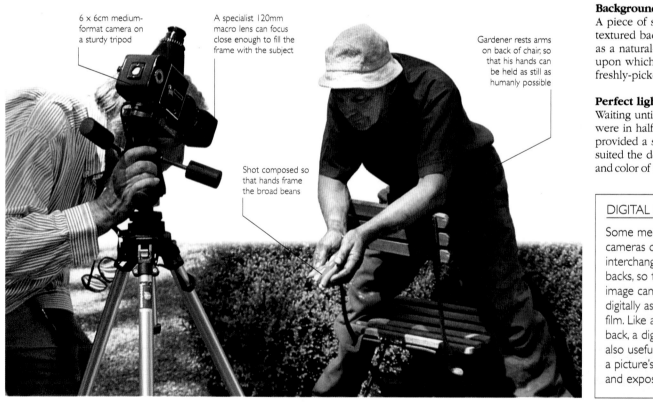

6 x 6cm medium-format camera on a sturdy tripod

A specialist 120mm macro lens can focus close enough to fill the frame with the subject

Gardener rests arms on back of chair, so that his hands can be held as still as humanly possible

Shot composed so that hands frame the broad beans

Background texture, *above*
A piece of stone creates a textured backdrop, as well as a natural-looking surface upon which to arrange the freshly-picked peas.

Perfect lighting, *opposite*
Waiting until the hands were in half shadow provided a softer light that suited the delicate shape and color of the broad beans.

DIGITAL SOLUTIONS

Some medium-format cameras can take interchangeable digital backs, so the final image can be recorded digitally as well as on film. Like a Polaroid film back, a digital back is also useful for checking a picture's composition and exposure.

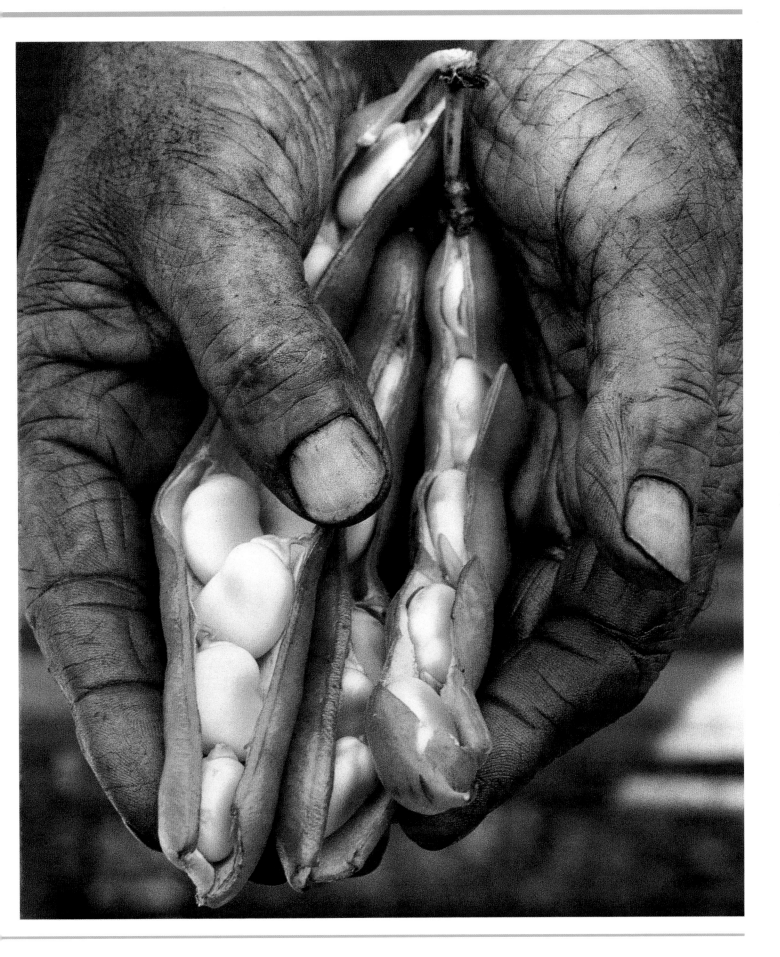

PHOTOGRAPHING FOUND STILL LIFE

Any arrangement of everyday objects that forms a pleasing composition, but has not been put together specifically to be photographed, can be termed a found still life. The art of photographing found still life lies in finding the appropriate camera angle and using sympathetic lighting so that the final image you have in your mind's eye becomes the image captured on film.

NATURAL ORDER AND PATTERN

In one way or another, all of us tend to impose order on our surroundings – in our homes, at work, and in our gardens. Manifestations of this are all around us. We organize ordinary cooking ingredients in the kitchen so that the ones we use most often are easy to find, or we change the position of everyday items on a shelf so that they make a more attractive grouping. The secret is to recognize the picture possibilities of these arrangements.

PHOTO SET-UP: Greenhouse detail

The sunlight filtering through the greenhouse creates a dappled lighting effect. The white wall behind the objects acts both as a textured background and as a reflector, raising light levels and relieving areas of shadow.

35mm camera on a tripod with a 70–210mm zoom lens

Collection of objects among the clutter on a garden work bench is isolated in the viewfinder

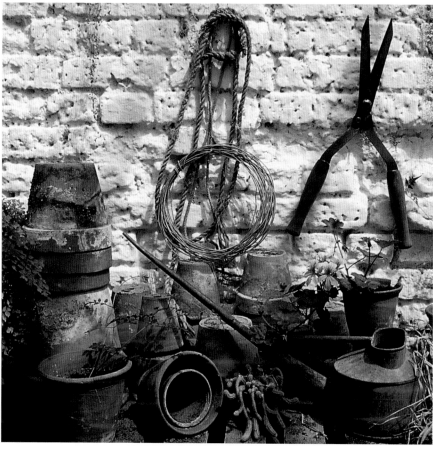

Nostalgic mood, *above*
Sunlight entering through the window adds to the mood of this picture. Strewn with cobwebs, the glass bottles and scales are a glimpse into the past.

Work bench, *right*
A collection of plant pots, garden tools, a weathered watering can, and drying bulbs, makes a harmonious still life with a unity of color, form, and purpose.

Rhubarb, *left*
These sticks of rhubarb had just been picked and left on a garden table. The white background and diffused light shows off the delicate coloration well.

PROFESSIONAL TIPS

● Lighting can transform a rather ordinary arrangement of objects into a captivating composition – depending on its intensity, direction, and color temperature. Be prepared to come back to a found still life at different times of day to see the effect of alternative lighting.

● View a potential still life subject from all possible angles before deciding on the final camera position.

● Use your thumbs and index fingers to make a frame, to previsualize how the image will appear. But always use the viewfinder for final compositional changes.

Repetition of shape
Finding a coherent theme for the objects making up a composition is one of the most difficult aspects of still life photography. In this collection of objects, it is the repetition of shape that forms the common link. Note, too, how the arrangement sets up a strong diagonal flow within the frame.
5 x 7cm camera, 120mm lens, Fujichrome 100, f11, 1/60 sec.

Natural sunlight
Soft, directional light coming from a window to the right of this still life is the only illumination. The sense of calm would be marred if the contrast between the shadows and highlights were too marked, so a white cardboard reflector has been added on the left-hand side.
35mm camera, 100mm lens, Kodachrome 200, f16, 1/30 sec.

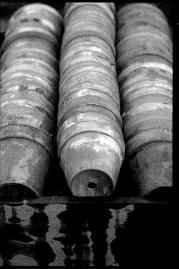

Found objects, *top*
A still life does not have to be a collection of objects arranged for the camera. Use the viewfinder to isolate found objects, such as these old, discarded boots, to form a pleasing composition.
35mm camera, 120mm lens, Ektachrome 200, f11, 1/125 sec.

Shape and symmetry, *above*
The repeating shapes and symmetrical composition of these terra-cotta plant pots convey a sense of balance and harmony. The low camera angle introduces a depth that would be missing from an overhead viewpoint.
35mm camera, 50mm lens, Ektachrome 100, f5.6, 1/250 sec.

Multifaceted imagery
Although the components making up this still life are very simple, the combination of elements with the lighting and background results in a multifaceted image comprising shape, form, texture, and tone.
6 x 6cm camera, 80mm lens, Ektachrome 100, f16, 1/250 sec.

Dominant color
The two principal colors in this composition – the yellow of the sunflowers and the blue of the table top – represent a potentially discordant color combination. However, the intensity of the daylight spotlighting the flowers is such that the yellow relegates all other colors to supporting roles.
35mm camera, 28mm lens, Fujichrome 100, f8, 1/500 sec.

LANDSCAPES

Landscapes are constantly changing. Depending on the time of day, and weather conditions, they can take on many different personalities and moods. Learning to see and capture on film the potential in a scene is perhaps the hardest part of landscape photography.

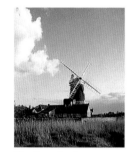

Viewing a landscape
See pages 156–157

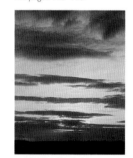

Water and light
See pages 170–175

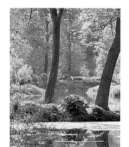

Dramatic skies
See pages 176–179

Urban landscapes
See pages 180–183

The light factor

Unlike an outdoor portrait, where a subject can be moved into position for the most beneficial lighting effect, with a landscape picture you must work with the prevailing light. This does not mean that you cannot influence how the subject will appear in the photograph. For example, from one angle, a pool lying at the bottom of a ravine may appear black and lifeless, while seen from another, the water may be a mirror holding a flawless reflection of blue sky and white clouds.

Compositional control

Before taking any pictures you should explore the surroundings to find the best viewpoint. A landscape may be dramatically improved by the inclusion of a feature in the foreground or when photographed in a particular light. Even if your camera angle is restricted to a single viewpoint, you should be able to move to the left and right to find the best perspective. The height from which you shoot is also critical. Squatting down tends to stress the foreground, while gaining extra height may allow you to exclude an unwanted foreground detail. Look at the scene through the viewfinder to see how landscape features relate as you move around.

Lenses for landscapes

A wide-angle lens is ideal for broad panoramas with a wide sky and plenty of foreground. If the sky is flat and dull, you can use a long-focus lens to restrict the angle of view to parts of the scene that have maximum impact. It is best to use a tripod and cable release to avoid camera shake, even if you are not working with slow shutter speeds. Remember that a landscape may look most dramatic toward dusk or in dark stormy light, conditions that make long exposures essential.

LANDSCAPE SET-UP

A 12th-century priory in the heart of the English countryside is the focal point of this landscape picture. The camera viewpoint and the position of the sun show some sides of the ruins in bright sunlight, while other sides of the building are in shadow. The camera angle does not show the reflections of any of the clouds in the pool of foreground water, but it does reveal the reflections of the higher parts of the building and the ancient tree to the left.

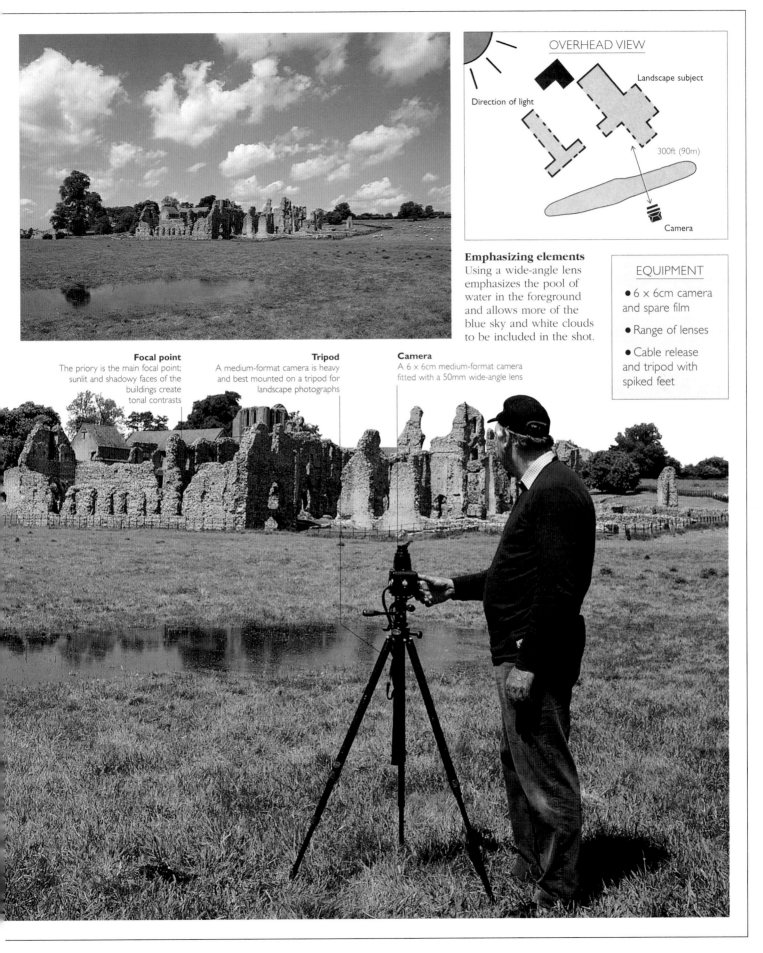

OVERHEAD VIEW

Direction of light

Landscape subject

300ft (90m)

Camera

Emphasizing elements
Using a wide-angle lens emphasizes the pool of water in the foreground and allows more of the blue sky and white clouds to be included in the shot.

EQUIPMENT

● 6 × 6cm camera and spare film

● Range of lenses

● Cable release and tripod with spiked feet

Focal point
The priory is the main focal point; sunlit and shadowy faces of the buildings create tonal contrasts

Tripod
A medium-format camera is heavy and best mounted on a tripod for landscape photographs

Camera
A 6 × 6cm medium-format camera fitted with a 50mm wide-angle lens

VIEWING A LANDSCAPE

Photographing a landscape is more difficult than it seems because it involves translating a three-dimensional panoramic scene complete with all its nuances into a flat image.

CHOOSING A DOMINANT ELEMENT

Any landscape is a complicated mixture of colors, tones, textures, forms, and perspectives. If you simply point the camera in a general way at such a potential jumble of subject matter it is likely to result in an uninspiring picture, so it is important to have a clear idea of how you want the elements to relate to each other. Try to be selective about what you include in the picture. By careful choice of viewpoint and lens focal length you can decide which elements are important and how you can best arrange them within the confines of the viewfinder. This task is often simplified if you can identify one element as being the main subject.

PHOTO SET-UP: High viewpoint

Relatively small differences in camera position can create huge shifts of emphasis in a photograph. The extra height afforded by shooting from the top of a four-wheel drive car lessens the effect of the field in the foreground and emphasizes the main subject – the windmill in the distance.

35mm camera with a 100mm long-focus lens

Platform on roof gives high viewpoint

Tripod ensures that the camera is level and steady

Distant windmill is made more prominent by the use of a long-focus lens

Distant viewpoint
A high camera viewpoint is essential to keep the green field from dominating this landscape. The 100mm long-focus lens with its narrow angle of view (*see page 17*) isolates the main subject and crops unwanted elements. This viewpoint also assigns the trees in the middleground a subsidiary role as an attractive frame for the windmill.

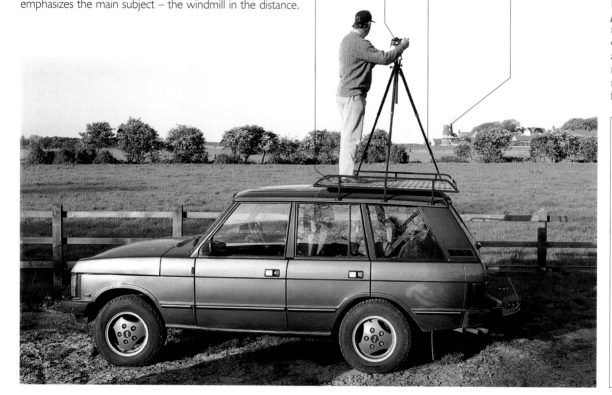

PROFESSIONAL TIPS

• If the light is not favorable, try to find a different viewpoint or wait until the light is in the right direction.

• Shooting from a high viewpoint minimizes the foreground.

• Shooting from a low viewpoint emphasizes the foreground.

• A landscape composition needs one principal feature.

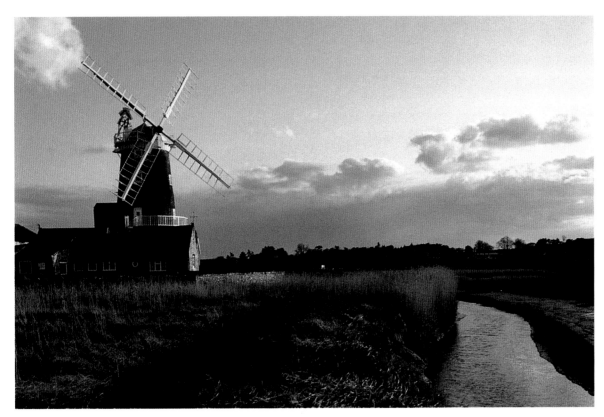

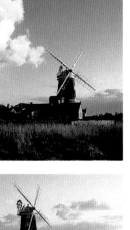

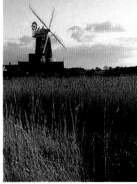

PHOTO SET-UP: Changing the angle

Moving in closer to the windmill gives a different emphasis to the landscape. The merits of the camera viewpoint in terms of composition and lighting are considered in the viewfinder before pressing the shutter release button.

Foreground feature
Inclusion of the stream in the foreground adds shape and color. Its curve helps draw the eye to the mill.

Placing the horizon
A low horizon emphasizes the sky and introduces a feeling of space (*top*). A high horizon shifts the emphasis to the bottom of the frame (*above*). The landscape now seems more enclosed than previously.

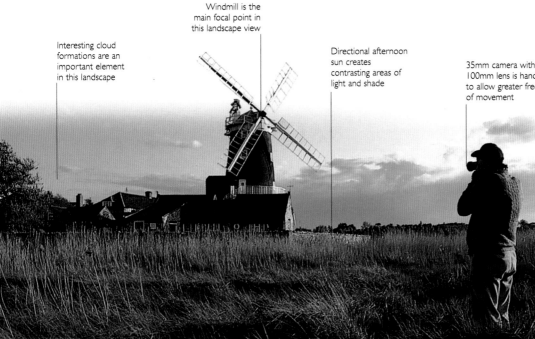

Interesting cloud formations are an important element in this landscape

Windmill is the main focal point in this landscape view

Directional afternoon sun creates contrasting areas of light and shade

35mm camera with a 100mm lens is hand-held to allow greater freedom of movement

Extreme viewpoint
Moving in closer to the windmill and pointing the camera up results in an architectural shot that excludes any clue as to the landscape or surrounding elements.

RECORDING TIMES OF DAY

Light is the key ingredient in a successful landscape photograph. Its intensity and the angle at which it illuminates the subject play a vital role in conveying mood. Dawn light is of low intensity and has a gentleness that softens colors and definition. As the sun climbs, the angle of light accentuates texture and form. Toward noon the sun is overhead and the contrast between light and shade is intense. The light can be so strong that colors are bleached out and the landscape seems lifeless. In the afternoon as the sun descends, color intensity, form, and texture improve, and by dusk the scene has a rosy warmth.

Early afternoon
Light, color, form, and texture are evident in this scene, shot in the soft light of early afternoon.

Mid-morning
Although a clear morning, the sun is not yet high in the sky, and a grayness hangs over the beach.

PHOTO SET-UP: Time of day

One of the best ways to see how the mood of a
landscape is influenced by different light is to take a series
of pictures of the same subject throughout the course of
a single day, perhaps at mid-morning, in the afternoon, and
at sunset. To ensure the framing of all the shots is
consistent, take a careful note of your camera position,
camera height, and focal length, and line each shot up
with a prominent landmark, such as this seaside pier.

Toward sunset
With the sun low, contrast
is extreme. It is just
possible to discern a hint
of pink in the clouds close
to the sun, an effect that
will intensify as the sun
dips below the horizon.

Position of the corner of
the pier is carefully noted
so that the framing of
each picture is identical

35mm camera with a
28mm wide-angle lens

Low wall makes a handy
support to lean on and ensures
that all pictures in the sequence
are shot from the same height
and camera position

Day to night sequence
Dawn at Rio de Janeiro's
Copacabana beach (*top
row left and right*). Colors
intensify as the sun climbs
in the sky (*bottom row
left*), until by late
afternoon (*bottom row
right*) the glass towers are
in shadow with a blue sky
behind. As night falls, the
sky turns a warm reddish
pink (*below*).

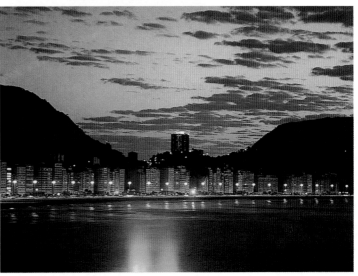

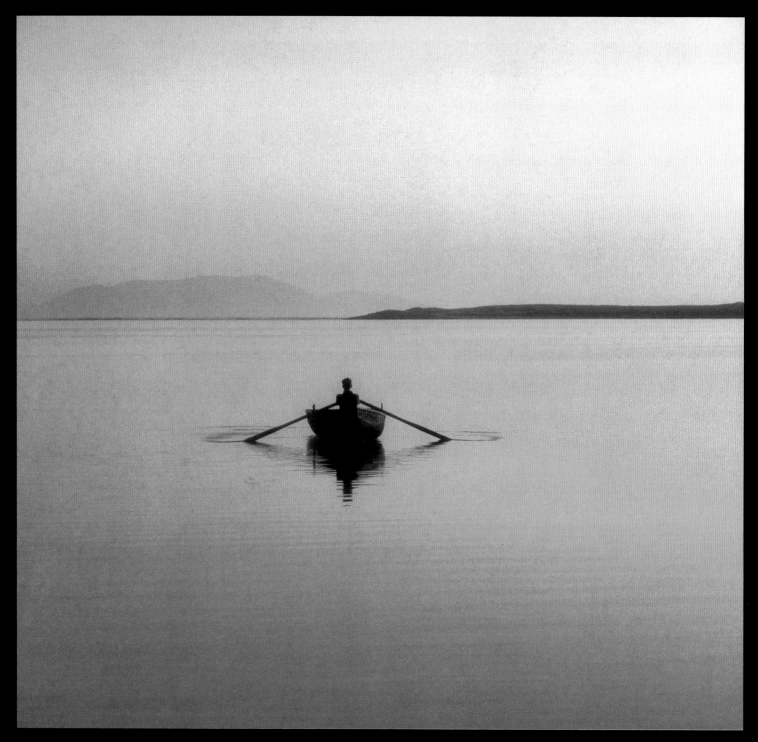

Highlight exposure, *left*
Scenes containing large areas of water tend to be brighter because they reflect available light – even the weak light from a twilight sky. Here the land is darkened by taking an exposure reading from the sky, which is the brightest part of the scene, leaving the rest of the image underexposed.
35mm camera, 135mm lens, Ektachrome 100, f8, 1/250 sec.

Afternoon light, *above*
The mirrorlike water of this Irish estuary is broken only by the boatman's oars. The wooden boat and finger of land provide contrast to the pastel pink-green scene.
6 x 6cm camera, 150mm lens, Ektachrome 200, f5.6, 1/250 sec.

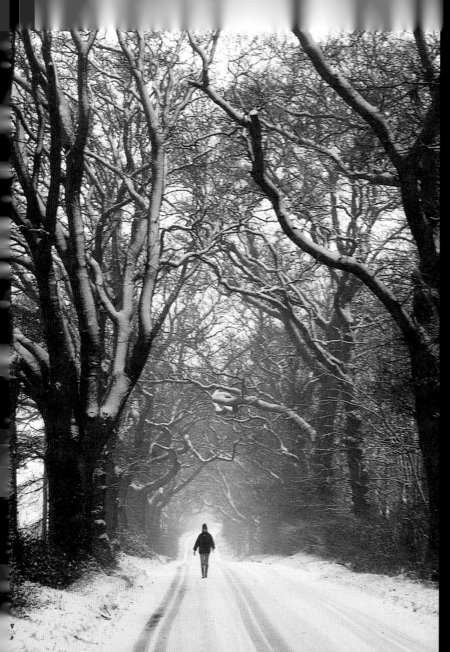

Snow exposure, *left*
Snow reflects light, giving too high
a light reading for the subject, which
can result in underexposure. Here,
the lens is opened by one f-stop.
*35mm camera, 55mm lens,
Kodachrome 64, f8, 1/60 sec.*

Sunset color, *below*
At sunset the landscape takes on an
orange cast. Wavelengths of blue light
are scattered, and longer red
wavelengths illuminate the scene.
*35mm camera, 80mm lens,
Kodachrome 64, f11, 1/125 sec.*

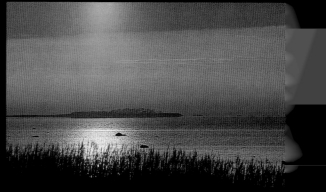

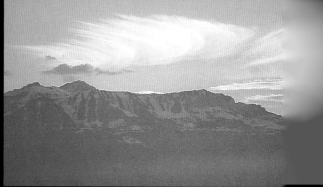

Ultra-violet light, *above*
Large amounts of ultra-violet light
contribute to the overall coloration and
slight haziness of this scene. The fact that
the landscape is illuminated by light from a
deep blue sky rather than direct sunlight
also influences the strong color-cast.
*35mm camera, 135mm lens,
Ektachrome 200, f16, 1/125 sec.*

Monochromatic landscape, *left*
This aerial composition consists almost
exclusively of shades of green, relieved
only by farm buildings, stone walls, and
grazing cattle. The sun is low in the sky
and throws long shadows across the
fields, producing almost tangible
surface textures.
*35mm camera, 100mm lens,
Fujichrome 100, f5.6, 1/250 sec.*

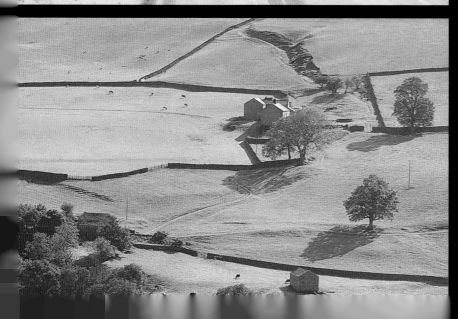

CHANGING LIGHT AND WEATHER

In unpredictable weather, light is variable, changing from second to second, and this presents specific problems when judging exposure. Wet weather does not necessarily lead to bad or uninteresting pictures, and it certainly does not need to keep you from taking photographs. Although you should always take precautions to protect the camera and lens from getting wet, a few drops of rain will not cause damage.

Storm light, misty conditions, and heavy rain can dramatically alter the appearance of a landscape, merging and simplifying colors, distorting perspective, and creating a varied vista. Landscapes do not have to be shot in fair weather – scenes shot in unfavorable conditions can result in spectacular pictures.

EXPOSURE FOR VARIABLE LIGHT

Areas of bright highlight with clear detail immediately stand out in a landscape picture, and appear visually stronger in the frame. In order to record an accurate impression, you may need to override the light meter and expose for the highlight to keep the shot from being dominated by the shadow areas.

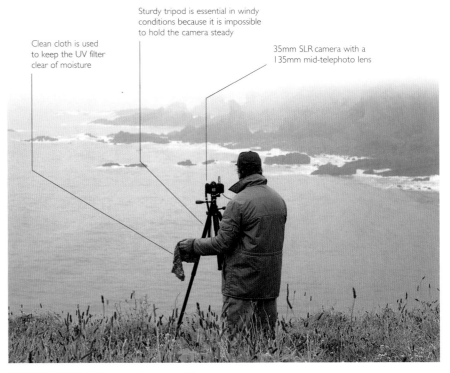

Sturdy tripod is essential in windy conditions because it is impossible to hold the camera steady

Clean cloth is used to keep the UV filter clear of moisture

35mm SLR camera with a 135mm mid-telephoto lens

PHOTO SET-UP: Wet weather conditions
Although it is not raining, the air is saturated with sea mist and spray at this location overlooking steep cliffs. A clear ultraviolet filter (also known as a UV filter) is used to protect the lens, which must be wiped with a soft, clean cloth to keep the glass completely clear of moisture. The UV filter has no effect on exposure.

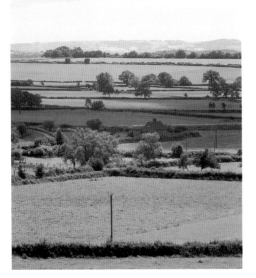

Moving shadows, *above*
Gaps between the clouds produce shafts of light, so every minute different parts of the landscape are illuminated. Here, everything is lit except for the house in the center of the shot.

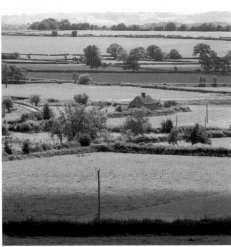

Foreground in shadow, *above*
A few seconds later, and the house and country road are now well illuminated. However, the foreground is now in deep shadow, creating a dark band across the shot.

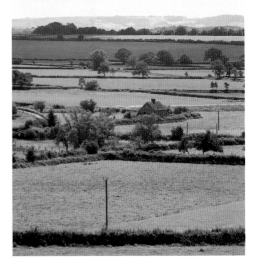

The final shot, *above*
The most successful of the three landscape pictures shows a band of shadow in the distance. However, the house, foreground, and the hills on the horizon are well lit.

Worsening weather, *right*
Shot with a 135mm lens, this seascape shows the outline of the rocks quite clearly. A few minutes later and the mood of the scene changes completely.

The mist descends, *below*
The worsening weather conditions have led to a drop in light levels and a shift in color temperature, producing a more atmospheric blue tinge on the daylight-balanced slide film. This is shot with the same camera set-up and 135mm lens.

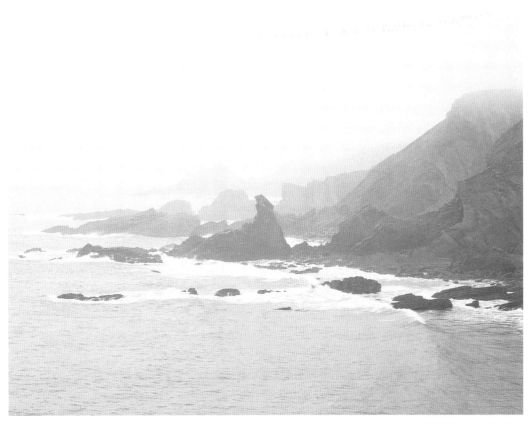

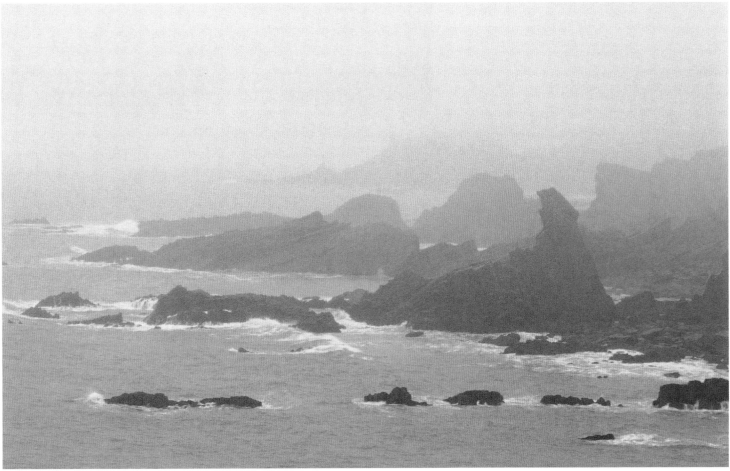

BLACK AND WHITE VERSUS COLOR

If you try to take landscape shots using black and white film in the same way you would use color film, the resulting photographs are likely to be disappointing. Often, it is the color content of a landscape scene that creates an exciting picture – the bright yellow of a cornfield, the myriad shades of green in a forest panorama, the autumnal reds and golds of a woodland carpeted with fallen leaves.

SIMPLIFIED TONES

In black and white photographs, however, it is the contrast of light and shade and the tonal gradations of white through black that dominate the picture. What might appear distinct and obvious in color often becomes more ambiguous once the color content is removed, resulting in a more subtle picture open to a different interpretation.

PHOTO SET-UP: Black and white landscape

The photographs shown on this page illustrate the difference between a landscape scene shot in color and one shot in black and white. These images were shot within a few minutes of one another from the same camera position. A tripod is useful to maintain the same framing of shots while cameras loaded with black and white and color film are switched.

Color versus pattern
The most striking feature of the color version of the landscape (*left*) is the colorful russet hues of the rust on the old barn's roof and sides. In the black and white version (*below*) that same area of the picture is dominated by strong pattern and texture. The graphic effect of the black and white landscape is emphasized by the directional early evening sunlight.

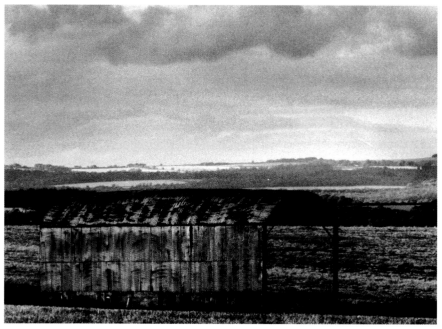

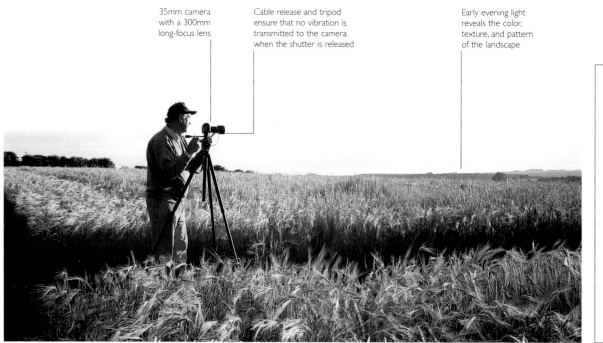

35mm camera with a 300mm long-focus lens

Cable release and tripod ensure that no vibration is transmitted to the camera when the shutter is released

Early evening light reveals the color, texture, and pattern of the landscape

DIGITAL SOLUTIONS

Many digital cameras can record the invisible infra-red parts of the spectrum, giving similar ghostly images as when using black and white infra-red film. To harness this ability, use a deep red filter (such as a Wratten 89B). This blocks nearly all visible light, so long shutter speeds and a tripod are necessary. Shoot using the camera's black and white mode.

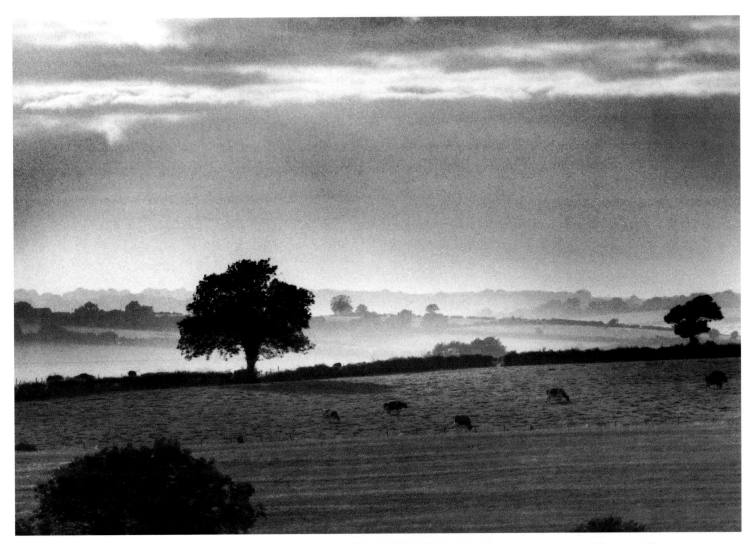

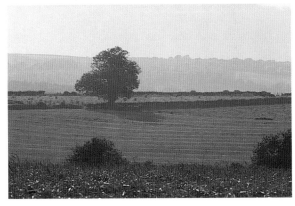

Color versus shape
Comparing these landscape pictures, it is the bold shape of the semi-silhouetted tree that dominates the black and white version (*top*). In the color picture (*above*) it is the foreground stubble and plowed field that attract immediate attention.

Infra-red film, *right*
Objects appear to have different colors because they absorb and reflect different wavelengths of light. Infra-red sensitive film can capture light that is invisible to the eye, transforming images into unfamiliar tones and shades.

Unreal effect, *top*
Black and white infra-red film gives
almost unreal tonal appearances.
6 x 6cm camera, 80mm lens,
Kodak IR, f8, 1/125 sec.

Tonal range, *above*
Delicate shades of white through gray
make up this tranquil scene.
6 x 6cm camera, 50mm lens,
Pan F, f11, 1/60 sec.

Storm light, *right*
Low clouds, failing light, and falling
rain might restrict some scenes
taken on color film to just a few
indistinct hues. The same scene
photographed on black and
white film reveals a wide range
of tones from deep black to
nearly pure white.
6 x 6cm camera, 80mm lens,
Plus-X, f16, 1/60 sec.

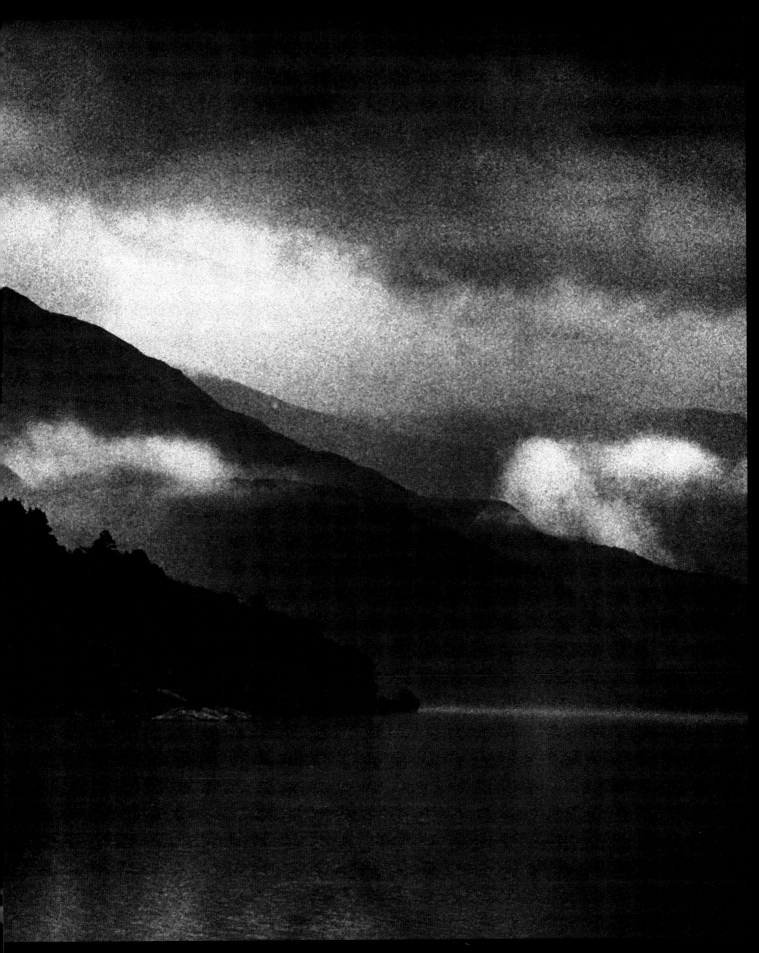

RECORDING THE CHANGING SEASONS

It is in the temperate regions that seasonal variations in the weather are most distinct. In tropical regions the sun stays high above the horizon and seasonal changes are between wet and dry rather than hot and cold.

THE CHANGING LANDSCAPE

The photographic potential of a landscape can be transformed by seasonal changes in light and weather. In temperate regions, the sun stays low in winter and high in summer, which affects the quality of light. It is best to shoot summer landscapes when the sun is low in the sky, which restricts photography to mornings and afternoons. Remember that latitude affects the color of the sky, so that it appears a deeper blue at high latitudes.

PHOTO SET-UP: Woodland scene

A woodland clearing is the setting for this early summer scene. A wide-angle shift lens (see page 192) is used to avoid distorting perspective by tilting the camera upward.

Winter landscape
A snow-covered hedgerow and icy country lane have produced a wintry scene of monochromatic simplicity. Snow scenes often need slight overexposure to keep the whites free from any appearance of dirtiness.

Early summer
The light filtering through the tree canopy makes exposure difficult, and overexposure by just one f-stop could rob the scene of its color and density of shadow. The scene is shot using several shutter speeds to avoid any miscalculation of the exposure.

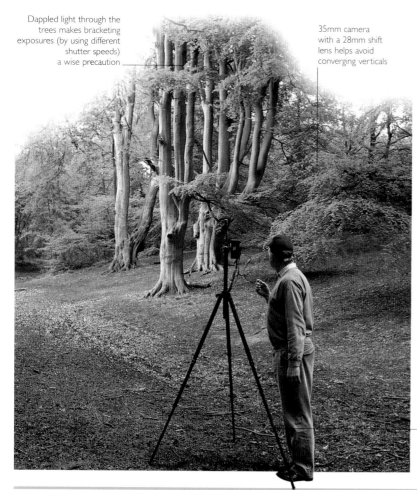

Dappled light through the trees makes bracketing exposures (by using different shutter speeds) a wise precaution

35mm camera with a 28mm shift lens helps avoid converging verticals

Cable release and tripod are essential to avoid camera shake when using slow shutter speeds

Spring landscape, *left*
Wild forest flowers such as these bluebells are one of the harbingers of spring. By keeping the camera angle low, just enough of the trees can be seen to give the picture context. Lighting is even across the scene because the tree canopy is not yet fully grown. Note that the color is more saturated in the shaded foreground.

Summer landscape
Viewed against the yellow field, the old tree appears almost silhouetted. The fully saturated green at the bottom of the frame and the intense blue sky above epitomize summer colors.

Fall landscape
With no foliage to obscure its path to the ground, a fall sun infuses this leafy carpet with a fiery bronze.

PHOTOGRAPHING WATER AND LIGHT

Light reflected from a lake, river, or pond can enhance an otherwise uninteresting landscape scene. An expanse of water in itself often makes an obvious focal point around which to build your landscape composition.

It is also important that you view the scene from different angles and heights. Seen from one particular angle, an area of water may appear emerald green as it reflects light from foliage on nearby hillsides. When viewed from a different angle, the surface of the water may sparkle with bright blue highlights as it mirrors the sky directly above it.

When light strikes the water's surface, the intensity of the reflection provides extra illumination, radically altering the exposure. To record reflected light in water you will probably have to take exposure readings for both the highlight and the shadow and select an aperture somewhere in between.

PHOTO SET-UP: Calm water reflections

Looking across this landscaped pond it is obvious that the brightest highlight in the frame is the reflection of the distant trees, vegetation, and blue sky on the water's calm surface. The lighting is bright and even, coming from a mid-afternoon sky unobscured by clouds.

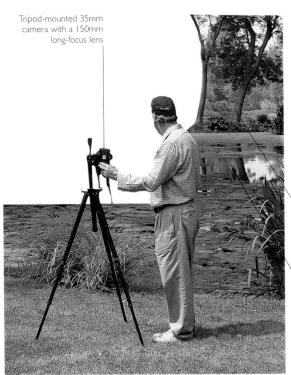

Tripod-mounted 35mm camera with a 150mm long-focus lens

Distant trees are the principal subject of the photograph

Reflections of the trees and the bright sky appear on the water's surface

Long-focus lens view
In this close-up of the far bank, shot with a long-focus lens, the backlit foliage has taken on a delicate translucency, while light reflecting off the water's surface looks like a sheet of shimmering silver. The strong afternoon light filters through the trees to create a calm, tranquil image.

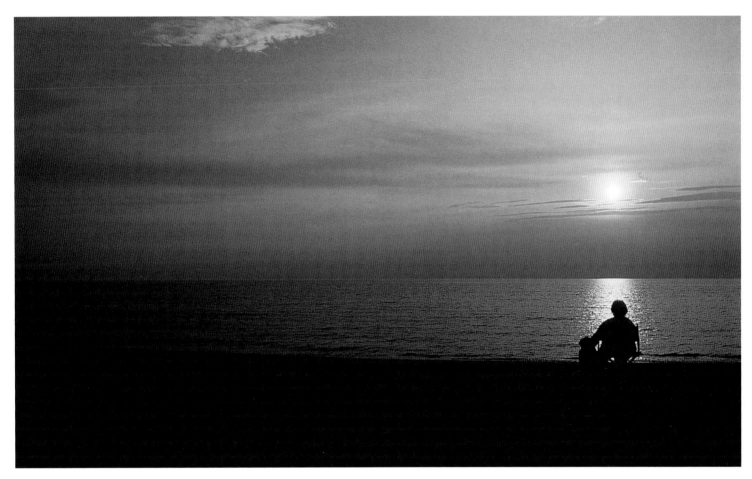

PHOTO SET-UP: Sunset reflections

Spectacular reflections can be seen looking across a seascape at sunset. A range of different color effects is possible depending on the exposure selected, the most intense resulting from a highlight exposure reading.

Hand-held 35mm camera
with 28–70mm zoom lens

Subject is rendered as a silhouette due to highlight exposure reading

Setting sun on the horizon casts a bright reflection on the water

Sunset silhouette

By selecting a low camera angle, the seated figure is aligned with the finger of reflected light. A higher camera position would lessen the graphic impact.

COLOR-ENHANCING FILTERS

Filters can be used to improve colors or eliminate unwanted reflections. Polarizing filters remove reflections from water surfaces and intensify blue skies. For a warm effect, use a light red skylight filter. A light blue filter, in contrast, cools colors down.

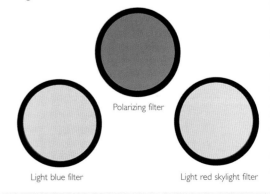

Polarizing filter

Light blue filter

Light red skylight filter

CREATING IMAGES OF MOVING WATER

Landscape scenes with moving water have a special charm for photographers. A small area of fast-moving water in an otherwise placid landscape scene introduces a strong contrast – white against blue, turbulence against smoothness and mirrorlike calm. Moving water in a landscape scene allows you to experiment with a variety of shutter speed effects. A rapidly moving mountain stream shot in close-up needs a shutter speed of at least 1/500 or 1/1000 second to capture its motion. If you shoot it at 1/15 second, or even slower, film speed and light levels permitting, you will find that the moving water takes on an entirely different character.

PHOTO SET-UP: Water movement

Even very minor changes in camera position can create very different photographs of the same subject. Compare, for example, the appearance of the sea spray in this set-up picture with the version opposite, in which a lower viewpoint is taken. Careful selection of exposure and a fast shutter speed are needed to capture and highlight the way in which the light dances on the breaking waves.

Frozen movement
A fast shutter speed of about 1/500 second is used to freeze the movement of water over the stony bed of this fast-flowing stream. A shutter speed this brief often requires the use of fast film and a wide maximum aperture.

Blurred movement
A slower shutter speed results in the water appearing soft and blurred. This picture of the stream was shot at 1/4 second. Use a tripod (which keeps the camera steady) and a small aperture to compensate for this length of exposure time.

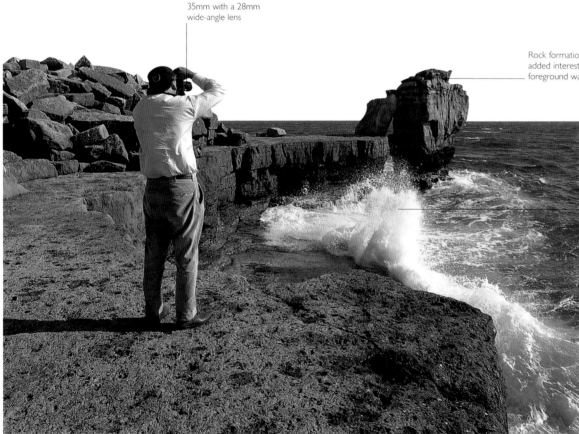

35mm with a 28mm wide-angle lens

Rock formation gives added interest to the foreground water

Brief shutter speed effectively stops the movement of the spray and allows a hand-held exposure

Low viewpoint, *opposite*
A low viewpoint is selected for maximum impact. The inclusion of the shoreline in the foreground, around which the water is boiling, and the menacing rock in the distance add drama to the breaking waves.

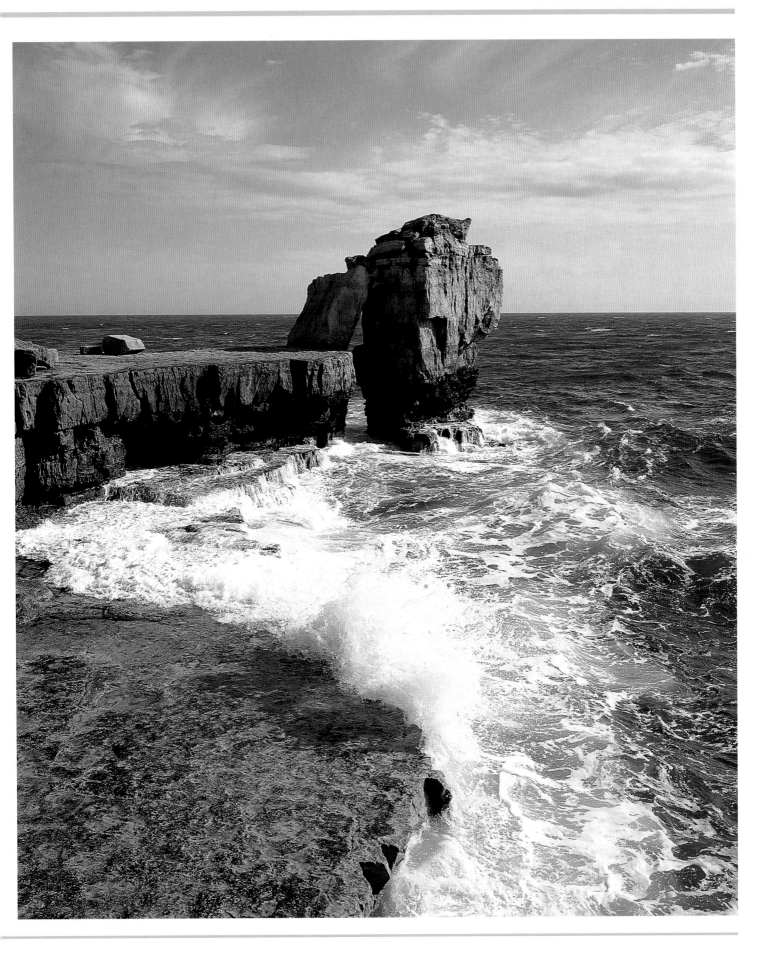

PHOTOGRAPHING SEASCAPES

Capturing the sea and its many moods is a constant challenge to the photographer. The extreme variations in appearance associated with the sea are due to the fact that the water not only mirrors the changing moods of the weather, but also magnifies them many times over. Coastal conditions can be very different from the weather just a few miles inland, so it is advisable to check on local conditions by telephoning the local coastguard beforehand.

When photographing coastal scenes, time of day is important, since this may dictate the state of the tide, which affects the appearance and accessiblity of the coast you want to photograph. Remember to protect your camera against damage from salt water and sand by cleaning it with a dry cloth after use.

PHOTO SET-UP: Moods of the sea
The inclusion of a prominent coastal feature adds interest to what would otherwise be a picture of just the sea and sky. In this photo set-up a majestic arch of limestone rock makes a perfect backdrop for the breaking waves.

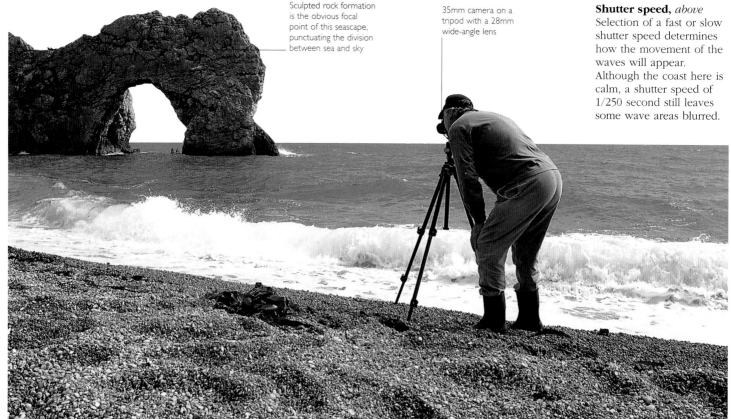

Sculpted rock formation is the obvious focal point of this seascape, punctuating the division between sea and sky

35mm camera on a tripod with a 28mm wide-angle lens

Shutter speed, *above*
Selection of a fast or slow shutter speed determines how the movement of the waves will appear. Although the coast here is calm, a shutter speed of 1/250 second still leaves some wave areas blurred.

SPECIAL-EFFECT FILTERS

Polarizing, gradated, neutral density, and light-balancing filters are intended to cut down reflections and correct variations in lighting without changing the overall color. There are also filters that produce strong color-casts for dramatic effect. Red, yellow, and orange are the most popular filters for use with black and white film. These filters can darken a blue sky to emphasize the white of the clouds. Color filters can also be used with color film to enliven an otherwise uninteresting landscape. Remember that all filters absorb some light, so you must allow for a longer exposure time.

Filter effects
Strongly colored filters are designed for special effects and can radically alter our perception of a scene. The deep blue filter used with this seascape produces the most normal-looking image and the orange filter results in the most dramatic image.

COLOR FILTERS

Color filters are available in a range of hues and strengths for creating special effects with color film. All filters subtract some of the light that strikes the glass, making slower shutter speeds and/or wider apertures necessary to achieve a correct exposure as the filter color becomes darker. The more the image is underexposed, the stronger the color.

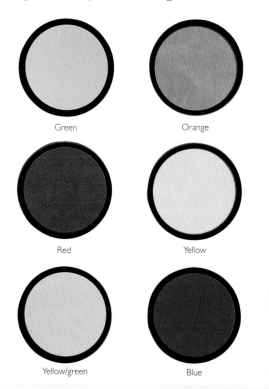

Green

Orange

Red

Yellow

Yellow/green

Blue

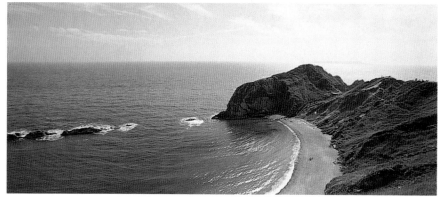

Seascape without filter

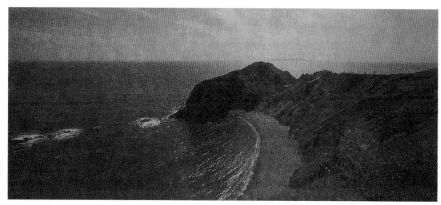

Seascape with orange filter

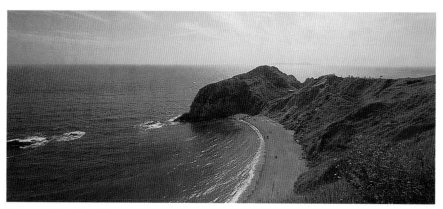

Seascape with yellow filter

Seascape with blue filter

CAPTURING DRAMATIC SKIES

The sky, which may be an important element in a landscape photograph, can also make a fascinating pictorial subject in its own right. Not only does the sky have an almost endless capacity for color change – from the deepest blues to vibrant gold and crimson – but the variety of cloud formations visible from one location in the course of a single day may be breathtakingly wide, especially when the weather is changeable.

SUN AND CLOUD EFFECTS

The most dramatic photographic opportunities are when the sun illuminates banks of clouds at an angle or when small, billowing clouds are partially obscuring the sun. Dawn and sunset are the times of day when the colors of the sky are at their most variable and dramatic, and usually most photogenic.

PHOTO SET-UP: Sky at sunset

In order to photograph the sky at sunset, set up your camera on a tripod in advance and wait for the sun to dip below the horizon. Shooting the sun itself may create flare spots so it is better to wait until the sun is partly obscured by clouds. The exposure reading is taken for the brightest part of the sky so that the landscape appears black.

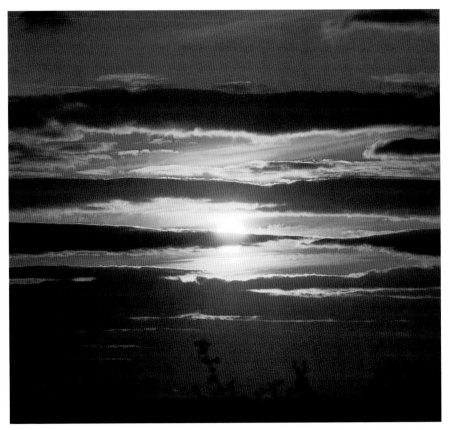

Close-up view, *above*
The limited angle of view of a long-focus lens fills the frame with the intense yellow of this particular stage of the sunset.

Sky and land, *right*
Vertical framing emphasizes the contrast between the vivid sunset colors and the black of the landscape.

Sun is just above the horizon and largely obscured by clouds

35mm camera with a 200mm long-focus lens

Tripod is always necessary when using a long, heavy lens, even if the exposure time is brief

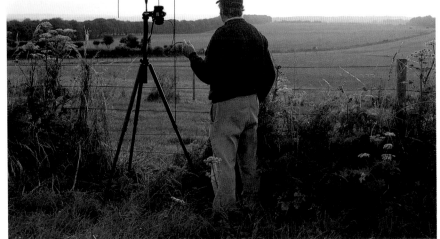

Obscured sun, *left*
When the sun is obscured
by clouds, those closest to
the camera position appear
dark and menacing, while
dramatic shafts of light
penetrate the gaps beyond
and illuminate the peaks
of the clouds farther away.

Stormy sky, *above*
In this picture, high banks
of thunderous cumulus
clouds are gathering over
the hills flanking a city,
signalling the onset of a
rainstorm. Storm cloud
formations can change
from second to second.

PROFESSIONAL TIPS

● Keep the horizon low in the frame to give the sky
greater compositional weight.

● To accentuate the colors of a sunset sky, take a
light reading from the brightest part of the sky.

● When using a digital camera, do not use automatic
white balance, as this may try to neutralize the colors.
Instead, use the manual setting for cloudy conditions,
which will boost the warm glow of the sunset.

Scale and interest
A dramatic sunset scene illustrates just how effectively water or, in this case, wet sand, mirrors and reflects the colors of the sky. Note, too, how the lone figure walking on the beach adds an important element of scale and interest to the composition.
6 x 6cm camera, 80mm lens, Ektachrome 100, f11, 1/125 sec.

Wide-angle view, *below left*
Dramatic clumps of cumulus clouds, with cirrus formations above, transform this sunset sky into a poem of shape, form, texture, and color. A wide-angle lens gives a sense of depth and perspective to the photograph.
35mm camera, 19mm lens, Ektachrome 100, f8, 1/125 sec.

Hidden light, *below right*
Timing is critical when there are banks of moving clouds and the sun itself is in the shot. From the angle that this picture was taken, the cloud shields the camera from the intensity of the sun.
35mm camera, 135mm lens, Kodachrome 200, f16, 1/1000 sec.

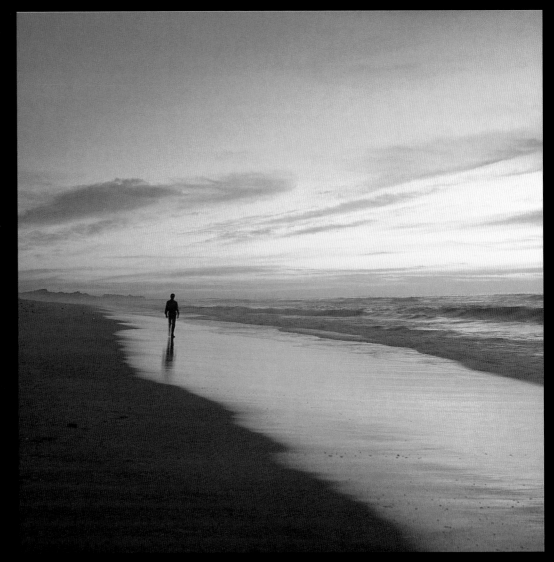

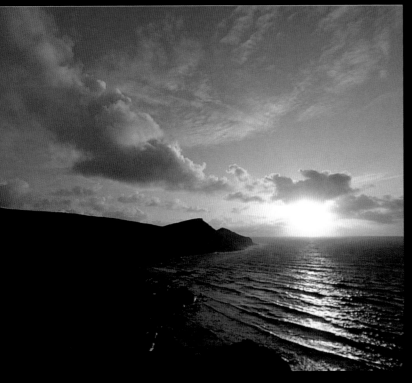

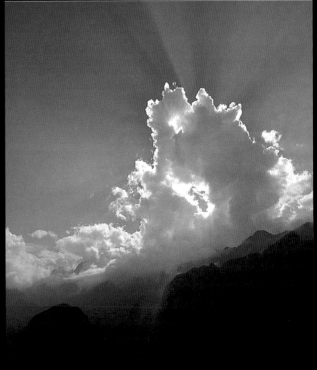

Silhouette lighting

For this spectacular view of
St. Michael's Mount in Cornwall,
England, a light reading was first
taken from the brightest part of the
sky. The camera was then redirected
and the scene photographed. The
result is a stark silhouette
dominating the horizon.
*6 x 6cm camera, 50mm lens,
Ektachrome 100, f8, 1/125 sec.*

Rainbow hues

Rainbows occur when droplets of
moisture refract the sun's rays and
split them into their constituent
wavelengths. To intensify the
strength of a rainbow's colors, this
shot is underexposed by between
a half and one full f-stop.
*6 x 7cm camera, 80mm lens,
Ektachrome 100, f22, 1/125 sec.*

PHOTOGRAPHING URBAN LANDSCAPES

One of the most visually rich photographic resources we have readily at hand is the city. City centers, dominated by towering glass and steel structures, can be a fascinating mix of architectural statements, especially when contrasted with more traditional building styles, or when seen in the context of urban areas awaiting renewal. Watch for repeating patterns, dramatic shapes, contrasts of natural and artificial features, the use of color, even the written word on billboards, the sides of delivery vans, and neon signs.

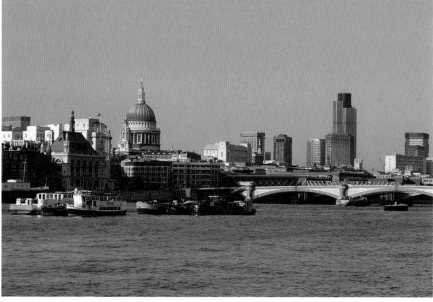

Brand color bias
The early evening summer light casts shadows over waterfront buildings in dramatic contrast to the lit area behind. Color can vary depending on the film brand used (*see page 31*). For example, these two images were both taken from the camera position shown in the photo set-up under identical lighting conditions. Whereas one picture (*above*) has a strong green cast and is lighter, the other picture (*left*) has a blue cast and is much darker.

PHOTO SET-UP: London Embankment
A personal view of urban life could include landmarks that typify a city for you. The location for this picture set-up is the Embankment beside the River Thames in London, and the view takes in St. Paul's Cathedral.

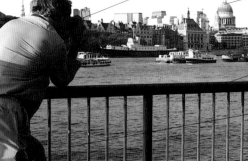

Hand-held 35mm camera fitted with a 70–210mm zoom lens

Choose a city landmark as the focal point of the picture

Railings make a convenient place to lean against to steady the camera

Early evening light casts strong shadows on the water's surface

PROFESSIONAL TIPS

• Choose a camera position that will give a good overall view of the city.

• Contrast between old and new buildings may make an interesting subject for photographs.

• Use a tripod and a long exposure to record subject detail at dusk.

Time of day

Cityscapes change radically when viewed at different times of day. In this shot, taken just after dusk, there is enough daylight to reveal details in the buildings and streets, yet there is also sufficient artificial light to add extra color and interest.

Dramatic sky, *below left*

Framing to give a low horizon imparts great emphasis to the sky in this cityscape. The storm-laden clouds are dramatic in themselves, but the composition is full of tension, as if the forces of nature are gathering to assault the city below.

Selected viewpoint, *below*

Finding a high viewpoint from which to shoot is an excellent way of showing tall buildings without the intrusion of converging verticals typical of ground-level shots. Here, the high viewpoint shows another aspect of urban topography – the contrast between recently built skyscrapers and lower, older buildings.

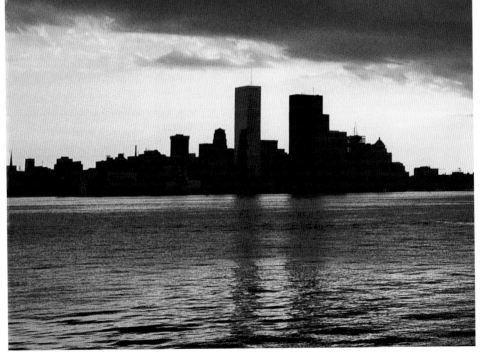

PHOTOGRAPHING LANDSCAPES AT NIGHT

As night draws near, a range of picture-taking opportunities opens up. One of the best times to shoot is at dusk. At this time there is still sufficient ambient light to define subject detail and add color to the sky, but street lamps and car lights start to become visible. These factors combine to make great lowlight photographs.

EXPERIMENTING WITH EXPOSURE

As the sky becomes darker, exposure times increase dramatically, but with a tripod or some other form of camera-steadying device this should not present a problem. Bracketing shots by experimenting with several different exposures is essential for night photography. Make a note of your exposure times and compare these with your processed results. If you do this regularly you will soon start to build up an instinct for nighttime exposures under a range of different lighting conditions.

The structure of the bridge is well defined with lights

35mm camera with a 135mm long-focus lens

PHOTO SET-UP:
Luminescent bridge
The long shutter speeds mean a tripod is necessary – the high contrast scene makes accurate metering difficult, so a bracketed sequence with exposures of two, four and eight seconds was taken. Note how the water reflects the lights along the bridge and riverside.

The tripod is essential to prevent camera shake

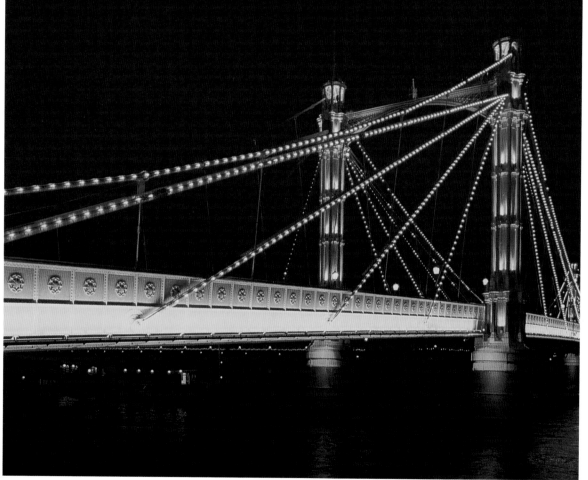

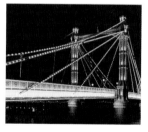

Colored filters
These three pictures were all taken from the position shown in the set-up picture. Different colored filters were used for dramatic effect. For the first picture of the illuminated bridge no lens filter was used (*top*). The color is not entirely natural, however, because of the effect of the tungsten lights on the daylight film. For the subsequent images, yellow (*above*) and orange filters (*left*) were used.

MOVING LIGHTS AT NIGHT

Some of the most impressive nightscapes are produced when you include moving lights in the frame. A long exposure turns cars into streaks of red and white, created by their taillights and headlights. These trails add a sense of movement and added interest to a city scene after dark. Set up your camera on a tripod at the side of the road or on a high vantage point overlooking the roadway. The length of the streaks of light is determined by the length of the exposure – for the best results, shutter speeds of around 30 seconds or more are usually necessary.

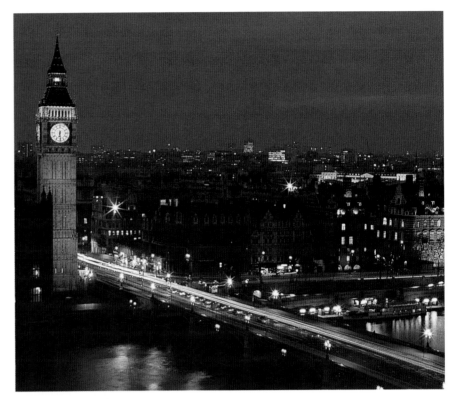

> ### DIGITAL SOLUTION
>
> Experiment with the different manual white balance settings to see which works best with the mixture of light sources available.

Light of the moon, *below*
A full moon is surprisingly bright, creating a high-contrast scene when included in a nightscape. Here, the moon was allowed to burn out, to ensure that the lights of the city in the foreground were exposed properly.

Overview, *above*
A high roof gives a great view of London's Big Ben. The long 40-second exposure, using the camera's B-setting, makes the view more colorful – turning cars crossing the bridge into streaks of red and white light.

Tunnel vision, *below*
The dashboard of a moving vehicle is used to support the camera for this shot taken inside a tunnel in New York. The tiles of the tunnel roof and walls reflect the red taillights of the cars creating an interesting abstract scene.

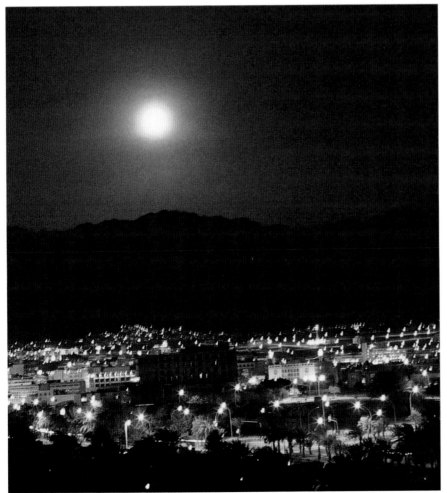

ARCHITECTURE

Architecture is a very broad subject area, encompassing both modern, state-of-the-art developments and traditional buildings; places of work and industry; religious centers; homes both suburban and stately; and bridges and dams, as well as interiors and decorative details.

Using a wide angle lens
See pages 188–189

Using a shift lens
See pages 192–193

Interiors
See pages 198–201

Interior details
See pages 202–205

Viewpoint and perspective

Some professional cameras allow the normal focusing screen to be removed and replaced by an architectural screen – a grid of parallel vertical and horizontal lines. This screen is used as a guide to ensure that your framing shows the subject square and perfectly upright.

Practical considerations

Outdoor architectural photography is largely dependent on available light. Take the time to see how the light reacts with the features you want to emphasize. Is the angle of the light from direct sun casting shadows over the detailing you want to see, or do you regard those same shadows as a positive asset in your picture, creating interesting patterns of light and shade? If the lighting is not right on one side of the building, then it may be better on the other, or you may have to come back at a different time of day. The sky is also a major consideration when photographing buildings. Dramatic pictures can result from cloudless or stormy skies, but overcast gray skies should be avoided if at all possible. Extreme weather conditions, such as mist or fog, will add a new dimension to your photographs.

Working in confined space

If space outside or inside a building is tight, then a wide-angle lens (and sometimes a shift, or perspective-control, lens) will be invaluable for including all of the subject in the frame. Often it will be a detail or an isolated feature of the building that catches your eye, and to record this a long-focus lens may be the answer. For lighting a small interior (or a small area of a large one), a hand-held flash unit may be useful, but you will also need to use fast film and long exposures that require a tripod or some other camera-steadying device.

ARCHITECTURE SET-UP

This newly built shopping mall is surrounded by tall metal railings, which make it problematic to photograph. The only way to achieve an unobstructed view of the building is to stand as close to the railings as possible and shoot over the top of them. From this angle it is not possible to include the whole of the building, so it had to be decided at the outset which part of the building to emphasize. It would also have been possible to shoot down from the pathway above, but from that angle views of the adjacent street would have been unavoidably included in the shot.

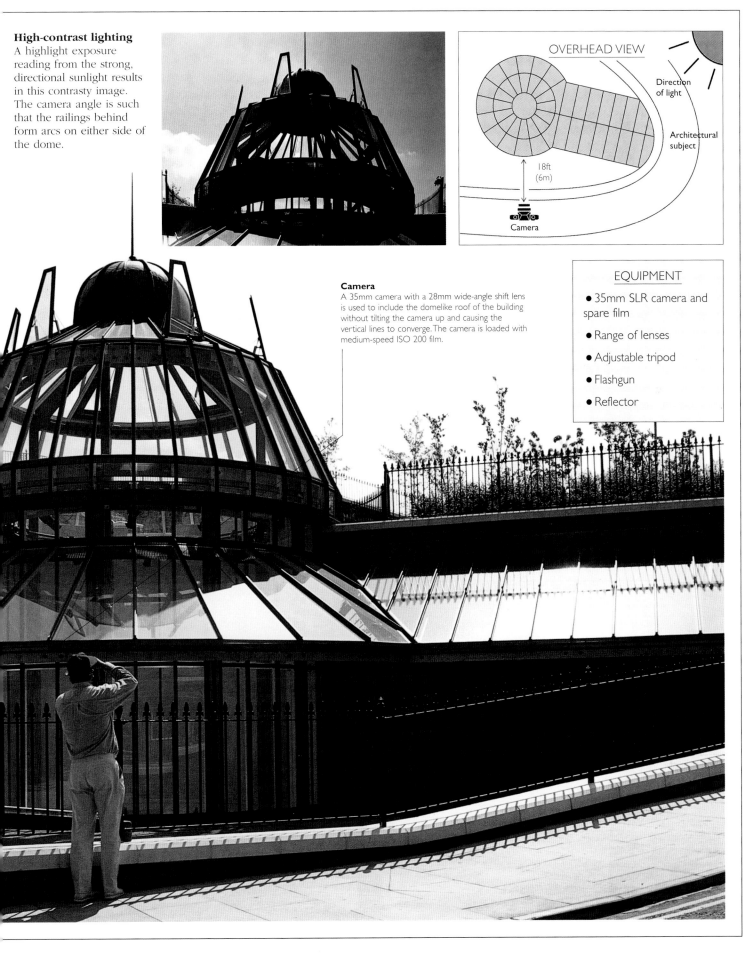

High-contrast lighting
A highlight exposure reading from the strong, directional sunlight results in this contrasty image. The camera angle is such that the railings behind form arcs on either side of the dome.

OVERHEAD VIEW

Direction of light

Architectural subject

18ft (6m)

Camera

Camera
A 35mm camera with a 28mm wide-angle shift lens is used to include the domelike roof of the building without tilting the camera up and causing the vertical lines to converge. The camera is loaded with medium-speed ISO 200 film.

EQUIPMENT

- 35mm SLR camera and spare film
- Range of lenses
- Adjustable tripod
- Flashgun
- Reflector

VIEWING A BUILDING

Most buildings, unless they are slab-sided and featureless towers, have countless different angles, faces, moods, and features to offer the camera. As you move around the building you are interested in photographing, keep a careful watch for architectural details both above and below your usual eyeline. Look for the flow or rhythm that the building projects and see how you might enhance these characteristics on film, or even suppress them for a more personal interpretation.

Look, too, at how the angle of light strikes the building, and decide when the optimum time of day is in terms of lighting for your photographs. Lenses of varying focal lengths, or different settings on a zoom, can influence the appearance of a building dramatically. Try viewing the subject through the camera with a series of different lenses attached before you start to take any pictures.

PHOTO SET-UP: Lloyds of London

A visually complex building such as the Lloyds Building in London provides innumerable photographic opportunities. The overall shape of the structure makes a powerful design statement and the geometric arrangement of steel pipes and girders is striking.

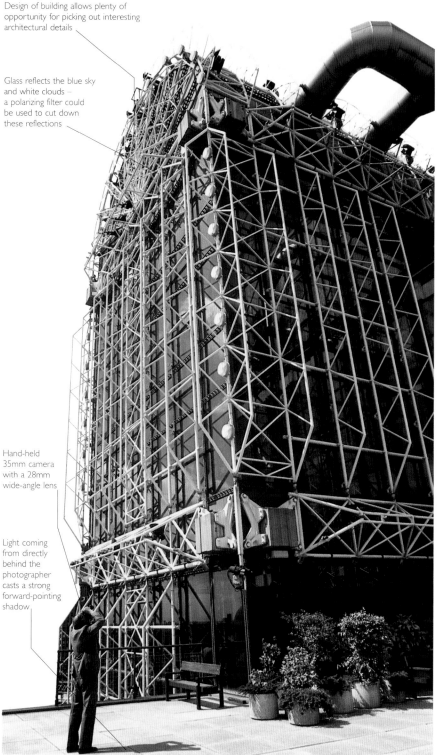

Design of building allows plenty of opportunity for picking out interesting architectural details

Glass reflects the blue sky and white clouds – a polarizing filter could be used to cut down these reflections

Hand-held 35mm camera with a 28mm wide-angle lens

Light coming from directly behind the photographer casts a strong forward-pointing shadow

Extreme viewpoint, *above*
The dizzying convergence of vertical lines is produced by an extreme camera angle, near ground level and shooting upward. This approach imparts a sense of exaggerated height.

Usual viewpoint, *left*
This picture is taken from slightly farther back than the position shown in the photo set-up. There is some convergence of the parallel lines, but the distortion effect is minimal.

Tilting the camera
An interpretative approach
has been achieved here by
photographing the building
from an unusual angle.
This effect is created by
tilting the camera at an
angle to the subject.

Abstract pattern
A striking way to portray
this modern building is to
emphasize the abstract
pattern produced by the
gleaming steel pipes.

Implied movement
The camera viewpoint in
this shot emphasizes the
vertical nature of the
architecture and introduces
movement in the frame.

USING A WIDE-ANGLE LENS

Wide-angle lenses are essential for many architectural subjects, simply because it is often impossible or impractical to move far enough back to use a longer lens. When outdoors, other structures usually restrict your vantage point, and when shooting interiors, walls present an insurmountable hurdle.

Moderate wide-angle lenses (with a focal length of around 28mm) allow you to tackle most exteriors. A lens with an even wider angle (16–20mm), however, is useful for shooting smaller rooms. Such ultra-wide lenses also seem to suit modern architecture well. Lenses in this focal length range produce a certain amount of distortion that can be inappropriate with some subjects, but suits the forms found in many modern landmarks. By framing the subject symmetrically, the bowed lines created by such lenses seem to become part of the design.

Handheld SLR, *above*
A wide-angle lens gives enough depth of field without using small apertures, so camera shake is minimized.

Barrel distortion, *left*
The extreme angle of view turns the straight paving stones into curved lines.

Elevated position, *above*
Shooting from halfway up
the structure gives a fairly
undistorted view of both
atrium floor and roof.

Leading the eye, *right*
Wide-angle lenses can be
used to create a strong
feeling of linear perspective.
Photographing this staircase
from the bottom step
creates strong, converging
diagonal lines.

Unusual angles, *opposite*
Many grand-scale interiors
look interesting if you look
upward at the ceiling. This
may mean lying down on
the floor, or resting the
camera on the ground as
impromptu support.

DIGITAL SOLUTIONS

● To achieve ultra-
wide focal lengths on
digital cameras with
built-in lenses, use a
wide-angle or semi-
fisheye attachment.

● Set the white balance
manually for interiors to
allow for a mixture of
light sources.

Searching for symmetry, *right*
One of the most successful techniques to use with all modern architecture is to search out the shapes and patterns used in the building – and then show these in isolation. This frequently produces powerful abstract studies.
Digital SLR, 11–22mm zoom lens, ISO 200, f8, 1/250 sec.

Adding curves, *right*
The use of an ultra-wide-angle lens does not always have to be apparent, but here the distortion has been used to contribute to the composition. The straight, rectangular barriers of the balcony have been transformed into a curved shape that echoes the curves seen in the roof.
Digital SLR, 11–22mm zoom lens, ISO 200, f8, 1/60 sec.

Sense of space, *far right*
In most pictures you avoid showing large, empty areas in the foreground. Here, the white floor tiles help to convey the feeling of space, light, and openness of this public building.
Digital SLR, 11–22mm zoom lens, ISO 200, f4, 1/60 sec.

The Forum, *above*
All the pictures in this gallery are taken of, or from, the same building in Norwich, England. It is such a fascinating, well-lit building that wherever you point your camera there is a picture. This view shows the entrance with the church framed in the windows.
Digital SLR, 11–22mm zoom lens, ISO 200, f8, 1/60sec.

Ancient and modern,
above right
It is sometimes possible to contrast different styles of architecture by photographing old buildings reflected in the mirror-like glass of new ones. Here a slightly different approach has been used. Using an ultra wide-angle lens, the entrance of the new building becomes a frame for the neighboring church.
Digital SLR, 11–22mm zoom lens, ISO 200, f8, 1/250 sec.

Surroundings, *right*
Avoid always showing buildings in isolation. Often the neighboring landscape and street scene are important to show their impact, as well as their context. By including The Forum small in the frame, it is possible to see how well this ultra-modern structure has been integrated into the historic city around it.
Digital SLR, 11–22mm zoom lens, ISO 200, f8, 1/250 sec.

USING A SHIFT LENS

The apparent convergence of vertical lines at the top of a picture frame is most noticeable when a camera is tilted up to include the top of a tall building. This is caused because the back of the camera, and the film plane, are no longer parallel with the subject. The base of the structure is closer to the film and seems larger; the top is farther away and appears smaller. This results in the sides of the building appearing to converge at the top. By moving back from the subject, you may be able to get all the building in without tilting the camera, but details might then look small. Using a shift lens is the solution to this problem.

PHOTO SET-UP: Perspective problems

This 17th-century customs house on a quayside in Kings Lynn, England, illustrates the problems of distorted perspective. If shot from close-up with a wide-angle lens, the building would appear to fall away and topple backward.

SHIFT LENS

A shift, or perspective control (PC), lens alters the appearance of vertical lines. By turning a knob on the lens you can make the front of the lens shift upward, downward, or sideways. So instead of tilting the camera to include the top of a building, simply shift the lens upward until the top of the building comes into view on the focusing screen. Shift lenses are costly, are only available for certain 35mm and digital SLRs, and usually have a fixed wide-angle focal length.

Before and after
These photographs taken with a shift lens (*left*) and without (*far left*) show how this lens corrects the appearance of converging vertical lines. A shift lens has greater covering power than a normal lens, allowing you to change the image without having to move the camera.

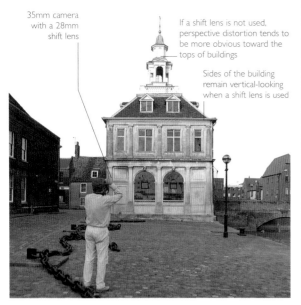

35mm camera with a 28mm shift lens

If a shift lens is not used, perspective distortion tends to be more obvious toward the tops of buildings

Sides of the building remain vertical-looking when a shift lens is used

Telephoto lens result, *left*
Distortion occurs if a shift lens is not used; compare the top of the building with the result of the set-up (*right*).

Shift lens result, *right*
The sides of the building now appear perfectly square. The shift control raised the front of the lens, which straightens vertical lines and corrects any perspective distortion.

PHOTOGRAPHING EXTERIOR DETAILS

The details on the outside of a building can sometimes tell you more about the building than the whole structure. An entire building, especially a large one, would appear so small in the frame that much of interest could be lost or overlooked. Another point to consider is that the lighting might be ideal for features such as a doorway, colonnade, or windows, but unsuitable for the building as a whole.

The focal length of the lens required for exterior details is dependent on the size of the feature to be photographed and how close you can get to it. For example, a gargoyle under the eaves of a cathedral roof may require a lens of at least 300mm for a reasonably sized image, while to include all of the main entrance of that same building, a 28mm wide-angle lens may well be needed. A typical standard zoom lens will provide a range of options.

PHOTO SET-UP: Architectural details
The subject of this set-up is the carved stonework of a church doorway and surround. A 28mm wide-angle shift lens is used to make sure there is no perspective distortion caused by converging vertical lines. The doorway is lit by diffused, directional daylight from a bright sky, but with no direct sunlight falling within the picture area.

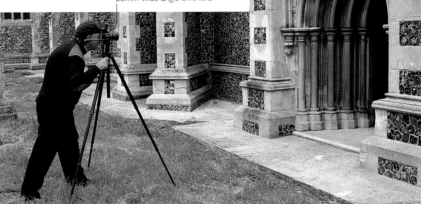

Doorway is lit by diffused daylight that emphasizes the texture of the stonework

35mm camera on a tripod with a 28mm wide-angle shift lens

Textural emphasis, *above*
The doorway in the set-up picture is lit by diffused daylight that helps bring out the texture of the stone. Bright, direct sunlight would result in dark shadows that would mask important detail.

Long lens details
Using a long telephoto lens allows you to record architectural details that you might easily miss with the naked eye, or with a general wide-angle shot.

Taken with a 250mm lens setting, the elaborate carving on the columns (*above left*) and the grotesque face of the gargoyle (*above*) fill the picture frame, and so can be studied in detail.

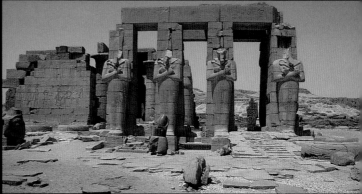

Introducing drama, *top*
An intense sun and low camera viewpoint highlight the walls of this Canadian granary, producing dramatic contrast against the deep shadows of the unlit surfaces.
35mm camera, 28mm lens, Ektachrome 64, f16, 1/125 sec.

Foreground addition, *left*
The space in front of this mosque in Istanbul is relieved by placing a figure in the foreground.
6 x 6cm camera, 50mm lens, Ektachrome 64, f11, 1/125sec.

Time of day, *above*
Photographs of ancient sites, such as this of the Ramesseum (the mortuary temple of Ramesses II on the west bank of the Nile at Luxor in Egypt) are often best taken at midday when the sun is overhead, creating strong contrast between highlights and shadows.
35mm camera, 35mm lens, Kodachrome 25, f22, 1/250 sec.

By moving in close to the base of this building and tilting the camera back, the towering glass edifice appears almost to be toppling over, as if giving up its struggle against gravity. The curved gridwork adds dynamic pattern to the composition.
35mm camera, 24mm lens, Ektachrome 200, f22, 1/60 sec.

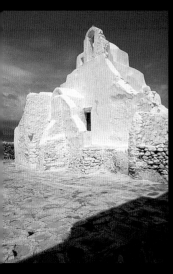

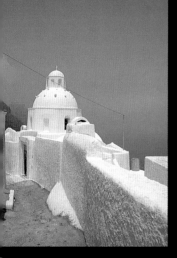

Polarizing filter, *top*
The impact of this stark, white building would have been diminished without the use of a polarizing filter, which darkens the blue of the slightly stormy sky.
35mm camera, 35mm lens, Ektachrome 200, f8, 1/250 sec.

Lead-in lines, *above*
A shadowy wall guides the eye toward the main subject of this scene, a church on a Greek island.
35mm camera, 50mm lens, Ektachrome 200, f16, 1/250sec.

Color content, *left*
Even when the architectural merits of a building are dubious, its color content may still make it an eyecatching subject for a photograph. In the drab surroundings of a Moroccan backstreet, the birthday-cake pink, green, and blue color scheme of this building has immediate impact.
35mm camera, 85mm lens, Ektachrome 100, f22, 1/60 sec.

PHOTOGRAPHING INTERIORS

Photographing the interiors of buildings has its limitations, primarily associated with working in a confined space and the quality and intensity of the lighting. Relying on natural light can result in strong contrasts, with beams of light entering through well-defined window areas and casting distant parts of the room into shadow. If this is not the effect you want to achieve, use a white cardboard reflector or mirror to bounce light into dark corners or supplement the light using an add-on flash unit.

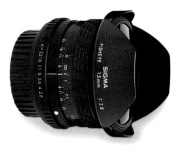

FISHEYE LENSES AND CONVERTERS

Fisheye lenses give an extreme wide-angle, but distorted, view of the world. Those that give a full-frame image typically have a focal length of around 15 or 16mm. Circular fisheyes, with a focal length of around 8mm, produce a round image in the center of the film area. The angle of view for both is around 180°. Fisheye converters, which produce similar effects, are made for digital cameras with built-in zooms.

USING A WIDE-ANGLE LENS

Unless you want shots of specific details that require the use of a long-focus lens, a 28mm or 35mm wide-angle lens is best for limited spaces if your aim is to include as much of the room as possible in the shot. You will still need to select the most appropriate angle and rearrange furniture if it is a vital element.

PHOTO SET-UP: Using a fisheye lens
Photographing this old-fashioned kitchen would be difficult without an extreme wide-angle lens. A 15mm fisheye lens fits in as much of the room as possible. This results in extreme distortion – most noticeable at the front of the frame. The front-to-back distance is also very exaggerated.

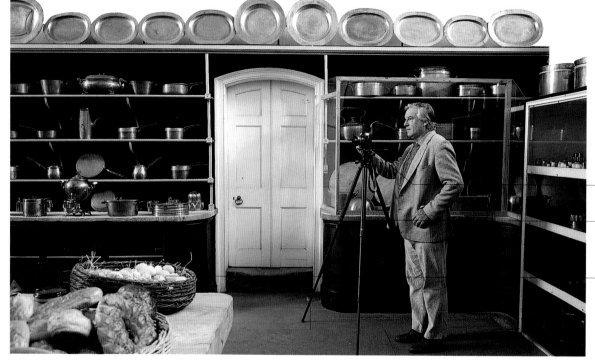

Extreme views, *above*
The bowing of all vertical lines positioned near the frame edges evident in this picture is typical of images taken with extreme wide-angle lenses. Depth of field at every aperture is so great with a 15mm fisheye lens that there is virtually no need to focus.

35mm camera with a 15mm fisheye lens

Tripod is required to hold camera steady during long exposure of two seconds

Objects are positioned at the front of the frame to emphasize the distortion effect of this extreme wide-angle lens

PHOTO SET-UP: Additional flash lighting

The living room of architect Richard Rogers' ultra-modern home is used as a portrait setting in this picture set-up. An interior containing a figure requires an even, balanced lighting scheme to light the surroundings as well as the subject. This means you will nearly always have to use additional flash lighting to supplement available light.

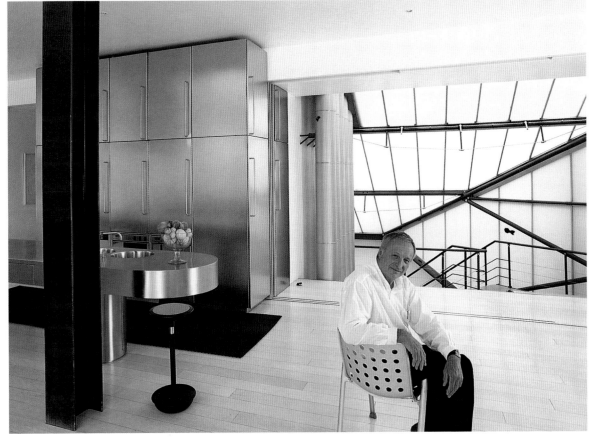

6 x 7cm camera with a standard 80mm lens is positioned on a high tripod

Two lighting units bounce soft, indirect frontlighting onto the seated figure

Single lighting unit close to the subject is used to bounce sidelighting off a light-colored canvas

Standing figure, *above*
By positioning the subject away from the skylight, the potential lighting problems are at once lessened. The flash lights become more important, but there is now no need to balance them with the natural light.

Seated figure, *left*
Positioning the subject off-center is a useful device when both the figure and the interior are important. The figure is backlit by natural light and the flash is just used as a fill-in.

WORKING IN LARGE INTERIORS

Working inside a large interior usually means being selective about what you include in the picture and what you leave out. If you cannot accommodate everything in the frame even by using your widest lens, then look for the angle that shows the most revealing or impressive aspects of the particular location.

Often you will find that the best camera position is directly in front of the windows, with the camera looking into the interior. In this way the light will be behind you and the interior features will be lit from the front or side. If there are windows in both flanking walls, then a more central camera position may result in the most flexible lighting.

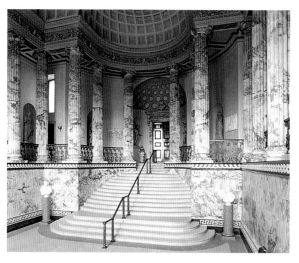

High viewpoint
This shot of the entrance hall is taken from a higher angle than the photo set-up. Taken from a standard viewpoint, the ceiling is excluded from the picture.

Low viewpoint, *below*
This dramatic picture results from the low camera angle in the set-up photo. The pillars appear to converge, directing the viewer's gaze to the ceiling. The staircase seems far steeper from this position and the foreground area has been minimized.

PHOTO SET-UP: Camera viewpoint
The marble hall of this stately home, with a grand staircase leading up past ornamental pillars to a galleried landing, is best viewed from the center of the ground floor to take full advantage of the daylight entering through the windows in the side walls above and behind the camera.

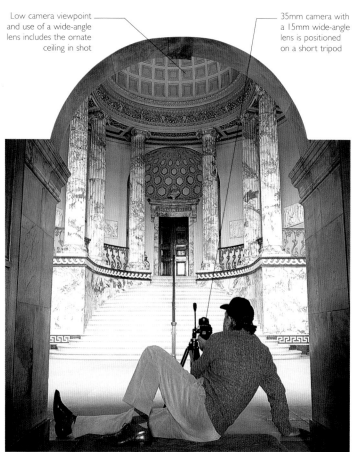

Low camera viewpoint and use of a wide-angle lens includes the ornate ceiling in shot

35mm camera with a 15mm wide-angle lens is positioned on a short tripod

FLASH TECHNIQUES

A single burst of light from a hand-held flash unit does not make much of a difference in terms of lighting a large interior, especially one with a high ceiling like the church shown in this photo set-up. Rather than firing the flash just once, try setting the camera's shutter to T (time), then press the cable release to lock it open and fire the flash manually as many times as you think you need for a correct exposure. A tripod is essential if you use this technique during an exposure of many seconds. You may need the help of an assistant to shield the lens while you move between flash positions.

PHOTO SET-UP: Painting with light

To light the high ceiling in this church, a flash unit is fired from a variety of positions around the interior to direct the light at different parts of the roof.

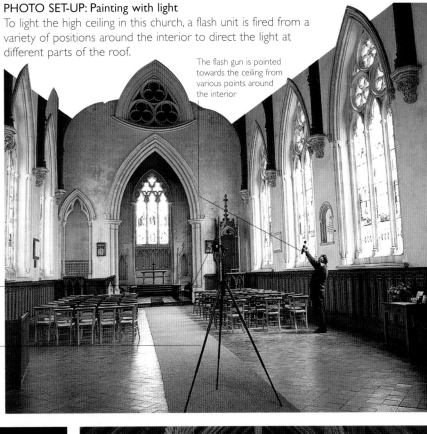

The flash gun is pointed towards the ceiling from various points around the interior

Camera shutter is held open throughout the exposure using a locking cable release

35mm camera on a tripod with a 28mm shift lens

With and without flash

The first picture (*below*) was taken without flash. An exposure of six seconds gives detail where the light falls, but the roof area is lost in shadow. For the next shot (*below right*), the shutter was held open while a hand-held flash was fired at different parts of the roof.

LIGHTING SIMPLE INTERIORS

Simple interiors can make fascinating subjects for the camera. Whereas large public buildings are designed to project an impersonal public image, people's homes are full of private, intimate touches that can reveal much about those who live there.

NATURAL LIGHTING

When shooting an interior you must decide whether to rely on natural daylight from windows, doors, or skylights, or to use artificial lighting such as flash or tungsten lights. The color temperature of daylight and flash are the same, so color-casts are not a problem on ordinary, daylight-balanced film. Do not, however, turn on any of the room lights unless you want an orange cast.

PHOTO SET-UP: Directional daylight

This kitchen is lit solely by light entering through the large windows on the right. Contrast could have been a problem were it not for the white walls, which reflect light and so keep the shadows from becoming too dense.

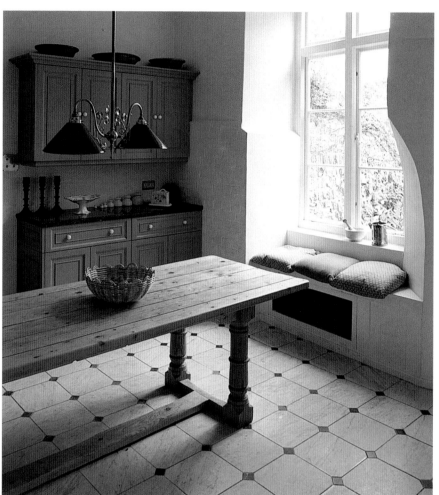

35mm camera with a 28mm wide-angle lens is positioned on a tripod in one corner of the room

Directional daylight from the windows is the only source of illumination

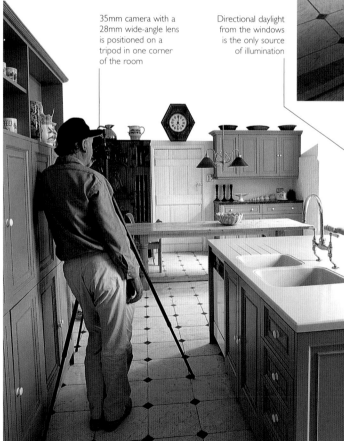

Country kitchen, *above*
This shot is composed in the camera viewfinder to exclude unwanted details. The high camera position looks over the top of the sink unit and the framing is tight in on the cabinets to avoid the edge of the door frame appearing in the shot.

Church interior, *left*
Directional daylight from windows on the left of the frame is the chief illumination for this simple church interior. Natural daylight casts shadows into the central aisle, adding to the mood and atmosphere of the tranquil scene.

Lit by flash
Note how evenly the scene is illuminated using fill-in flash. However, in this flash version some of the mood has been lost and the absence of shadows removes the sense of depth.

DIGITAL SOLUTIONS

• Set the white balance manually, particularly if the room is lit by a mixture of lighting sources.

• Look at the image on the screen to make sure that there are no extraneous details.

• Minor marks on walls, etc., can be removed later using cloning techniques.

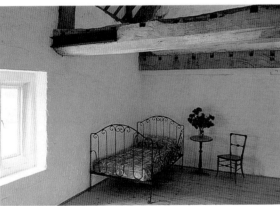

Lit by daylight
This picture is taken in natural daylight without using flash. In comparison with the shot taken using flash (*top*), the scene looks more natural and has an intimate atmosphere.

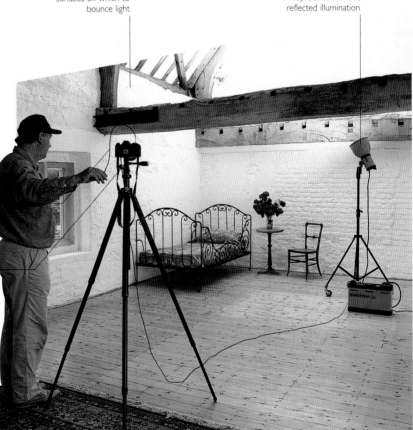

White-painted wall and ceiling make ideal surfaces off which to bounce light

Flash lighting head is angled upward to produce indirect, reflected illumination

Cable release

35mm camera with a 28mm wide-angle lens is positioned on a high tripod

PHOTO SET-UP: Supplementing light
Although supplementary flash can be used to light an interior when daylight is not sufficient, the effect of even lighting is difficult to achieve and can ruin the atmosphere of a room. To illuminate this entire bedroom with flash would require a minimum of three lighting units. One flash unit is used here to light a corner of the room.

PHOTOGRAPHING INTERIOR DETAILS

Stairwells, windows, and doorways are just some of the interior details that often make a far more revealing and interesting subject for a photograph than the setting as a whole.

DETAILS IN PUBLIC BUILDINGS

If you are shooting in a large public building, such as a church, museum, or stately home, you may need a long-focus lens to enlarge the detail in the frame. In addition, camera angles may be restricted; a 70–210mm zoom allows you the flexibility to adjust the size of the subject in the frame without changing position. However, zoom lenses have small maximum apertures, limiting their use in poor light. It is best to use a fast film to avoid blurred pictures caused by slow shutter speeds and to overcome problems of shallow depth of field due to shooting at maximum aperture. Remember that you may need to ask permission to use a tripod in a public building.

PHOTO SET-UP: Stairway detail

Although flash could be used for a small interior detail such as this stairway, it is preferable to rely on daylight whenever possible. Natural light lends a moody and atmospheric quality that is almost impossible to achieve with flash or tungsten. Although the levels of ambient light appear high, a long four-second exposure using fast film makes the use of a tripod essential.

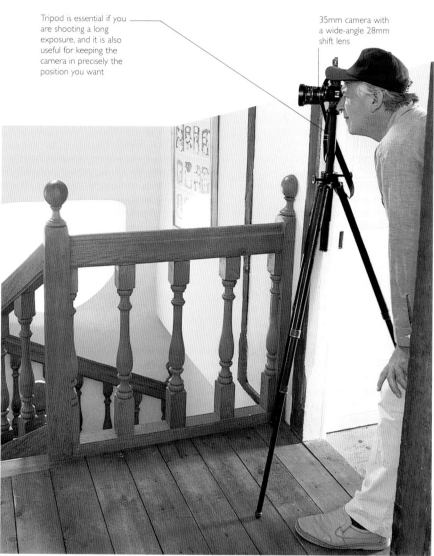

Tripod is essential if you are shooting a long exposure, and it is also useful for keeping the camera in precisely the position you want

35mm camera with a wide-angle 28mm shift lens

Framing of detail, *left*
Space is very restricted on the upper landing of this oak stairway, making it difficult to position the tripod and to frame the shot correctly. In order to keep the lens level and avoid any perspective distortion, a 28mm wide-angle shift lens is used.

PROFESSIONAL TIPS

• If using an ordinary wide-angle lens, keep the camera back parallel with the subject to avoid unwanted distortion of perspective.

• Interiors lit by natural window light alone can be contrasty; use a simple reflector to lighten shadows.

STAINED GLASS WINDOWS

Although most often seen in churches, stained glass windows are also found in some secular buildings. For successful results, try to get as close as possible to the window and level with the detail you want to record. If the windows are high up, use a long-focus lens. The light coming through the glass is best from an evenly lit, overcast sky. The lower the light levels, the deeper the color of the glass will appear. Always use a tripod and allow long exposure times.

PHOTO SET-UP: Stained glass detail

It is best to position the camera as level with the window as possible, so that it is neither pointing up nor down. Because of the height of the window being photographed in this photo set-up, the tripod is raised higher than normal by placing its legs on three identical chairs.

35mm camera with a 28–70mm wide-angle zoom lens

Tripod is needed to support the camera since low light levels require a long exposure

Chairs are used to raise the camera level with the windows

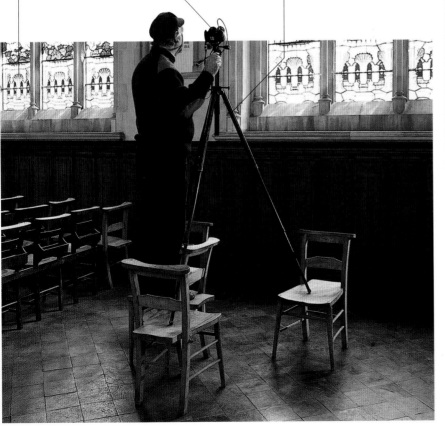

Subdued lighting
Light from a bright but overcast sky usually gives the best results when photographing stained glass. In these pictures (*above*) there is an even intensity of color over the glass. Positioning the windows in the viewfinder so that the black metal borders serve to frame the scenes strengthens the resulting effect.

Powerful symmetry, *right*
Some of the finest architectural features in churches are to be found high above the heads of the worshippers and visitors below: majestic arches, delicate stained-glass windows, and intricately detailed columns and ceilings.
6 x 6cm camera, 120mm lens, Ektachrome 200, f22, 1/15 sec.

Harmony of tone, *below*
Overcast light is often the least flattering for architectural work. The lack of contrast in this detail, however, has created an image composed of harmonious tones. The only black that can be seen is the view into the interior, framing the window on the other side.
35mm camera, 50mm lens, Ektachrome 100, f11, 1/60 sec.

Indirect lighting, *far left*
The ornately carved stonework and marble floor of this building are seen to best advantage when the sun bounces off the walls of the courtyard and indirectly reaches the interior depicted here.
35mm camera, 35mm lens, Ektachrome 100, f22, 1/125 sec.

Focusing on detail, *left*
By selecting the appropriate focal length lens, or focal setting on a zoom lens, you can isolate a single detail of architectural merit, such as this ancient wooden door and surround, in an otherwise uninteresting scene.
35mm camera, 100mm lens, Kodachrome 200, f8, 1/125 sec.

Selective focus

The choice of a relatively large aperture to focus on the opaque glass and ironwork of this light fixture renders the background slightly out of focus so that it does not compete for attention.
35mm camera, 90mm lens, Kodachrome 64, f5.6, 1/60 sec.

Graphic imagery

By omitting the doors, windows, and other features of this Tudor house, the black of the timbers seen against the white of the infill makes for a strong, graphic image.
35mm camera, 50mm lens, Kodachrome 64, f8, 1/125 sec.

Domestic tungsten, *above*

When shooting an interior, you will often have to rely on the available light. This scene of a stairway is lit by a mixture of natural daylight and domestic tungsten bulbs. Where the tungsten lighting is strongest, a warm orange color-cast is noticeable.
35mm camera, 28mm lens, Ektachrome 200, f8, 1/60 sec.

Venetian detail

These candy-striped mooring poles make the location of the image (Venice) immediately obvious to the viewer. There is no need for a wider angle to communicate more clues as to the identity of the locale.
35mm camera, 135mm lens, Kodachrome 200, f11, 1/60 sec.

Interpretative result

For this interior view of the Guggenheim Museum, New York, which has a series of spiraling galleries, the exposure is set for the brightest parts of the scene. The result is abstract.
35mm camera, 28mm lens, Kodachrome 64, f16, 1/125 sec.

Selective geometry, *right*

All types of architectural styles provide interesting details for the camera lens. In this picture, the view has been chosen so that the image is composed of geometric shapes – squares, rectangles, and triangles.
35mm camera, 85mm lens, Fujichrome 100, f16, 1/250 sec.

NATURE

Photography has an increasingly important role to play in recording the natural world. As human habitation spreads ever deeper into the landscape, submerging meadows and forests, photography can reveal a unique beauty of form, color, and texture that might otherwise pass unnoticed.

A question of scale

The key to successful nature photography is to move in close to capture the many guises of nature. Close-up photography no longer represents a technical problem. Many modern cameras allow close focusing with ordinary lenses and many zoom lenses also have macro mode settings that let you shoot with the front element almost touching the subject.

Close-up equipment

Additional close-up equipment such as bellows units and extension tubes allow you to get extremely close to your subject. Successful nature photography relies to a large degree on you, the photographer, adjusting your sense of scale. Viewed from a distance, a bluebell patch is a subtle wash of color, but you can move in closer so that your view is of a single plant, and then closer still so that a single flower fills the frame, and then perhaps even closer so that a detail of a single flower is revealed.

Confined view

Although your view is more restricted when working with natural history subjects than when you are photographing landscapes, the basic disciplines that are needed to make good pictures in any field of interest still apply. First, use your judgment to find the most appropriate camera angle from which to photograph your subject. Second, think about the best possible composition and adjust framing to maximize the distribution of color and tone within the frame. Third, experiment with horizontal and vertical framing: even try framing the subject diagonally if that seems best. Finally, consider the lighting for your subject and if it is not appropriate, think about returning at another time of day when the lighting direction and quality are more favorable.

NATURE SET-UP

Photographing this lily pond requires careful framing with a zoom lens to avoid unwanted details. The lighting is diffused, with the sun hidden behind clouds. An overhanging tree also reduces available light. Note how the green of the lily pads seems to be intensified by the heavy shade, while the white lilies show up starkly in comparison. However, conditions change rapidly, and later in the day the sun broke through the clouds to bathe the lilies with direct light and completely change the atmosphere of the scene.

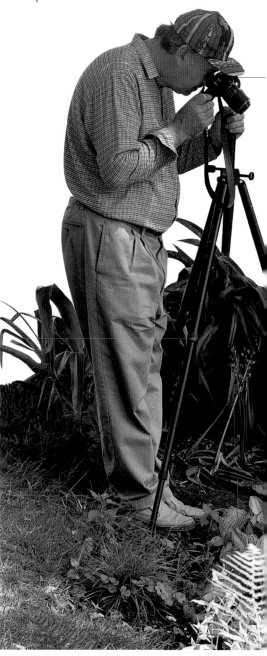

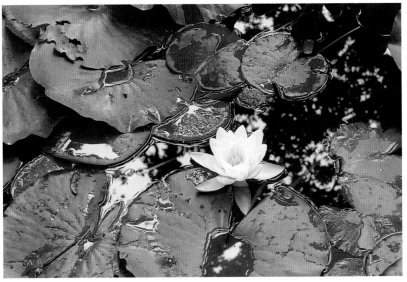

Direction of light

Camera and tripod

6ft (2m)

Nature subject

Effect of sunlight
Direct sunlight lessens the contrast between the lily pads and flowers, but highlights the difference between the plant and the dark, reflective surface of the surrounding water.

EQUIPMENT

- 35mm SLR camera and plenty of spare film

- Range of lenses including a 100mm macro lens

- Bellows and extension tubes

- Adjustable tripod

Camera
A 35mm camera with a 70–210mm zoom lens set at about 90mm and positioned on a tripod. The camera is **loaded** with medium-speed ISO 200 film

Lighting
Dappled light from overhanging tree casts shadows over part of the water and intensifies the color saturation of the leaves and flowers beneath

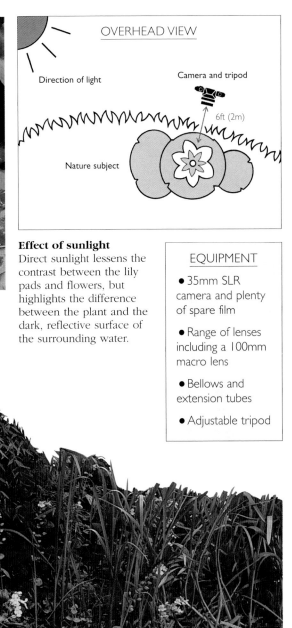

REVEALING NATURE IN CLOSE UP

Natural history photography is not restricted to those who have specialized macro lenses. All of the images shown on these pages were taken using a 35mm camera with a 150mm long-focus lens. Many modern zoom lenses also have a macro mode setting, which is useful when photographing smaller subjects (*see page 210*).

The principal problem with close-up shots using either a long-focus or macro lens is the restricted zone of sharp focus, known as the depth of field. This problem is made worse because depth of field is even more restricted at close focusing distances. Small apertures are needed to make sure everything is in focus, and this often results in long shutter speeds, which can introduce problems of camera shake or subject movement. To avoid camera shake, use a tripod and cable release and choose fast film to speed up exposure.

Natural pattern
The camera looks into the open trumpets of the lilies. The angle of view of the 150mm lens excludes all other details, creating a strong composition of color, pattern, and form.

PHOTO SET-UP: Close-up on flowers
Although the subject is lit by bright daylight, a small aperture of f22 results in a shutter speed of 1/60 second. Remember that even at this shutter speed you should wait for any breeze to die down before taking the picture so that subject movement does not spoil the shot.

35mm camera fixed on a tripod with a 150mm long-focus lens

Viewpoint is chosen so that the camera looks down into the open flowers

DIGITAL SOLUTIONS

● Many digital cameras allow you to focus very close to subjects, particularly if a special macro mode is used. The amount of magnification, however, may not be as great as it seems as the image has already been enlarged when it is displayed on the LCD viewing screen.

● To magnify an image more, use a close-up lens, which attaches to the front of the camera like a filter.

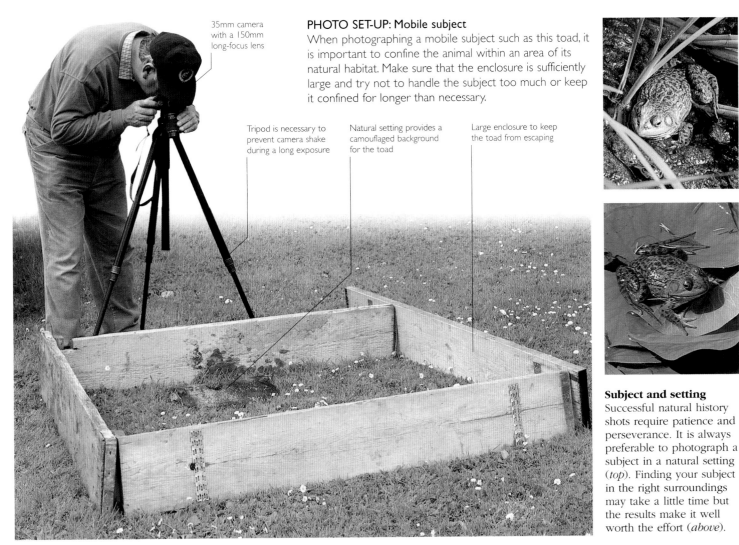

35mm camera
with a 150mm
long-focus lens

PHOTO SET-UP: Mobile subject

When photographing a mobile subject such as this toad, it is important to confine the animal within an area of its natural habitat. Make sure that the enclosure is sufficiently large and try not to handle the subject too much or keep it confined for longer than necessary.

Tripod is necessary to
prevent camera shake
during a long exposure

Natural setting provides a
camouflaged background
for the toad

Large enclosure to keep
the toad from escaping

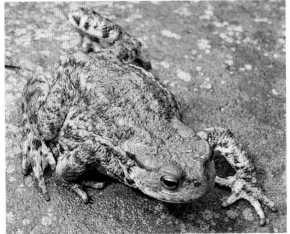

Subject and setting

Successful natural history shots require patience and perseverance. It is always preferable to photograph a subject in a natural setting (*top*). Finding your subject in the right surroundings may take a little time but the results make it well worth the effort (*above*).

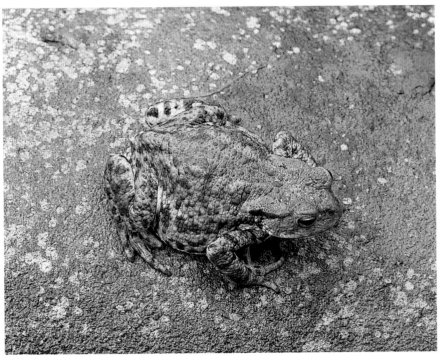

Depth of field

The light for this shot is slightly overcast, and this, linked with an aperture of f32 to ensure sufficient depth of field for subject and background, means using a slow shutter speed of 1/30 second. Careful timing of the shot so that the toad is sitting still on the stone results in a sharp image (*left*), whereas even a tiny movement of the toad will cause the picture to be slightly blurred (*above*).

MACROPHOTOGRAPHY

Look at a lens when it is focusing on a close-up subject and you will see that as it moves away from the camera body, the closer the focusing distance becomes. Many zoom lenses have a macro setting that extends the lens beyond its normal range.

MACRO TECHNIQUES

Macro lenses have greatly extended focusing ranges and they are used for high-definition, close-up photography. Other close-up techniques involve using extension tubes or bellows between the camera body and lens. Lighting for macro shots can be difficult since the camera, lens, and tripod are so close that they may cast unwanted shadows. This problem can be partly overcome by using a longer 100mm lens rather than a standard 50mm lens on a 35mm camera. Ring flash offers the most controllable form of lighting for close-up subjects (*see box opposite*).

PHOTO SET-UP: Macro lens

When working at very close distances, even the most minute degree of subject movement will result in a very blurred image. To prevent any movement of the flower in this set-up, a white cardboard reflector is propped up on one side to act as a windbreak. The stem of the flower can also be secured using a piece of wire (see inset).

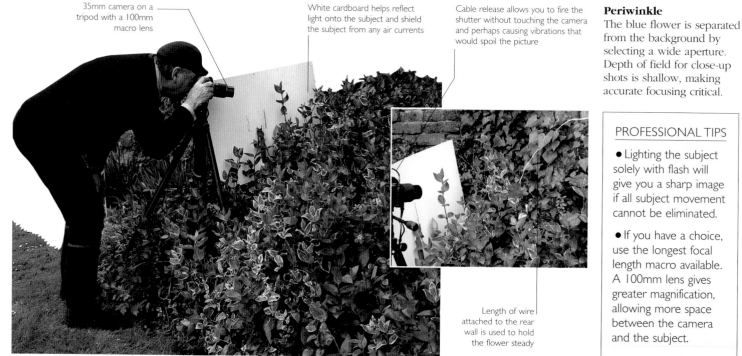

35mm camera on a tripod with a 100mm macro lens

White cardboard helps reflect light onto the subject and shield the subject from any air currents

Cable release allows you to fire the shutter without touching the camera and perhaps causing vibrations that would spoil the picture

Length of wire attached to the rear wall is used to hold the flower steady

Periwinkle
The blue flower is separated from the background by selecting a wide aperture. Depth of field for close-up shots is shallow, making accurate focusing critical.

PROFESSIONAL TIPS

• Lighting the subject solely with flash will give you a sharp image if all subject movement cannot be eliminated.

• If you have a choice, use the longest focal length macro available. A 100mm lens gives greater magnification, allowing more space between the camera and the subject.

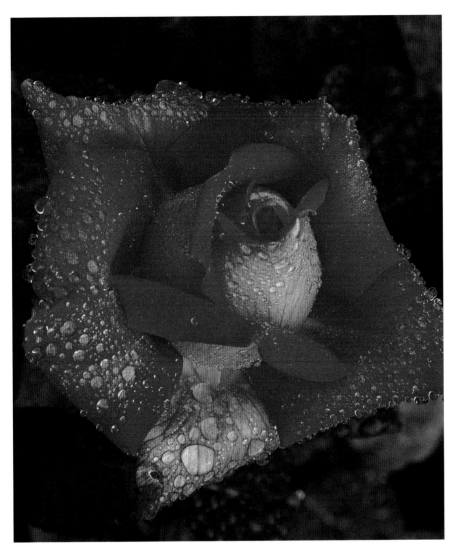

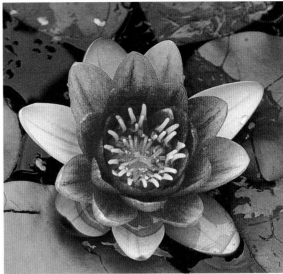

Water lily, *above*
Restricted depth of field emphasizes the flower and gives a sense of depth.

Pale rose, *left*
Ring flash produces an almost shadowless result and creates an exposure difference that shows the background subdued by slight underexposure.

Rose and dew, *far left*
The beads of dew add extra interest to this picture of a rose. The effect is easily achieved by misting the flower with a water spray.

MACRO AND CLOSE-UP EQUIPMENT

The term macrophotography describes film images that are life-sized or larger. For 35mm SLRs and the various medium-format roll-film cameras, the most flexible systems for macro and general close-up work include macro lenses, bellows, and extension tubes.

Macro lenses
Macro lenses for 35mm wSLRs range from 50mm to 200mm. Although they can be used for ordinary work, they are designed to give best resolution for subjects very close to the lens. Sharpness is slightly poorer for distant subjects in comparison with an ordinary lens. A macro lens is expensive and should be considered only for specialized close-up work.

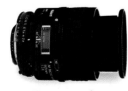

60mm macro lens

100mm macro lens

Bellows unit
Fitting a bellows onto your camera gives you a wide range of possible image magnifications. One end of the bellows fits into the camera while the other accepts a normal lens. Moving the bellows along its track takes the lens closer to or farther away from the subject to alter magnification.

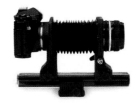

Standard bellows

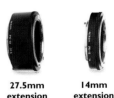

27.5mm extension **14mm extension**

105mm extension

Extension tubes
Extension tubes, usually available in sets of three, can be used individually or in combination to alter lens-to-film distance, and so produce fixed degrees of subject magnification.

Ring flash
This specialized unit has a circular flash tube that fits around the front element of the lens. Designed for use with small close-up subjects, it gives an almost shadowless light effect.

Ring flash for 35mm camera

LIGHTING FOR INDOOR MACRO

In order to take close-ups of small subjects such as butterflies, insects, coins, or jewelry, you often need to position the camera lens extremely close to your subject. This can result in problems, since the camera and lens are so close that it may be difficult to get sufficient light where it is needed. A 100mm macro lens makes lighting easier since it allows you to work farther away from your subject.

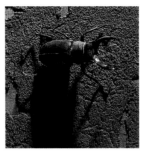

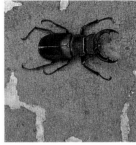

Enhancing the subject
It is important to use the right lighting to enhance your subject's form, color, or other characteristics. The differences in these pictures are startling, with sidelighting used for the first image (*far left*), and diffused toplighting for the second image (*left*).

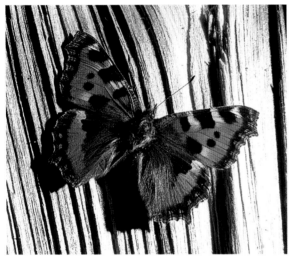

Directional light
Strong, directional light from the right-hand side of this small red butterfly emphasizes the texture and color contrasts. Sidelighting also highlights the deeply grooved surface of the wood on which the insect has been placed.

PHOTO SET-UP: Directional lighting
A single flash lighting unit is used in this set-up. The light is positioned low down to give a strongly directional effect. The snoot attachment ensures that a concentrated beam of light falls onto the subject.

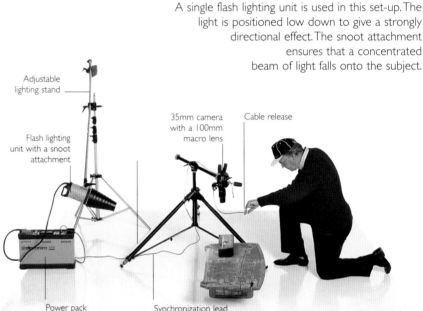

Adjustable lighting stand

Flash lighting unit with a snoot attachment

35mm camera with a 100mm macro lens

Cable release

Power pack

Synchronization lead

Soft lighting
This time the small red butterfly has been lit with soft light from above. Its color and shape are now more obviously the subject of the photograph, the wood background is less intrusive, and the effect of the toplighting is warmer.

PHOTO SET-UP: Diffused toplighting
Toplighting is provided by a flash unit fitted with a softbox diffuser. Although this amount of light may seem overpowering for a small subject, much of the light is lost due to the proximity of the camera, lens, and tripod.

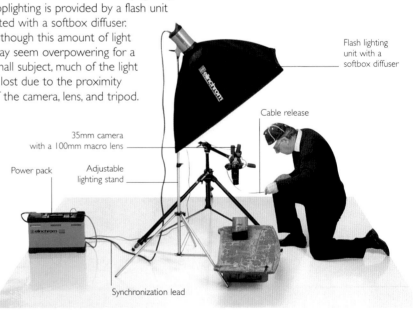

Flash lighting unit with a softbox diffuser

Cable release

35mm camera with a 100mm macro lens

Power pack

Adjustable lighting stand

Synchronization lead

Blue butterfly, *left*
With some subjects, the
direction of the lighting
will have a profound
effect on the way their
color is recorded. For this
image, diffused toplighting
was used so the brilliant
blue and black-edged
coloration of the butterfly's
wings is highlighted.

Gray butterfly, *above*
Although the subject is the
same blue butterfly (*left*),
strong sidelighting
produces a very different
picture. Here the insect is
illuminated by light
reflected up through its
translucent wings from the
surface of the stone, rather
than from above.

PROFESSIONAL TIPS

● If you do not have a snoot, cut a hole in the center
of a piece of card to create a narrow beam of light.

● Lighting is easier using a long lens and bellows since
you are able to work farther away from the subject.

● Extremely shallow depth of field associated with
close-ups means working with a small aperture.

● A ring flash is useful for lighting a small subject.

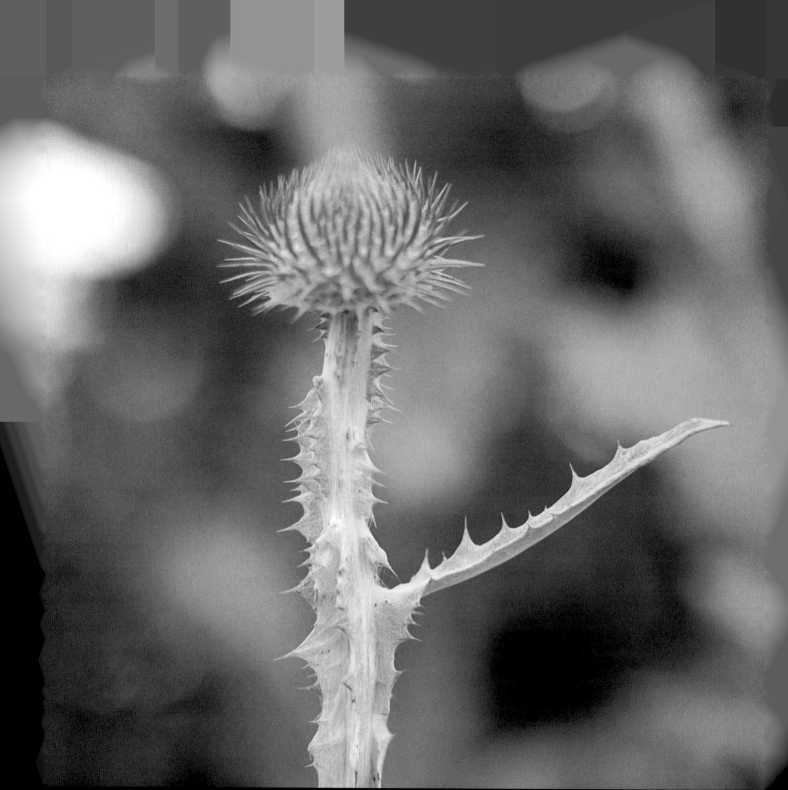

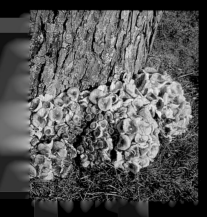

Light and texture, *far left*
In this shot, intense sunlight falls at an angle that accentuates the rich color of the fungus and the texture of the supporting bark.
35mm camera, 90mm lens, Fujichrome 100, f16, 1/125 sec.

Abstract effect, *left*
At first glance, this picture seems to be an abstract pattern of shapes in the long grass. In fact, the subject is a field of fallen apples.
35mm camera, 50mm lens, Ektachrome 100, f11, 1/60 sec.

Wide aperture
A large flower can be photographed without specialized equipment. To keep the background from being too prominent, use a wide aperture.
6 x 6cm camera, 150mm lens, Ektachrome 200, f4, 1/60 sec.

New life

A few days before being photographed, this fern barely showed above the soil. Part of the fascination of nature photography is the awareness it gives you of the natural cycle of growth and decay.
35mm camera, 80mm lens, Fujichrome 100, f8, 1/30 sec.

Color rendition

The color of the toadstools varies subtly, from near white to blue, according to where the sunlight and shadows fall.
35mm camera, 135mm lens (plus extension tube), Kodachrome 64, f16, 1/15 sec.

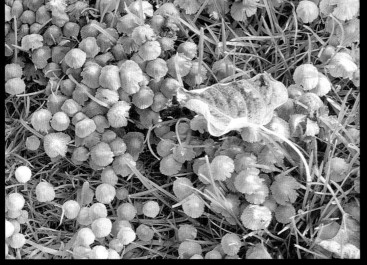

Supplementary lighting

With a tightly framed subject, it is possible to supplement lighting with a flashgun. The angles of the flash and natural light must correspond to prevent a double set of shadows.
35mm camera, 100mm macro lens, Ektachrome 100, f22, 1/60 sec.

Early morning

Crisp, clear, winter sunshine has a particular steely clarity not found at other times of the year. To record the frost still clinging to evergreen leaves, however, you need to photograph your subject early in the morning before the sun has warmed the surrounding air.
35mm camera, 135mm lens, Ektachrome 200, f5.6, 1/30 sec.

PHOTOGRAPHING GARDENS

When taking a picture of a garden setting, the details of the location are less important than the way in which they interact with each other to create a unified whole. A standard and a wide-angle lens are generally more useful than longer focal lengths, though this depends on the size of the garden and the vantage points its design and layout allow.

THE GARDEN AT ITS BEST

Gardens are at their best at different times of the year, depending on the plants – some are spectacular in early summer when in full bloom, while others may be spring or fall gardens. The time of day is also important. To the naked eye, a garden may look most impressive in bright, midday sunlight; on film, however, early morning and late afternoon light usually produce the best results.

PHOTO SET-UP: Garden as a setting

This is a mature garden, and the house is an integral part of the overall setting. By positioning the camera on the riverbank opposite the house, it is possible to convey some of the atmosphere of the scene.

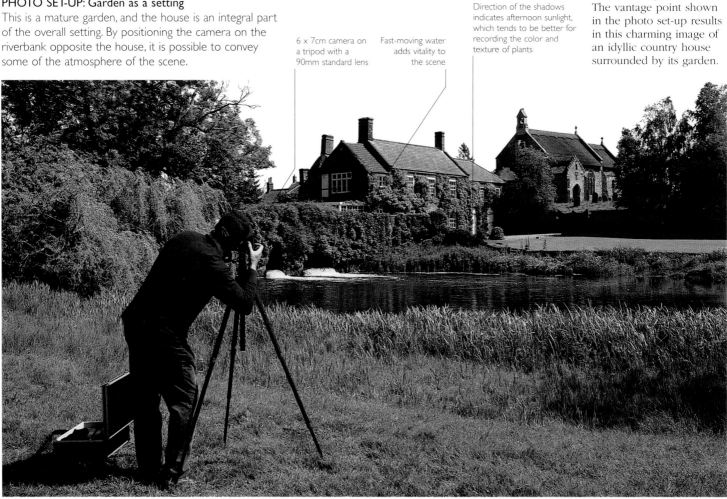

Direction of the shadows indicates afternoon sunlight, which tends to be better for recording the color and texture of plants

6 x 7cm camera on a tripod with a 90mm standard lens

Fast-moving water adds vitality to the scene

House and garden, *above*
The vantage point shown in the photo set-up results in this charming image of an idyllic country house surrounded by its garden.

Use of color, *above*
At first glance, this formal garden setting at Villandry, France, appears to be a riot of random color separated by hedges. However, the repetition of colors, notably the yellow, leads the gaze back toward the château.

Leading the eye, *left*
Many devices can be used to direct attention to a specific area of the picture frame. It could be the repetitive use of color or, as here, a statue that seems to compel you to follow its gaze into a sheltered corner of a much larger garden setting.

PHOTOGRAPHING FLOWERS AND SHRUBS

Unless carefully considered, photographs of flowerbeds and planted borders can be a disappointing amalgam of discordant color with no particular center of interest, form, or structure. Avoid this pitfall by finding an individual plant or group of plants around which to build your composition. Once you have this focal point, look for angles that show other parts of the garden in supporting roles to give your picture a coherent structure.

EQUIPMENT AND CONDITIONS

The selective angle of view of a long-focus lens is best for filling the frame with an individual plant. Wind is the main problem when photographing flowers. Gusty conditions require a fast shutter speed to avoid subject movement, and this in turn requires a wide aperture, resulting in shallow depth of field.

PHOTO SET-UP: Coordinating color
By concentrating on flowerbed and planting details you can create an interesting picture, even if the garden as a whole does not have photographic potential. The chief attraction of the flowerbed shown in this photo set-up is the coordinated color theme. The flowerbed is in shade, which accounts for the slight intensifying of the color.

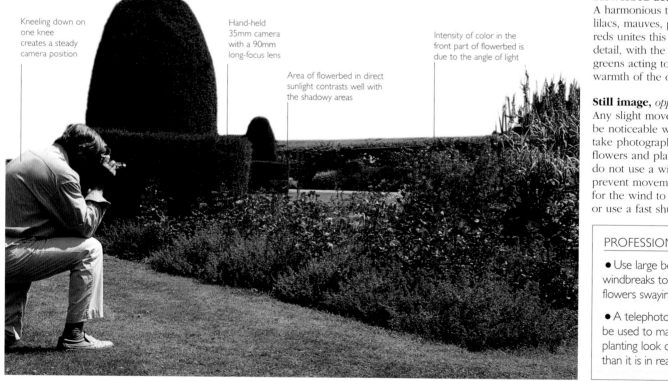

Kneeling down on one knee creates a steady camera position

Hand-held 35mm camera with a 90mm long-focus lens

Area of flowerbed in direct sunlight contrasts well with the shadowy areas

Intensity of color in the front part of flowerbed is due to the angle of light

Flowerbed detail, *above*
A harmonious theme of lilacs, mauves, pinks, and reds unites this flowerbed detail, with the whites and greens acting to cool the warmth of the other colors.

Still image, *opposite*
Any slight movement will be noticeable when you take photographs of flowers and plants. If you do not use a windbreak to prevent movement, wait for the wind to die down, or use a fast shutter speed.

PROFESSIONAL TIPS

• Use large boards as windbreaks to stop flowers swaying.

• A telephoto lens can be used to make planting look denser than it is in reality.

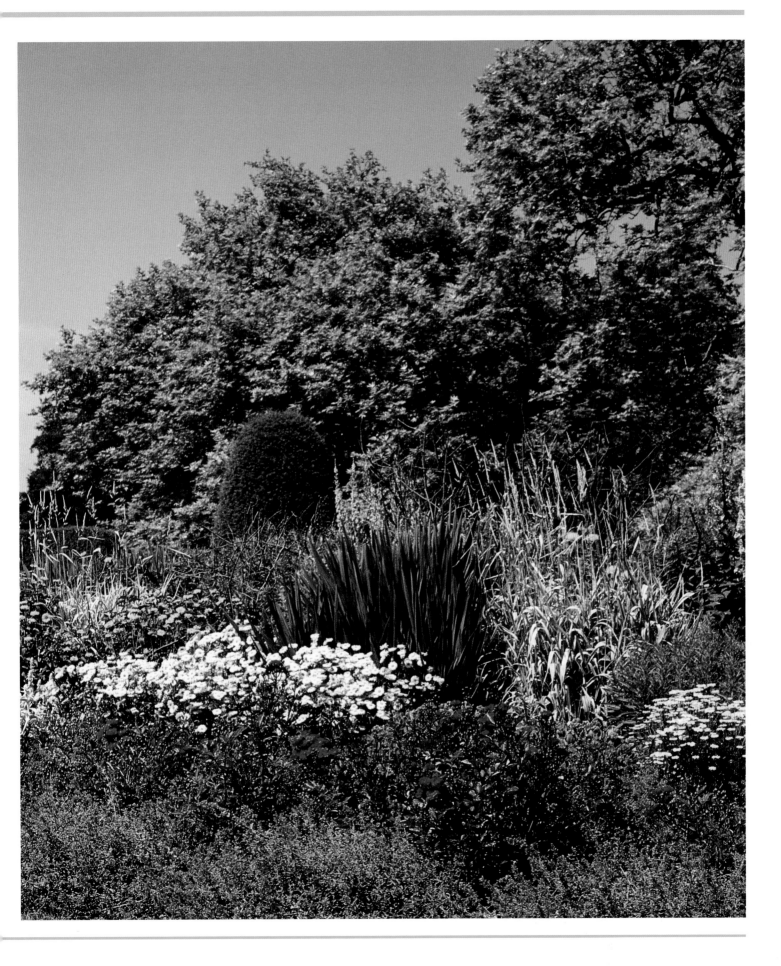

Frame-filling form

Large flower heads, such as that of this sunflower, allow you to take detailed, frame-filling close-ups without going to the expense of using specialized macro equipment. Here the bloom dominates the frame, even though it was taken using only a moderately long lens. *35mm camera, 90mm lens, Kodachrome 64, f11, 1/125 sec.*

Indoor light levels, *below*

An exotic clivia photographed in a large, glass-covered conservatory requires a slow shutter speed. A wide aperture ensures correct exposure for the dim conditions, since the flower is surrounded by other plants and lit only by daylight filtering through the glass. *5 x 6cm camera, 80mm lens, Ektachrome 100, f4, 1/15 sec.*

Controlled imagery, *above*

A combination of aperture, focal length, and camera distance produces this image of a brilliant red hibiscus flower. The green leaves are softened and out of focus, but add extra information and interest to the picture. *35mm camera, 70mm lens, Fujichrome 100, f5.6, 1/60 sec.*

Ring flash, *opposite*

By fitting a ring flash to the lens, exposure on the orchid bloom alone is increased, making the background appear much darker in comparison. The ring flash gives almost shadowless illumination of the orchid itself. *35mm camera, 100mm lens, Ektachrome 100, f11, 1/60 sec.*

PHOTOGRAPHING GARDEN ARCHITECTURE

It is quite common to find ornate structures, such as dovecotes, summerhouses, follies, and even classical temples in large gardens. The best way to photograph garden architecture does not differ from that used for any other outdoor architecture, except that the setting – the garden itself – should be an integral part of the photograph. For the most harmonious composition, try to imagine how the landscape designer planned the garden to be viewed, and visit it at different times of the day to capture the best lighting effect.

Before shooting, try to find the vantage point that shows the garden to best advantage. The garden may vary at particular times of the day, from different viewpoints, in certain seasons, or when seen from a distance.

PHOTO SET-UP: Afternoon light

A low, bright afternoon sun in a sky strewn with white clouds provides the perfect illumination and backdrop for this building – a large dovecote, with box hedges and an ornamental fish pond in the foreground.

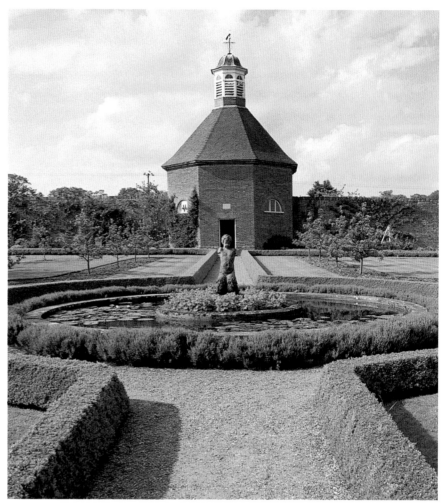

Symmetry, *above*
This viewpoint records the symmetrical arrangement of clipped box hedges, the circular fish pond, and the avenue of trees leading to the large brick dovecote.

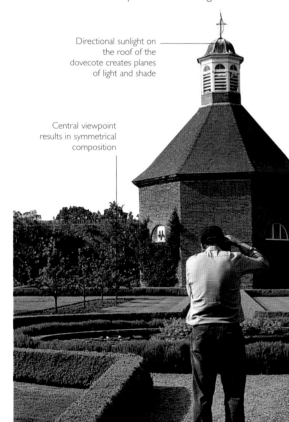

Directional sunlight on the roof of the dovecote creates planes of light and shade

Central viewpoint results in symmetrical composition

Hand-held 35mm camera with a 28mm wide-angle lens

Long shadows indicate that the sun is low in the sky

PROFESSIONAL TIPS

● Avoid shooting when the sun is high in the sky, since this tends to produce excessive contrast and poor color saturation.

● Look for a camera angle that corresponds to the way the garden was originally intended to be viewed.

Romantic image, *left*
This image successfully
captures the romantic and
secluded atmosphere
evoked by the ruined,
medieval-type folly.

Silent grotto, *above*
Framed by lavender and
roses, this folly is the
perfect backdrop for this
small garden. The angle of
the light adds impact.

PHOTO SET-UP: Ruined folly

The position of this folly in a quiet, shady corner of the garden
makes a slow shutter speed and the use of a tripod essential.
Although the day is bright, much of the light is obscured by the
overhanging foliage. The need for a small aperture to ensure
adequate depth of field results in a long exposure time.

Tripod-mounted 35mm
camera with a 50mm
standard lens

Flower colors
help brighten the
resulting image

Overhanging foliage
casts dappled shade
over the folly

RECORDING GARDEN FEATURES

The finishing touches to a landscaped garden are the ornaments used and the focal points created by them. Statues, urns, garden seats, pergolas, rose arches, and similar devices are the nonorganic features intended by the garden designer to enhance the beauty of the setting, and they can make ideal subjects.

For small garden features and close-ups of larger ones, a 35mm SLR camera fitted with a 100mm lens is useful. This lens allows you to exclude extraneous detail, but the angle of view is not so narrow that it removes all traces of the setting.

PHOTO SET-UP: Garden statue

To photograph this garden statue, it is important to wait until the sun is low in the sky so that the bust is lit from an angle of about 45°. This lighting direction is best suited to show the bust's texture and form, which are emphasized by the interaction of light and shade (see page 46).

Decorative urn, *above*
A low camera angle is essential to show the decorative basketweave molding on this garden urn.

35mm camera with a 70–210mm telephoto zoom lens

Early evening light is striking the statue from an angle of about 45°, apparent in the direction of the shadow

Garden statue
The lichen-covered garden statue in the photo set-up is made to stand out from the surrounding greenery by using a long lens with a restricted angle of view.

Selecting a detail, *above*
A telephoto zoom is useful for isolating a garden detail and adjusting subject framing without changing the camera position.

Informal planting
A rich and varied planting theme
using a mixed color palette has
been created by the designer of
this garden. The yellow rose
bushes in the background create a
feeling of depth and distance.
*35mm camera, 35mm lens,
Fujichrome 100, f16, 1/250 sec.*

Sculpted beauty, *below*
The formal topiary shapes in this
garden create large blocks of
dense, hard-edged greenery,
unlike the softer, more organic
shapes normally associated with
garden photography. A carefully
chosen camera angle allows a
tunnel-like view through to the
rear of the garden.
*35mm camera, 50mm lens,
Ektachrome 200, f16, 1/30 sec.*

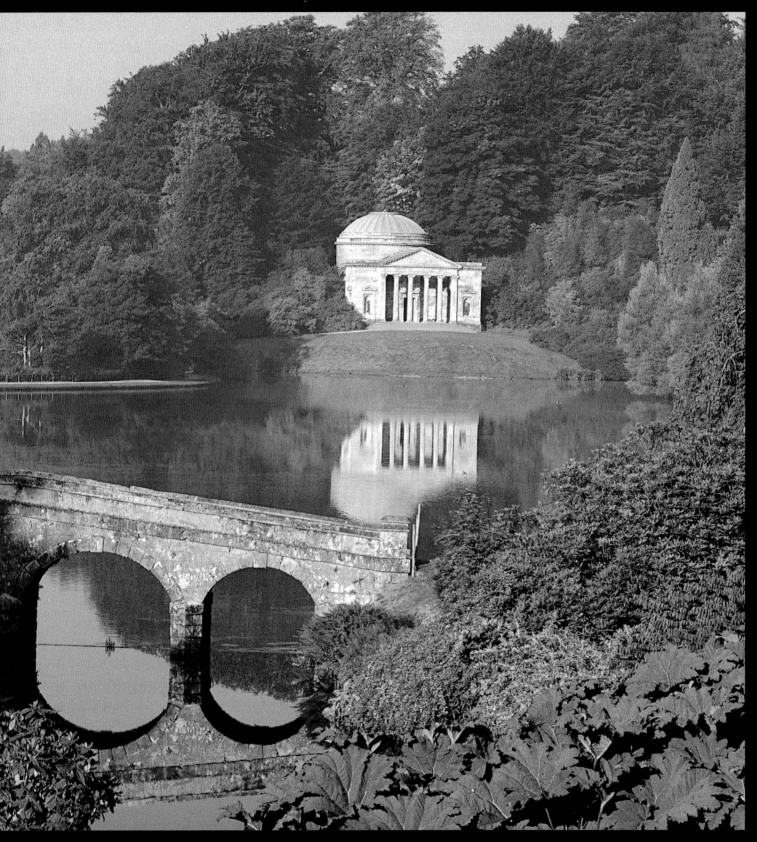

Water view
The early morning light shows up
perfectly the shades of green and still
water in this shot of the gardens at
Stourhead, England.
*35mm camera, 35mm lens, Fujichrome
100, f16, 1/250 sec.*

ANIMALS

Animals have long held a fascination for the photographer. While luck can play a part in taking a successful wildlife photograph, a knowledge of animal behavior is essential, as are patience and perseverance. When the opportunity for a good shot arises, you should be prepared to act quickly.

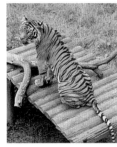

Wild animals
See pages 230–231

Birds
See pages 232–233

Pet portraits
See pages 234–235

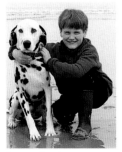

Pets on location
See pages 234–235

Early cameras and lenses

Until the early years of the twentieth century, the only pictures you were likely to see of wild animals were of dead specimens. Cameras and lenses were bulky and film so insensitive and slow that long exposures of several minutes were common. Rather than seeing a picture of a bird in flight, you were more likely to be confronted by a photograph of a stuffed collector's specimen behind a protective glass dome. Today, with cameras a fraction of their former size, and lenses and film hundreds of times faster, the scope for photographing wild animals in their natural habitat is vast.

Wild animals

Most of us normally see wild animals only in zoos, nature reserves, wildlife and safari parks, and animal sanctuaries, but the spread of human habitation into the countryside and wilderness areas has brought humans into closer contact with many animal species. Even if accustomed to the presence of people, wild animals should always be approached with caution. Long-focus lenses allow you to stand back from your subject, and fast film permits a brief shutter speed or small lens aperture for freezing subject movement or creating the necessary depth of field.

Domestic animals

The most readily available animal subjects for photography are, of course, pets. Since most pets, especially dogs and cats, are not at all camera shy, you will be able to move in much closer and use a shorter lens. Try for portraits that show your pet's facial expression, and remember that shots taken from the animal's eye level usually work better than ones taken from standing height. Be prepared to shoot a lot of film and select the best shots afterward.

ANIMAL SET-UP

The location for this set-up picture is the reptile house in a safari park. Light levels are not high in the glazed building due to the dense vegetation. The rail surrounding the observation platform makes an ideal surface on which to steady the camera during the long exposure.

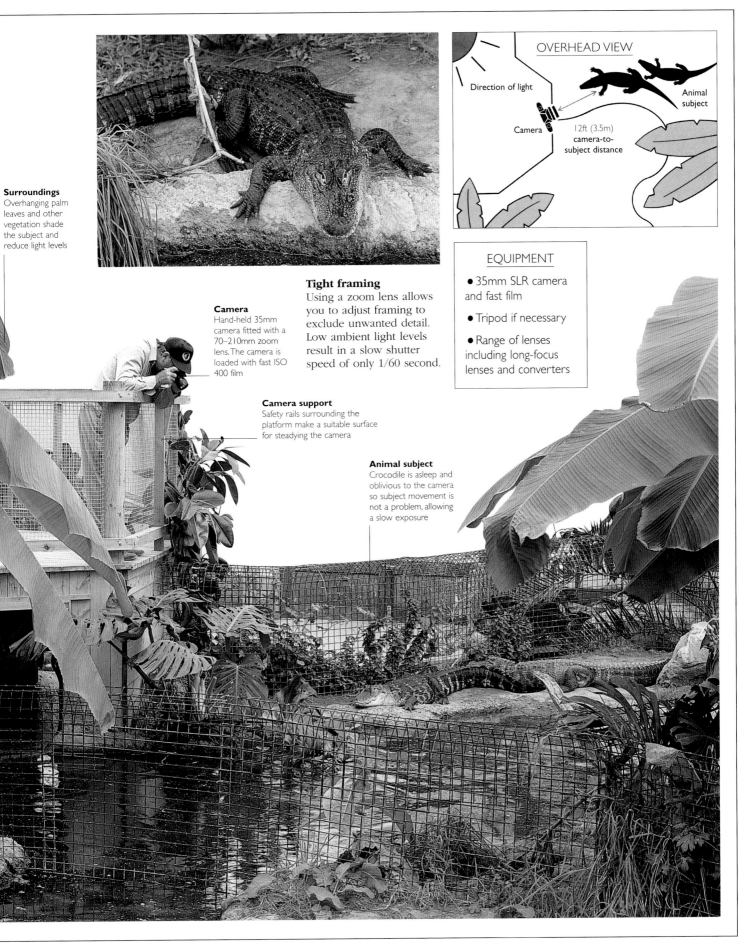

Surroundings
Overhanging palm leaves and other vegetation shade the subject and reduce light levels

OVERHEAD VIEW

Direction of light

Camera

Animal subject

12ft (3.5m) camera-to-subject distance

Tight framing
Using a zoom lens allows you to adjust framing to exclude unwanted detail. Low ambient light levels result in a slow shutter speed of only 1/60 second.

Camera
Hand-held 35mm camera fitted with a 70–210mm zoom lens. The camera is loaded with fast ISO 400 film

EQUIPMENT

● 35mm SLR camera and fast film

● Tripod if necessary

● Range of lenses including long-focus lenses and converters

Camera support
Safety rails surrounding the platform make a suitable surface for steadying the camera

Animal subject
Crocodile is asleep and oblivious to the camera so subject movement is not a problem, allowing a slow exposure

PHOTOGRAPHING WILD ANIMALS

Although bars and wire fences can present a problem when photographing wild animals in captivity, modern enclosures with high observation walkways offer superb picture-taking opportunities. As with all animal photography, the most important attributes required are patience and timing.

ELIMINATING UNWANTED ELEMENTS

A high camera position can often eliminate an unattractive background by showing the animal subject against a backdrop of grass or stone. If this is not possible, use a long-focus or zoom lens and a wide aperture to restrict angle of view and depth of field. A motor drive is useful since you do not have to look up from the viewfinder to advance the film.

Overhead viewpoint
The viewpoint shown in the photo set-up results in these photographs in which the subject is seen against a background of grass and foliage. The diffused sunlight is excellent, because it ensures that the rich color of the tiger's coat is well recorded.

PHOTO SET-UP: Wildlife park
The high walkway at a wildlife park is the perfect vantage point for this photo set-up overlooking a large enclosure of Sumatran tigers. A long-focus lens with a x2 converter ensures that the framing is tight on the tiger and that none of the resulting shots reveals the encircling safety fences.

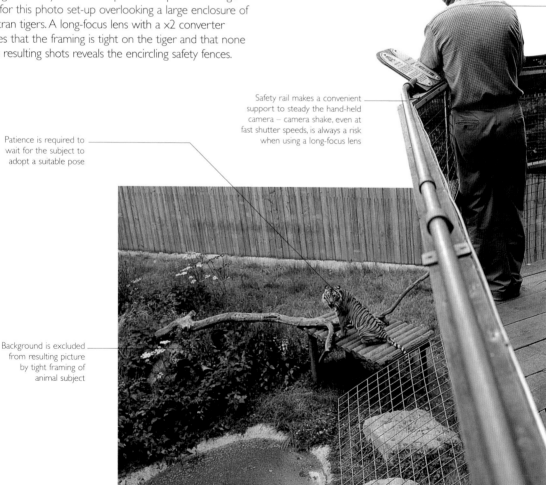

Hand-held 35mm camera with a 135mm long-focus lens and × 2 converter

Safety rail makes a convenient support to steady the hand-held camera – camera shake, even at fast shutter speeds, is always a risk when using a long-focus lens

Patience is required to wait for the subject to adopt a suitable pose

Background is excluded from resulting picture by tight framing of animal subject

Timing, *opposite*
A slight change in the tiger's posture or facial expression can make all the difference between an ordinary or an outstanding shot. Working with an unpredictable subject means that you have to keep your finger on the shutter release at all times. In this shot the tiger momentarily looks back toward the camera.

PROFESSIONAL TIPS

- In a wildlife park, obey all the safety rules and take no risks.

- Take the minimum equipment if you are stalking wildlife.

- A motor drive may disturb the animals.

- Bring out the color of your animal subject by including contrasting vegetation in the shot.

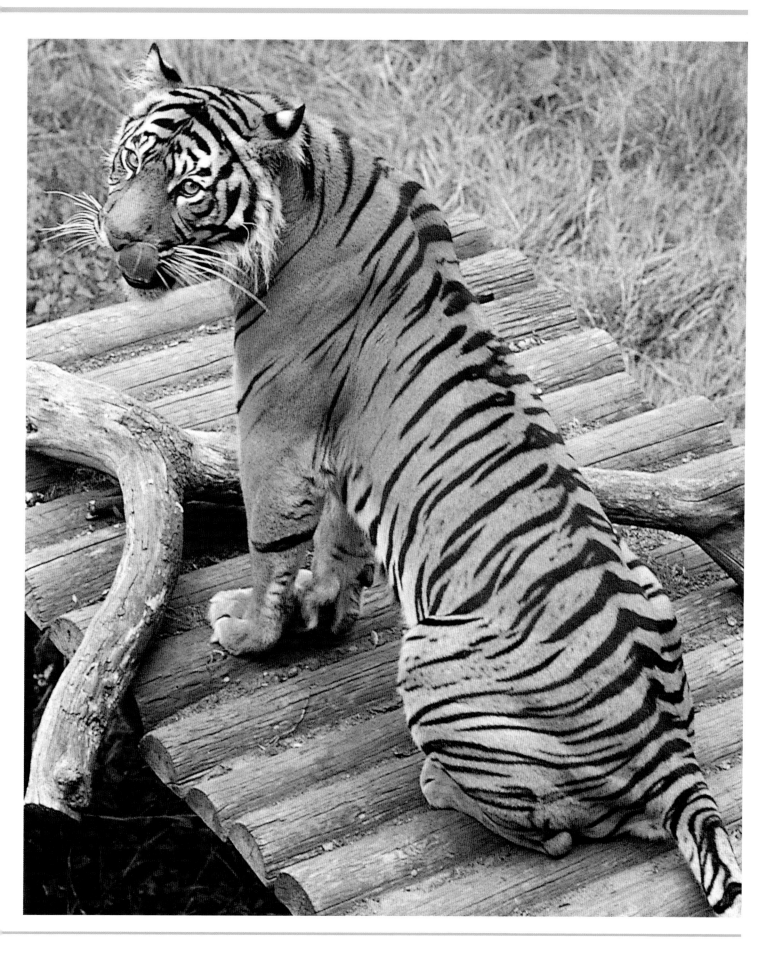

PHOTOGRAPHING BIRDS

With their senses of hearing and sight far sharper than our own, wild birds can be difficult subjects to observe and to photograph. Whether or not your intended subjects will let you come within camera range often depends on whether they regard you as a potential threat or just as a harmless observer.

OBSERVING BIRDS

Many birds, such as common garden visitors, and others found in parks, sanctuaries, and lakesides have developed a tolerance of people and can be easily approached. However, it is best to assume that all wild birds will be cautious, making a long-focus lens and tripod essential for detailed close-ups. To avoid scaring birds, keep out of sight, using natural cover or a manmade shelter if available, and make as little noise as possible.

PHOTO SET-UP: Nesting birds

You cannot approach too close to nesting birds since they may damage the eggs or even abandon the nest. A long-focus lens and converter is useful for recording detailed images of the birds without causing unnecessary stress.

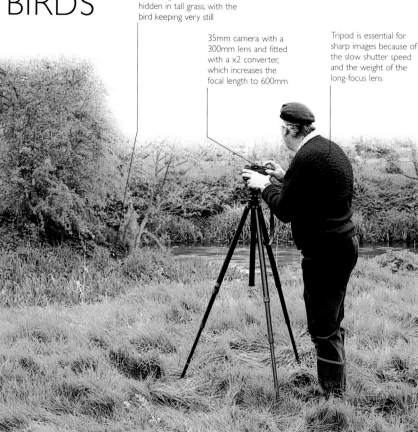

Canada goose's nest is well hidden in tall grass, with the bird keeping very still

35mm camera with a 300mm lens and fitted with a x2 converter, which increases the focal length to 600mm

Tripod is essential for sharp images because of the slow shutter speed and the weight of the long-focus lens

White swan
Surrounded by tall reeds, this swan's nest is sunlit for only a short period each day. Without this direct sunlight, the swan's white plumage would take on a gray coloration, and the surrounding plants would lose their vibrancy of color.

Canada goose
Although in a sleeping position, with its head resting on its back, this goose is alert to danger. A 300mm long-focus lens with a x2 converter is used to avoid getting too close to the subject and possibly frightening it.

PHOTO SET-UP: Natural camouflage

The less obvious your presence, the more natural the behavior of the birds that you want to photograph will be. These geese are aware of the intruder, but with the lake nearby for a quick escape they are not too concerned. A 500mm long-focus lens makes it possible to use natural cover and to be positioned some distance from the subject.

Conveniently located tree provides cover

35mm camera with a 500mm lens

Tripod is essential to avoid camera shake because of the combined weight of the camera and lens

Geese congregate near the water for a swift escape if necessary

Family outing, *above*
This family scene shows a clutch of goslings under the guardianship of two adult geese. Depth of field with the 500mm lens is shallow and isolates the birds from the surroundings.

Lighting direction, *above*
Patient observation and a concealed position results in natural-looking pictures.

DIGITAL SOLUTIONS

Use a teleconverter to extend the telephoto range of a digital camera with a fixed zoom. These can increase the focal length by 1.4–3 times.

PHOTOGRAPHING PETS

Many people regard their pet as one of the family, so it is not surprising that owners often want an animal portrait and that this is a popular area of photography. The main difficulty is persuading the animal to stay still long enough to be photographed.

DECIDING ON A SETTING

The controlled environment of an indoor setting is ideal if you want a detailed, well-illuminated, and carefully composed image of your pet. However, if you are working with an animal that you do not know, make sure the owner is present and that it is well trained and not of a nervous disposition. For more informal portraits you can choose an outdoor location. Depending on the animal being photographed, your back yard, a local park, or a beach could make a perfect setting.

Full-length portrait
This portrait of a Boxer shows the dog's stance and facial expression, as well as its distinctive markings and coloring.

Close-up portrait
An endearing image is achieved by closing in on the dog's face. The bubble at the corner of his mouth makes the portrait amusing.

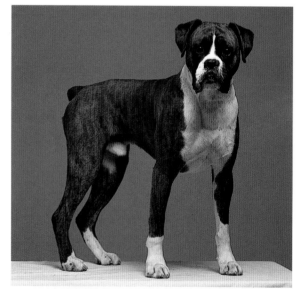

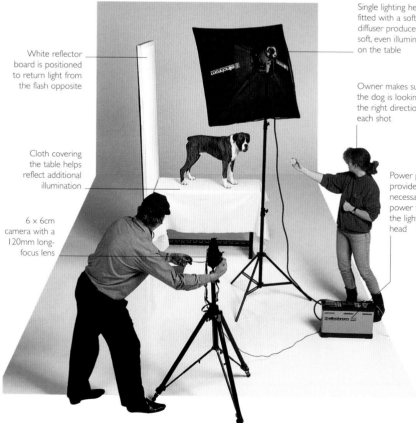

White reflector board is positioned to return light from the flash opposite

Cloth covering the table helps reflect additional illumination

6 x 6cm camera with a 120mm long-focus lens

Single lighting head fitted with a softbox diffuser produces soft, even illumination on the table

Owner makes sure the dog is looking in the right direction for each shot

Power pack provides the necessary power for the lighting head

PHOTO SET-UP: Working with pets
Animals can be very difficult to photograph in an unfamiliar environment and may need to be restrained. A large dog can be a danger to those around it if it becomes frightened, and it could also damage equipment. A useful tip is to remember that most pets respond to their owner. In this set-up, the dog's attention is focused on its owner, who is standing out of shot, and on the rubber ball she is holding.

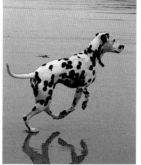 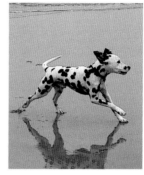

A boy and his dog, *left*
This close-up image of the
boy and dog was taken
using a long-focus zoom
lens to alter framing
without having to change
the camera position, which
might distract the dog.

Dog on the move, *above*
The Dalmatian's high spirits
are illustrated in the first
image, as the dog pulls
against the leash. The boy
lets the dog run along the
sand, the surface of which
throws back reflections.

PHOTO SET-UP: Pets on location

Early morning is chosen for the photographic session
because at this time of day the beach is nearly deserted.
The dog's young owner helps to keep his pet's high spirits
in check, and a low camera angle ensures that both faces
can be clearly seen. A long-focus zoom lens is especially
useful when the dog is off the leash and running freely.

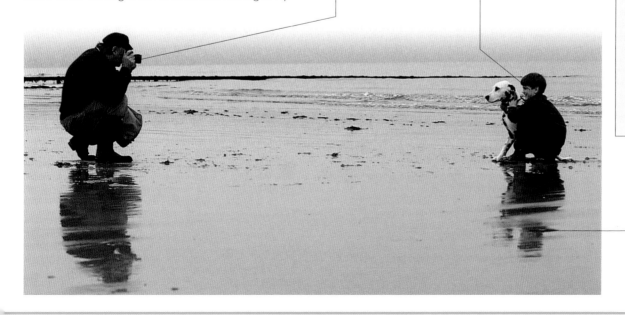

35mm camera with
a 70–210mm long-
focus zoom lens
allows a range of
framing options

Boy squats down
beside the dog to
restrain him, bringing
their faces level

Wet surface of the sand
acts as a mirror, reflecting
the images of the boy
and the spotted dog

PROFESSIONAL TIPS

● Be ready to react
quickly to an animal's
changeable and
unpredictable moods.

● Using an autofocus
and autoexposure
camera, you can give
your complete
attention to the animal.

● Use a long-focus
zoom lens to take
many shots in rapid
succession.

Exposure override, *above*
To prevent overexposure of this toucan perched in sunlight with the dark forest behind, the exposure reading is overridden by increasing the recommended shutter speed by one f-stop.
35mm camera, 135mm lens, Ektachrome 200, f11, 1/60 sec.

Shooting through glass, *left*
Some zoos and wildlife parks provide observation windows so that the public can see a different view of the animals, such as this pair of seals. The water is clear and shallow enough to allow sufficient light to filter through from the surface for a hand-held exposure using medium-fast film.
35mm camera, 135mm lens, Fujichrome 400, f8, 1/125 sec.

Shooting through mesh, *far left*
The mesh surrounding this tiger's zoo enclosure is rendered invisible by placing the front of the camera lens close to the wire and then selecting a wide aperture.
35mm camera, 300mm lens, Ektachrome 200, f8, 1/60 sec.

Camera angle, *left*
An unusual camera angle can often hide an unwanted background. To disguise its zoo enclosure, a high vantage point is used for this shot of a swimming tiger.
35 mm camera, 100 mm lens, Ektachrome 200, f4, 1/30 sec.

Choice of aperture, *above*
A wide lens aperture is selected
for this shot of a tree frog. The
shallow depth of field resulting
from the aperture separates the
small creature from a similarly
colored background. A very fast
shutter speed is used to arrest any
sudden movement of the subject
or hand-held camera.
35mm camera, 135mm lens,
Ektachrome 200, f2.8, 1/2000 sec.

Backlighting
When any subject is backlit, such
as this puma sunning itself on a log
platform, you need to select
a wide aperture (or use a slow
shutter speed) to avoid any risk
of underexposing the subject.
35mm camera, 210mm lens,
Fujichrome 100, f5.6, 1/125 sec.

DIGITAL
MANIPULATION

Digital imaging is not just about using filmless
cameras. One of the main advantages of
having pictures in a binary form is the ease in
which images can be tweaked, improved
upon, or completely reconstructed using a
computer. The amount of control you have
over the result is far greater than that ever
enjoyed in a traditional darkroom.

SETTING UP A DIGITAL DARKROOM

Whether you use film or a digital camera, digital manipulation provides a degree of control and craftsmanship over your pictures that is simply not possible in the traditional darkroom. The key piece of equipment required is a computer. To get started in digital image editing, practically any relatively recent PC or Mac will be more than sufficient. The only other essential requirement is the software (see box). The images can be downloaded direct from your digital camera to the computer's hard drive.

To work on conventional photographs, the slides, negatives or prints need to be converted into digital form. This can be done commercially, with the images supplied on CD – or accessed from a password-protected webpage. Alternatively you can use a desktop scanner. Flatbed models are ideal for prints, and some models have built-in transparency hoods handle negatives and slides; alternatively use a special film scanner.

As you will use the computer screen to judge how much correction an image needs, it is essential that the screen is set up to show the image as accurately as possible. Some computers and image manipulation packages have utilities that allow you to calibrate the monitor correctly – and as the screen's color changes over time, this set-up procedure must be carried out periodically. To ensure that your eyes see the image without any distraction, it is sensible to choose a plain grey background as your desktop pattern – bright patterns and pictures may lead you to misjudge colors. You should also ensure that desk lights and windows do not create reflections on the screen surface.

THE DIGITAL PHOTOGRAPHER'S DESK

The ideal workstation has everything positioned within easy reach. However, if you do not have much space, items such as scanners and back-up drives need only be plugged in to the computer as and when they are required.

Computer monitor
Fitting a hood around the screen helps minimize surface reflections. This can be made from black card

Slide scanner
Produces high-resolution image files direct from mounted slides or from negative strips

Laptop
An alternative to the desktop computer – and can be taken on location. Some pro digital cameras can record images direct to a PC, and can be controlled from it

Printer
Inkjet models are the most popular choice – but the paper used is key to getting good results

External hard drive
Low-cost solution for increasing the storage capacity of your computer

Work surface
If possible, choose a working environment away from windows. Or ensure they have efficient blinds or curtains

Disk burner
Records blank CDs which store up to 700MB of data. CD-Rs can only be used once, but are more affordable than rewritable CD-RWs.

Zip drive
Each rewritable disk can store up to 250MB of data. Less popular since CD burners have become so inexpensive.

Keyboard
The use of time-saving keyboard shortcuts minimizes effort and results in less strain on the wrists.

CHOOSING A PRINTER

Although digital images could be viewed entirely on PC and TV screen – and shown to others using email and the web – most photographers like to have a hardcopy of at least some of their images. Prints can be made from your digital files by commercial labs, but can be output at home easily.

A standard desktop color inkjet printer can produce very reasonable results, especially if printed on photo-grade paper. Special photo printers use additional inks to the standard cyan, magenta, yellow and black, to create a richer range of tones. Some models also offer 'bleed' printing, so that shots are printed up to the edge without a white border. Dye sublimation printers provide prints that look more like traditional photographs by vaporizing colored ribbons so that the dye penetrates the surface of the specially-coated paper. These can be expensive to run.

DVD'S

Recordable DVDs and drivers continue to fall in cost, making them an increasingly popular storage medium for slides. With each disk having a capacity of nine gigabytes, they are more space-efficient than CD-Rs – particularly for those working with large image file sizes.

CARD READERS

An alternative to plugging your camera into your computer is to download your images using a card reader. Multi-format designs can read several different card types. Also a solution for computers which have 'wrong' sockets, or operating system, for the leads or software supplied with the camera.

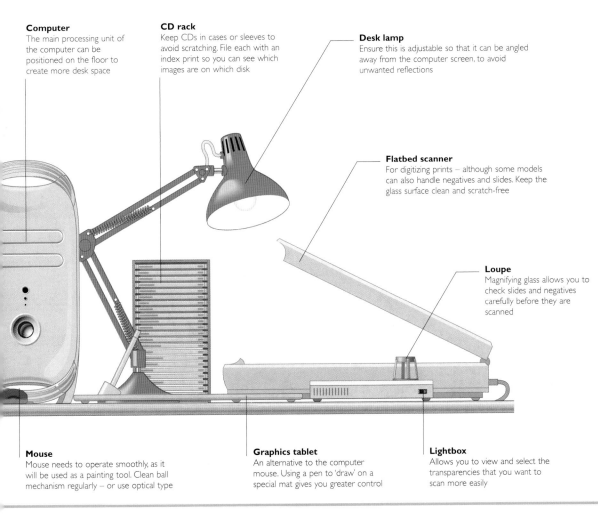

Computer
The main processing unit of the computer can be positioned on the floor to create more desk space

CD rack
Keep CDs in cases or sleeves to avoid scratching. File each with an index print so you can see which images are on which disk

Desk lamp
Ensure this is adjustable so that it can be angled away from the computer screen, to avoid unwanted reflections

Flatbed scanner
For digitizing prints – although some models can also handle negatives and slides. Keep the glass surface clean and scratch-free

Loupe
Magnifying glass allows you to check slides and negatives carefully before they are scanned

Mouse
Mouse needs to operate smoothly, as it will be used as a painting tool. Clean ball mechanism regularly – or use optical type

Graphics tablet
An alternative to the computer mouse. Using a pen to 'draw' on a special mat gives you greater control

Lightbox
Allows you to view and select the transparencies that you want to scan more easily

OTHER ITEMS

- Comfort is a key requirement if you are sitting at your computer for long periods. Your chair must support your back and should be at the correct height so that your forearms are horizontal when you are working at the keyboard.

- Old slides and negatives are likely to be covered in a layer of mold, fingerprints and grime. These should be removed using a special cleaning solution and lint-free cloth – such as PEC-12 and PEC Pads. This will minimize digital touch-up work after scanning, and will maximize image quality.

- A blower brush, or compressed air, is also useful for removing dust immediately before scanning.

COMPUTER RETOUCHING

Digital image manipulation software can change pictures in many different ways, but it is often the straightforward techniques that are the most useful. Whether you shoot your pictures on film or with a digital camera, nearly all shots benefit from minor adjustment. Small blemishes to the film or the composition can be removed with the use of the cloning tool, which copies neighboring groups of pixels over an offending scratch or unwanted element in a picture.

Exposure can usually be improved, either globally or just in small areas of the image, in ways that simply are not possible with conventional darkroom techniques. For instance, areas of a picture can be selected by color, and then the hue changed to get a more pleasing composition.

When retouching images on screen you can see exactly what you are achieving at each stage and can go back one or more steps if you are not happy with the result.

Change of scenery, *left*
In this image the backdrop color has been changed to create a stronger contrast with the color of the dancer's dress. Compare the image with the original (*see page 129*). This is achieved most easily using the hue/saturation command in a program such as Photoshop Elements. An effect similar to using a slow shutter speed has also been added by using a blur filter.

Change of angle, *below*
The original image (*see page 237*) has been rotated, reversed, and recropped for this version, and the feeling of movement has been emphasized by the addition of blur lines.

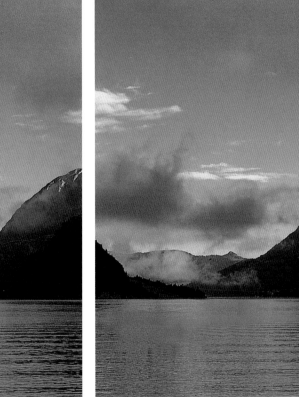

Removing picture elements, *far left & left*
One of the advantages of digital manipulation is the ease with which minor tweaks can be made to a composition. Litter, road markings, advertising hoardings, and unwanted passers-by can be removed with relative ease. In this shot, cloning techniques have been used to remove the wooden piles from the water, and to increase the area of blue sky. Even old pictures shot on film can be manipulated in this way once they have been digitized using a scanner.

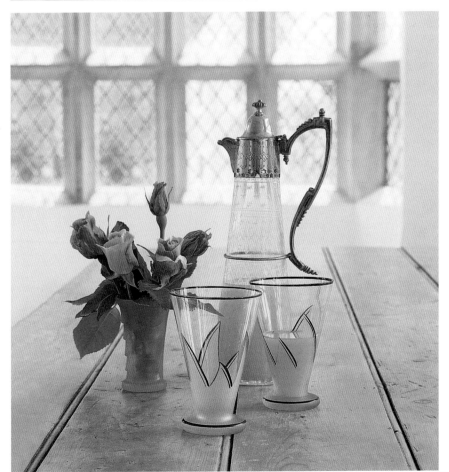

Original shot, *above*
This still life shot is slightly tilted. The image could be cropped traditionally, but much of the window in the background would be lost from the composition.

Corrected version, *right*
Using digital techniques, extra areas of table and window can be added to the shot, by cloning them from other areas. The shot can then be rotated so the verticals are upright without losing any of the photograph's setting.

DIGITAL FILTER EFFECTS

Most digital manipulation software comes with a variety of special effects that can be added to an image with a single mouse-click. Inevitably, a number of these effects recreate those that have been available for decades to photographers using darkroom techniques or optical filters. The advantage that the computer brings is in the amount of control that is available over the final result. Moreover, once the desired effect is achieved, the image can be printed again and again without further work, and the chosen settings can also be applied to other shots.

As with all special effects, most digital filters are best used only occasionally. But there are some that merit more regular use, such as blur and sharpening controls. Gaussian blur, for instance, allows you to throw out of focus details that were not possible to hide when taking the original shot. The unsharp mask (USM), meanwhile, can be applied in varying degrees to practically every picture once other adjustments have been made, to improve the apparent sharpness of the shot.

Mono conversion
Creating a black and white print from a color original traditionally involves copying the film to create an interneg, then printing the result. On screen, a monochrome shot can be created almost instantly from a color file. With some programs it is also possible to control the exact tone of gray that each hue becomes.

Going for grain
Traditionally, a grainy effect is created by using a fast film, by push processing, or by selective enlargement of a print. Digitally, however the original shot was taken, the effect can be achieved by selecting a filter from a pull-down menu. The original still life (*above*), was shot on slow film in the studio, but when scanned digitally the shot can be given a grainy, atmospheric look (*right*). The program will often allow you precise control over both the size and the pattern of the grain.

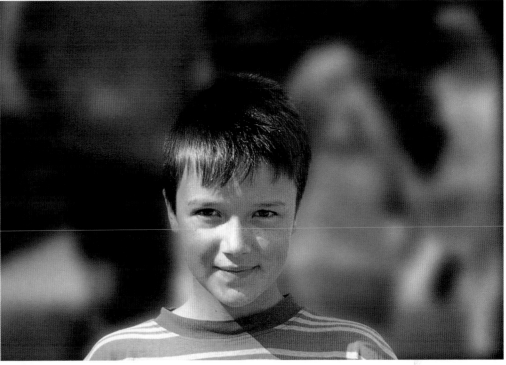

Gaussian blur

In the original shot (*above*), the people in the background are not sufficiently out of focus and create a distraction to the main subject of the portrait. Using digital manipulation software it is possible to work on a very specific area of a picture. In this case, the background is thrown out of focus using the Gaussian blur filter (*left*). The amount of blur can be adjusted until the effect looks convincing; sometimes it is necessary to blur different elements by different amounts in order to achieve this.

Watercolor filter

There is a wide range of filters available that can be used to add artistic effects to images. The filters are supplied either with popular programs or separately as plug-ins. The effects can give photographs the appearance of oil paintings, etchings, stained-glass windows, or charcoal sketches, for instance. In this example, the original image (*above*), has been transformed to look like a watercolor painting (*left*). Always keep a copy of the original photograph (as a separate file or layer), when using this type of effect, otherwise it is impossible to revert to the original digital image.

COMBINING IMAGES ON COMPUTER

Digital darkroom software provides powerful tools for combining two or more images into one picture. Not only can different elements be cut from one image file and seamlessly inserted into a different picture, but many programs offer the ability to work in layers. Layers allow you to work on different elements separately, and to include multiple copies of the image, with slight differences between each. This allows you to check whether the image has improved by switching layers on or off, and also means that you can return to a former state by deleting unsuccessful layers. The transparency of each layer can be altered, and it can be combined with the layer below in different ways. These layer blending modes can be used for a wide range of creative effects, even when two layers are identical.

Whatever your artistic intent, layers are an important way of structuring your manipulation work. They allow you to undo each stage of your work and avoid irreparable mistakes.

The original shots, *above*
Two charming individual portraits of brother and sister, with great smiles. It would be nice to capture the two expressions in the same frame. Fortunately, digital imaging allows you to do this without too much difficulty.

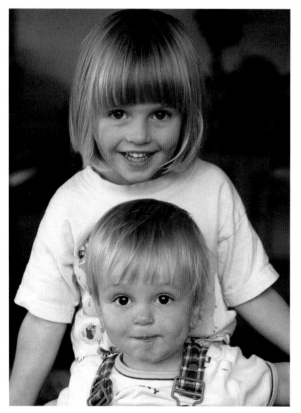

The template, *above*
With groups, it is hard to get everyone looking perfect. This is the best shot of the session, but the girl's pose and boy's expression are not quite natural. The solution is to combine elements from more than one shot.

Finished image, *right*
Combining the three different pictures creates a perfect portrait of the children. Each shot was put on a separate layer, cropped, and adjusted in size, color, and exposure so that they matched well. The visible joins between each of the elements were hidden by careful use of the cloning tool.

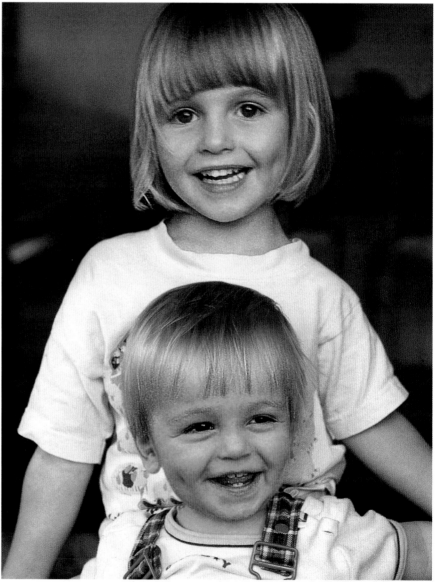

Top layer
This is a nice portrait, but the backdrop is bland, and the horizon line distracting.

Bottom layer
Spectacular sunsets like this make ideal backdrops for using with other images.

Combining layers, *right*
The two original pictures were put on separate layers. The background of the portrait was removed using the digital rubber so the sunset showed through. The efficiency of the eraser tool was reduced near the outlines of the girls to ensure a seamless result.

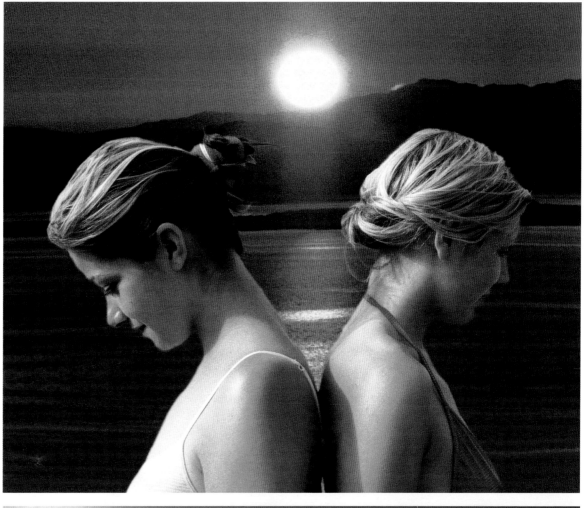

Action shot, *right*
This photograph uses similar techniques to the above, with pictures combined on separate layers. In this case, the image sizes were adjusted to give a feeling of depth and movement.

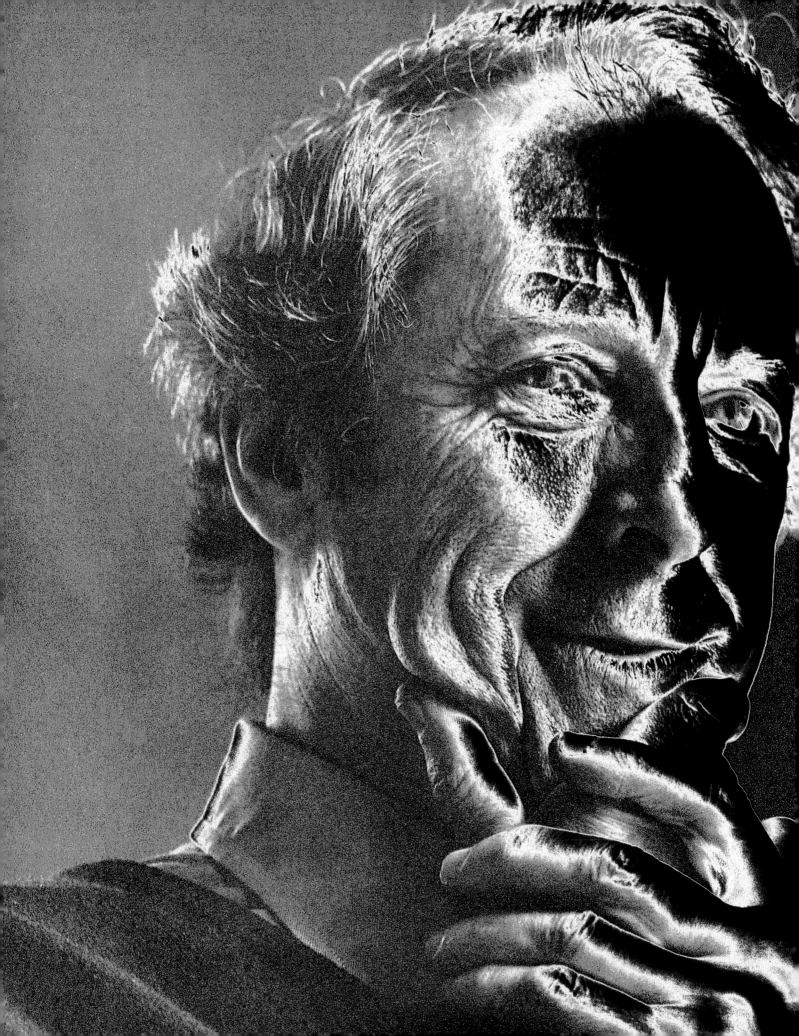

TRADITIONAL
MANIPULATION

A wide range of photographic techniques can be used to create special-effect photographs that are far removed from normal images. This section shows effects that can be achieved by using special films, by darkroom manipulations of both color and black and white originals, and by combining traditional photographic chemistry with software.

SPECIAL FILMS

Using special films is a simple way to create unusual imagery. Special films include black and white and color infra-red-sensitive emulsions and high-contrast recording film.

Infra-red film is sensitive to the infra-red region of the electromagnetic spectrum and can therefore record images by light that is normally invisible. The film is usually used in conjunction with an infra-red-transmitting filter over the camera lens, which blocks all visible lightwaves. Infra-red radiation comes into focus on a slightly different plane than visible light, so you may need to adjust your lens according to the infra-red focusing index (a red or orange line engraved next to the ordinary focus index on the lens barrel).

Special recording film mainly registers black and white, rather than the intervening shades of gray. To achieve a similar effect, use regular black and white emulsion film, then use high-contrast film developer and print onto high-contrast lith paper.

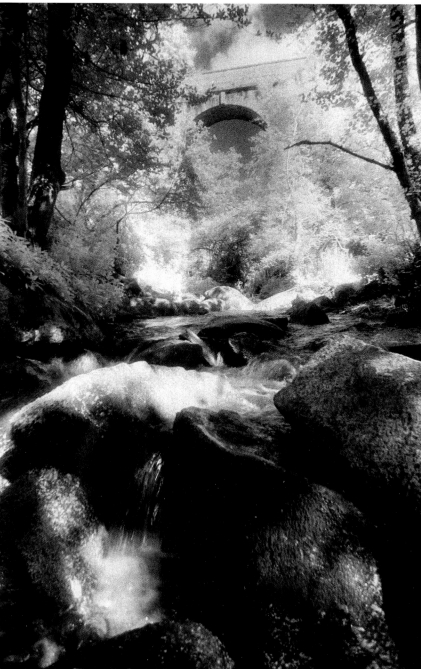

Color infra-red, *left*
This film can be used in conjunction with colored filters for a range of special effects. The result will depend on how much individual elements in a scene reflect infra-red radiation, as illustrated (*left*) and (*above left*). Some elements reflect no infra-red, appearing near-black.

Striking tones, *above*
Atmospheric haze is invisible to black and white infra-red film, so images taken with it are often rendered with great clarity. In addition, striking tones are made apparent, notably the snowy white foliage in this scene, which seems to give the image an almost surreal appearance.

Grain effect, *opposite*
Film manufacturers go to great lengths to produce ultra-fast emulsions with the minimum amount of graininess. However, if you want to achieve the type of impressionistic result shown here, use a fast ISO 3200 emulsion and then develop the film in a grain-enhancing developer.

Streaky light effect
The atmosphere of this carnival scene at dusk was enhanced by using artificial-light film. Using a slow shutter speed has recorded the fairground lights as colorful blurred streaks.

DIGITAL SOLUTIONS

Most digital cameras are sensitive to infrared light. They produce effects similar to black-and-white infra-red film if you use a deep red or special IR filter over the lens — then convert the recorded result to monochrome.

High-contrast treatment
A scene that is inherently contrasty provides the best starting point for this technique. Photographed on ordinary black and white emulsion, this image of a horse and young rider in the burned ruins of a barn was developed in a high-contrast developer to suppress most of the half-tones and then printed onto lith paper.

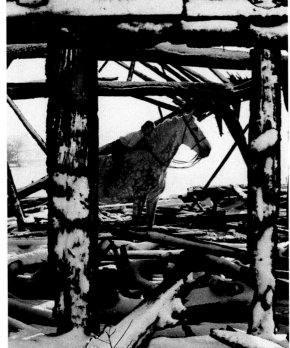

MULTIPLE IMAGES

There are many ways to create multiple images on film. One simple method is to use a mini-strobe flashgun, which fires a rapid burst of flashes during a single exposure. A moving subject will be caught in a different position every time the flash goes off. However, too much ambient lighting will cause blurring in the final image. On some cameras it is possible to reset the shutter without advancing the film; you can then make repeat exposures either on top of each image or in selected areas.

SANDWICHING

The traditional and easiest technique for creating multiple images is to sandwich film originals together in a single slide mount and project the result onto a screen. This can then be rephotographed directly. Alternatively, the film sandwich can simply be loaded into an enlarger and printed in the normal fashion.

Slide sandwich, *above*
A slide of windmills and one of reflections in water were sandwiched to make this image. First experiment by combining different slides on a light box, then mount the chosen slides for projection or reshooting, or to use in the enlarger.

Double exposure, *below*
Many film and digital SLR cameras allow you to combine two or more exposures in the same frame. Here a shot of a dried river bed has been combined with a close-up portrait. Such multiple exposures give a textured canvas to an image.

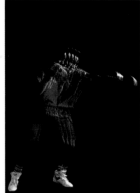

Strobed action, *above*
The flash used to take this multiple image of a boxer is an amateur unit capable of only six rapid flashes. Professional plug-in strobe units are also used by athletes to make detailed photographic records of their events, which are then used to analyze how slight changes in technique could improve their performance.

Seeing double, *left*
For this image the model wore black clothes and was placed in a dark room. A series of flash-lit shots was taken with the shutter held open on setting B. The model shifted position for each shot. When super-imposed, the images make a dramatic composition.

DIGITAL SOLUTIONS

Digital manipulation programs allow you to combine images in a number of ways. Each element is put on a different layer – and can be resized, color corrected, and so on, to suit. By changing the opacity of each layer, and by experimenting with different blending modes you can create effects that are similar or very different to those with traditional techniques.

BLACK AND WHITE DARKROOM TECHNIQUES

There are many techniques available for working in black and white; the few radical effects here are just a sample. These include printing a negative in combination with a patterned screen to break up the image, or introducing color into a print by hand or by chemical toning.

Changes you may want to make to an image include rectifying tonal imbalances. The sky in a landscape, for example, may have been overexposed if the land required extra exposure to define enough detail. In this case, give the sky on the negative extra exposure under the enlarger to balance the picture.

Patterned screens
Various effects are possible by printing with patterned screens. The chimneys (*below*) were printed with a linear screen and the ponies with a mezzotint (*below right*). Screens can also be used for color.

Local density, *right*
A shaped piece of dark cardboard known as a dodger was held over the the image of the sculptor Elisabeth Frink on the printing paper for the last quarter of the exposure time under the enlarger.

Hand coloring, *opposite*
Any black and white print produced on fiber-based paper can be selectively colored – using special dyes, pens, or crayons.

DIGITAL SOLUTIONS

Most darkroom effects can easily be achieved on a computer using editing software. An image can be toned, for instance, in seconds without chemicals, and the effect saved so that it can be printed again.

Color toning, *left*
Toning solutions not only add color to a print, they can help to preserve the image. The toners used here are sepia, copper, and blue, respectively.

SOLARIZATION AND LITH FILM SANDWICHING

Solarization (also called the Sabattier effect) is a technique for producing a black and white or color image that is part positive, part negative. This is done by exposing the partially developed image (on paper or film) to white light. For the best results, an image with contrast should be used, because the re-exposure flattens contrast considerably.

To solarize, introduce light selectively when a print is partially developed in a tray – using a small flashlight is a handy way to do this. A more advanced technique is to solarize a film negative or positive. You can then make as many prints as you want.

Lith film sandwiches are made by contact printing a lith film negative to form a lith film positive, then placing the two together in register. You can then make prints from this sandwich onto either black and white or color printing paper, with good results.

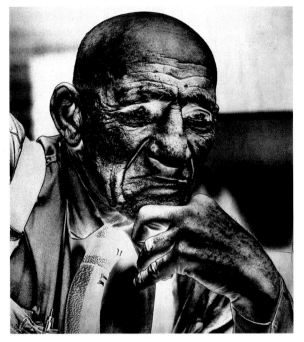

Black and white effect
A normal black and white print was the starting point for this image. A black and white copy negative was then made from it. The negative was then solarized and used to make a print on regular black and white printing paper.

Color solarization
For this striking image, a copy negative was made from a 35mm transparency, then solarized using a color head enlarger. The color of a film image can be altered by adjusting the filtration of the light used for solarization.

DIGITAL SOLUTIONS

The easiest way to create a solarized image digitally is to use the "Curves" control found on programs such as Photoshop. The line of the on-screen graph is simply pulled into a U-shaped curve.

Black and white lith, *left*
For this print, a lith film positive was made, then contact printed to make a lith film negative. The negative and positive were sandwiched in register.

Color lith, *below*
For this color result, the negative/positive lith film sandwich described above was used together with color printing paper.

COLOR MASKING TECHNIQUES

All the images shown here were printed from slides onto positive/positive color printing paper, which is designed to produce a positive print from a positive original. The color response of the prints was manipulated using different types of mask.

A highlight mask is made by contact printing a slide onto high-contrast lith film. The slide and lith mask are then combined in register and printed. The highlight areas of the slide print as black or gray depending on the density of the lith; other areas appear normal. To adjust the colors of the shadow areas, first make print-sized negative and positive masks from the slide. With the slide in the enlarger and the positive mask in contact with the printing paper, make a first exposure. Remove the positive and register the negative mask in contact with the paper, then expose to light to tint the shadows.

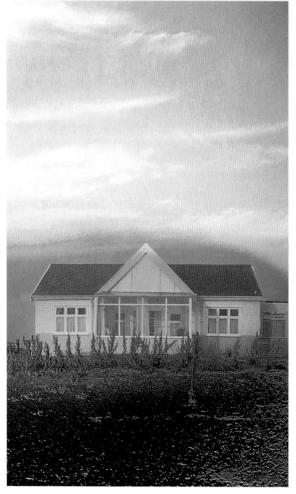

Shadow mask, *above*
The shadow colors here were created by first using a positive mask in contact with the printing paper. This covered the shadow areas, but the rest of the print was normally exposed. Another exposure was made with a negative mask, and the enlarger filtration controls set appropriately.

Flat area mask, *far left*
A negative and a positive mask were contact-printed in register to produce this effect. With the slide in the enlarger, the paper was exposed for three-quarters of the correct exposure time. The positive mask was then removed and the exposure completed.

Solarization effect, *left*
This print was made in the manner described above, but the enlarger lens aperture was opened one stop, doubling the amount of light reaching the paper and creating a pseudo-solarization effect. Colored filtration was used to get the eerie, surreal result.

Highlight masking
This technique involves a lith film negative mask being printed in register with the slide original. Depending on the density of tone, the mask keeps a certain amount of light from shining through the highlight areas of the slide. However, if the mask is tinted rather than left as a gray tone, as it was here, dramatic prints with a mixture of real and unreal colors can be produced.

DIGITAL SOLUTIONS

• Digital manipulation packages allow you to "sandwich" different versions of the same image together in different ways. There are many possibilities, and you can try out different effects until you get the image you require on screen without wasting paper.

• To get the effects shown here, open up your image and copy it onto a separate layer. Convert this layer into a "lith" negative by using the "Invert" command. Increase the contrast, then reduce the color saturation to zero. Combine the two layers using a blending tool such as the Difference or Multiply options in Photoshop. Also try altering the opacity of the layer.

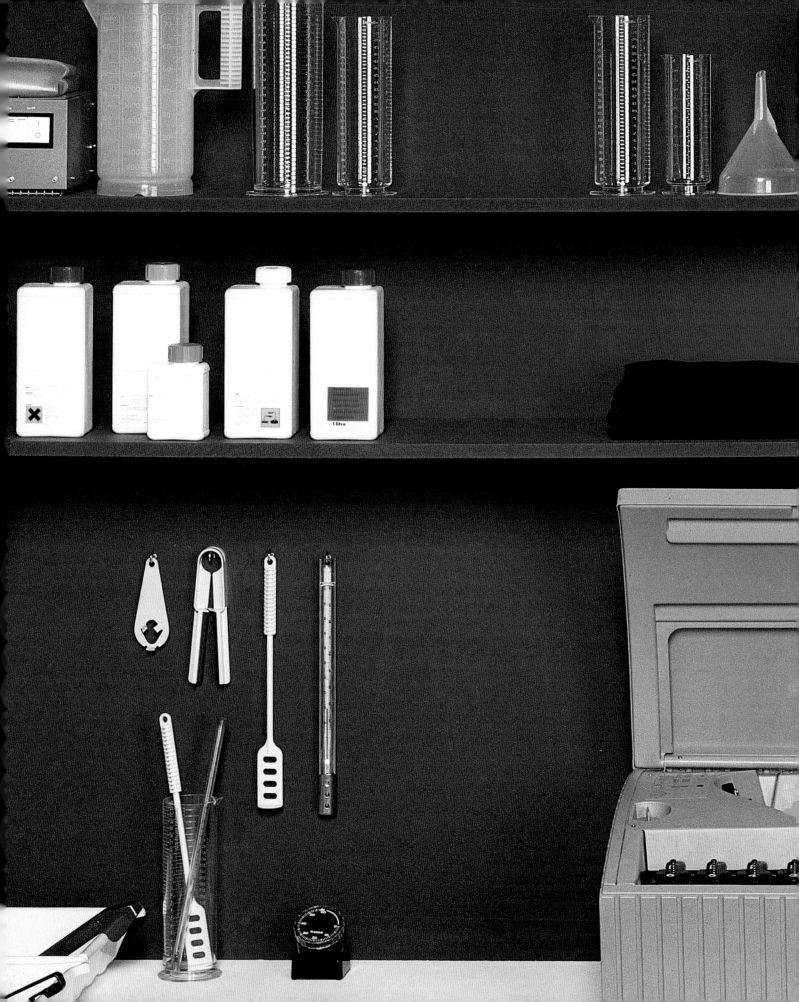

DARKROOM **AND** STUDIO EQUIPMENT

In a studio environment you have complete control over the lighting, which allows you to concentrate on producing precisely the type of image you want. Taking the picture is only half the creative process, however. It is in the darkroom that you can exercise ultimate control over the final appearance of the image. This section shows all the basic equipment you need to set up a home darkroom. Also included is useful information on systems for viewing and storing slides, negatives, and prints.

THE HOME STUDIO

Many amateur photographers would like to create their own studio but are discouraged from doing so because they mistakenly believe that a studio necessarily requires a lot of space and that this area would have to be permanently set aside.

SPACE REQUIREMENTS

The size of a home studio depends on what types of subject you intend to photograph. If most of your photography involves table-top subjects, such as small still life objects, then an area measuring about 8 x 8ft (2.5 x 2.5m) will usually be sufficient. For portraits, however, especially full-length shots, you will probably need an area about twice that size at least. Generally, square rooms are best, since they give you the greatest flexibility in positioning lights and reflectors.

A spare bedroom is excellent for setting up a studio because you can leave camera, tripod, lights, reflectors, and background papers permanently in place. If this is not possible, equipment can be stored in a large closet and assembled in about 30 minutes when required.

WINDOWS AND LIGHTING

In a room with large windows (and ideally a skylight for additional lighting), you may not need to use flash or other lights if you restrict yourself to working during daylight. If possible, a home studio should have a good-sized window to supplement any lights used. A darkening shade or blinds can be used to exclude all window light when necessary.

STUDIO REQUIREMENTS

• White walls and ceiling to maximize ambient lighting levels and to double as reflectors without creating unwanted color-casts.

• Storage shelves or closets to store accessories and equipment when not in use, so that the working part of the studio can be kept free of clutter.

• A solid floor to stop vibrations being transmitted through the tripod to the camera.

• A ceiling high enough to allow you to position lighting units above the height of a standing figure.

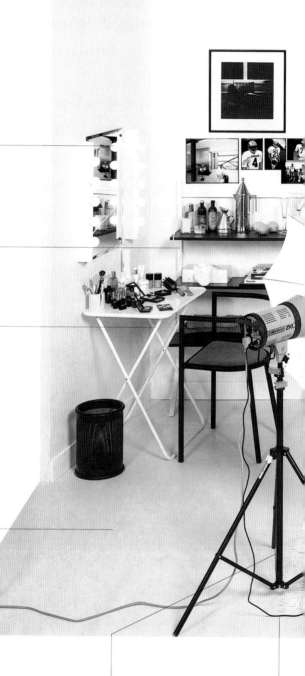

Neutral-colored walls
Walls and ceiling should be painted either white or a pale neutral color so that they reflect light without introducing an unwanted color-cast

Make-up mirror
The camera is critical of imperfections, so a well-lit make-up mirror is essential

Storage shelves
Extra storage areas are always useful for camera and lens accessories, props, clamps, tape, reflectors, and numerous other items

Make-up table
Table for cosmetics, hair accessories, and brushes is useful for portraiture and all shots involving life models

Floor
Solid floor is essential to keep movement on the set from causing vibrations that might affect the camera

Flash unit
Main light is positioned about 45° to the subject

Synchronization lead
Links camera to the power pack so that the flash fires at the same time as the shutter is released

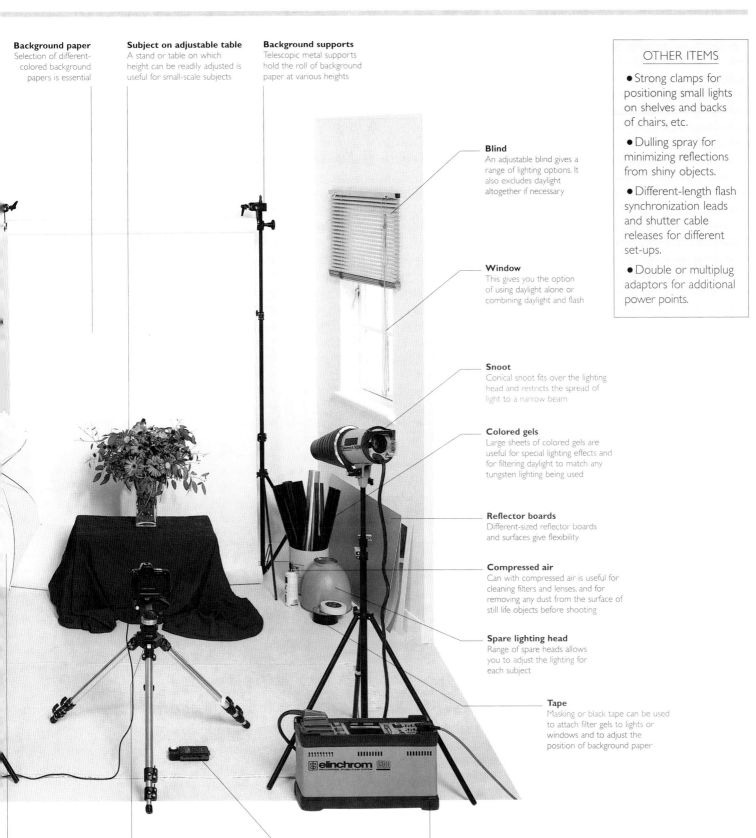

Background paper
Selection of different-colored background papers is essential

Subject on adjustable table
A stand or table on which height can be readily adjusted is useful for small-scale subjects

Background supports
Telescopic metal supports hold the roll of background paper at various heights

Blind
An adjustable blind gives a range of lighting options. It also excludes daylight altogether if necessary

Window
This gives you the option of using daylight alone or combining daylight and flash

Snoot
Conical snoot fits over the lighting head and restricts the spread of light to a narrow beam

Colored gels
Large sheets of colored gels are useful for special lighting effects and for filtering daylight to match any tungsten lighting being used

Reflector boards
Different-sized reflector boards and surfaces give flexibility

Compressed air
Can with compressed air is useful for cleaning filters and lenses, and for removing any dust from the surface of still life objects before shooting

Spare lighting head
Range of spare heads allows you to adjust the lighting for each subject

Tape
Masking or black tape can be used to attach filter gels to lights or windows and to adjust the position of background paper

Umbrella diffuser
Light is diffused through the umbrella to provide a softer light source

Camera and tripod
The camera should, whenever possible, be mounted on a sturdy, adjustable tripod

Flash meter
If possible, choose a light meter that can also be used as a flash meter

Power pack
Heavy-duty power source is required for the high output and rapid recycling times required of studio flash units

OTHER ITEMS

- Strong clamps for positioning small lights on shelves and backs of chairs, etc.

- Dulling spray for minimizing reflections from shiny objects.

- Different-length flash synchronization leads and shutter cable releases for different set-ups.

- Double or multiplug adaptors for additional power points.

THE HOME DARKROOM

All you need to set up a home darkroom is a windowless area, such as a walk-in closet or a spare room that can be sealed against outside light. The essential equipment required is shown on these pages. Arrange your darkroom to separate the wet and dry darkroom processes as much as possible. The wet side of the room is where all the film and paper processing and washing takes place and the dry side is where unprocessed and processed film and printing paper are handled, and where the enlarger is found.

It is best to have running water, but you can use a room that does not have a sink if you use a pail to move processed prints for washing elsewhere. The walls and ceiling of your darkroom can be a light color except for the area around the enlarger, which should be black. Proper ventilation, so that there is a flow of air through the darkroom, is essential.

FILM AND PRINT PROCESSING

Total darkness is required when removing an exposed film from its cassette and loading it onto a spiral. Once the spiral is inside a processing tank and the lid is firmly in place, the room lights can then be turned on.

The chemicals used in film and print processing must be diluted in exactly the proportions stated, and solutions must be brought to the correct temperature, and kept in contact with the film or printing paper for exactly the right time. Consistency of time and temperature ensures standardized results.

PRACTICAL ADVICE

● All light sources in the darkroom should be operated by pull-cords. Ordinary light switches used with wet hands are potentially dangerous.

● Use correct strength bulbs in safelights to prevent film fogging.

● All ventilation units should be sealed to keep outside light from entering the darkroom.

DARKROOM PROCESSING SIDE

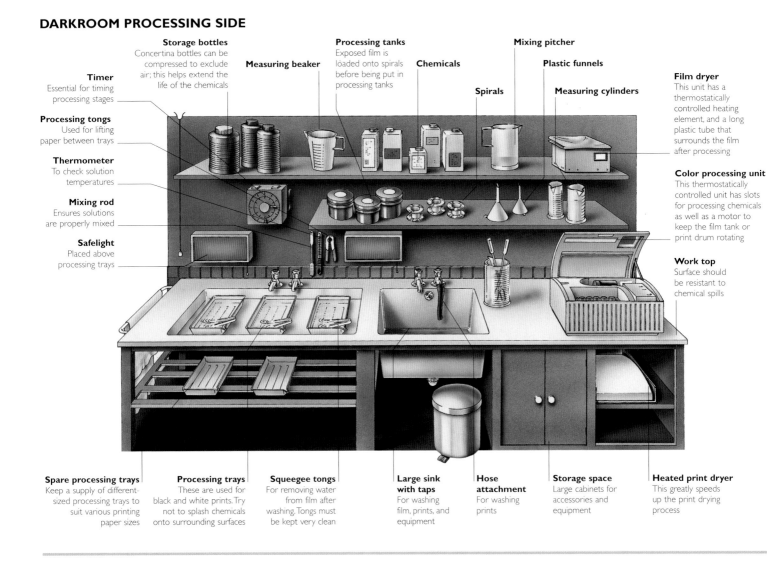

Storage bottles
Concertina bottles can be compressed to exclude air; this helps extend the life of the chemicals

Measuring beaker

Processing tanks
Exposed film is loaded onto spirals before being put in processing tanks

Chemicals

Mixing pitcher

Plastic funnels

Spirals

Measuring cylinders

Timer
Essential for timing processing stages

Processing tongs
Used for lifting paper between trays

Thermometer
To check solution temperatures

Mixing rod
Ensures solutions are properly mixed

Safelight
Placed above processing trays

Film dryer
This unit has a thermostatically controlled heating element, and a long plastic tube that surrounds the film after processing

Color processing unit
This thermostatically controlled unit has slots for processing chemicals as well as a motor to keep the film tank or print drum rotating

Work top
Surface should be resistant to chemical spills

Spare processing trays
Keep a supply of different-sized processing trays to suit various printing paper sizes

Processing trays
These are used for black and white prints. Try not to splash chemicals onto surrounding surfaces

Squeegee tongs
For removing water from film after washing. Tongs must be kept very clean

Large sink with taps
For washing film, prints, and equipment

Hose attachment
For washing prints

Storage space
Large cabinets for accessories and equipment

Heated print dryer
This greatly speeds up the print drying process

DARKROOM PRINTING SIDE

Enlarger column
The enlarger head can be moved up and down on the column to make different-sized enlargements

Enlarger head
This contains the light source and mixes the light before it reaches the film original and the lens. It also houses colored printing filters of varying strengths

Timer
Easy-to-read timer to check the length of exposure of the printing paper

Light
Wall-mounted white light with string pull-cord

Wall color
The dry side of the darkroom where the enlarger is located should be painted black

Compressed air
Useful for removing dust and hairs from negatives and for cleaning the enlarger lens

Focus magnifier
Magnifies a small section of the projected image from the enlarger to ensure focus is accurate

Bench
Work top should have an easy-to-clean surface

Color analyzer sensor
This is held under the lens when a color original is being projected by the enlarger. It analyzes the color content of the image and recommends exposure times and filter settings

Printing papers
Different sizes of printing paper are required and, for black and white printing, different contrast grades

Printing easel
This holds the paper flat on the enlarger's baseboard during exposure; the metal arms can be adjusted to give different-width white borders around the finished print

Contact printing frame
Strips of negatives are loaded into slots on the glass cover and then brought into contact with a sheet of printing paper on the base

Negative carrier
Individual negatives, or short strips of negatives, are held in position between the enlarger's light source and the lens

Additional printing papers
Store little-used or large-sized papers on shelves out of the way

Floor
Hard wearing, easy-to-clean floor made of a nonslip material

Print trimming equipment
Gives a straight, clean edge; a sharp craft knife can also be used

VIEWING AND STORING IMAGES

As your interest in photography develops, you will need to create an effective system for storing and cataloging your increasing number of slides, negatives, and prints.

Slides generally come from the processing laboratory ready-mounted and packed in convenient plastic boxes to protect them from dust. If you want to be able to see all of them at a glance, file them in clear plastic sleeves. Slides can also be conveniently stored in projector trays, but these can be costly and they take up a lot of space.

Keep negatives in acid-free paper sleeves in a file, and, for quick reference, file the negative contact sheets alongside. Prints are best displayed in albums, mounts, or frames.

SLIDE CHECKING, SELECTION, STORAGE, AND PROJECTION

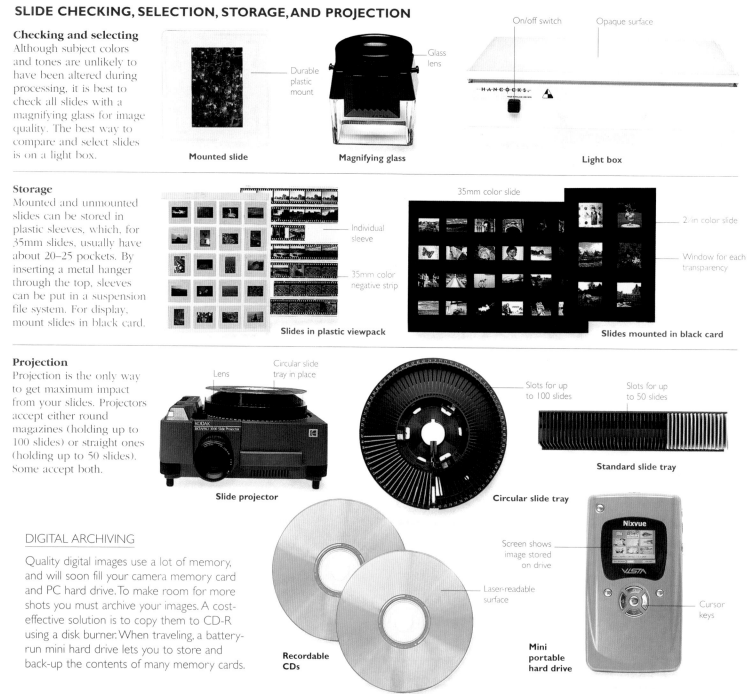

Checking and selecting
Although subject colors and tones are unlikely to have been altered during processing, it is best to check all slides with a magnifying glass for image quality. The best way to compare and select slides is on a light box.

Mounted slide — Durable plastic mount

Magnifying glass — Glass lens

Light box — On/off switch, Opaque surface

Storage
Mounted and unmounted slides can be stored in plastic sleeves, which, for 35mm slides, usually have about 20–25 pockets. By inserting a metal hanger through the top, sleeves can be put in a suspension file system. For display, mount slides in black card.

Slides in plastic viewpack — Individual sleeve, 35mm color negative strip

Slides mounted in black card — 35mm color slide, 2¼in color slide, Window for each transparency

Projection
Projection is the only way to get maximum impact from your slides. Projectors accept either round magazines (holding up to 100 slides) or straight ones (holding up to 50 slides). Some accept both.

Slide projector — Lens, Circular slide tray in place

Circular slide tray — Slots for up to 100 slides

Standard slide tray — Slots for up to 50 slides

DIGITAL ARCHIVING

Quality digital images use a lot of memory, and will soon fill your camera memory card and PC hard drive. To make room for more shots you must archive your images. A cost-effective solution is to copy them to CD-R using a disk burner. When traveling, a battery-run mini hard drive lets you to store and back-up the contents of many memory cards.

Recordable CDs — Laser-readable surface

Mini portable hard drive — Screen shows image stored on drive, Cursor keys

VIEWING AND STORING NEGATIVES

Viewing negatives

Even with careful scrutiny it is often difficult to make out the details of an image on a negative, and almost impossible to compare image quality. Contact sheets are very useful for selecting the best image, as they give an approximate idea of what your negatives will look like when printed and they can be stored adjacent to the negatives in an ordinary ring binder.

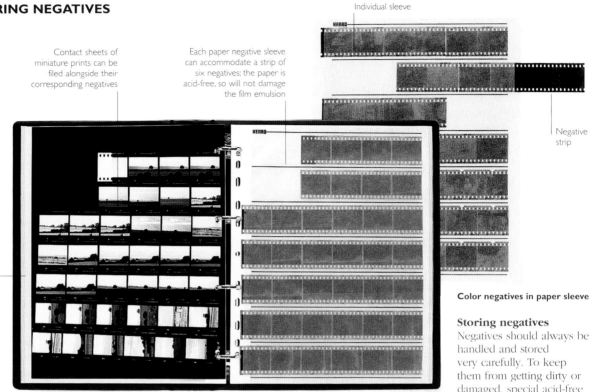

Contact sheets of miniature prints can be filed alongside their corresponding negatives

Each paper negative sleeve can accommodate a strip of six negatives; the paper is acid-free, so will not damage the film emulsion

Individual sleeve

Negative strip

Color negatives in paper sleeve

Hard ring binder protects the contact sheets and negative sleeves; mark each page with a date or reference number so that all the images can be readily identified

Ring binder with paper negative sleeves and contact sheet

Storing negatives

Negatives should always be handled and stored very carefully. To keep them from getting dirty or damaged, special acid-free paper sleeves are available.

VIEWING AND FRAMING PRINTS

Viewing prints

Albums for standard-sized prints include those with sticky pages to hold prints in place, in which every page is covered with a plastic overlay. Others require adhesive "corners" to hold prints in place.

Prints are held in place by a thin plastic overlay in this spiral-bound album; the dark album pages enhance the photographs

Lightweight glass frame is secured onto backboard with metal clips

Print can be cut to size to fit the frame if necessary

Dark card can be used to create a border around an image

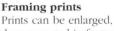

Framing prints

Prints can be enlarged, then mounted in frames for display. Of the many easy framing and mounting kits available, those shown here use clips to hold the glass and backboard together. Others have wood or aluminum frames.

Spiral-bound album with color prints arranged beneath plastic overlay

Framed prints

PICTURE-TAKING ERRORS

Modern camera film is made to very high standards. It is unusual for there to be anything wrong with quality or consistency when it leaves the factory. Even own-brand and promotional packs of film should present few problems – they have more than likely been produced by a leading film manufacturer. Remember that film should always be kept in a cool place, out of direct sunlight, in low humidity, and away from all sources of chemical fumes, such as household cleaners and bleaches. Many photographers store their film in a refrigerator. Always use and process film by the date indicated on the carton.

COLOR AND EXPOSURE PROBLEMS

Some pictures display odd color faults, such as an orange or blue color-cast. Such faults usually have nothing to do with film quality; color-casts are caused by exposing film designed for specific lighting conditions incorrectly. On color print film, casts can be corrected or minimized by the printer. With color slide film, however, there is no printing stage, so always use the correct film for the light source, or use a correcting filter over the lens. A green color-cast can result from using old or badly stored film. Most modern cameras have an automatic exposure control that will generally produce good, well-exposed images in average conditions (where the subject is frontally lit and the entire frame has evenly distributed light and dark tones). Autoexposure problems are most likely to occur if the subject is lit from behind or if it is much lighter or darker than its surroundings. If you consistently experience exposure problems, have your camera tested and serviced.

CAMERA CARE AND USE

Faults such as tilted horizons, lens obstructions, and framing problems that often result in a subject being chopped in half, are the typical errors of inexperienced photographers or those working with a camera that is new to them. The only cure is patience and attention to detail. Before exposing each frame, take extra care that the image you see in the viewfinder is the way you want it and that there is nothing obscuring the lens. Your fingers or the camera strap can get in the way, especially if you are using a compact camera. Establish a simple routine for camera care, checking that the lens is not dusty or smudged, and that the inside of the camera is free of hair, dust, and grit. This will guarantee a high percentage of successful, sharply focused, blemish-free photographs.

COLOR-CASTS

Overall orange color-cast
This usually occurs when film made for use in daylight or flash is exposed indoors by domestic tungsten lighting. Be sure to use the correct film for the lighting conditions or use a correction filter over the camera lens or light source. An orange cast can also occur if flash is bounced off an orange-colored surface before reaching the subject. Use neutral surfaces for bouncing light.

Orange color-cast

Overall blue color-cast (i)
This problem is rare and usually the result of exposing tungsten-balanced film by daylight or by flashlight. Again, use the right film for the lighting conditions, or use an appropriate correction filter. A blue cast can also occur if flash is bounced off a blue-colored surface before reaching the subject. Use neutral surfaces for bouncing light.

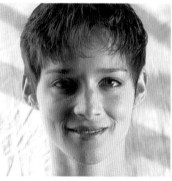
Blue color-cast

Overall blue color-cast (ii)
A strong blue cast can be caused by a very smoky atmosphere in the room where a shot is taken or excessive amounts of ultra-violet light, which are particularly associated with coastal areas and mountain landscapes. Attach a clear UV filter to the lens to minimize this problem. A polarizing filter can sometimes have a stronger effect than a UV filter, but it will result in increased exposure times.

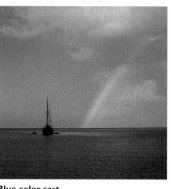
Blue color-cast

Overall green color-cast
In outdoor shots, this usually means that the film is old or has been badly stored. Always check the use-by date on film cartons. A green cast on photographs taken indoors may mean that daylight-balanced film has been exposed by fluorescent lighting. Overcome this problem by finding out precisely what type of fluorescent lighting is being used, then use the a correction filter, if available.

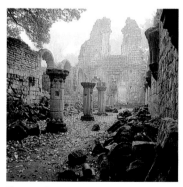
Green color-cast

COMPOSITIONAL ERRORS

Obstruction
If you are using an SLR camera, always check the viewfinder before taking a photograph to see if there is anything obscuring the lens. If you are using a compact camera, be sure that your fingers and camera strap are well away from the lens, because they will not appear on the direct vision viewfinder.

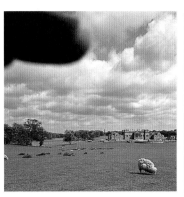
Lens obstruction

Parallax error
This occurs when parts of a subject are accidentally omitted. This usually happens when the parallax correction marks in the viewfinder of a compact camera are not taken into account, or the shot is taken too close to the subject. Frame your subject within the marks and do not come in closer than the nearest recommended focusing distance. Also examine your negatives carefully to check that this problem is not due to a printing error.

Subject partly obscured

Image distortion
Distortions can be caused by using the wrong type of lens to photograph a particular scene – for example, when a wide-angle lens is used too close to a subject or when a converging vertical distortion results from tilting the camera up to include the top of a tall building. To avoid distortion, be sure always to select the correct lens and camera position.

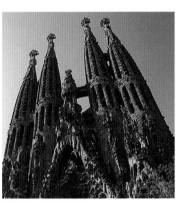
Distorted image

Tilted image
To avoid this problem, look carefully through the viewfinder before taking a picture to make sure that the horizon is parallel to the top or bottom of the frame.

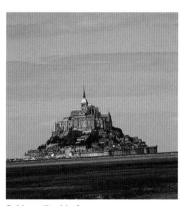
Subject tilted in frame

FLASH FAULTS

Flash-lit subject overexposed
This occurs when the flash is used too close to the subject, if the wrong aperture is used, or if the flash has been set with the wrong film speed. Follow your flash instructions regarding the correct working distance and aperture required for your unit, and make sure that you set the correct film ISO number on nonautomatic flash units.

Subject overexposed

Flash fall-off
This describes underexposure of all or part of a flash-lit subject. Check that the subject is within the recommended working distance for your flash unit (assuming that you are shooting indoors with enough reflective surfaces to bounce the light back). Outdoors, flash fall-off is rapid, so move closer to the subject or select a wider aperture. If you are using a manual flash, set it to the correct film ISO number.

Subject underexposed

Unsynchronized flash
This results in all or part of the image being black, and is most often associated with SLR cameras; it is caused by the flash firing when the shutter has only partially cleared the film plane. On manual cameras, check that you have set the flash-synchronization speed (usually 1/125 or 1/60 second) or the lightning flash symbol on the shutter speed dial correctly.

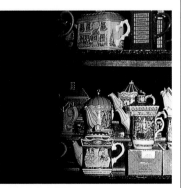
Image partially blacked-out

Vignetting
This shows as dark edges and corners on an image and can be caused if the spread of light from a flash is inadequate for the angle of view of your lens. Fitting a diffuser over the flash or bouncing a flash off reflective surfaces helps. Vignetting on nonflash images can be caused by using the wrong lens hood on a wide-angle lens, using more than one filter on a lens at the same time, or if a polarizing filter is fixed to a lens.

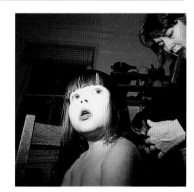
Vignetted image

CONTRAST AND EXPOSURE

Camera shake

This results in multiple images of the subject and general blurring. Adopting a steady, relaxed shooting posture is the best way to avoid it. If the shutter speed being used is very slow and likely to result in camera shake, support the camera on a tripod or level surface, such as a wall or the roof of a car. Using a fast film often allows a sufficiently fast shutter speed to be selected, which will avoid the problem altogether.

Blurred image

Multiple exposure

More than one image recorded on the same film frame indicates that the film has not been correctly loaded and is therefore not advancing properly. Be sure to follow the loading instructions in your camera manual carefully. If your camera has a rewind crank, check that it turns in the opposite direction from the direction the film is wound (this means that the film is loaded properly).

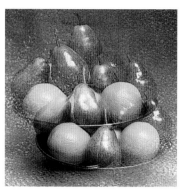

Double exposure

Subject movement

Part of the subject is blurred but all stationary parts of the scene are sharp. This occurs when the shutter speed being used is too slow to arrest the rapid movement of part of the subject. If possible, use a faster shutter speed, or find a more head-on camera viewpoint so that subject movement is effectively minimized.

Moving subject blurred

Excessive contrast

The shadowy areas of the print are too dark or highlight areas too bright. Unfortunately, the recording ability of film cannot resolve detail in both very bright highlights and deep shadows. Decide which is more important for the composition of the image and set the exposure accordingly. Alternatively, wait until contrast is less extreme, or, for close-ups, artificially lessen contrast by using a flash or a reflector.

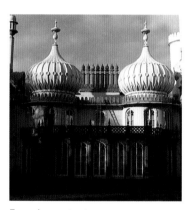

Excessive contrast

Flat contrast

This is when there is very little difference between the brightest and darkest areas of the image or subject, which is a problem if the photographer is relying on shape to make the image interesting. This problems occurs often in twilight shots. To light an appealing foreground or subject in such conditions, use a fill-in flash to create artificial contrast.

Image with flat contrast

Pale image or colors

Assuming that it is not a lighting problem, washed-out colors or a distinct lack of image contrast are often caused by a dirty lens or lens filter. Make sure all front lens elements, filters, and, on an SLR, the back lens element, are clean and free of scratches.

Image with washed-out colors

Overexposure

This is when too much light reaches the film, causing light shadow areas and bleached-out highlights. The fault lies in selecting the wrong shutter speed/aperture combination for the film speed. If overexposure happens consistently on an autoexposure camera, there may be a problem that needs professional repair.

Image overexposed

Underexposure

Like overexposure, this is when the wrong shutter speed/aperture combination has been selected for the film speed, resulting in too little light reaching the film, which causes heavy shadow areas and dull highlights. If underexposure happens consistently on an autoexposure camera, there may be a problem that needs professional repair.

Image underexposed

MISCELLANEOUS FAULTS

Unexposed film
Processed film that is perfectly clear has never been exposed. This happens as a result of the film not advancing. Follow the loading instructions in your camera manual carefully and always remember to wind the end of an exposed film back inside the cassette.

Unexposed film frame

Image out of focus
If the final image is partially blurred, the aperture selected may have resulted in insufficient depth of field. Autofocus cameras may focus incorrectly through glass or if the subject is not center-frame. If the subject is off-center, use the focus lock (if your camera has one) and consult your camera manual regarding potential autofocus problems. If the shutter speed is below 1/30, slight camera shake can also cause this problem.

Image out of focus

Blemishes on print
These usually take the form of spots, lines, and scratches on the film caused by dust, dirt, hair, or grit inside the camera. Check the inside of the camera whenever you remove a film. Blemishes or out-of-focus spots are also often due to raindrops on the lens when the photograph was taken.

Out-of-focus spot on image

Red eye
A subject's eyes glowing red usually happens when the built-in flash on compact cameras and SLRs is very closely aligned with the lens. If you cannot bounce the flashlight from a nearby wall or ceiling before it reaches the subject, use a film that is faster and correct for the available light minus the flash.

Subject's eyes glowing red

Film fogging
This happens when non-image-forming light reaches the film, usually when you open the back of a camera before rewinding the film. Remember always to rewind the film before removing it. An ill-fitting or loose camera back can also allow enough light in to cause fogging.

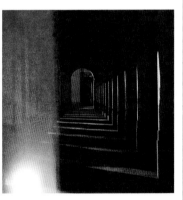

Film fogged by light

Flare
Never point the camera directly at a bright light source unless the lens is adequately shaded, otherwise bright patches of light (flare) will obscure parts of the film and produce a washed-out image. Flare can also be caused by fine scratches on the mat-black interior of the camera.

Flare surrounding light source

Grainy image
Using the wrong film speed results in an overly grainy image. This usually occurs if extremely fast film is used. It is most apparent when an image is greatly enlarged – a smaller print minimizes it. To avoid excessive graininess, use a slower, finer-grain film with an increased exposure time, or add extra lighting. Grain shows up more in the neutral and light-toned areas of an image.

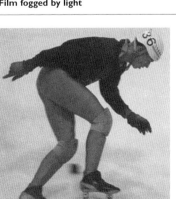

Overly grainy image

Half-framed image
This happens when you try to squeeze an extra frame of film at the end of a roll. Although film comes in standard lengths, you can occasionally take an extra frame. If the picture is important, however, it is worth taking the shot again when you have reloaded, in case the processing laboratory has to cut into the frame to detach the film from the core or attach a clip to the end while the film is drying.

Half-framed image

PRINTING ERRORS

At a large processing laboratory, films requiring the same type of chemical processing (E-6 for most color slides and C-41 for color negatives) are processed in long strips and passed through a series of chemical baths, which are constantly monitored to ensure that they are at the correct temperature. Depending on the volume of film being processed, the chemical solutions are constantly renewed to give consistent results; likewise at the printing stage. Each film image is printed by an enlarger that automatically analyzes its density and color content and sets the required color filtration and exposure length. A conveyor-belt system transports the individual sheets of exposed printing paper through another series of chemical baths and hot-air dryers, delivering hundreds of finished prints every hour.

HOME DARKROOM PROBLEMS

Naturally, the degree of automation in a film laboratory is not possible or desirable in the home darkroom, where you can work creatively on individual images as you process them. Inherent in home processing, however, is the likelihood of error. The most common problems to be avoided are related to darkroom cleanliness; dust,

hair, or grit on the surface of a negative or positive will result in a blemished and flawed print, even if filtration and exposure are perfect. More serious is the contamination of one processing solution with another. Even one drop of bleach or fixing agent spilled in a developer solution will mean a waste of expensive paper and chemicals.

CHEMICAL PROCESSES

The temperature of solutions and the timing of the separate chemical stages of print processing are other major sources of potentially avoidable problems for the home darkroom user. Some chemical solutions, particularly those used in color printing, have only to be fractionally off the exact working temperatures stated in their accompanying instructions to seriously affect the color balance of the print. It is also worth remembering that only a fixed number of chemical solutions can be used to process prints. Avoid having to throw away ruined printing paper and wasting your creative efforts by keeping accurate records of the number of prints passing through these solutions before their chemical action is exhausted.

BLACK AND WHITE PRINTS

Blurred prints
If a negative is sharp but the resulting print blurred, first check that the enlarger is focused correctly. As an aid, use a focus magnifier to view an enlarged part of the projected image on the baseboard prior to exposure. Also use a printing frame to ensure that the printing paper cannot move during exposure.

Blurred image

Inaccurate highlight detail
This can happen even though a negative has been correctly exposed. If details in the highlight areas of a negative do not appear in the corresponding dark areas on the processed print, you may need to print on a softer grade of paper, because hard grades yield fewer intermediate tones.

Lack of highlight detail

Soft print with "muddy" tones
Black and white prints can sometimes turn out too soft and muddy looking, even though the negative is satisfactory. To achieve increased contrast – when there are areas of solid black and bright white present – try using a harder grade of paper, which eliminates more intermediate tones to create a crisper, more contrasty image. Also make sure the developer you use is not contaminated.

"Muddy" tones

Spots and lines on a print
These are generally caused by dust, hair, or similar debris on the negative and are very noticeable on a print. The only way to prevent such blemishes is to keep your darkroom scrupulously clean. Inspect both sides of a negative each time you load one into the enlarger. When cleaning negatives, take particular care with the emulsion side, which scratches easily.

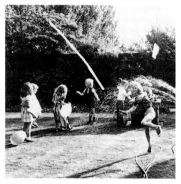

Spots and lines

COLOR PRINTS FROM NEGATIVES

Brownish streaks on print

The most likely cause of brownish streaks appearing on a print is that light hit the paper before exposure and fogged it. Be sure that your darkroom is completely sealed against white light, especially around doors and windows. If you have a safelight, check that it is the correct type for color printing, that the filter cover is secure, and that the bulb is the right wattage.

Brown streaks

Dark image lacking in contrast

Usually caused by exhausted bleach solution. Keep a note of the number and size of all prints passing though the solution. Discard and replace it before exhaustion point is reached. Read the instructions accompanying the chemicals to determine how often they should be renewed.

Lack of contrast

Heavy shadows and color-cast

These are probably due to the temperature of the developer solution being incorrect. The correct working temperature of the solution can be found in the instructions accompanying it. Use a thermometer to gauge the exact temperature of a solution before pouring it into a print drum. A thermostatically controlled processing unit for solutions and print drums makes these critical controls easier to maintain.

Heavy shadow areas

Pale, reversed image

If a processed print shows a pale image, reversed left to right, the paper was probably placed under the enlarger with the emulsion side face down, so that the paper was exposed through the back. (Note that prints like this can also have a blotchy, cyan color-cast.) Practice with a spare, waste piece of paper until you are confident you can tell the emulsion side by touch in complete darkness.

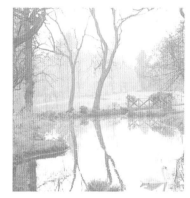

Image reversed

COLOR PRINTS FROM SLIDES

Purple color-cast

If the print has a purple color-cast, the paper was slightly fogged by white light before exposure, which destroyed most of the top yellow dye layer. Seal the darkroom completely against white light, and if you are using a safelight, make sure it is the correct type for color printing, that the filter cover is securely in place, and that the bulb is of the recommended wattage.

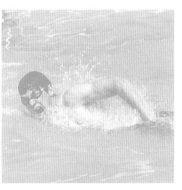

Light purple color-cast

Magenta color-cast

If a processed print shows a pale image, reversed left to right, the paper was probably placed under the enlarger with the emulsion side face down, so that the paper was exposed through the back. (Note that prints like this can also have a blotchy, cyan color-cast.) Practice with a spare, waste piece of paper until you are confident you can tell the emulsion side by touch in complete darkness.

Bright magenta color-cast

Blotchy, uneven image

This is usually due to the printing paper being loaded into the processing drum with the emulsion side the wrong way up, so that uneven amounts of each chemical solution reach the emulsion. The same happens if the paper is correctly oriented but not enough solution is used. Be very careful at every stage.

Unevenly processed image

White or colored scratches

These indicate that the delicate surface of the printing paper has been damaged. Scratches often come up white, but can also be blue, yellow, magenta, or cyan, depending on the depth of the scratch. Always handle the paper gently, especially when still wet, because this is the time when the emulsion is most easily affected.

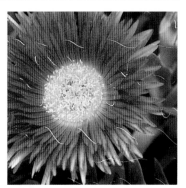

Scratches on print

GLOSSARY

A

Adobe Photoshop Professional-standard image manipulation software package. Although it is costly and requires a powerful computer, the program offers a wide range of techniques and effects. Suitable for PCs and Macs.

AE See *Autoexposure.*

Aerial perspective Illusion of depth and distance in a photograph due to the light-scattering effect of atmospheric haze.

AF See *Autofocus.*

Ambient light See *Available light.*

Analogue A non-digital recording system where the strength of the signal is in direct proportion to the strength of the source.

Angle of view Most widely separated parts of a scene that a lens is capable of resolving into an acceptable image on a piece of film. The angle of view varies according to the focal length of the lens and the camera format.

Anti-aliasing A method of smoothing diagonal lines in digital images, to avoid a staircase, or stepping, effect created by the individual pixels.

Antihalation layer Coating of dye on the back of films that absorbs light. Without this layer, light would be reflected back from the film base and through the emulsion, creating ill-defined haloes around sources of bright light in the image.

Aperture Circular opening within a lens that determines the amount of light that is allowed to pass through to reach the film. On all but the simplest of cameras, the size of the aperture can be varied by a diaphragm, which is set to different-sized openings, known as "stops," calibrated in f-numbers.

Aperture priority Type of semi-automatic exposure system whereby the photographer sets the aperture and the camera selects the corresponding shutter speed to ensure correct exposure of the scene.

APS (Advanced Photo System) Miniature film format used for compact cameras and some SLRs. Film is automatically loaded from the cassette by the camera, and is returned in the cassette after processing. An indicator shows whether the film is unused, partly used, completely used, or developed. A five-digit reference number on the cassette is also printed on the back of prints to allow you to identify negatives. The image area of the format is 30.2 x 16.7mm, but the user can choose from three print sizes at the time of shooting. Information about each picture is marked invisibly on the film's magnetic strip, and this data is used during printing.

Archival Any process or material that is specifically designed to significantly improve the life expectancy of the image.

Array The arrangement of image sensors in a digital device.

Artefacts Unwanted information in a digital image, caused by limitations in the recording process.

Attachment A digital file attached to an e-mail.

Autoexposure Camera system designed to set the size of the aperture and/or the shutter speed, to ensure correct exposure of a scene. Film speed is also taken into account.

Autofocus A system where the lens is adjusted automatically by the camera to bring the image into sharp focus.

Autofocus illuminator System used in some cameras to assist autofocus in low light situations. A red pattern is projected onto the subject, which enhances the contrast-detection function of the autofocus, allowing the lens to be adjusted correctly.

Available light Light that is normally available in a scene, such as extra domestic tungsten lighting, but not including artificial light such as flash. Also known as ambient or existing light.

B

B (Bulb) setting Shutter setting found on many cameras that holds the shutter open for as long as the release is depressed. Used for manually timing exposures that are longer than the standard shutter speeds available.

Backlight compensation control Manual exposure control found on many modern cameras that opens the aperture by a predetermined amount to compensate when the main subject is backlit. Most exposure-measuring systems tend to underexpose a backlit subject because the side of the subject facing the lens is in shadow.

Backlighting Lighting that illuminates the subject from the rear. See also *Backlight compensation control.*

Back-up Copy of a digital file, kept in case of damage to or deletion of the original.

Ball-and-socket head Simple type of camera-mounting system found on some tripods. It consists of a ball that can be rotated in a cup-shaped fixture, allowing sideways and up-and-down camera movements. See also *Tripod.*

Barn doors Set of four hinged metal flaps on a frame that fit around a spotlight. Moving the flaps in or out of the light beam controls the spread of light.

Barrel distortion Design fault, usually associated with wide-angle lenses, that causes vertical lines near the edges of the frame to bulge outward.

Bellows See *Extension bellows.*

Between-the-lens shutter Shutter system on most compact cameras that is built within the lens itself. See also *Focal-plane shutter.*

Bit The basic unit from which any digital piece of data is made up. Each bit has a value of 0 or 1. Digital files are usually measured in bytes, which are each made up of 8 bits.

Bleed A picture that is printed or cut so that the image extends to the edge of the paper.

Bluetooth Wireless connection system used to link different computer peripherals and digital devices using radio signals.

Blur Unsharp image area caused by camera or subject movement, inaccurate focusing, or a limited depth of field.

Bounced flash Light from a flash that is first directed at a surface, such as a wall, ceiling, or reflector, before it reaches the subject. This creates a broad, soft area of lighting.

Bracketing Taking a series of photographs of the same scene with each frame at a different exposure setting. Useful when you want to select slightly darker or lighter prints than the exposure system would normally produce, or when it is difficult to judge the best exposure.

Burning-in Photographic printing term used to indicate those parts of an image that would benefit from extra exposure. Parts of the image not requiring burning-in must be shaded from the enlarger light during this process. The procedure can be mimicked by most digital manipulation programs.

Byte Standard unit for measuring memory capacity of digital devices. Each byte can have one of 256 values, and is equal to 8 *bits.*

C

Cable release Mechanical or electrical device used to trigger the shutter. Useful if a camera is mounted on a tripod, as it ensures that the camera is stable at the moment of exposure.

Cassette Metal or plastic holder for 35mm and APS film.

Catadioptric lens See *Mirror lens.*

CC filter Abbreviation for Color conversion

filters – pale color filters designed to provide small changes in color balance when using color slide film.

CCD (Charge Coupled Device) An imaging sensor used in digital cameras, found at the focal plane. It converts the focused image into an electrical signal. See *CMOS sensor*.

Center-weighted metering Type of exposure-measuring system that assumes the subject is placed in the center of the frame so weights the exposure in favor of that area.

Chromatic aberration Lens fault that causes the different wavelengths of light to focus on slightly different planes. It appears as a series of different-colored fringes around the subject. Occurs with some cheap camera lenses, and lenses with long focal lengths.

Clip test Small length of film clipped from the beginning of an exposed roll. This is processed in advance so that processing times can be adjusted if necessary for the rest of the film.

Clone tool Facility on many digital image manipulation programs that allows you to replace an area of the image with a copy taken from another part of the image. Extensively used for removing blemishes, dust marks and unwanted subject matter from a digital photograph.

CMOS (Complementary Metal Oxide Semiconductor) An imaging sensor used in digital cameras similar to a CCD sensor. It is found at the focal plane, and converts the focused image into an electrical signal.

CMYK Cyan, Magenta, Yellow, and Black – the four primary inks used in commercial and desktop printing to produce full-color images. Digital photographs and scans are recorded in RGB (red, green, and blue), but can be converted to the CMYK color space using imaging editing software. It is not, however, necessary to convert before printing.

Color balance The matching of film or imaging chip settings to ensure that white and grey tones appear in a picture as they would to the human eye. With color film, color balance can be changed using filters. With digital cameras, color balance is changed electronically using the white balance system.

Color-cast Unwanted color tint on an image, usually created by incorrect color balance or by a reflection from a strongly-colored object.

Color depth The amount of color information in a digital image. 8-bit color offers 256 distinct colors, 16-bit color offers over 65,000 colors, whilst the human eye is capable of distinguishing over 16-million colors (32-bit color).

Color gamut The range of colors that can be displayed by a computer screen, or printed by a printer. This range of possible colors may well be different for both – and different from those recorded in the digital file.

Color management A system that warns you of color gamut problems, and helps to ensure that the colors that are printed look the same as those you see on screen.

Color temperature Measurement of the color of light, often expressed in Kelvin (K). The human eye adjusts for the color temperature of different light sources without us realising. A digital camera can make electronic adjustments using its white balance system. When using color film, if accurate color balance is essential, correct filtration is often necessary when shooting or printing.

Compact A type of camera that has a shutter mechanism built into the lens. Compacts use point-and-shoot designs that are easy to carry around. Many have built-in zooms and either record images digitally or on film.

Complementary colors In a photographic context, this term refers to the colors yellow, magenta, and cyan, which are complementary to the primary colors blue, green, and red. Colors are complementary to one another if, when mixed in the correct proportions, they form white or gray.

Contact sheet A print with the images from the same roll of film exactly the same size as the negatives. Contacts are produced by placing the negatives in contact with a sheet of photographic printing paper, pressing them down under a piece of glass, and exposing them to light.

Continuous AF Autofocus setting where the focus is constantly adjusted up until the moment the shutter is fired. Useful for moving subjects, where it is inappropriate for the focus distance to be locked once correct focus is initially found.

Continuous tone Term used in black and white photography to describe a negative or print that has gradations of tone from black to white, which correspond to the different tones of the original subject.

Contrast range A measurement of the difference in brightness between the darkest and lightest part of an image. Films and image sensors are capable of successfully dealing with differing, but generally limited, contrast ranges.

Contre jour Another term for backlighting.

Converging verticals An effect usually associated with a wide-angle lens that occurs when the film plane and the subject are not parallel. This results in the vertical sides of a tall building appearing to converge when the camera is tilted back to include the top.

Cropping Removing unwanted parts of an image by enlarging only part of the frame during printing or digital manipulation.

D

Daylight-balanced film Film designed to reproduce correct subject colors when exposed in daylight or by the light of electronic flash or blue flash cubes. See also *Tungsten-balanced film*.

Dedicated flash Type of flashgun designed to be used with a specific camera or range of cameras. Once attached to the camera, the flashgun effectively becomes an extension of that camera's circuitry, controlling shutter speed, receiving film speed information, and using the exposure meter.

Depth of field Zone of acceptably sharp focus extending in front of and behind the point of true focus. Depth of field varies depending on the aperture selected, the focal length of the lens (or zoom setting), and the focused distance. Depth of field is increased if a smaller aperture is set, a lens with a shorter focal length is selected, or the further the subject focused on is away from the camera.

Depth of field scale Pairs of f-numbers engraved on a lens barrel that indicate the effective depth of field surrounding a subject when the lens is focused on the subject and the desired aperture has been selected.

Depth of focus Distance that the film plane can be moved without requiring the camera to be refocused.

Diaphragm Adjustable aperture of a lens. The size of the aperture affects the amount of light reaching the film, and the depth of field.

Diffuser Any material that is used to scatter and soften light.

Digital manipulation Any alteration to a digital image on a computer that changes its appearance. Digital manipulation software provides a range of tools and techniques that are similar to those of the traditional darkroom, hence the fact that digital manipulation processes are often referred to as the digital darkroom.

Dodging Masking selected areas of the image at the printing stage to reduce exposure in that area in relation to the rest of the image. A process that is often recreated with tools available during digital manipulation.

Downrating Exposing film as if it were less sensitive to light than its ISO rating indicates. Allowances for downrated film have to be made during development. Also known as pulling.

dpi (dots per inch) A measure of the resolution of a printer or other digital device.

DPOF (Digital Print Order Format) Facility available on some digital cameras that allows users to mark the images that they wish to have processed into prints.

Driver A piece of software that is used by a computer to control and communicate with a printer, scanner, or other peripheral.

DX coding Black and silver markings on a 35mm film canister that can be read by many cameras. These usually only tell the camera the film's ISO speed (its sensitivity to light), but the code can also communicate the length of the roll and its exposure latitude.

Dye sublimation Printing method used to make high-quality prints from digital image files. The results look and feel very similar to traditional photographic prints.

E

Electronic flash Type of flash that discharges an electric current through a gas-filled tube to produce a short burst of bright light.

Emulsion Light-sensitive coating on photographic film and printing paper consisting of silver halides suspended in gelatin.

Enlargement Any size of print that is larger than the transparency or negative from which it is produced.

Enlarger Darkroom device that projects the image of a negative or transparency onto a piece of photographic printing paper.

EXIF (Exchangeable Image File) Data recorded by many digital cameras as part of the image file. This data automatically records a wide range of information about the picture, including the date and time it was recorded, aperture, shutter speed, model of camera, whether flash was used, number of pixels used, metering mode, exposure mode, exposure compensation used, and zoom setting. This information can be read by certain software. However, the information can easily be lost if the image is subsequently saved in an incompatible file format.

Exposure Amount of light received by a photographic emulsion or imaging chip. Overall exposure is the product of the intensity of the light, the aperture size, and the shutter speed.

Exposure latitude Amount by which a film may be over- or underexposed and still produce an acceptable result when given standard processing. Fast films in general have a wider exposure latitude than slow films.

Exposure latitude will depend on the contrast range of the subject.

Exposure lock Feature found on many automatics SLR cameras that allows the photographer to take a light reading from one part of a scene, lock the reading into the camera, and recompose the picture and shoot. A useful feature when the subject is backlit or when the main subject is either much lighter or darker than the surrounding scene.

Exposure meter A device that measures the amount of light reflected from or falling onto the subject, assesses the film speed, and recommends a shutter speed and aperture to achieve the correct exposure. Can be built into the camera or hand-held; it is also known as a light meter.

Extension bellows Close-up attachment for SLR cameras and view cameras that fits between the camera body and the lens. The bellows unit is made of flexible material and mounted on rails.

Extension tubes Similar in principle to an extension bellows, extension tubes are made of metal in different lengths and can be used singly or in combination to give different degrees of subject enlargement.

F

Feathering Technique used in digital manipulation to soften the edge of a selection or an effect. A certain amount of feathering is necessary with most selective operations so that the joins between images do not show.

File format The way in which a digital file is saved. A digital image can be saved in a wide variety of file formats – the most commonly-used being TIFF and JPEG. The format dictates which programs will be able to read and open the file. It also dictates the amount of information and the detail that is stored. Other formats include RAW, GIF, and Photoshop.

Fill-in light Supplementary lighting from a flash or reflector that is used most often to lighten shadowy areas of the subject and reduce overall contrast. Also used to add highlights if the subject is flatly lit.

Film back Preloadable film holder designed for use with a medium-format camera. It is possible to change from black and white to color or from color negative to color transparency film at any time (even halfway through a film), simply by removing the film back from the camera and attaching another, loaded with the appropriate film. A thin, dark plate protects the film from accidental exposure. Digital backs are also available.

Film plane Plane on which the film lies in a camera. The camera lens is designed to bring images into focus precisely at the film plane to ensure correctly exposed pictures.

Film speed The more sensitive a film is to light, the "faster" it is. The speed of a film is indicated by its ISO number. Each doubling of the ISO number represents a doubling of light sensitivity (for example from ISO 100 to 200 or from ISO 400 to 800). Slow films are in the range ISO 50–100; medium-speed films ISO 200–400; and fast films ISO 800–3200.

Filter Glass, plastic, or gelatin disks or squares that fit over a camera lens or, less commonly, the light source, in order to change the appearance of the finished image.

Filter factor Most filters subtract some of the light passing through them. Through-the-lens (TTL) exposure-metering cameras automatically compensate for any extra exposure required, but for non-TTL and manual cameras, the mount of the filter may be engraved with a filter factor that indicates the additional exposure that has to be given.

Fisheye lens Extreme wide-angle lens that produces highly distorted, circular images, sometimes with an angle of view in excess of 200˚. Depth of field at every aperture is so extensive that focusing may not be necessary.

Fixed-focus lens Lens that is set to one subject distance from the camera and cannot be selectively focused closer than or beyond the subject. Used on the simplest of cameras, the lens is usually set at the hyperfocal point, which, when coupled with a small maximum aperture, renders most subjects relatively sharp. See also *Hyperfocal point*.

Flare Non-image-forming light caused by light scattering as it passes through the glass surfaces of a lens, or light reflected from inside the camera body itself.

Flash See *Electronic flash*.

Flash fall-off Progressive underexposure of those parts of a subject that are beyond the working distance of the flash.

Flash fall-in See *Fill-in light*.

Flash meter Type of hand-held exposure meter designed to register the very brief burst of light produced by a flash. Some exposure meters can be used in both continuous light and flashlight.

Flash synchronization speed Fastest shutter speed available that ensures the shutter is fully open when the flash is fired.

Flash umbrella Umbrella-shaped reflector that casts a broad area of soft, diffused

light onto the subject when flashlight is bounced off its inside surfaces. Also known as a brolly.

Flashgun Any type of add-on flash unit.

Floodlight Studio light designed to produce a broad beam of light.

f-number Series of numbers engraved on the barrel of a lens that represent the sizes of aperture available. Moving the aperture ring up one stop (for example from f4 to f5.6) makes the aperture smaller and halves the amount of light passing through the lens. Moving the aperture ring down one stop (for example from f11 to f8) makes the aperture larger and doubles the amount of light passing through the lens. The scale of f-numbers is calculated by dividing the focal length of the lens by the effective diameter of the aperture, so a 110mm lens and an effective aperture diameter of 10mm would equal f11. f-numbers are also known as f-stops.

Focal length Lenses are most often described by their focal length, measured in millimeters (mm); this is the distance between the optical center of the lens when the lens is focused on infinity, and the focal plane. Zoom lenses offer a range of focal lengths.

Focal plane Plane at which light from the lens is brought into focus. In order to ensure sharp images, the focal plane and the film plane must precisely coincide.

Focal-plane shutter Type of shutter consisting of fabric or metal blinds situated just in front of the focal plane. Focal-plane shutters are normally found only in cameras with interchangeable lenses.

Focal point Point of light on the optical axis where all rays of light emanating from a given subject converge and come into sharp focus.

Focus lock Feature found on autofocus SLR cameras and many compact cameras that allows the photographer to focus the lens on one part of a scene, lock that setting into the camera, and then recompose the picture and shoot. A useful feature when the subject is off-center, as most AF systems focus on anything that is positioned in the middle of the frame.

Focusing Adjustment of the lens-to-film distance in order to achieve a sharp image of the subject.

Focusing screen Glass or plastic screen mounted inside the camera that allows the image to be viewed and focused accurately.

Format Size or shape of a film original, printing paper, or camera viewing area.

f-stop See *f-number*.

G

Gain Amplification of an electrical circuit. Used in digital cameras as a way of electronically boosting the sensitivity of the imaging chip in lowlight. This allows digital cameras to allow a range of different sensor sensitivities, equivalent to using film with different ISO ratings.

Gamma A method for measuring or setting contrast.

GIF (Graphic Interchange Format) Digital file format that can be used for saving graphics and images.

Grain Exposed and developed black silver halide grains making up a photographic image.

Graininess Term describing the visual appearance of irregular clumps of exposed and developed silver halide grains on films and printing papers. Graininess is most apparent in light-toned areas of an image.

Granularity Qualitative measurement of the degree of clumping together of silver halide grains within a photographic emulsion.

Guide number Measure of the maximum output of an electronic bulb or flashgun that varies according to the film speed used. Lens apertures can be calculated by dividing the guide number by the distance between the subject and the flash. Suppose the number is 40 (metres with ISO 100 film), then at 10m (33ft) the lens would be set at f4, at 5m (16ft) f8, and so on.

H

High-key image An image composed predominantly of light tones or colors. See also *Low-key image*.

Highlights Brightest parts of an image.

Histogram Graphical display – used as a way of depicting and manipulating the brightness, tonal range and contrast of a digital image.

Hot shoe Metal plate usually found on the top of the camera, which is designed to hold a flashgun securely. Electrical contacts on the base of the hot shoe correspond to contacts on the bottom of the flash, so completing a circuit when the shutter is fired.

Hybrid camera A compact digital camera that is designed to handle like an SLR. Combines the fixed lens of a standard compact camera with SLR features such as adjustable aperture, shutter speed, and color balance.

Hyperfocal point The nearest point of sharp focus to a camera when a lens is focused on infinity (for a particular aperture). If the lens is focused at the hyperfocal point, depth of field extends from infinity to a point halfway between it and the camera.

I

Incident light The light falling on a subject, as opposed to that being reflected by it.

Infra-red (IR) film Film that is sensitive to invisible infra-red light. IR film is most commonly used for black-and-white photography because it is relatively insensitive to blue. This produces dark, moody images, which can be made even more dramatic by using a red filter. Colour IR film available but less widespread.

Inverse square law Law that states that a doubling of the distance between a subject and a compact light source, such as a flash, results in a quartering of the light illuminating the subject.

ISO Abbreviation for International Standards Organization, the internationally agreed film speed rating system that amalgamated the older ASA and DIN scales.

IX240 Another name for the APS film format.

J

JPEG (Joint Photographic Experts Group) A file format used widely for digital images. A variable amount of compression can be used to vary both the detail stored and the resulting size of the file. It is the standard format used by most digital cameras (although RAW or TIFF formats may be available for the highest resolution capture settings).

K

Kelvin (K) Unit of measurement used to describe the color temperature of light sources. See *Color temperature*.

Key light Alternative term for *Main light*.

L

Large-format camera See *View camera*.

Lasso Selection tool used in digital manipulation software. Allows you to outline an area of an image by drawing a series of points around it.

Latent image Invisible image on film or photographic printing paper formed by the action of light from the subject and made visible by the development process.

Layer Feature available on some digital manipulation software that allows you to lay different versions or elements of an image on top of each other. The original image can be protected as the background layer, whilst alterations are made to copy layers. Layers can be opaque – or they can be merged with layers below in a number of different ways. Layers are an essential way of working for any serious manipulation work.

LCD (liquid crystal display) Type of display panel used widely on cameras to provide information to the user. Color LCDs are capable of showing detailed images, and are often used as viewing screens on digital cameras.

LED (light emitting diode) Colored indicator lamp used on many cameras for a variety of purposes.

Lens Glass or plastic optical instrument that can refract light. A photographic lens consists of different-shaped glass elements arranged in groups to form a compound lens. In a compound lens, some elements are convex in shape, causing rays of light to converge, and some concave, causing rays to diverge.

Lens hood Attachment made of metal or rubber that screws into the filter mount on the front of a lens and prevents unwanted light from reaching the surface of the lens and affecting the image.

Lens speed Refers to the maximum aperture available with a lens. Lenses with wide maximum apertures admit most light, and so can be used in dimmer lighting conditions or to compensate for faster shutter speeds; these are known as fast lenses.

Light box Box containing fluorescent tubes with an opaque glass or plastic top used for viewing transparencies.

Light meter See *Exposure meter*.

Linear perspective Sense of depth and distance in a two-dimensional photograph caused by the apparent convergence of parallel lines receding from the camera.

Lith film Black-and-white film with a tonal range that is reduced to black and white with only minimal greys. Must be developed with a special lith developer.

Low-key image An image composed predominantly of dark tones or colors.

— M —

Macro Term used to describe equipment or features that allow you to take pictures at a closer shooting distance than usual, to provide a more magnified image.

Magic wand Selection tool used in digital manipulation that lets you select an area of similar color or tone simply by clicking on it.

Main light Principal lighting unit that provides illumination for a subject or scene.

Marquee Selection tool used in digital image manipulation programs that allows you to draw regular shapes – such as ovals or rectangles.

Medium-format camera Camera with a picture format larger than 35mm but smaller than a view camera. The rolls of film measure 6cm (2 ¼ in) across - but the image size varies from camera to camera. Popular formats include 6 x 6cm, 6 x 4.5cm and 6 x 7cm – with a variety of panoramic sizes also available.

Megabyte (MB) Unit for measuring the capacity of computer memory. Equal to 1,024 bytes (two to the power of ten bytes).

Megapixel Measurement of the resolution of a digital camera, equal to one million pixels.

Memory card A removable electronic card used in most digital cameras to save and store digital images. Cards of different memory capacity are available.

Mirror lens Telephoto lens with mirrors replacing some of the glass elements found in a traditional lens. The effect of the mirrors is to reflect light rays up and down the length of the lens to produce a long focal length in a relatively short lens barrel. The aperture of such lenses is usually fixed at around f8. Also known as a catadioptric or reflex lens.

Modeling lamp Low-wattage, continuous-output lamp mounted in the lighting head of a flash unit. Allows the photographer to preview the effects of light and shade, especially the fall of the shadows that will be produced when the flash fires.

Monochromatic Describes a photographic image that is solely or predominantly composed of a single color or shades of a single color.

Montage Composite picture made from a number of photographs.

Motordrive Automatic film advance system, either built into the camera or available as an add-on accessory. The system allows continuous shooting, taking picture after picture as long as the trigger is held down.

Motorized film transport Automatic feature found on many cameras, which uses a motor inside the camera to advance the film at the beginning of a roll, advance the film after each exposure, and rewind the film after the last shot is taken.

Multiple exposure Technique of making more than one exposure appear on the same image. Sometimes done for special effect but can also occur due to a fault with the film advance system.

Negative Developed film image in which colors or tones of the original subject are reversed. An intermediate stage in the production of a print.

Neutral density filter Gray-colored lens filter that reduces the amount of light reaching the film without affecting color balance.

Off the film (OTF) A light-reading system that gauges exposure by measuring the amount of light being reflected by the film.

Open flash Button on some flashguns that allows the flash to be fired without exposing the film. Very important feature on any flash unit if exposure using a flash meter is required. Also used for "painting with light" technique.

Opening up Increasing the size of the aperture to allow more light to reach the film.

Overexposure Occurs if a film receives too much light, either by exposing it to too bright a light or by allowing the light to act on it for too long. It results in light prints or slides and a reduction in subject contrast.

— P —

Pan-and-tilt head Versatile type of camera-mounting system found on some tripods. The tripod head can be swiveled from side to side or tilted up and down, and the camera turned either horizontally or vertically and locked securely in any position. See also *Tripod*.

Panning Action of turning the camera while the shutter is open to keep pace with a moving subject. The subject should appear reasonably sharp while all stationary parts of the scene are blurred.

Panorama A broad, continuous scene taken either with a panoramic camera or produced by taking a series of different photographs of a scene and joining the individual pictures together to create a panoramic view.

Panoramic camera Camera that offers an image size where the width is significantly greater than the height.

Parallax error Framing error almost always associated with direct vision viewfinders, which results in a slight difference in viewpoint between the image as seen in the viewfinder and that recorded on the film.

Passive autofocus Autofocus system that adjusts the focus of the lens by looking at the image itself, rather than actively measuring the subject distance. This type of autofocus is widely used on 35mm SLRs and on some other types of camera. It is also known as contrast-detection or phase-detection autofocus.

Pentaprism Five-sided prism usually found on the top of SLR cameras. Its inside surfaces are silvered so that the image produced by the reflex mirror appears in the viewfinder the right way up and correctly oriented left to right.

Perspective control lens See *Shift lens*.

Photoflood See *Floodlight*.

Photogram Picture made by placing opaque and/or translucent objects in contact with photographic paper or film, exposing the paper to light, and then developing normally.

Photomicrography Production of larger-than-life images of small subjects by attaching the camera to a microscope.

Pixel Short for picture element. A single light-sensitive cell in a digital camera's image sensor. The basic unit used when measuring the maximum resolution of a digital camera or a digital image.

Pixelated A digital image in which the individual picture elements that make it up have become visible. This is usually due to over-enlargement to poor resolution of the original image. The effect can also be created with manipulation software, using effects such as a mosaic filter.

Plug-in Piece of software which adds functionality to an existing computer program. Plug-ins are available for some digital image manipulation programs, providing an increased range of effects and transformations.

Point-and-shoot See *Compact*

Polarizer A filter that only lets through light vibrating in one plane. It can be used to deepen the color of part of a picture, such as the sky. It can also be used to eliminate or reduce reflections from non-metallic surfaces such as water or glass. It must be rotated in front of the lens until you achieve the desired effect. Linear polarizers can be used with some cameras, but can interfere with the metering and autofocus systems of many models. Circular polarizers avoid such problems.

Polaroid camera Instant camera that produces an image within minutes of exposure. Each print contains its own processing chemicals and is automatically fed out of the camera, whereupon the processing chemicals develop the print.

Polaroid film There are two types of polaroid film: the first is used in a Polaroid camera, while the second is used in an interchangeable Polaroid back that can be added to specially designed SLR, medium-, and large-format cameras. This second type is used by professional photographers to preview the shot before re-taking with the desired film.

Portrait lens Short telephoto lens with a focal length of about 90mm (for a 35mm camera).

Posterization Technique where the number of colors or tones in a photograph is drastically reduced. Instead of gradual changes in density and color, the picture is made up of bands of identical color – similar to a painting-by-numbers picture. The effect can be achieved in the darkroom, but is produced far more easily using digital image manipulation software. Posterization can also be an unwanted side-effect of digital imaging – caused by over manipulation of the image.

ppi (points per inch) Also known as pixels per inch, ppi is an indication of the resolution of a digital image produced by a digital camera or scanner.

Predictive autofocus Autofocus setting where the focus is not only constantly adjusted until the shutter is actually fired, but is also adjusted during the delay between pressing the trigger and the shutter actually opening. The camera can therefore track moving subjects more accurately. A common feature on autofocus SLRs.

Preview button See *Stop-down button*.

Primary colors In a photographic context, the term usually refers to the colors blue, green, and red. In terms of painters' pigments, the primary colors are blue, yellow, and red.

Prime lens See *Fixed focal length lens*.

Printing-in See *Burning-in*.

Pulling See *Downrating*.

Push processing Technique for increasing the sensitivity of a film. The film is exposed at a higher-than-normal ISO rating, and is then developed for longer to compensate.

R

RAM (random access memory) A computer's working memory – the storage area it uses whilst working on files and processing information. Digital manipulation programs can require more RAM than many other computer programs, particularly when handling large image files.

Rangefinder Manual focusing system that superimposes two views of the subject. When they coincide, the subject is in focus.

Rebate Non-image area on a film in which the frame numbers and, on some films, the sprocket holes are located.

Rear curtain sync Facility found on some SLRs and flashguns that synchronizes the flash output with the moment when the second shutter curtain is about to close. Normally a flashgun synchronizes with the point where the first shutter is fully open. The facility gives more natural-looking images when using slow synch flash with a moving subject, as the blurred after-image created by the ambient light appears behind the line of movement, rather than in front of it.

Reciprocity failure Loss of sensitivity of a photographic emulsion when given either a very brief or a very long exposure. Color material may also experience uncorrectable shifts in color balance.

Red-eye Fault caused by light reflected from a subject's eyes when exposed by flash. A particular problem with cameras with built-in flash with telephoto zoom settings – as the angle between flash and lens axis is narrow. If possible, move the flash unit to one side or bounce the light before it reaches the subject. Some cameras have settings that use a preflash to reduce the size of the irises of the subject's eyes, to minimize the problem. Another solution is to move closer to the subject, using a wider lens setting.

Reflected light reading An exposure reading taken by measuring the amount of light reflected back from the subject toward the camera. All TTL (through-the-lens) exposure-measuring systems take a reflected light reading. See also *Through-the-lens metering*.

Reflex camera Camera design that uses a mirror between the lens and focusing screen to correct the upside-down image produced by the lens.

Reflex lens See *Mirror lens*.

Resolution The ability of a lens, film or digital imaging device to record fine detail.

Retouching Removing blemishes and/or changing the tonal values of negatives, slides, prints or digital images.

RGB Red, green, and blue. The three colors used by digital cameras, scanners, and computer monitors to display or record images. Digital images are therefore usually RGB models – but they can be converted to other color models (such as CMYK).

Ring flash Circular flash lighting unit that fits around the outside of the front of the lens. Most often used in close-up photography to produce localized, shadow-free illumination.

Roll-film camera See *Medium-format camera.*

S

Safelight Low-output darkroom light filtered through an appropriate color (orange is usual) so as not to affect unexposed printing paper. Black and white printing paper is not affected by safelighting, but most films and color papers will be, so different colored filters are used.

Scanner Device that converts a physical image into a digital one.

Sheet film Large-format film cut to a specific size rather than in roll form. Each sheet is used for just one photograph.

Shift lens Lens in which some elements can be shifted vertically or horizontally off-center, to overcome the type of problem encountered when a camera is tilted (to include the tops of tall structures, for example). Also known as a perspective control (PC) lens.

Shutter Device that controls the moment of exposure and the length of time light is allowed to act on the film to produce an image. See also *Between-the-lens shutter* and *Focal-plane shutter.*

Shutter priority Type of semi-automatic exposure system whereby the photographer sets the shutter and the camera selects the corresponding lens aperture to ensure correct exposure of the scene.

Single lens reflex (SLR) Type of camera in which the viewfinder image shows the subject through the same lens that will be used to expose the film or imaging chip. A mirror is used to reflect the image to the viewing screen, which moves out of the way when the picture is taken.

Skylight filter Pale amber filter that can be used with color film to introduce a slight, natural-looking color-cast. Useful with cold-looking scenes and to counteract the tendency of some films to produce a blue cast in shadow areas.

Slave unit Fires additional synchronized flashes when the principal flash lighting unit connected to a camera fires.

Slide Positive film image designed to be viewed by projection. Also commonly known as a transparency or a positive.

Slow film See *Film speed.*

Slow lens See *Lens speed.*

Slow sync flash Technique where a slow shutter speed is combined with a burst of flash. The flash usually provides the main illumination, but the ambient light creates a secondary image that can be useful in suggesting movement. The technique can also be used to ensure that the background receives more exposure than it would otherwise have done.

SLR See *Single lens reflex.*

Snoot Type of flash head used to direct a narrow beam of light over a small area.

Soft-focus lens Lens designed to produce a slightly soft image, with not all in-focus elements critically sharp. A portrait lens may also be a soft-focus lens.

Solarization Complete or partial reversal of an image, caused by massive overexposure to white light. The effect can easily be mimicked using digital manipulation software.

Spot meter Type of exposure meter with an extremely narrow angle of view. A spot meter is used to take a light reading from a specific part of a subject.

Spotlight Unit that produces a strong beam of light, which can easily be trained on a subject.

Spotting Removing blemishes or small unwanted areas of detail on a print using a paintbrush and dyes, watercolors, or graphite. Similar correction is possible with digital images using manipulation software, most usually with the aid of the clone tool.

Standard lens Lens with a focal length approximately equal to the diagonal of the image area of the format with which it is used. With 35mm format film the standard lens is 50–55mm, and an 80mm lens with 6 x 6cm medium format film. A standard lens reproduces about as much of a scene as you would see with the naked eye (excluding peripheral vision).

Starburst filter Special effects filter that produces starlike patterns around the sources of light in a photograph.

Stop Another name for aperture. See *Aperture.*

Stop bath Chemical solution (usually weak acid) that halts the action of film or paper developer and neutralizes any developer residues, so preventing contamination of other processing chemicals.

Stop-down button Manual control that closes down the aperture to that selected for exposure. The photographer can then judge depth of field on the focusing screen. Also known as a preview button.

Stopping down Closing down the aperture.

Strobe light Low-output flash light that is capable of delivering many thousands of flashes per second.

Studio flash Large flash units, often connected to heavy-duty power packs and mounted on adjustable stands, and designed to illuminate large areas of a photographic studio or for use on location.

T

Technical camera See *View camera.*

Telephoto lens Lens with a focal length that is longer than the standard lens for the format being used. See *Standard lens.*

Test strip Strip of printing paper or film that is given a range of trial exposures.

Through-the-lens metering A type of light-measuring system used commonly in reflex cameras to measure the light that is reflected from a subject and then passes through the lens. Commonly abbreviated to TTL.

TIFF (Tagged Image File Format) Digital image format used to record files with maximum available detail. File sizes can, however, be large.

TWAIN (technology without an interesting name) Piece of software, similar to a driver, that allows you to control a scanner, or similar computer peripheral, from another application – such as a digital image manipulation package.

TLR See *Twin lens reflex.*

Tonal range Range of shades of gray, between the extremes of black and white, which can be distinguished in a photograph.

Tone An area on a print or negative that has a uniform density and that can be distinguished from other lighter or darker parts.

Transmitted light Light that passes through a transparent or translucent material.

Transparency See *Slide.*

Tripod Camera-steadying device consisting of three legs and some form of mounting system to hold the camera. Tripod legs are extendable so that the camera height can be adjusted, and most also have an extendable central column (on top of which the camera is mounted) for finer height adjustments. The two most commonly available camera-mounting heads are ball-and-socket and pan-and-tilt types.

TTL See *Through-the-lens metering*.

Tungsten-balanced film Film designed to reproduce correct subject colors when exposed in tungsten light. If exposed in daylight without the appropriate correction filter over the lens, subject colors will appear unnaturally blue. See also *Daylight-balanced film*.

Twin lens reflex (TLR) Type of medium-format camera that uses two lenses of identical focal length mounted one under the other on a lens panel. The top lens is used for viewing and focusing and the bottom lens for taking the picture. Some models have interchangeable lenses, which are changed as paired units.

U

Ultra-violet (UV) filter Colorless filter designed to remove excessive ultra-violet from the light passing through the lens. A UV filter may be left on the lens all the time to protect the lens from dirt, knocks, and scratches. UV filters do not affect exposure.

Ultra-violet light Part of the electro-magnetic spectrum beyond visible blue. In distant scenes, such as mountainous areas, ultra-violet radiation increases the effects of aerial perspective by creating a blue haze. Ultra-violet effects can be minimized by using an ultra-violet filter.

Underexposure Occurs if a film or imaging chip receives too little light, causing dark pictures and a reduction in subject contrast.

Uprating Exposing film as if it is more sensitive to light than its ISO rating indicates. Allowances for uprated film have to be made during development. Also known as pushing.

Unsharp mask (USM) A facility provided on digital image manipulation programs that allows you to sharpen an image. Takes its name from a printing process, where a soft-focus negative is sandwiched with the original in order to increase edge contrast.

UV filter See *Ultra-violet filter*.

V

Vanishing point Point at which parallel lines appear to converge in the distance. Used by artists to give realistic perspective in a two-dimensional representation.

View camera Large-format camera, using individual sheets of 5 x 4in (12.7 x 10cm) film or larger, with a lens panel mounted on a flexible bellows and a ground-glass screen at the image plane for viewing and focusing.

There are two main designs. The monorail camera allows a full, independent movement of film and lens planes – allowing a high degree of control over image distortion, perspective and depth of field. However, they are heavy and cumbersome so are best suited to studio use where they can be supported on a heavy stand. Field cameras have a baseboard to support the bellows and are slightly more portable. Also known as technical, field, or baseboard cameras.

Viewfinder Viewing system that allows a camera to be aimed and focused accurately. The viewfinder often contains exposure-related information around the edges of the screen.

Viewpoint In photography, the position from which the picture is taken in relation to the subject. Very small changes in camera viewpoint can result in considerable differences in finished prints or slides.

Vignette Gradual fading of a photographic image to white or black. The effect can be achieved in the darkroom either by holding light away from the edges to create a white vignette (see *Dodging*) or by giving a large amount of extra exposure to the edges to create a black vignette (see *Burning-in*).

Visible spectrum The part of the electro-magnetic spectrum between infra-red and ultra-violet that is visible to the naked eye.

W

White balance System by which a digital camera measures the color temperature of a light source and then corrects it so that the whites, and therefore all the other colors, appear normally to the human eye.

Wide-angle lens Lens with a focal length shorter than the diagonal of the film format with which it is used. Commonly used wide-angle lenses for 35mm-format cameras include 35mm, 28mm, and 24mm focal lengths. Lenses wider than this may show signs of barrel distortion.

X

X-ray fogging A gray veil produced when unprocessed photographic emulsions are exposed to excessive X-ray radiation. This can occur as a result of baggage screening at airports, but modern systems use X-ray dosages that should be safe for most emulsions. Repeated screenings of films, especially fast films, may have a cumulative effect.

X-sync socket External socket found on some cameras that accepts a cable connecting the shutter to an electronic flashgun used off-camera. It ensures that the firing of the flash is synchronized with the opening of the shutter.

Z

Zoom lens Type of lens designed so that groups of internal elements can be shifted in relation to each other to produce a range of different focal lengths. See also *Fixed-focus lens*.

INDEX

ACKNOWLEDGMENTS

Author's acknowledgments:
Producing this book was essentially a team effort. Special thanks go to Jane Ewart.
Steve Gorton, Alison Melvin, and Robyn Tomlinson. I would also like to thank Miranda Talbot,
Auberon Hedgecoe, Jenny Mackintosh, Mrs Surridge, Mrs Last, The Carter family, Lara and
Luke Evans and, of course, the many models who appear in the book.

Dorling Kindersley would like to thank the following:
Jemima Dunne for all her work on the initial stages of the project; Roddy Craig, editor for the last three months
of the project; Claire Edwards and Nathalie Godwin for design help; Lorna Damms, Julee Binder, and Camela
Decaire for editorial help; Leigh Priest for the index; Pippa Ward for administrative help; Iain Pusey for
computer image manipulations; Carol Hart for make-up; Slag for supplying the hats on pp.78-9; Richard
Lewington for supplying the butterflies on pp.212-13; Hazel Taylor and Doreen Mitchell for supplying the pets
on pp.234-35, and Ben Pulsford for building the sets on p.260, pp.262-3, and p.265. Thanks also to the
following for modeling: Anna Kunst, Ella Milroy, Tim Ridley, Hilary Nash and Nuala Morris (Take 2 models),
Lucy Fawcett, Kate Douglas, Lucy Keeler, Ivan Inversion, Kevin O'Kane, Arthur Pita, Georgia Cooper, Jo Cligget,
Sandra and Rosie Kuys, Oliver Swan-Jackson, Emily Gorton, Alice Surridge, Jennifer Smith, Freddy Harrold,
Daniel Evans, Shaun Rebbeck, and Croydon Kings American football team (coach Brian Smallwood).

Editor on revised edition, Nicky Munro.
Designers on revised edition, Ted Kinsey, Alison Shackleton and Phil Gilderdale.

All photographs by John Hedgecoe with the exception of the following by Steve Gorton: photo set-ups;
cameras and equipment (pp.18-19, pp.22-3, p.25, pp.26-7, pp.28-9, p.30, p.33, pp.74-75, p.76, pp.78-9, pp.86-7,
pp.90-1, pp.94-5, p.96, pp.102-3, p.104, p.106, pp.110-111, p.112, p.114, pp.118-119, p.120, pp.124-5, pp.128-9,
p.130, pp.132-3, pp.142-3, pp.144-5, pp.146-7, p.150, p.155, p.156-7, p.159, p.162, p.164, p.168, pp.170-1, p.172,
p.174, p.176, p.180, p182, p.185, p.186, p.192, p.193, pp.196-7, pp.198-9, pp.200-1, pp.202-3, p.207, p.208-9,
p.212, p.216, p.218, pp.222-223, p.224, p.229, p.230, pp.232-3, pp.234-5); darkroom (pp.260-1, pp.264-5);
home studio (pp.262-3); and photographs of John Hedgecoe (p.1, p.3, p5).

Illustrations:
Patrick Mulrey: pp.14-15, p.17, p.24, pp.240-241
Mike Garland: pp.46-46, p.73, p.139, p.155, p.185, p.207, p.229,
Janos Marffy: p.16, p.264

Information and assistance was kindly provided by:
C.Z. Scientific Instruments Limited
Canon (UK) Limited
The Flash Centre
Johnson's Photopia
Leeds Photovisual Limited
Linhof & Studio Professional Sales
Nikon (UK) Limited
Olympus Optical Company (UK) Limited
Pentax UK Limited
Polaroid (UK) Limited
The Pro Centre
Teamwork

Special thanks to Joe's Basement, London W1, for technical assistance, notably Kerrin Roberts and Godfrey Pope (color),
and Ian MacMaster and Simon Lloyd (black and white). Thanks also to Danny at DGP Photographic, London W1.

Photographic location credits:
St. Moritz, Switzerland Tourism: p.58-9
Holkham Hall, Norfolk (Seat of the Earls of Leicester):p.25 (kitchen), p.65 middle right, p.145 (kitchen), p.196, p.198, p.200
Black Sheep Mill House, Ingworth, Norfolk: p.216
Felbrigg Hall, Norfolk (National Trust property): p.222
Blickling Hall, Norfolk (National Trust property): p.27 & 192 (views of garden pavilion), p.218, p.219 top, p.224 bottom, p.225
The Mill House, Corpusti, Norfolk: p.223, p.224 top, p.251 top left
Porchester Centre Baths, London: p.254 (bottom three photos)
The Lloyds Building, London: pp.186–7